OXFORD IN ASIA STUDIES IN CERAMICS
General Editor: I. L. LEGEZA

ORIENTAL TRADE CERAMICS IN SOUTH-EAST ASIA NINTH TO SIXTEENTH CENTURIES

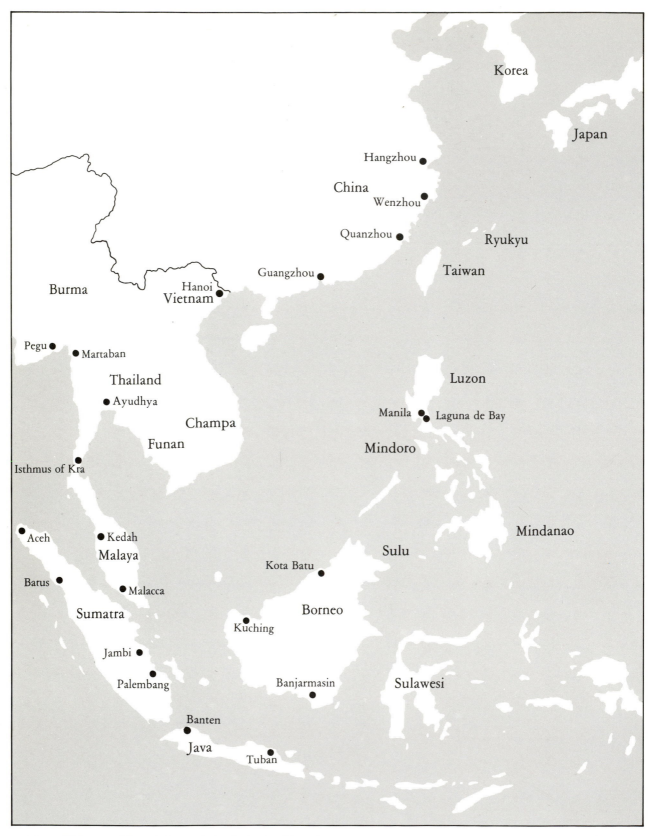

MAP 1 China and South-East Asia: Principal Trade Centres

Oriental Trade Ceramics in South~East Asia Ninth to Sixteenth Centuries

With a Catalogue of Chinese, Vietnamese and
Thai Wares in Australian Collections

JOHN S. GUY

SINGAPORE
OXFORD UNIVERSITY PRESS
OXFORD NEW YORK
1990

Oxford University Press

Oxford New York Toronto
Delhi Bombay Calcutta Madras Karachi
Petaling Jaya Singapore Hong Kong Tokyo
Nairobi Dar es Salaam Cape Town
Melbourne Auckland
and associated companies in
Berlin Ibadan

Oxford is a trade mark of Oxford University Press

© *Oxford University Press 1986*

First published 1986
First issued with updated bibliography as an Oxford University Press paperback 1990

ISBN 0 19 588963 0

Printed in Malaysia by Percetakan Mun Sun Sdn. Bhd.
Published by Oxford University Press Pte. Ltd.,
Unit 221, Ubi Avenue 4, Singapore 1440

To the memory of
Frederick W. Bodor
(1910–1985)
collector and friend

Preface

TRADE ceramics in South-East Asia are a persistent and pervasive indicator of cultural contact over at least a millennium of the region's history. They commonly take the form of Chinese glazed stoneware and porcelain ceramics with smaller contributions from the kilns of northern Vietnam and Central Thailand. Unlike other components of the early Asian trade, glazed ceramics

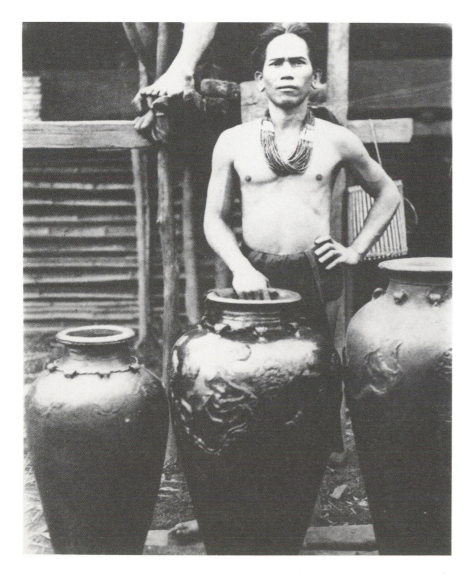

Fig. 1
An aristocrat of Balawit, Kalimantan, posing with his prized Chinese 'dragon jars'.
(Photograph Tom Harrisson, c.1945)

have displayed both a physical resilience and a social relevance shared by few other trade items. They assumed a cultural significance which transcended considerations of function and utility. As highly prized possessions, trade ceramics became an important measure of wealth and status in South-East Asian societies (Fig. 1). They also entered the realm of ritual practice, becoming an integral part of the social and spiritual life of the people, including funerary practices (Figs. 12, 14 and 15). Other art-forms absorbed decorative motifs from ceramics and imbued them with local meaning (Fig. 16).

This study traces the introduction of trade ceramics into the South-East Asian region, from its beginnings in the ninth century, through to the end of the sixteenth century when traditional Asian trade began to be significantly disrupted by European intrusion. Later classes of trade ceramics, such as the fine blue-and-white *Kraak* ware, largely a seventeenth-century ware directed to the European market, and those ceramics broadly classed as *Swatow* ware, are not included.

This historical survey of trade ceramics in South-East Asia is illustrated by a catalogue of ceramics selected from Australian collections, with introductions to technical and stylistic aspects of the ceramic traditions of China, Vietnam, and Thailand. In the catalogue a brief description of each piece is given, noting its characteristics in the following order: type, form, decoration, glaze, body, and firing-support technique. Where a piece can be attributed a specific place of manufacture this has been done, along with a date range for its production. However, as recent investigations in China indicate, caution must be exercised in attributing wares to specific kilns or groups of kilns. Many types of wares were produced over a wider area than has traditionally been believed. For example, *yingqing* ware was produced widely in South China in the fourteenth century, although areas in Jiangxi and Fujian appear to have been the principal sources for this ware. It is therefore difficult to attribute a provenance to the fine quality *yingqing* wares, richly represented in this catalogue; they may be Jingdezhen ware from Jiangxi or the products of Fujian kilns. Variations need not necessarily indicate different regions; perhaps only different kilns in the same region. A physical comparison of these wares against documented sherds from each of these regions is necessary to resolve the attribution. In the notes that follow the catalogue entries, comparable examples retrieved from documented South-East Asian contexts are cited. The principal sources for comparison are to be found in published reports of controlled archaeological excavations.

National Gallery of Victoria JOHN S. GUY
Melbourne
July 1984

A Note on the Transliteration of Chinese Words

Chinese words and names have been transliterated according to the pinyin system of romanization, in keeping with the method employed by the Government of the People's Republic of China and using *The Chinese-English Dictionary* (Hong Kong, Commercial Press, 1979).

Acknowledgements

THIS work is a revised and expanded version of a publication prepared to accompany an exhibition held in Australia in 1980, entitled *Oriental Trade Ceramics in Southeast Asia, 10th to 16th Century*. It grew out of a fascination with an aspect of South-East Asian culture which has received wide recognition only in the last fifteen years. The pioneering work of William Willetts must be acknowledged in this regard, together with that of Roxanna Brown. These writers have lucidly identified and described the ceramic traditions of the South-East Asian region, providing much of the necessary foundations for subsequent research. I was greatly encouraged in this study by Professor Wang Gungwu, and am indebted to him in many ways, not least for his inspired work on the *Nanhai*.

Colleagues at various museums have generously assisted me through critical discussions and access to collections. In particular I must thank R. J. Richards and Don Hein, Art Gallery of South Australia, Adelaide; Abu Ridho, Museum Nasional, Jakarta; Alfredo Evangelista, National Museum of Philippines; Meitoku Kamei, Kyushu Historical Museum, Dazaifu; Professor Tsugio Mikami and staff, Idemitsu Museum of Arts, Tokyo; Mde. Janine Schotsmans, Musées Royaux d'Art et d'Histoire, Brussels; Dr U. Wiesner, Museum für Ostasiatische Kunst, Cologne; and Dr Barbara Harrisson, Gemeentelijk Museum Het Princessehof, Leeuwarden. Private collectors have shared with me their collections, experiences, and wisdom. Particular mention should be made of Mr and Mrs F. W. Bodor, whose collection of early Chinese and Vietnamese ceramics is a model of coherent and discriminating collecting.

A Research Fellowship from the Research School of Pacific Studies at the Australian National University, Canberra, enabled me to spend time away from my museum duties while working on this project, and the Australia–China Council generously assisted field research in Guangdong and Fujian provinces, South China. A travel grant from the Australia–Japan Foundation made possible a review of archaeological evidence in Japan. Within my own institution, the Director, Patrick McCaughey, has been highly supportive. Finally I wish to thank Dr C. C. Macknight of the Australian National University, who has taken a close interest in this project.

Public and Private Collections Represented

Mr Michael L. Abbott
Art Gallery of South Australia,
 Adelaide
Mrs E. Bailleau
Mr and Mrs Frederick W. Bodor
Mr and Mrs T. L. Bolster
Mrs L. Borland
Miss Jane Carnegie
Mr John Cole
Dr Peter M. Elliott
Mr and Mrs D. Eysbertse
Mr Michael Hiscock
Dr H. S. K. Kent
Mrs D. Komesaroff
Mr R. H. Longden
Professor J. A. C. Mackie
Museum of Applied Arts and
 Sciences, Sydney
Mr J. H. Myrtle
National Gallery of Victoria,
 Melbourne
Mrs C. Nicholas
Northern Territory Museum of
 Arts and Sciences, Darwin
Mrs S. Probert
Lady Ramsay
Mrs Diana Stock
Mr J. M. C. Watson
Dr J. S. Yu

Contents

Figures

Maps

1. Early Chinese Contacts with South-East Asia

THE region today known as South-East Asia has held an attraction for foreign merchants and traders since early in the first millennium. It was, first, the passage through which those seeking commercial contact between the Chinese and Arabic worlds had to pass. Secondly, it was a region rich in natural resources, many of an exotic nature, which were much desired by the cosmopolitan élites of China and the Middle East. The region was therefore ideally located to function both as an entrepôt, facilitating the movement and exchange of commodities East and West, and as an active contributor to that trade, introducing rare and highly prized items into the international trade network.

From the earliest references to the region, it was renowned as a land of fabled riches and wealth, a source of gold and exotic products. To the Chinese, South-East Asia was the land of the Southern Ocean (*Nanhai*) which lay to the south beyond the Yue regions of Guangdong and Tonkin. The dynastic histories record that from the *Nanhai* came the many exotic products so valued by the Chinese nobility. To the Indian authors of some of the early Sanskrit epic literature, the lands to the east were known as *Suvanadvipa*, the 'Golden Island',[1] a source of many riches. Early Arab geographers conceived of South-East Asia less as an autonomous region; rather, they viewed it as the cultural interface between two worlds, 'the first country in India, on the edge of China'.[2]

The earliest Chinese contacts with the region of the *Nanhai* were undertaken in pursuit of those luxury commodities which were most sought after in court and palace circles. Rhinoceros horn, ivory, tortoise shell, pearls and kingfisher feathers were amongst the most desired of the exotic commodities of the Southern Ocean.[3] As early as the reign of Emperor Han Wu-ti (141–87 BC) imperial envoys were dispatched with the assistance of the Nan-yue (people on the southern frontier skilled in sailing) to search for the 'rare' and 'precious' items.[4] The ports of embarkation for the *Nanhai* at this time were in the Gulf of Tonkin.[5] The dynastic history of the period, the *Han Shu*, written in AD 80, provides one of the earliest descriptions of the luxury trade in South-East Asia and of the lands themselves:

These countries are very large and populous and are full of strange things. They have all come with tribute [for the Emperor] since the time of Wu-ti.

There are chief interpreters attached to the Yellow Gate [eunuchs serving in the palace] who go to sea...to buy bright pearls, *pi-liu-li* [opaque glass] rare stones and strange things, taking with them gold and various fine silks to offer in exchange....

The merchant ships of the barbarians are used to transfer them to their destination. The barbarians also profit from the trade....[6]

This first century AD passage is invaluable for the information it contains on both the nature and content of the trade. The earliest finds of Chinese ceramics in South-East Asia have been claimed to belong to this period.[7] A group of glazed earthenware pieces of the Eastern Han period (AD 25–220) is housed in the National Museum, Jakarta, having been reportedly collected from sites in Sumatra, Java, and Kalimantan. They appear to be of the period claimed and it has been contended that they represent the earliest evidence of trade between China and South-East Asia.[8]

However, no archaeological evidence exists to demonstrate that these pieces have been present in Indonesia from the Han period. The *Han Shu* passage quoted above points to the luxury nature of Chinese trade at this time and lists gold and silk as the principal items of exchange. The presence of low-quality funerary and ritual wares in Indonesia at this time consequently seems incompatible with the character of Han trade as described in the *Han Shu*. Moreover, when Chinese ceramics do appear in archaeological contexts in South-East Asia, they simultaneously appear further westward, for South-East Asia was but one link in a long chain of commerce and exchange. No Han ceramics are known in archaeological contexts in South-East Asia beyond northern Vietnam, which came under direct Chinese control in the first century AD.[9]

The trade with South-East Asia does not appear to have been vigorously pursued after the collapse of the Eastern Han empire, and it was not until the reunification of China in the sixth century under the Sui Dynasty (AD 581–618) that the Chinese began to explore the Southern Ocean systematically in pursuit of 'the strange and the precious'.[10] Occasional instances of long-distance navigation by the Chinese are reported to have taken place earlier; from the fourth century 'Chinese ships' were reported on the west coast of the Malay Peninsula.[11] However, such journeys were probably conducted in South-East Asian or Indian craft. When Fa-hsien returned to Guangzhou in 413–14, after his overland pilgrimage to India and Sri Lanka, he recorded travelling in an Indian boat of some size and sophistication, which carried '200 souls' and which was capable of sailing direct from the Malay region to South China (Fig. 2).

Fig. 2
Sixth-century mural in Cave No. 2 at Ajanta, western India, depicting an ocean-going ship, possibly of the type known to have visited South-East Asia and China from at least the fifth century. It shares a number of design features with later South-East Asian ships.

1. P. Wheatley (1975), p. 232.
2. B. Colless (1969b), p. 41.
3. Wang Gungwu (1958), p. 8.
4. Described in the *Chi'en Han Shu*, cited in P. Wheatley (1959), p. 19.
5. Wang Gungwu (1958), p. 18.
6. Ibid., pp. 19–20.
7. Van Orsoy de Flines reported the finding of Han-period glazed pottery in Indonesia in the 1949 edition of *Gids voor de Keramische Verzameling* (reprinted in English translation 1972).
8. G. Wong (1977), p. 7.
9. See O. R. Janse (1947–58) for the type of Han-period ceramics discovered, and J. Holmgren (1980) for a discussion of sinicization of the Tonkin area in this period.
10. Expression used in the *Sui Shu*, cited in P. Wheatley (1959), p. 20.
11. J. Needham (1954), Vol. 1, p. 179.

2. South-East Asia as Entrepôt

THE early international trade route, which in the third and fourth centuries AD connected China with the Indian and Middle Eastern worlds, ran from ports in the Persian Gulf and the Red Sea to the Indian coast, Sri Lanka, the Bay of Bengal, and the Malay Peninsula. The cargoes were traded at a number of points along the Kra Isthmus and transhipped to the east coast of the Peninsula. The Middle Eastern goods then continued their journey to China via the Funan coast to South-east China. Centred in the Mekong delta region of southern Vietnam, the Kingdom of Funan was active as an entrepôt, possibly from as early as the first century AD until its collapse in the sixth century. Throughout much of this period it controlled a large part of the East–West trade, providing the trading link between the world of the Indian Ocean and China.[1] A third-century description of a dependency of Funan on the Malay Peninsula, *Tun-sun*, explains Funan's significance as South-East Asia's first great entrepot:

The eastern frontier of *Tun-sun* is in communication with *Chiao-chou* [Tonkin], the western with *Tien-Chu* [northern India] and *An-hsi* [Parthia]. All the countries beyond the frontier [of China] come and go in pursuit of trade.... The *Chang hai* [South China Sea] is of great extent and ocean-going junks have not yet crossed it direct. At this mart east and west meet together.... Precious goods and rare merchandise—there is nothing which is not there.[2]

This passage conveys vividly much of the character of South-East Asian trade in the third century and points to the reason for the abandonment of the transhipment routes across the Malay Peninsula and the subsequent demise of Funan: the mastery of the ocean journey from the Straits of Malacca–Java Sea region direct to China, a journey which Fa-hsien informs us he completed in an Indian ship in the early fifth century. At this time the trade was conducted in the western sphere principally by Arabs and Indians and very probably Persians, and in the eastern sphere by local traders, mainly Malay and Funanese.

With the navigational development a major shift in the international trade routes occurred. The transhipment across the Malay Peninsula was gradually abandoned in favour of sea travel through the Straits of Malacca to the western edge of the Java Sea and then north to China. The south-eastern region of Sumatra was ideally located as a point for the exchange of goods flowing in each direction on this international sea route and it soon supplanted Funan as the principal entrepôt region in South-East Asia serving the East–West trade. This area, which came to be identified with the Kingdom of Srivijaya, was also a convenient port at which to break the journey whilst waiting for the appropriate monsoon winds. The Sumatran city-state of Srivijaya grew up around the seventh century in response to these conditions

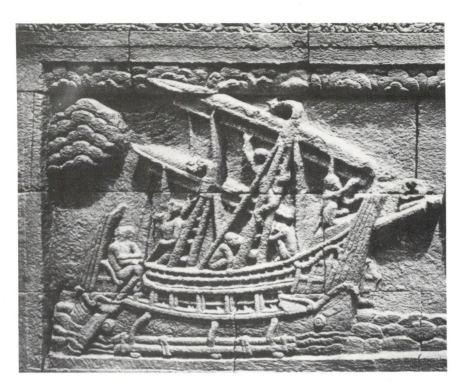

Fig. 3
Ninth-century relief at Candi Borobudur,
Central Java, depicting a Javanese(?) ship with
outriggers and twin lateral rudders, suited to
use in the sheltered waters of insular South-
East Asia but not to sailing in the open ocean.

and quickly became the dominant regional power in South-East Asia, drawing its wealth directly from the traffic in exotic and luxury goods with China.[3] This trade in luxury goods was of necessity limited in volume by virtue of the small élite it served, comprising principally the emperor and his circle. The limited nature of the trade was, however, radically altered by a new development in China—the adoption of Buddhism at a popular level. The spread of Buddhist worship and the resultant demand it generated for foreign goods associated with worship—chiefly aromatics—altered not only the content of China's precious imports but also the volume. The potentialities of the *Nanhai* trade became unlimited. In addition to the importation of Buddhist texts (sutras) and innumerable sacred 'relics', mainly from India and Sri Lanka, new aromatics and drugs from the Middle East appeared. Frankincense and myrrh were particularly prized and the Chinese displayed a seemingly insatiable appetite for these and other aromatics.

China's early interest in the *Nanhai* can largely be explained in terms of the difficulties encountered in maintaining the flow of luxury goods from the West via the overland 'Silk Routes'. The southern sea trade had become China's 'second Silk Route'.[4] From the fifth century the Persians looked to the sea routes for alternative access to the Chinese silk they so desired. India also appears to have been an important market for Chinese silk, as the great poet of the Gupta era, Kalidasa, observed.[5] Throughout the Sui and Tang Dynasties silk remained China's chief export, generating much of the wealth used to maintain the luxury consumption of cosmopolitan China.

Unlike ceramics, silk leaves no archaeological evidence of its presence and one must be cautioned against seeing early trade only in terms of that which survives. Lacquer and textiles were undoubtedly more important than ceramics in the first millennium. Two indirect pieces of evidence point to the important role of Chinese silk in early South-East Asian trade. The first is a Srivijayan inscription which, in celebrating the founding of a Buddhist monastery at Nakhon Si Thammarat on the east coast of the Thai Peninsula, describes the temple appointments as including 'banners of Chinese cloth'.[6] The second comprises the designs appearing on the carved walls of Candi

5

Sewu, a ninth-century temple in Central Java, which have been identified as being Chinese in origin and presumed therefore to have been derived from an imported fabric.[7] Such items must have been acquired through the early trade in luxury goods. Well-endowed monasteries may indeed have been one of the principal markets for the Chinese exports which were traded to South-East Asia.

Two developments within China late in the first millennium were to alter irrevocably its perception of the importance of the *Nanhai* region and of the trade which prospered from China's southern ports. The first was a gradual awareness in China of South-East Asia as the place of origin of many of the desired luxury commodities which had previously been attributed to the world of the *Po'ssi* (Persians). The substitution of South-East Asian products for those of Western Asia had long been practised and well disguised from the Chinese.[8] Secondly, South China was no longer a frontier region but was developing its own internal economy and its own market for the products of the *Nanhai* trade.

Until the Tang Dynasty the volume of the Southern Ocean trade had been relatively small despite the immense value placed on it. With the introduction of aromatics from the Middle East and spices and various forest products from South-East Asia for an increasingly urbanized element of Chinese society, a much greater volume of trade developed. But even more significantly, it was a different trade, not merely replicating the overland Silk Route sources, but providing a growing number of luxury items unique to the South-East Asian region. This development ensured South-East Asia's permanent place in the trade of China for the next millennium and set the scene for a flourishing trade in which ceramics were to play an increasingly important role.

Unified under the Tang Dynasty, prosperous and cosmopolitan in outlook, China attracted many merchants to its shores. These foreign traders passed through either the Straits of Malacca or the Straits of Sunda on their journey, and utilized the trading, storage, refurbishing and accommodation facilities offered by Srivijaya. Early traders were described by the Chinese as 'Po'ssi' or 'Persian' and the products they brought were believed to have come from that part of the world. Even as the Arabs began to displace the Persians as the middlemen in the China trade, the term 'Po'ssi' persisted. Srivijaya, in turn, began to inject local forest products into the international trade route and these were successfully passed off to the Chinese as part of the 'Persian' trade. Pine resin and benzoin from Sumatra were substituted for West Asian frankincense and myrrh respectively, and until around the sixth century were accepted as products of *Po'ssi*. Pine resin was valued in China for its medicinal powers, and by Taoists as an aid to longevity. Myrrh, and its substitute benzoin, were much favoured as powerful aromatics, especially when burnt. Gradually the South-East Asian pine resin became known to the Chinese as 'ju' from the *Nanhai*, distinguished from the Persian frankincense for which it had first been substituted.

With the introduction of Sumatran pine resin, benzoin, and the famous 'Barus' camphor, South-East Asia established itself as a significant contributor to the East–West trade beyond its traditional role as an entrepot. An Arab envoy of 1066 was careful to describe amongst its tribute 'true frankincense', no doubt to distinguish it from South-East Asian substitutes.[9] The contribution of Sumatra to the trade is recorded in a mid-seventh-century work, the *T'ang pen ts'ao*, which states that 'camphor perfume and ointment ...come from *P'o-lu* ["Barus", northern Sumatra] country'.[10] Added to this was a growing demand in China for spices, for which the rich resources of eastern Indonesia were being tapped by Sumatran and Javanese entrepreneurs. Elaborate inter-regional trading networks must have emerged to supply these products to Srivijaya for injection into the international trade.

6

The prosperity of this early South-East Asian maritime power and much of the regional wealth was, therefore, directly linked to that of China and her demand for the luxury items available through this trade network.

Not only were the Chinese ill-equipped to undertake extensive open-sea trading at this time, they were also largely disinclined to do so, and much of the commerce relating to the importation of goods was left in the hands of foreigners. Communities of foreign traders are known in China. The *Po'ssi* and *Ta-shih* (Arab) traders appear to have dominated the maritime trade with China at the height of the Tang Dynasty. They established settlements at Chinese ports and enjoyed great wealth from the profits of trade. The Arab and Persian Muslim residents in Guangzhou, a great trading port from the Tang period onwards, were strong enough to sack that city in 758–9 in an act of frustration prompted by the corruption of Chinese port officials, and escape by sea, probably to Tonkin where they could continue their trading activities.[11] The sacking of Yang-chou in 760 by Chinese rebels resulted in the deaths of 'several thousand of *Po'ssi* and *Ta-shih* merchants',[12] and when massacres occurred in Guangzhou in 878, a contemporary Arab geographer, Abū Zaid, recorded that 'Muslims, Jews, Christians and Parsees perished'.[13] These accounts illustrate the size, power, and cosmopolitan nature of the foreign trading communities in China in the eighth and ninth centuries.

Foreign trading communities were not confined to China itself but appeared along the entire East–West trade route. After the disturbances in China in the late Tang Dynasty so many foreign merchants fled, particularly to Vietnam, that a Chinese official was moved to petition the Emperor that 'lately the precious and strange [goods] brought by ocean junks have mostly been taken to Annam [port of Hanoi] to be traded there' and called for action against Annam.[14] Arabic inscriptions found in Champa dating from the eleventh century are probably also evidence of Muslim traders abandoning Chinese ports over the preceding two centuries.[15] The rise to prominence of 'Kalāh' as an important terminus for the Western trade was recorded by Arab writings of the tenth century.[16] This prosperous entrepôt situated on the Malay Peninsula was reported by the Arab geographer Fatimid al-Aziz to be inhabited by Muslims, Hindus, and Persians.[17] A reluctance to deal directly with China at this time may have contributed to the prosperity of 'Kalāh'.

Ceramic archaeological evidence begins to appear at this time which collaborates much of what is indicated in the Chinese and Arabic sources. The Kra Isthmus region of the Malay Peninsula, which featured in the earliest accounts of East–West trade as an important entrepôt area, re-emerged as an alternative to the sea passage through the Straits of Malacca. The land passage across the isthmus was employed whenever disturbances in the Straits threatened the security of merchants. By the tenth century Srivijaya's hold on the region was weakening, piracy was on the increase, and a number of alternative entrepôts, former dependencies of Srivijaya, now sought their independence. The South Indian raid by the Cōla king, Rājēndra Cōla, in 1025 may have finally broken the Srivijayan hegemony over the international trade. Java emerged to fill the vacuum, as did a number of city-states on the Malay Peninsula, the most important of which, on current knowledge, appears to have been Takuapa.

It is at Takuapa that the earliest reliable archaeological evidence has been found of Chinese ceramics as an integral part of South-East Asian and international trade. The site, on the west coast of the Kra Isthmus, appears to have been a terminus for the Arab–Persian trade during the ninth and tenth centuries, and probably retained this role until the focus shifted down the coast to the Kedah region in the mid-eleventh century. Takuapa was clearly as cosmopolitan as the great trading ports of Tang China. A ninth-century Tamil inscription found in the area recorded the presence of a South Indian

merchant guild.[18] Stone sculptures of Hindu deities are, in Lamb's opinion, essentially Indian rather than 'Indianized', supporting the epigraphic evidence for an Indian community at Takuapa.[19] Surface finds in the area have yielded evidence of Islamic and Chinese trade goods. Fragments of Islamic glass and glazed earthenware, albeit in small quantities, point to the presence of Middle Eastern traders, though they may not necessarily represent items of trade. Chinese glazed stoneware of the *Yue* type from southern Zhejiang appears for the first time. It is important in this context to note that the earliest dated archaeological context for true *Yue* ware in China is 810.[20] The evidence points to Takuapa being a ninth- to tenth-century terminus of some importance. The trans-peninsular route would probably have led from Takuapa to the Bay of Brandon on the Gulf of Thailand, where the remains of the city of Chaiya are to be found.

As mentioned earlier, with the weakening of Srivijaya's power Java too

Fig. 4a & b
Fragments of Changsha-*ware bowls and covered box, c. ninth century, found in the vicinity of Prambanan, Central Java. (Museum Nasional, Jakarta)*

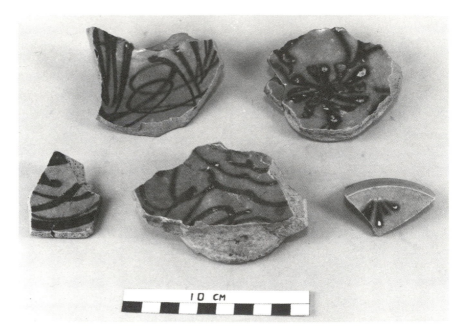

Fig. 5
Fragments of Changsha-ware *spouted ewers
with appliqué relief decoration, ninth to tenth
centuries, found in the vicinity of Prambanan,
Central Java. (Museum Nasional, Jakarta)*

began to assert itself, claiming an increasing share of the rich international
trade with China. It is from this period that Chinese ceramics also begin to
appear in the region. Late Tang and Five Dynasties wares of the ninth and
tenth centuries are known from Java, especially the distinctive *Changsha* ware
(Figs. 4 and 5). A *Yue* jar with a lotus pattern design of Late Tang–Five
Dynasties date has been excavated in the Sarawak River delta area of western
Borneo, an important trading post on the China route.[21]

Although the evidence from South-East Asia is sparse, it is clear that the
Chinese were using glazed ceramics as a significant trade item by the ninth
century, such wares having been introduced in the course of the eighth
century. This impression is supported by an abundance of literary and
archaeological evidence from the Middle East which collaborates the early
South-East Asian findings. An Arab geographer, Mas'ūdī, writing in the
tenth century, referred to the trading centre known as 'Kalāh', on the west
coast of the Malay Peninsula, as 'the general rendezvous of the Muslim ships
of Sīrāf and Oman, where they meet the ships of China'.[22] The Arab ships, on
their return journeys, would have supplied the hinterlands of the Persian and
Arabian worlds with the most esteemed Chinese goods—silk and ceramics.

An investigation of the ruined port-city of Sīrāf, a Sassanian entrepôt on
the Persian Gulf, confirms this. Excavation of the foundations of the Great
Mosque of Sīrāf, built in the first quarter of the ninth century, revealed
Chinese storage jars of the 'Dusun' type[23] and Chinese bowls with painted
decoration (Fig. 7). These finds constitute the earliest dated context for
Chinese ceramics in the Middle East. By implication they are also immensely
important for dating the earliest Chinese ceramic presence in South-East Asia,
not only because they are identical to some South-East Asian finds, but
because they were traded *through* South-East Asia, and in all probability
changed hands (and ships) in an entrepôt such as 'Kalāh', where the 'ships of
Sīrāf. . . meet the ships of China'.

The kiln origin of the 'Dusun'-type jar has not been identified but two
fragments from the Great Mosque excavation have Muslim names incised

Fig. 6a & b
Fragments of Changsha *bowls and spouted
ewers with appliqué relief decoration, ninth
to tenth centuries. (a) Excavated at the port
settlement of Mantai, north-east Sri Lanka.
(Archaeological Museum, Anuradhapura,
Sri Lanka) (b) Excavated in the vicinity of
Abhayagiri monastery, Anuradhapura, in
1983. (Abhayagiri Site Office, Central
Cultural Fund)*

a

b

Fig. 7
*Fragments of a 'Dusun'-type Chinese
stoneware jar, excavated from the foundation
of the Great Mosque at Sīrāf, Persian Gulf;
early ninth century. (Courtesy David
Whitehouse)*

beneath the glaze, suggesting a direct Muslim presence at the place of manufacture. This can reasonably be assumed to be close to one of the great South China port-cities, of which Guangzhou was the most prosperous at that time.[24] The bowls with painted decoration excavated in the same site at Sīrāf[25] belong to the well-known *Changsha* type, identified in 1956 with the kilns near Tongguan, Hunan, some twenty miles north of Changsha.[26] A dated example is known, bearing the inscription in iron-oxide 'third year of "Kaicheng"' (= 838), contemporary with the Sīrāf finds.[27]

The kilns in the Changsha region also produced the distinctive spouted ewers with appliqué relief decoration for which Changsha is famous (Plate 3). Fragments of such ewers were excavated at the Sīrāf mosque site, but at a higher stratum than the bowls, indicating that they were not imported until after the early ninth century.[28]

The painted bowls and spouted ewers of the Changsha region of Hunan are encountered all along the international sea trade route, beginning in the ports of China itself. Significant quantities have been found along the lower reaches of the Yangzi-jiang, and at Ningbo, an important international port in late Tang China.[29] The ports of southern Zhejiang, together with Guangzhou in the south, would therefore appear to have been amongst the earliest Chinese ports exporting ceramics. Beyond China *Changsha* wares have been found as far west as Sri Lanka (Fig. 6), at Nishapur in northern Iran,[30] and at Manda, on the Kenyan coast of East Africa.[31] Within South-East Asia finds have been reported from Kudus and Parakan, Central Java.[32] Reports of both painted bowl and spouted ewer fragments, along with *Yue*-type green-glazed, spur-marked bowls and the remains of stoneware jars found in the vicinity of the Prambanan temple complex in Central Java, suggest that Chinese trade ceramics enjoyed some popularity in ninth-century Java.[33] A datable context for the jars is provided by reference to details in some of the relief sculptures on the temples themselves. One of the earliest depictions of ceramic vessels of Chinese appearance in insular South-East Asia is to be found in the relief sculpture of the temple of Lara Jonggrang, Prambanan. It depicts what may be assumed to be a ninth-century Javanese genre scene, which serves as a backdrop to the dramatic events of the Ramayana epic which are being enacted on the frieze (Fig. 8). The depiction

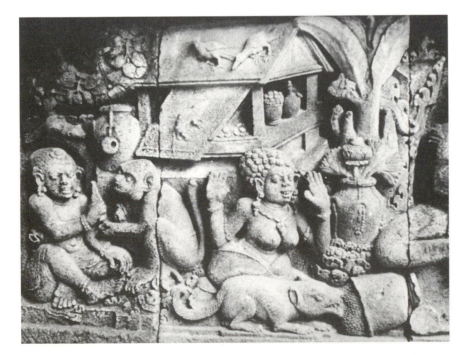

Fig. 8
Ninth-century relief sculpture showing a Javanese domestic scene. Five containers are depicted, two at least apparently ceramic: a storage jar with its coconut-shell ladle, set on the plinth of the shelter, and a similar jar serving as a lotus vase, draped with strings of pearls(?). Jars of this form, with a high shoulder, a heavy rolled lip, broad horizontal lugs and tapering to the base, are a known Chinese export type from late Tang times (compare Plate 8). Of the other three vessels, the two stem bowls are probably ceramic, but may be metal; the spouted vessel is known as a bronze ceremonial ewer in Java and served as a prototype for the ceramic kendi *(compare Plates 87 and 88). Candi Lara Jonggrang, Prambanan, Central Java.*

11

contains five vessels, two of which appear to be of a known Chinese export type.

Java's traditional role in the East–West trade had been to supply spices from eastern Indonesia, which were experiencing an increasing demand in both China and Western Asia. Tension with Srivijaya prompted the Javanese to send their own tribute missions to China as early as 670. However, from the late seventh century until the early eleventh century Srivijaya was able to maintain its position as the principal South-East Asian entrepôt, with Arab traders dominating the sea routes. A proliferation of accounts by Arab traders and geographers from the middle of the ninth century reflects this Arab interest in South-East Asia, both as a link in the East–West trade and as an important source of the spices and drugs used in Arabic medicine.[34]

Meanwhile, with the reunification of China under the Northern Song Dynasty in 960 a new era of vigorous maritime trade began. In South-East Asia the geopolitical map was becoming more complex. East Java was challenging Srivijaya's hegemony, and on the mainland the emerging powers of the Khmer at Angkor and the Burmans at Pagan were involving themselves in international trade, utilizing overland as well as sea routes.

1. For a discussion of the cosmopolitan and far-reaching nature of this trade network, based on archaeological finds at the Oc-eo site, see L. Malleret (1959–63).

2. *Liang shu*, cited in O. W. Wolters (1967), p. 44.

3. For a study of the origins and rise of Srivijaya, see O. W. Wolters (1967).

4. Wang Gungwu (1958), p. 6.

5. Kalidasa, *Kumarasambhava*, cited in O. W. Wolters (1967), p. 82.

6. J. Stargardt (1973), p. 17.

7. H. W. Woodward (1977).

8. For a discussion of this practice, see O. W. Wolters (1967), Chapter 9.

9. Ibid., p. 107.

10. Ibid., p. 95.

11. Lo Hsiang-lin (1967), p. 177.

12. Wang Gungwu (1958), p. 80.

13. Lo Hsiang-lin, op. cit., p. 177.

14. K. R. Hall (1979), p. 427.

15. G. R. Tibbetts (1957), p. 38.

16. 'Kalah' has been variously located by different writers at Mergui, Tenasserim coast (P. Wheatley, 1961), Takuapa, Kra Isthmus (A. Lamb, 1964a), and Klang, Selangor (S. Q. Fatami, 1960, and B. E. Colless, 1969b).

17. G. R. Tibbetts (1957), p. 38.

18. K. A. Nilakantra Sastri (1949).

19. A. Lamb (1964a), p. 79.

20. M. Medley (1981), p. 101.

21. S. Suzuki (1982), p. 105.

22. Mas'ūdī, cited in G. R. Tibbetts (1979), p. 37.

23. Compare Plate 8 with Fig. 7.

24. A jar of this type, displayed in the Guangdong Provincial Museum, was reportedly excavated at Chou Hai.

25. D. Whitehouse (1973), Pl. 18.3 (a–d).

26. M. Medley (1981), p. 90.

27. M. Sato (1981), p. 88.

28. D. Whitehouse (1973), p. 252. This is at variance with the results of the kiln-site investigations in China which suggest the appliqué technique accompanied by brown splashed underglaze decoration preceded the use of underglaze brown and green calligraphic style (Changsha Cultural Bureau, 1981, p. 16). However, production and export patterns need not necessarily correspond.

29. Changsha Cultural Bureau, op. cit., p. 19.

30. C. K. Wilkinson (1974), p. 257, and M. Medley (1981), Pl. 90.

31. Reported by N. Chittick; see D. Whitehouse (1973), p. 250.

32. E. W. van Orsoy de Flines (1972), Pl. 9, and A. Ridho (1982), Pl. 1.

33. A. Ridho (1978), Pls. 2, a, b, c, 3, and 5.

34. See P. Wheatley (1961), Chapter XIV, and G. R. Tibbetts (1979), Part 1.

3. The Expansion of China's Trade with South-East Asia

A major development from the tenth century onwards was the expansion of direct Chinese participation in the maritime trade of the *Nanhai*. The Arab merchants were most acutely affected by this development and it is in a tenth-century Arabic source, the *Murūj al-Dhahab* by Mas'ūdī (d. 956), that the changes are most clearly recorded:

The ships from Basra, Siraf, Oman, India, the islands of Zabaj and Sanf came to the mouth of the river of Khanfu [Guangzhou] with their merchandise and their cargo [before AH 264, i.e. AD 877–8].

Then [the trader] went to sea to the land of Killah [i.e. Kalah] which is approximately half way to China. Today this town is the terminus for Muslim ships from Siraf and Oman, where they meet the ships which come down from China, but it was not so once.... This trader then embarked at the city of Killah on a Chinese ship in order to go to the port of Khanfu.[1]

Mas'ūdī's account describes two new developments of interest: that Chinese ships were now regularly trading as far south as the Malay Peninsula, and that foreign merchants could use Chinese ships for the journey from South-East Asia to China. The Song government was instrumental in these developments, encouraging foreign merchants to trade with China and offering incentives to a growing Chinese merchant class to sponsor overseas trade and even to venture abroad themselves.[2] The office of Superintendent of Maritime Trade (*Si po-si*) was established in Guangzhou in 971 to regulate foreign trade and to supervise Chinese merchant shipping. The office was extended to the other major port-cities along China's south-eastern coast over the next century, most notably Hangzhou, Ningbo, and Quanzhou.

Foreign trade by the Southern Sea route was of unprecedented significance for the economy of Song China, a situation largely created by the insecurity of the north-west border regions. A related development was the steady southward migration of the Chinese people which intensified at this time.[3] The rapid growth of the coastal cities produced a large urban class. The Southern Ocean trade was pressed to service the requirements of an increasingly prosperous populace in South China. Consumer affluence had reached a level where the luxuries of the past had become the necessities of the present. The growth in the economy of South China thus contributed significantly to the expansion of the Southern Ocean trade.

The Chinese government benefited directly from this trade, through the resale of tribute and the taxing of shipping and cargo. The northern provinces of China, deprived of foreign commodities since the disruption of the overland trade routes, proved a ready market for these items. The Song government therefore consciously sought to encourage this trade. In 987 it dispatched

four missions armed with gifts of textiles to attract 'foreign traders of the South Sea and those who went to foreign lands beyond the sea to trade'.[4] The government opened new ports, subsidized harbour and hospitality facilities, and extended to foreign trading communities some degree of extra-territoriality. The success of these measures was seen in the large numbers of foreigners who settled in such port-cities as Quanzhou and Guangzhou. In Quanzhou, the 'Zaiton' of Marco Polo's account, the remains of mosques, tombs, and temples built by these Muslim and Hindu merchant communities can still be seen.[5]

Not only was the volume of trade between China and the *Nanhai* increasing dramatically as the Chinese themselves assumed a more direct role, but also the nature of the trade was changing. From the earliest times the trade with China had been in luxury and exotic goods—aromatics and drugs in exchange for silks. The Song administration accrued a serious trade deficit as a result of the immense demand for the Middle Eastern and South-East Asian products within China, and it became concerned at the outflow of metal. Particular concern was expressed at the outflow of copper cash, which in the Southern Song period was so great as to threaten its internal availability. Between 1160 and 1265 the export of coins was prohibited in ten separate edicts. The ineffectiveness of these moves prompted the government to prohibit the wearing of such exotic commodities as kingfisher feathers and pearls, items for which copper cash was being given in payment. The government encouraged the export of less valued commodities in an attempt to conserve the reserves of copper, gold, and silver. In 1216 an edict was issued officially encouraging the export of porcelain,[6] and in 1219 an official declared that 'using gold and silver to trade for maritime products is a regrettable practice. Therefore the Emperor ordered the officers-in-charge to use only silk, rough sewn silk, brocade, patterned silk, porcelain and lacquer-ware to trade.'[7]

Ceramic production in China received a considerable stimulus from the trade deficit situation and the export market began to assume a significance in the ceramic production of coastal regions in South China, particularly at the Zhejiang kilns which at that time were famous for greenwares. Chinese merchants saw the profitability of export ceramic production and provided much of the capital for the rapid increase in the number of kiln centres and for the improvement of distribution systems. This commercial impetus seems to have been behind the initial growth of the Dehua kilns of Fujian and the early *yingqing* production of Jingdezhen.[8]

The early stages of China's ceramic export trade are not well documented. The dynastic histories provide an official viewpoint which, although rich in the details of government and state affairs, including tributary trade, have little to say about the plebian aspects of society. Ceramics were not held in high esteem and very rarely appear in the lists of goods sent in exchange for tribute. Throughout the dynastic histories the attitudes to tribute, and the trade which inevitably accompanied it, were ambivalent.

Trade was potentially very lucrative for both the imperial and private purse and many emperors openly encouraged trade activities to flourish so long as the appropriate tribute observances were performed. An obligatory aspect of this trade with China was the formal presentation of tribute to the Emperor. Much of the trade with China was conducted under this guise and the handsome rewards given tribute-bearers served to encourage their continued co-operation. Each of the successive South-East Asian regional powers—Srivijaya in Sumatra, Majapahit in Java, and Malacca in Malaya—offered formal recognition of the supremacy of the Chinese Emperor in exchange for the privilege to trade and for the local political advantage that accrued from being seen as an ally of China. Sending tribute missions ensured

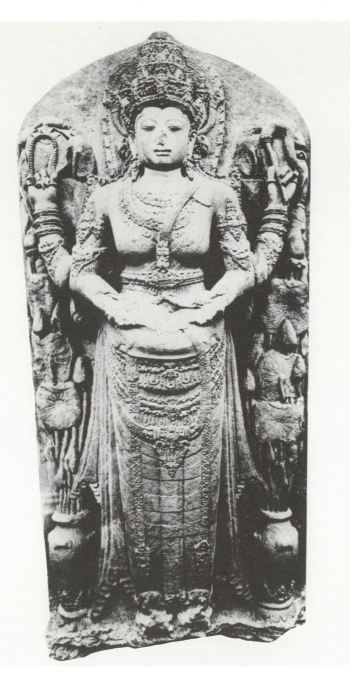

Fig. 9
Portrait stele of a Majapahit queen. Note the depiction of two jars set on elaborate openwork metal(?) stands flanking the figure of the queen. From Candi Rimbi, eastern Java, c. fourteenth century. (Museum Nasional, Jakarta)

the favourable treatment of a country's merchants and the profitable sale of their products. The Chinese in turn were happy to have a demonstration of the power of the imperial virtue (*te*) to penetrate even such distant lands, as well as having powerful allies to ensure that the mutually beneficial trade continued uninterrupted and the sea route remained open and comparatively free of pirates. With neither an empire, nor a formidable navy to police the sea routes, China thus ensured itself secure sea routes and contacts to the farthest points of the known world, through which it could conduct diplomatic relations and acquire the exotic goods which were so prized.

The tribute system could be seen to work according to the Confucian theory. Whilst its success was related to 'good government in China', in as much as it was no longer safe or lucrative to visit China in times of internal strife, its real success was dependent on the foreigners continuing to profit

15

from the China trade. From the seventh to the eleventh centuries the tributary system flourished. When in the early Song Dynasty the Chinese began to play a dominant role in their own trade, Srivijaya's entrepôts of Palembang and later Jambi lost their source of wealth and, with it, their motivation for sending tribute to the Son of Heaven. The tributary system continued into the Song era (960–1297), but with the collapse of the Northern Song capital to the Jurcheds in 1126 and the retreat to Hangzhou in 1127 the Southern Ocean maritime trade took on a new significance for the Chinese. They had lost the overland trade routes and much of their wealth. They set about stimulating the expansion of Chinese maritime activity as a commercial enterprise at the expense of the South-East Asian traders. Inevitably tribute missions diminished. The Song government was under economic strain even before the Northern collapse. The cost of defending the borders and the payment of 'peace money' strained the state finances. Ku Yan-wu, in *Tian Xia Jun Guo Li Bing Shu* (The Strength and Weakness of Every Country), recorded that 'after crossing the Yangzi to the south [i.e. the flight of the Song Court to Hangzhou], the economy of the government was in great difficulties. Every measure depended on the income derived from maritime trade.'[9] A need was felt to rationalize the direct imperial involvement in the commercial benefits of trade, and this was expressed in terms of serving a greater good, the Emperor Gaozong in an edict of 1137 declaring: 'The profit from maritime trade is very great. . . . Would it not be preferable to promote this trade than to tax the people? Because I hope to lighten their burden I have paid special attention to this problem.'[10] The official encouragement given to the use of ceramics for export contributed to the expansion of the ceramic centres of South China and to the establishment of new kilns, largely intended to service the overseas market. Many of these kilns were built near the port-cities in Zhejiang, Fujian, and Guangdong Provinces to meet the demand for trade wares. Prominent families evidently participated in these enterprises, as seen in a tenth-century clan register of the Liu family of Quanzhou. Liu Congxiao is recorded as being responsible in 944 for extending the city boundaries of Quanzhou to the east, and establishing kilns for the manufacture of porcelain to supply the growing foreign market.[11] Ruined kilns have been excavated outside the east gate of Quanzhou.[12]

Chinese ceramics, particularly *Yue* and *Longquan* greenwares, were enjoying an international reputation by this time, especially in the Muslim world. The author of the *Ahbar as-Sin wa'l-Hind* of *c.*850 wrote admiringly of Chinese glazed ceramics,[13] probably *Yue* ware of southern Zhejiang. The biographer of Salah-ed-din records that in 1171 he sent forty pieces of *Longquan* greenware to Nur-ed-din, Sultan of Damascus, as a gift.[14] This demand from the Islamic market must have been a considerable stimulus to greenware production in Zhejiang, particularly at the Longquan kilns whose wares displaced the *Yue* wares in the course of the eleventh and twelfth centuries.[15]

The shift in the ceramic centres seems partly to reflect the decline or rise of particular port-cities. Ningbo, which had served the *Yue* and other southern Zhejiang kilns, remained important for the Korean and Japanese trade but declined in overall importance with the rise of Wenzhou and Quanzhou to the south. Wenzhou, situated at the mouth of the River Chi which served as the transport highway from the Longquan kilns to the coast, prospered with the rise in popularity of the now-famous *Longquan* greenwares. The export ceramics of Zhejiang would then have been transported by coastal shipping to Quanzhou, which, by the twelfth century, had become China's main entrepôt. The ceramics were traded with Muslim and other merchants in Quanzhou for the frankincense, sandalwood and other aromatics, drugs and spices which constituted the main imports of Song China.[16] Others may have

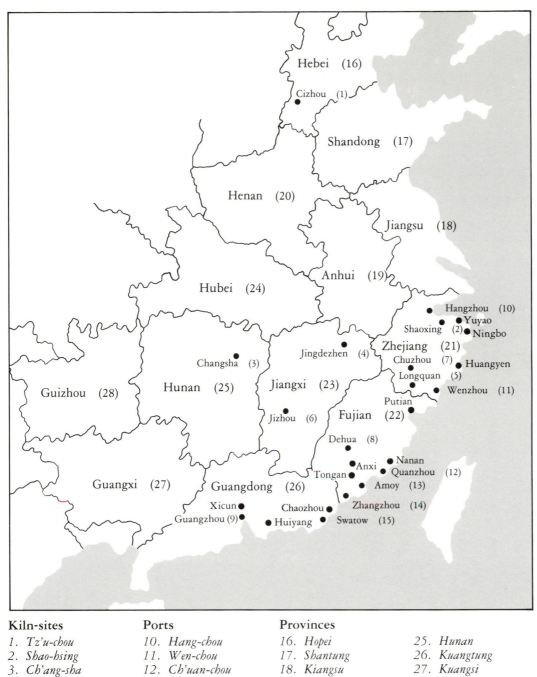

Kiln-sites

1. Tz'u-chou
2. Shao-hsing
3. Ch'ang-sha
4. Ching-te Chen
5. Lung-ch'uan
6. Chi-chou
7. Ch'u chou
8. Te-hua
9. Canton

Ports

10. Hang-chou
11. Wen-chou
12. Ch'uan-chou
13. Amoy
14. Ch'ang-chou
15. Swatow

Provinces

16. Hopei
17. Shantung
18. Kiangsu
19. Anhui
20. Honan
21. Chekiang
22. Fukien
23. Kiangsi
24. Hupei (Hupeh)
25. Hunan
26. Kuangtung
27. Kuangsi
28. Kueichow

MAP 2 China: Principal Kiln-sites Involved in the
Production of Trade Wares

been taken abroad by Chinese merchants to trade directly with the people of the *Nanhai*.

Chinese participation in the overseas trade steadily expanded. Syndicates of merchants began building ships and sending them to the *Nanhai* to trade directly for the native products of the region. Evidence of this appeared in 1973-4 when the remains of a thirteenth-century Chinese sea-going vessel of 200 tons were excavated in Quanzhou Bay, Fujian Province[17] (Fig. 10). It still contained traces of its original cargo of pepper and 'fragrant woods' (i.e. aromatics) which must have been brought back from South-East Asia. Such a cargo would have been of considerable value for pepper had, since the Tang period, been much sought after as a 'precious commodity'. The possession of pepper came to be synonymous with richness and luxury and remained so until the fifteenth century when it became commonly available as a result of Zheng He's voyages.[18] Though not large by Song standards, such a vessel was capable of the journey to Java, the most important source of pepper at that time. Visiting Quanzhou in 1292, Marco Polo wrote a vivid description of its trading activities, specifically noting the importance of pepper: 'Zaiton ... the port for all the ships that arrive from India laden with costly wares and precious stones.... It is also the port for the merchants ... of all the surrounding territory. And I assure you that for one spice ship that goes to Alexandria to pick up pepper for export to Christendom, Zaiton is visited by a hundred....'[19]

Zhao Rugua, writing in Quanzhou in the early thirteenth century, indicated that China acquired the bulk of its pepper from the island of Java ('there is a vast store of pepper in this foreign country')[20] and that the finest quality pepper came from Sunda, West Java. In the ninth and tenth centuries the Arab writers had spoken of India as the source of pepper for the China trade, with Arab and Indian merchants conducting the trade.[21] The discovery of this Chinese shipwreck with its cargo of pepper and aromatics reflects the changing character of China's trade with South-East Asia in the course of the Song period.

Rapid improvements in shipbuilding technology occurred in the eleventh and twelfth centuries, stimulated by the scale of shipbuilding activity and the scope that this provided for invention and experimentation. The *Song Huiyao Gao* records forty-three government shipbuilding localities. Private shipyards were even more numerous along the south-east coast, with Quanzhou specializing in huge ocean-going vessels.[22] A sturdy planking hull construction, watertight bulkheads, the use of a keel and sternrudder, and large

Fig. 10
Hull of a thirteenth-century Chinese sea-going ship, 24.2 metres in length, excavated in Quanzhou Bay, Fujian. Traces of its cargo of pepper and aromatic woods indicate it was returning from a journey to South-East Asia. (Quanzhou Overseas Communication Museum, Fujian)

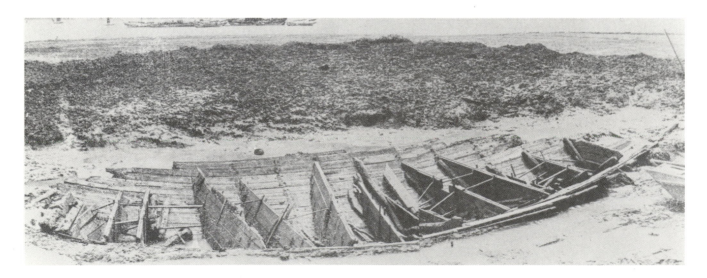

cargo capacity and superstructure all contributed to the reputation of the Chinese ships of the Song period.

The *P'ing-chou-k'o-t'an* (Discourse on the Floating Islands), written from the author's experience of Guangzhou in the period 1086–94, provides one of the earliest descriptions of the ships sailing in the *Nanhai*. He observed that the ships were squarely built 'like grain measures' and of a large scale, carrying several hundred men.[23] Zhou Qufei, writing a generation later in the early twelfth century, also described the nature of the ships used in trade and the conditions for sailing: 'The ships which sail the Southern Sea and south of it are like houses. When their sails are spread they are like great clouds in the sky. Their rudders are several tens of feet long. A single ship carries several hundred men. It has stored on board a year's supply of grain. They feed pigs and ferment liquors.'[24] That the Chinese had fully mastered ocean-sailing is confirmed by Zhou Qufei's observations that 'to the people on board all is hidden, mountains, land-marks, the countries of the foreigners, all are lost in space' and that 'the big ship with its heavy cargo has naught to fear of the great waves, but in shallow water it comes to grief'.

The development of Chinese shipbuilding technology and navigational skills were a necessary condition for the expansion of the ceramic export trade. Contemporary accounts specifically list grades of porcelain among the export items of this time. The *P'ing-chou-k'o-t'an* notes that of ships trading out of Guangzhou in the late eleventh century, the 'greater part of the cargo consists of pottery, the small pieces packed in the larger, till there is not a crevice left' and that this trade was conducted by small merchants, '[each] man gets several feet [of space for storing his goods] and at night he sleeps on top of them'.[25] This description is important not only because it is the earliest reference to the place of ceramics in the Chinese overseas trade, but also because it points to Guangdong Province as a significant source of ceramics for the export trade from at least the Northern Song period. Future kiln-site investigations in this region may establish Guangdong Province as being of no less importance than Fujian and Zhejiang Provinces in the production of China's early trade ceramics.[26]

The emphasis given to ceramics in China's export trade by the *P'ing-chou-k'o-t'an* is not reflected in the official history of the period, the *Song Huiyao*. The latter merely records that '[We used] gold, silver, copper coinage, lead, tin, mixed coloured silk, *rough and fine porcelain*, to trade and exchange for aromatic products, rhinoceros horns, coral, amber, pearl, iron, turtle shell, cornelian, giant clam, foreign cloths, ebony, sapanwood and the like'.[27] However, the distinguishing of 'rough' and 'fine' porcelain is a clue to the complexity that the ceramic trade was already assuming.

It was the *Chu-fan-chi* (Description of Barbarian Peoples), written by Zhao Rugua in 1225, that provided the first detailed account of Chinese trade in which the relative importance of ceramics is discussed, and types of ceramics distinguished, together with the extent of their distribution in the countries of South-East Asia and beyond, and an indication of which types of Chinese ceramics were preferred by particular countries.[28] The author was the Superintendent of Maritime Trade at Quanzhou, the most important port of Song China. He records that he found the existing Chinese sources scant and 'questioned foreign merchants about the names of the countries [in the Southern Seas], customs and habits of their peoples, their distances from China and their mountains and rivers and natural resources'.[29] The practice of writing such accounts on the basis of travellers' tales was commonplace. Both Abū Zaid and Mas'ūdī, important tenth-century Arabic commentators on maritime trade, were residents of the port of Sīrāf in the Persian Gulf and gathered their information in this way.[30]

Zhao Rugua listed forty-six countries with which Quanzhou traded and

described their products. Amongst the goods traded in exchange, he recorded that porcelain was exported to Annam, Cambodia, Srivijaya, the Malay Peninsula, Borneo, Java, eastern Indonesia, the Philippines, and as far west as Zanzibar; in total one-third of the countries trading with China received porcelain. He distinguished four types of porcelain and listed the regions in which each was preferred. 'White porcelain' (*bai ci qi*) is probably identifiable with the soft-paste *Dehua*-type characteristic of the Song-period Fujian kilns. Zhao Rugua associates this ware with *Ma-luo-ju*, somewhere east of Borneo. 'Green porcelain' (*qing ci qi*), which in the Southern Song context can be taken to refer to the greenwares of the 'celadon' type, was identified with *Bo-ni* (Borneo). '*Qingbai*' ware, most convincingly interpreted as the bluish-white porcelain produced widely in South China in the Southern Song period and particularly associated with early Fujian export kilns, was the preferred ware in *Ya-po* (Java). The fourth type of export ceramic referred to by Zhao Rugua was simply described as 'porcelain' (*ci qi*), presumably a miscellaneous category of all other types of wares exported at this time, including the ubiquitous glazed stoneware storage jars.

The reliability of Zhao Rugua's account can be evaluated by a review of the results of archaeological investigations of early South-East Asian trading centres. A typological survey of ceramic fragments excavated in numerous coastal sites throughout insular South-East Asia reveals that they largely conform to Zhao Rugua's broad description of the principal trade ceramics of the twelfth and thirteenth centuries as white porcelain, greenwares, and *yingqing*. The locations for these finds are numerous, but three regions reveal a concentration of sites and a consistency of types. These are Sumatra, particularly the east coast,[31] the west coast of the Malay Peninsula centred on Kedah,[32] and the west coast of Borneo, particularly the Sarawak River delta and the Kota Batu area of Brunei.[33]

The Sumatran sites provide some of the earliest evidence of the expanding trade in ceramics, beginning around the tenth century. Bulik Seguntang, near Palembang, East Sumatra, has yielded a number of Chinese green-glazed spur-marked stoneware fragments of bowls of the *Yue* type and the remains of white folded-rim bowls.[34] Both types are characteristic of late Tang and Five Dynasties wares known from Chinese sites.[35] A nearby site, Talang Kikim, has produced fragments of green-glazed stoneware jars of the 'Dusun' type, known from the Sīrāf mosque site excavation to have been exported by at least the early ninth century.[36] These would appear to be some of the earliest imported ceramics in South-East Asia. Zhao Rugua described Palembang (*Sanfoqi*) as 'a great shipping centre... lying in the ocean and controlling the straits through which the foreigner's sea and land traffic in either direction must pass'.[37] He recorded its many native products, mostly aromatics, and that porcelain was among the wares given in exchange by the foreign traders who conducted the trade between Sumatra and China.

The site which relates most closely to the period described by Zhao Rugua is that of Kota Cina, North-east Sumatra. Extensive investigations by Edwards McKinnon since 1972 have firmly identified this site as a foreign trading settlement active from the late twelfth century until the fourteenth century.[38] It had been suggested that *Pa-t'a* in Zhao Rugua's *Chu-fan-chi* may be identified as a trading kingdom in the vicinity of Kota Cina.[39] *Pa-t'a* is described as being 'of the same kind' as *Tan-ma-ling* on the Malay Peninsula, which traded in 'yellow wax, laka-wood, the *su* [variety of gharu-wood], incense, ebony, camphor, elephants' tusks and rhinoceros horns'. Among the imports of Chinese origin were silks and 'porcelain basins, bowls and the like common and heavy articles'.[40]

The range of ceramic types in Kota Cina is wider than from other Sumatran sites, supporting the notion that this was a trading entrepôt of some

importance, attracting trade from many sources. The site has produced a carbon-14 date of 1200 ± 75 which places occupation firmly in the Southern Song period. The ceramic evidence is compatible with this result. White wares, including early *Dehua*, were found, along with *yingqing* ware, greenwares including *Longquan* products, green and amber lead-glazed stonewares, and *temmoku* ware.[41] The kilns of Dehua, Anxi and Quanzhou in Fujian, and Longquan in Zhejiang, were at that time producing white wares, *yingqing*, lead-glazed stonewares, and greenwares, of the types found at Kota Cina.[42]

This brief review of the ceramic evidence from Palembang and Kota Cina serves to illustrate the general credibility of Zhao Rugua's statements. It also serves to give an impression of the nature of the early South-East Asian entrepôt. Epigraphic evidence is lacking for most of these sites and literary sources are vague regarding locations. The shifting nature of the city-state in early South-East Asia further complicates this problem.

It is important to recognize that in the dating of most South-East Asian sites the principal evidence is the presence of datable foreign ceramics. It follows that the reliability of the site dating is based on a secure knowledge of the internal chronology and production date range of the ceramics present. Integral to the rapid expansion of the ceramic trade in China was the growth of the export trade. Innumerable ceramic production centres sprang up in South China, concentrated along the coast with access to the main sea-ports. Some were short-lived; others prospered for centuries. The result of these enterprises was that many samples of Chinese ceramics discovered in South-East Asia are not readily identifiable with known kiln-sites. Archaeological surveys of ceramic centres conducted in China in recent years have begun to rectify this situation.[43] Increasingly lesser-known types of wares are being identified with specific kiln centres. Systematic excavations of these sites have in turn revealed information about the duration of production of particular types, including the contemporaneous or sequential position of wares in the life of a kiln, and stylistic developments and their relationship to technical innovations.

The picture which emerges during the Song period is one of diversification, innovation, cross-fertilization, and an altogether greater complexity in the ceramic map of South China. The popular types of export wares—*Yue*, greenwares, white wares including *Dehua*, *yingqing*, and black-brown wares including *temmoku*—appear to have been produced in many more locations than was once believed. Widespread imitation of successful types of wares appears endemic, both in the immediate vicinity of prospering kiln centres, and in the port regions through which the wares destined for the overseas market were sent.[44] Early in the Yuan period, Marco Polo tells us that in the region surrounding Quanzhou, for example, 'they make bowls of porcelain, large and small, of incomparable beauty... and from here they are exported all over the world'.[45]

1. G. R. Tibbetts (1979), p. 37.

2. See P. Wheatley (1959), p. 25 for examples of these incentives.

3. A Song census of 1080 identified one-third of the population as being 'transient' as opposed to 'settled' (Lo Jung-Pang (1955), p. 497).

4. *Sung Shih*, cited in P. Wheatley (1959), p. 24.

5. For a review of foreign archaeological remains in Quanzhou, see D. H. Smith (1958), and for Islam in Guangzhou, see Lo Hsiang-lin (1967).

6. *Sung Shih*, cited in P. Wheatley (1959), p. 39.

7. *Sung Shih*, cited by G. Wong in Southeast Asian Ceramic Society (1979), p. 94.

8. M. Tregear (1981), p. 14.

9. Cited by G. Wong in Southeast Asian Ceramic Society (1978), p. 67. Up to 20 per cent of the income of the early Southern Song government at this time came from the resale of imported goods (Lo Jung-Pang (1970), p. 171).

10. *Sung Hui-yao Kao, chih kuan*, cited in P. Wheatley (1959), p. 30.

11. D. H. Smith (1958), p. 172.

12. *Wen Wu*, 1955, No. 5, p. 98.

13. J. Sauvaget (1948), p. 16.

14. M. Beurdeley (1962), p. 5.

15. For a discussion of the shifts in Chinese patronage in the Northern Song period, see M. Medley (1973a), p. 39.

16. An inventory of 1141 listed 339 items of import of which the category '*hsiang yas*'—aromatics and drugs—were the most numerous; see P. Wheatley (1959), pp. 45–130, for detailed identification of these items and their places of origin.

17. Reported in *Wen Wu*, 1975, No. 10, pp. 1–18. See also C. Salmon and D. Lombard (1979), pp. 57–68.

18. T'ien Ju-K'ang (1982), p. 221.

19. R. Latham (1958), p. 237.

20. F. Hirth and W. W. Rockhill (1911), p. 78.

21. Ibid., p. 223.

22. Lo Jung-Pang (1970), pp. 170–1.

23. F. Hirth and W. W. Rockhill, op. cit., p. 30.

24. Ibid., pp. 33–4.

25. Ibid., p. 31.

26. For a report on recent investigations in the Guangdong region of Northern Song period kiln-sites see J. C. Y. Watt (1978).

27. Cited by G. Wong in Southeast Asian Ceramic Society (1978), p. 67.

28. For an annotated translation, see F. Hirth and W. W. Rockhill, op. cit.

29. Feng Xianming (1981b), p. 6.

30. G. R. Tibbetts (1979), p. 1.

31. E. P. Edwards McKinnon (1975–7, 1977).

32. A. Lamb (1961a, 1961b).

33. T. Harrisson (1955b), Cheng Te-kun (1969), W. G. Solheim (1978), M. Omar and P. M. Shariffuddin (1978).

34. For a discussion of the use of the term '*Yue*' see M. Tregear (1976), p. 1.

35. E. P. Edwards McKinnon (1979), p. 42.

36. E. P. Edwards McKinnon and A. C. Milner (1979), p. 15, and D. Whitehouse (1973), p. 245.

37. F. Hirth and W. W. Rockhill, op. cit., p. 62.

38. E. P. Edwards McKinnon (1975–7).

39. For a discussion of this and alternative locations and the historical sources, see A. C. Milner *et al.* (1978), pp. 3–4.

40. F. Hirth and W. W. Rockhill, op. cit., p. 67.

41. E. P. Edwards McKinnon (1975–7), pp. 31–50.

42. For the possible provenances for many of the ceramics excavated at the Kota Cina site, compare E. P. Edwards McKinnon (1975–7) and P. Hughes-Stanton and R. Kerr (1981), pp. 125–32.

43. See Feng Xianming (1967), and P. Hughes-Stanton and R. Kerr (1981).

44. A survey of identified kiln-sites and their products in South China, as documented in P. Hughes-Stanton and R. Kerr (1981), demonstrates this point.

45. R. Latham, op. cit., p. 238.

4. Fourteenth-century Trade Ceramics and the Mongol Contribution

THE Mongols ruled China for less than a century and left much of the cultural infrastructure largely untouched. They were content to occupy the country and exploit the opportunities for profit which the commercial policies of the Southern Song Dynasty had set in motion. This desire for profit from trade acted as a great stimulus to the Chinese ceramic industry. Technical innovations which enabled greater output were devised, and these, together with new design elements of Mongol and Middle Eastern origins, placed Chinese ceramics on a new course which was to influence its stylistic character for the remainder of its history. The commercial policies of the Yuan administration ensured that these ceramics were actively traded in unprecedented quantities throughout South-East Asia and the Islamic world.

The Mongols paid particular attention to the expansion of the Song navy which they had inherited. A vast shipbuilding programme was embarked upon, partly to supply invasion fleets to be used to satisfy the expansionist visions of the Yuan court.[1] The Song navy, which had consolidated Chinese control over the South China Sea by the first half of the thirteenth century, had been employed in defending coastal settlements and in eliminating the pirates who continued to interfere with the flow of trade. During the Southern Song period improvements in Chinese nautical technology had enabled full participation in open-sea voyages. By at least the late twelfth century Chinese ships were active in Sumatra, Java, and the Gulf of Thailand, and by the early Yuan period were reported in the Indian Ocean.[2] In the hands of the Mongols the Chinese navy became an instrument of aggression. Large-scale campaigns were launched against Japan (1281), Tonkin and Champa (1283–8), and Java (1293).

In other respects the Mongols continued the policies of the Southern Song Dynasty. They shared the Song administration's desire to extract the greatest profit through the taxation of trade. Indeed the Mongols were able to pursue this policy with even more vigour than the Song rulers, unrestrained as they were by any Confucian inhibitions regarding official participation in commerce. Like his predecessor, Kublai Khan sent diplomatic missions to the countries of South-East Asia inviting merchants to come to China to trade. Such moves appear to have produced the desired result: Marco Polo, speaking of the great Yuan port of Quanzhou in 1292, wrote that 'the revenue accruing to the Great Khan from this city and port is colossal'.[3]

Unlike the Song government, however, the Mongols did not give encouragement to the Chinese merchant class to extend their involvement in trade; rather, they fostered good relations with foreigners, often Muslims of Near Eastern origin. Whilst regulating overseas trade to an unprecedented degree,

23

the Yuan government was careful not to stifle it. Taxation was in fact lower than under the Song administration and the government itself directly sponsored trading ventures. All these moves ensured that China's maritime trade continued to expand. Since the Southern Song period ceramics had been a significant component of China's overseas trade and under the Yuan they gained even greater prominence, stimulated by the demands of the Islamic markets of the Middle East and of the states of South-East Asia.

The Mongols introduced regulations to ensure that they benefited directly from the expansion in the ceramic industry at the point of production, as well as from taxing shipping. Information on this period is scarce but one invaluable source is the *T'ao-ch'i lueh* (Appendix to the Ceramic Records), prepared in 1322 under official direction by Chiang Ch'i. During the Song period ceramics were taxed as merchandise. The *T'ao-ch'i lueh* speaks of a taxing system based on kiln capacity, regulated through a Porcelain Bureau.[4] The establishment of a government bureau expressly to supervise ceramic production is a clear indication of the economic importance of the ceramic industry in fourteenth-century China.

The Yuan government's desire to exploit fully the economic benefits of trade put unprecedented demands on the resources of the Chinese ceramic industry. The widespread adoption of the use of moulding, luting, and stamped and appliqué decoration were responses to this pressure, resulting in a range of standardized wares readily distinguishable from the variable and 'individualized' wares produced by the Song potters and decorators. These techniques, however, were not new. Moulding had been in use since the middle Tang period and was widely practised during the Northern Song period at Jingdezhen.[5] The earliest known example of *yingqing* ware with stamped decoration is a vase of *meiping* form discovered in a tomb dated to the year 1027 at Nanjing.[6]

The popularity of *yingqing* continued into the thirteenth century and maintained a significant place in the ceramic trade in the Yuan period. The *yingqing* of Jingdezhen was widely imitated by newly established kilns in the south-eastern coastal region. These wares feature prominently in trade ceramic finds in South-East Asia at this time and declined in relative importance only with the rapid rise to popularity of the *Longquan* greenwares of Zhejiang Province. The twelfth and thirteenth centuries saw the products of the Longquan region kilns, of which over three hundred had been located by 1979, reaching their peak of technical excellence. Numerous imitations of *Longquan* greenwares were produced by minor kilns in Fujian and Guangdong Provinces, but none matched the lustrous quality of the products of the 'dragon-spring' kilns of Zhejiang.

The distribution of greenwares in overseas markets, with *Longquan* wares appearing most commonly in West Asia and the provincial imitations in South-East Asia, can be taken as a reflection of the relative wealth of these markets. The residents of Fustāt, the old city of Cairo in lower Egypt, clearly valued *Longquan* greenwares highly. Extensive excavations have shown that around the mid-twelfth century Egypt was 'deluged with *Longquan* pottery, of all sizes and shapes' and that 'it far outnumbers any other specific type of Chinese import'.[7]

At Pengkalan Bujang in Kedah, on the west coast of the Malay Peninsula, extensive ceramic finds provide evidence of a prosperous trading centre, possibly a terminus for a land route crossing the Peninsula or an entrepôt for the exchange of goods on the East–West route. In either case, deposits of ceramics, heavily broken and found in a concentrated area, support the notion of Kedah as an important trading centre for the ceramic trade of the late Song and Yuan periods. The ceramics found at Pengkalan Bujang form a representative sample of Chinese export ceramics of the thirteenth and four-

teenth centuries. Significantly, the majority of wares excavated were Chinese greenwares and appear to include products of both Longquan and southern provincial kilns.[8] Other sites which also may have served as terminus points for regional and international trade, such as Nakhon Si Thammarat[9] and Satingphra,[10] both on Kra Isthmus, have also yielded mainly greenwares with lesser quantities of *yingqing* and *Dehua* ware.

Zhou Daquan, who accompanied the Yuan imperial envoy to Cambodia in 1296, observed that amongst the Chinese products valued at Yasodharapura (Angkor) 'Chinese gold and silver comes first in demand... next comes light and colourful silks, then pewter ware from Zhenzhou, lacquerware from Wenzhou and blue porcelain [i.e. greenware] from Quanzhou'.[11] Groslier's excavations at Angkor confirm the presence of Chinese ceramics, 'especially celadons', in considerable quantities from the tenth century onwards.[12]

It is evident that Chinese ceramics were extensively traded in South-East Asia and beyond during the Yuan period and that, at least until the beginning of the fourteenth century, greenwares were the supreme trade ceramic of Asia. A development of major significance occurred in the early fourteenth century which was to alter this situation irrevocably: the appearance of blue-and-white porcelain.

The importance of this innovation in the history of Chinese ceramics need not be dwelt on here, but it is important to recognize that the motivation for this development was generated from outside China, in the Islamic markets of the Middle East. As mentioned earlier, under the Mongol occupation China extended its close trading relations with the Islamic lands of West Asia and encouraged the activities of Muslim merchants in the port-cities of South China. The Islamic taste for rich elaboration of two-dimensional design, seen particularly in metalwork and manuscript decoration, had not been successfully translated to the local ceramic medium. Cobalt-blue had been used in thirteenth-century Persian ceramics but a tendency for the colour to run made the result unsatisfactory. The possibilities of combining the unsurpassed Chinese expertise in the production of high quality porcelain with Islamic design concepts and forms to produce a new class of decorated porcelain designed consciously for the Islamic market, appears to have been seized upon by Persian merchants and Chinese porcelain producers with great enthusiasm. Although limited sources of inferior cobalt must have been available in China by this time, and some tentative experiments in underglaze blue decoration are known from the Northern Song period,[13] the cobalt necessary for the development of fourteenth-century blue-and-white came from Persia, as it had done in the middle Tang period when it was used as a glaze colourant. The imported cobalt was known in China as 'su-ni-pu' or 'su-ma-pi', clearly an adoption of the Persian term for cobalt, 'sulimani'.[14] It seems most likely that cobalt was imported at the direction of Persian merchants resident in China. They in turn would have been responsible for placing the orders with the Chinese manufacturers and providing specifications of their requirements.

This new class of ware equalled *Longquan* greenwares in popularity for the remainder of the Yuan era and, after the disruptions to trade caused by the defeat of the Mongols in 1368, assumed the pre-eminent position. It not only dominated the export trade but gradually began to penetrate Chinese taste as well, initially amongst the urban classes, and, in the early Ming Dynasty, the imperial household itself. However, it seems beyond doubt that in the fourteenth century blue-and-white porcelain was primarily intended for the Islamic market. It is no coincidence that the two greatest collections of early blue-and-white are preserved in the Middle East.[15]

To argue that the initiative for the development of fourteenth-century blue-and-white was largely external, stimulated by the potentials of the ceramic trade, is not to underplay the critical importance of earlier Chinese innova-

tions in the use of underglaze decoration, as seen in the achievements of Changsha, Cizhou, Jizhou, and Jingdezhen. Over four centuries of experience and experimentation in the use of underglaze painting lay behind the development of fourteenth-century blue-and-white porcelain.

Considerable debate surrounds the origins of blue-and-white porcelain, but it is generally accepted that commercial production on any significant scale only began sometime in the first quarter of the fourteenth century. The earliest dated example, the pair of Percival David vases, occur only in 1351,[16] but by this time, we are informed by the Yuan traveller Wang Dayuan, blue-and-white porcelain had already become one of the most popular of China's trade ceramics in the countries of South-East Asia, India and the Islamic world (Fig. 11). Apparently a merchant, Wang Dayuan travelled widely and recorded his impressions of the countries which he claimed to have visited. His account, the *Dao Yi Zhi Lue* (A Brief Description of Island Foreigners), published in 1349, provides descriptions of the people and customs of ninety-nine countries, together with a record of their products and of those goods from China which they desired.[17] Of the forty-five countries listed as importing Chinese porcelain, eighteen preferred blue-and-white porcelain, and fifteen greenwares. Various types of porcelain are described among the desirable Chinese imports. In addition to the blue-and-white and various types of greenware listed, including *Longquan*, are *yingqing* and storage jars of various sizes. The countries listed as preferring blue-and-white and *yingqing* ware are the Philippines, South-west Borneo, Tambralinga, Pattani, Trengganu, Kelantan, Java, northern Sumatra, all the kingdoms of India with which trade was recorded, and Saudi Arabia. Greenwares were favoured by those countries which also accepted 'rough bowls' and/or storage jars, such

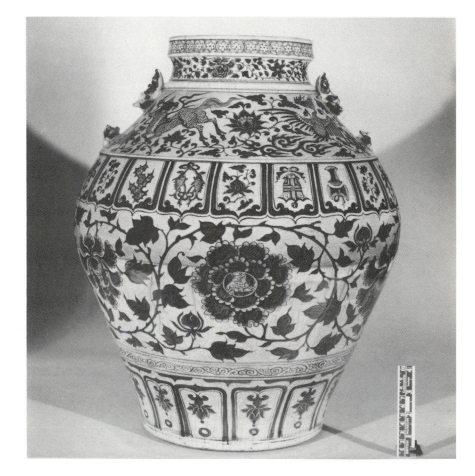

Fig. 11
Jar decorated in underglaze blue with qilin, phoenixes and peonies, Yuan Dynasty, c.1350. From a collection assembled in India by William Cummins between 1864 and 1883. Similar jars in the Ardebil Shrine Collection, Tehran (J. A. Pope, 1956, Pl. 26). Comparable example excavated from a tomb in Anhui, dated to Hongwu (r.1368–98). (British Museum, London)

as Taiwan, the Moluccas, Vietnam, and the Batak peoples of Sumatra. Those countries which imported blue-and-white are not recorded as purchasing either greenwares or 'rough bowls', which may be taken a reflection of the higher status attached to blue-and-white by the middle of the fourteenth century.

The decorative splendour and technical excellence of fourteenth-century Jingdezhen blue-and-white porcelain proved popular throughout the length of the maritime trade routes. The importance of Java as a market for early blue-and-white porcelain, mentioned by Wang Dayuan, has been confirmed by numerous ceramic discoveries, particularly in East Java.[18] The Majapahit Kingdom which, from its capital near Trowulan in East Java, controlled the Java Sea and much of the lucrative eastern Indonesian spice trade, was prosperous enough to purchase Chinese porcelains of high quality. A limited number of the large-scale plates, bowls, and ewers so popular in the Middle East have been found in Indonesia.[19] Small jars, cups, ewers, and figurines appear to have been produced primarily for the South-East Asian market, possibly intended to meet some funerary requirements of the people of the Philippines and Indonesia. They are particularly prevalent in burial excavations in the northern Philippines, in sites such as Laguna de Bay and Santa Ana in Luzon. Clandestine excavations in the Laguna de Bay area in the late 1960s produced some thousands of pieces which promptly appeared on the Manila art market.[20] Most common were soft-paste porcelain jars, ewers, and figurines with *yingqing* glaze, *Dehua* wares, *shufu* and *shufu*-type, lead-glazed vessels, and *yingqing* glazed wares with underglaze decoration in various combinations of blue, red, or brown. Identical finds have been made in Manila at the Santa Ana site[21] (Fig. 12). It has been suggested that, on the basis of Northern Song coins found at Santa Ana in association with these ceramics, the site may provide evidence for dating this early group of underglaze blue and red wares to the Song period.[22] Coins are, however, a notoriously unreliable means of securely dating a site, indicating only the earliest possible date. In South-East Asia, Tang coins have been found in Song- and Yuan-period sites, as seen for example at Kota Cina.[23] Investigations at the Hutian kiln-site in Jingdezhen, which have yielded sherds of the types known in the Philip-

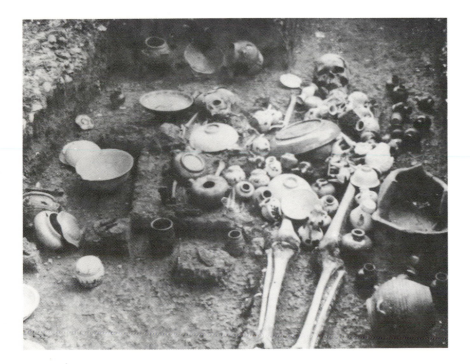

Fig. 12
Grave of a mother and child excavated at Santa Ana, Manila, Philippines, in June 1968. It was one of the richest yields of early trade ceramics from a single grave, containing seventy-nine pieces of porcelain and glazed stoneware, dating from the late thirteenth and fourteenth centuries. It included brown-spotted yingqing wares, early examples of blue-and-white, greenwares, and one rare piece decorated in underglaze red. (Courtesy National Museum, Philippines)

27

pines, point firmly to a fourteenth-century Yuan date.[24] Further evidence for this date was provided by the accidental discovery in 1976 of a fourteenth-century shipwreck off the southern coast of Korea, near Sinan. Over 7,000 ceramics pieces have been retrieved and classified, of which over half are *Longquan* greenwares.[25] Among the remainder are *yingqing* and iron-spotted *yingqing* of the types known previously only from sites in insular South-East Asia,[26] most notably in the Philippines. Ewers and gourd-shaped ewers, iron-spotted or plain, with handle in the form of a *chi* dragon or a simple strap handle, water-droppers in the form of 'a boy on a buffalo' figurines, and brushpots in the form of 'boys in a lotus pond' configuration, were represented (cf. Plates 42 and 43). The only significant type not represented in the Sinan shipwreck were wares decorated in underglaze blue. Given the wide range of wares represented in the cargo it is not unreasonable to postulate that the absence of underglaze blue suggests that it had not yet come into mainstream production. If this is so, then the Philippine finds may be assigned a late Yuan date, firmly in the fourteenth century. This dating questions the conventional chronology, which has viewed these wares as early, naïve, even primitive experiments in the new medium which preceded the splendidly elaborate and sophisticated classic Yuan blue-and-white. One implication of this proposed dating is that these two types of blue-and-white may have been produced concurrently, to satisfy entirely different market expectations.

Specific types of wares, such as the distinctive spouted ewer or *kendi*, were apparently made expressly for the South-East Asian market where indeed the majority of examples have been discovered. The origin of the form is uncertain but the Malay name '*kendi*' is generally accepted to derive from the Sanskrit '*kuṇḍikā*', meaning 'water-pot'. Two types are known and the term '*kuṇḍikā*' is used loosely for both. One has a cupped opening on the shoulder for filling and a slender, vertical spout for pouring (Fig. 8). The other type has its functions reversed, with a flowing neck for filling and a slender spout for pouring. It is the latter type that is depicted in a ninth-century Javanese relief, being used to pour libations over a miniaturized stupa, which most likely provided the prototype for the South-East Asian *kendi*. The examples depicted in the relief sculptures were probably both bronze, in keeping with most ritual vessels of this period, although earthenware examples are known.[27] The earliest known Chinese examples are of South Chinese, probably Fujian, manufacture, and belong to the fourteenth century. The early ritual function associated with the *kuṇḍikā* in the Hindu–Buddhist context of Central Java, is perpetuated in the practice of using *kendi* for ritual libations in twentieth-century Balinese religious observance.[28] In Islamized Indonesia the *kendi* has served its other more secular function as a drinking vessel.

The introduction of the large flat serving dish into the repertoire of Chinese ceramics, with a steep cavetto and foliate or plain rim, can be assumed to have grown out of the demands of the Middle Eastern consumers, to whose communal eating habits such dishes were suited. The popularity of the large serving plate in the Middle East is confirmed by two collections of such wares currently preserved in Istanbul and Tehran. The Tokapi Saray Museum, Istanbul, formerly a royal collection for which inventories listing Chinese porcelain exist from 1495, and the Ardebil Shrine Collection, presented by the Iranian ruler Shāh 'Abbās to his family's Shi-ite shrine in 1611, together house the finest and best provenanced collection of Yuan and early Ming blue-and-white porcelain.[29] These collections are also a testimony to the enduring appreciation of Chinese porcelain in the Islamic world.

The Yuan period also saw a new development in the trade routes between China and insular South-East Asia. The traditional *Nanhai* route, down the coast of Vietnam and across the South China Sea to Borneo, Java or Sumatra and then westward, was divided into two sea routes, the Eastern Route and

the Western Route. These are described by Ch'en Ta-chen's *Nan Hai Chih* (Records of the Southern Sea), written in 1304: the Straits of Karimata (South-east Borneo) and the Straits of Sunda (between Java and Sumatra) were given as the dividing line between the two routes. The Eastern Route passed from South China to the Philippines, the north coast of Borneo, Sulawesi, the Moluccas, as far east as Timor and west to Java.[30] The Western Route maintained the traditional trading links with the West, sailing from the South China Sea through the Straits of Malacca, westward to Sri Lanka and beyond. The new Eastern Route allowed greater direct penetration of South-East Asian markets by the Chinese both as a source of supply and as an outlet for Chinese trade wares.[31] The eastern Indonesian trade, traditionally funnelled by local traders through the leading entrepôt of the day, now saw a direct Chinese presence which remained until the coming of the Europeans.

It is likely that with the establishment of the Eastern Route the volume of Chinese trade ceramics penetrating these regions increased substantially. While Chinese ceramics were previously not unknown to these regions, flowing through the entrepôt centres where the local products were sold, from the Yuan period onwards, became more systematic and the volume of trade grew, with and without official encouragement from successive Ming rulers.

1. The *Yuan shih* records orders for 1,500 ships in 1279, 3,000 in 1281, and 4,000 in 1283 (Lo Jung-Pang, 1955, p. 492).

2. O. W. Wolters (1970), p. 42.

3. R. Latham (1958), p. 237.

4. This and other aspects of the organization of the ceramic industry under the Yuan administration are discussed by M. Medley (1974), pp. 7–8.

5. Liu Xinyuan and Bai Kun (1982).

6. M. Sato (1981), p. 123.

7. G. T. Scanlon (1970), p. 88.

8. See A. Lamb (1961a), Pls. 27–47.

9. S. J. O'Connor (1975), p. 163.

10. A. Lamb (1964c), and J. Stargardt (1983).

11. Quoted in Feng Xianming (1981b), p. 7.

12. B. P. Groslier (1981a), p. 20.

13. Feng Xianming (1981a), p. 53.

14. See M. Medley (1976), p. 273, and H. Garner (1956).

15. The Ardebil Shrine Collection, Tehran (see J. A. Pope (1956, rev. ed. 1981)) and the Topkapi Saray Museum, Istanbul (see J. A. Pope (1952, rev. ed. 1970) and S. Jenyns (1964–6)).

16. See H. Garner (1970), Pl. 6.

17. For a translation, see W. W. Rockhill (1915).

18. A. Ridho (1981).

19. See van Orsoy de Flines (1972), Pls. 37, 39 and 41, and A. Ridho (1982), Pls. III, 24, 25, 26, and 28.

20. J. M. Addis (1967–9), p. 18.

21. L. Locsin and C. Y. Locsin (1967).

22. Ibid., pp. 103–4.

23. E. P. Edwards McKinnon (1975–7), p. 65.

24. Liu Xinyuan and Bai Kun, op. cit., p. 10.

25. Chung Yang-Mo (1977), p. 261.

26. From the position of the ship it appears to have been destined for Japan and, by virtue of a number of Korean ceramics in the cargo, can be assumed to have already called at a Korean port en route. Yet, curiously, examples of the characteristically 'South-East Asian market' wares in the cargo have not been found in Japanese sites of this period.

27. A bronze *kuṇḍikā* was excavated in the vicinity of Prambanan, Central Java; see M. Sullivan (1957a). p. 54.

28. M. Sullivan (1957a), p. 42.

29. See note 15 above.

30. Hsu Yun-Ts'iao (1967), p. 12.

31. The extent of this penetration a century later is evident from the *Shun Feng Hsiang Sung* ('Fair Winds for East') text, *c.*1430, which contains sailing instructions for one hundred voyages by both the Western and Eastern Routes, twenty-seven within South-East Asian waters. See J. V. G. Mills (1979).

5. Early Ming Policies and South-East Asian Trade

THE restoration of a native dynasty in China with the founding of the Ming under the emperor Hongwu (r.1368–98) saw a development of major significance in the history of trade ceramics in South-East Asia. The Emperor restored the tributary trading system which had largely lapsed in the Song period in the face of lucrative commercialism and the discouragement of a court which was feeling the burden of repaying tribute missions in abundant measure. The Chinese world-order had experienced a major setback under a century of foreign occupation, and with the expulsion of the Mongols the need was felt to reassert traditional Confucian values, especially in relation to China's intercourse with the barbarian world. Immediately after Chu Yuan-chang's accession as the first Ming emperor, imperial envoys were dispatched to Japan and South-East Asia to announce the restoration of order in China. Foreign rulers were invited to establish tributary relations with the Emperor. The arrival of such missions was seen by the court as a demonstration of the power of the Emperor's moral virtue (*te*) to attract 'barbarian' rulers to the court of the Son of Heaven without the use of force. However, the lessons of the Song Dynasty were that moral virtue without military backing could be inadequate when dealing with elements of the barbarian world, as demonstrated by the Mongol conquest. The early Ming emperors therefore stressed the restoration of traditional Chinese attitudes in their relations with foreigners, backed by a considerable show of strength.

The emperor Hongwu restored the tributary system with an unprecedented degree of moral exactitude. Tributary relations had traditionally accommodated and facilitated trade to the degree that for periods of Chinese history 'tribute' became something of a euphemism for trade. Emperor Hongwu's conception was quite different. The tribute system was to be enacted in its formal and literal sense. Tributary trade was limited to permission to sell goods brought to China on the occasion of a tributary mission. Tributary relations were not to be seen as unrestricted ongoing commercial activity with those countries which had presented tribute to the Emperor and acknowledged his superiority. Thus foreign goods were to be brought to China only by those countries which had rendered tribute and observed the ritual. Trade was only to occur when tribute missions came, and private transactions between Chinese and 'barbarians' were prohibited. In addition Chinese were formally forbidden from participating in overseas trade. A decree of 1371 forbade the Chinese to 'proceed to the sea' and this prohibition was reiterated later in Hongwu's reign. The use of certain foreign goods was banned to reduce further the attractiveness of overseas trade.[1]

The combined effect of restoring formal tributary relations and prohibiting

private trade with foreigners led to profound changes in China's relations with South-East Asia. It also contributed significantly to altering the state of South-East Asia itself. The reasons underlying these two acts were related but must be distinguished. The establishment of tributary relations with foreign countries served to announce to the world that the Mongols had been expelled from China, and to give prestige to the Emperor through the display of his ability to attract foreign missions. The prohibition on private foreign trade reflected Hongwu's concern over the growing wealth and independence of the sea-merchants of South China. This concern was expressed in terms of foreigners having a corrupting influence on the Chinese people, specifically in regard to the piracy problem along China's seaboard. Japanese pirates (*Wako*) were largely responsible for these disturbances, but Chinese are also believed to have cooperated with the Japanese, especially those who raided the southern settlements in Zhejiang, Fujian, and Guangdong from bases in the Liaotung and Shantung peninsulas.[2] In 1383 alone fifty-five forts were built from Shantung Peninsula down the coast to Zhejiang, the most disturbed province, and in 1387 sixteen forts were set up along the Fujian coast.[3] These measures give some indication of the gravity of the piracy problem. However, the prohibition on private trade may have driven many Chinese merchants into cooperative ventures with pirates. The growth of the piracy problem may be partly explained by the Emperor's act of declaring illegal an activity which for centuries had been legal.

This unprecedented wave of anti-commercialism at court had a dampening effect on overseas trade. As a result extensive smuggling occurred, conducted by the wealthy Chinese merchants of South China, often in concert with tribute-bearing diplomatic missions from South-East Asia who were still permitted limited trading rights. Only designated ports were permitted to receive these missions, where limited trade could be undertaken under government supervision. Ningbo was to serve missions from Japan and Korea, and Guangzhou was nominated as the port of entry for all South-East Asian countries. The granting of limited trading rights to foreign missions was so exploited as a cover for an extensive smuggling business with Chinese merchants that the court issued an edict in 1381 depriving Java and other tributary countries in South-East Asia of this diplomatic privilege.[4]

Trade was, however, the *raison d'être* for tributary relations in the eyes of those countries which sent missions. Foreign envoys were accompanied by large fleets carrying the traditional trade goods. Unfortunately the official Chinese records of tribute missions received do not record the volume of private trade conducted. Some indication is given by a mission from Ayudhya which in 1392 presented over thirty-eight tons of aromatics. It would have been permitted to sell comparable quantities under official supervision.[5] For the return journey they were permitted to purchase textiles and porcelain. During the reigns of Yongle (1403–24) and Xuande (1426–35) the envoys of Taiwan were permitted to make yearly purchases of porcelain of up to 80,000 pieces.[6] Although such tribute missions carried substantial quantities of goods, the total volume of trade was adversely affected by the imperial prohibitions after the 1370s.

That private trade did occur nonetheless is evident from a number of sources. The need to reiterate the ban on overseas trade at regular intervals throughout the reign points to violations and to the government's inability to enforce it effectively. Incidents of Chinese merchants, and even officials, conspiring with foreign tribute missions in the pursuit of trade have been recorded.[7] In addition Chinese merchants ventured abroad in defiance of the bans on large-scale commercial expeditions: the *Ming shih-lu* records that the King of Champa informed Emperor Hongwu in 1373 that his navy had captured twenty private Chinese ships carrying sapanwood.[8] The import-

ation of precious goods, over which the court was attempting to maintain a monopoly, was also undertaken by officials for private gain. Imperial envoys dispatched on missions to South-East Asian countries rarely returned empty-handed, smuggling ivory, spices and other precious items.[9]

Profits were also to be made smuggling Chinese products to South-East Asia where a shortage of supply probably inflated the prices which could be demanded. An official Ming account complained that 'there were wicked traders who carried our country's silk, brocade, porcelain and such like valuable goods to these foreign countries. They did not take other produce for their exchange but only silver and gold. Then, when they returned, they burned the ship and sneaked back from other places.'[10] Such practices were not the basis of a viable trading system and alternative solutions were sought to ensure that the lucrative trade continued. The prohibitions were hard felt both by the Chinese merchants of South China who, for at least two centuries, had prospered under *laissez-faire* conditions promulgated by the Song and Yuan administrations, and by the entrepôt trading states of South-East Asia whose prosperity was heavily dependent on commercial intercourse with China.

The policies of Hongwu and his son Yongle had two significant effects on the nature of South-East Asian trade. The Malays and Indonesians had hoped, after the receipt of Hongwu's envoys inviting tributary missions, for a restoration of prosperous trade with China. Yet in the last decades of the fourteenth century it became evident to the trading kingdoms of South-East Asia that this was not China's intention. Increasingly the Malays turned to the Indian Ocean trade and strengthened their bonds with Muslim traders, a link which was to have lasting importance for the history of the region. Secondly, the prohibition on trade induced many Chinese merchants, who for generations had prospered by this commerce, to leave China permanently and settle in South-East Asia where commercial opportunities abounded. Ma Huan's observations early in the fifteenth century record this development. In Palembang, South Sumatra, he noted, 'many of the people...are men from Guangdong province and from Zhangzhou and Quanzhou who fled away and now live in this country'. He further observed that they were 'very rich and prosperous'. Tuban, the port of Majapahit, on the north coast of Java, also had many people from China. Tuban is known in the *Yuan-shih* as '*Tu-ping-chich*' and is believed to be the harbour where the Mongol punitive fleet, sent against the ruler of Singasari, landed in 1292. Extensive trade ceramic finds in the sea off Tuban since 1980 indicate that it continued to serve as a major Javanese port during the fourteenth and fifteenth centuries.[11] Gresik, which became a leading spice port from the early fifteenth century, was founded, according to Ma Huan, by Chinese late in the previous century during Hongwu's reign.[12] The migration of Chinese from the coastal regions of South China to South-East Asia was to have a permanent impact on the commercial and cultural life of South-East Asia.

The hopes of the mercantile kingdoms of South-East Asia were again raised in 1402. The emperor Yongle, within three months of ascending the throne, sent envoys to Vietnam, Champa, Ryukyu, Japan, Thailand, Java, Samudra (North-east Sumatra), and South India.[13] The mission sent to Malacca in 1403 marked the beginning of China's recognition of this newly established kingdom. These relations, fostered by Muslim merchants from South Indian ports, provided the diplomatic and military backing which Malacca needed to withstand the hostilities of Java and Thailand, neither of which wanted to see another economic power in the region.[14]

The most remarkable display of Chinese interest in South-East Asia and the lands beyond occurred between 1405 and 1433 when Emperor Yongle dispatched a series of large-scale naval expeditions to the Western Ocean,

Xiyang, with the sixth expedition (1421–2) reaching the east coast of Africa.[15] These voyages, led by the Grand Eunuch Zheng He, established China as the supreme maritime power in the Southern and Western Oceans with suzerainty over many of the lands of South-East Asia. Although the suppression of piracy was a major objective, these expeditions were primarily intended to establish official foreign trade under direct court control.[16] Personal aggrandizement on the part of the Emperor and a desire for political domination were also significant factors. The 'haughty emissaries of the Dragon Throne, armed to the teeth to enforce the imperial will',[17] made a powerful impression on the rulers of the lands they visited. Many tributary missions were sent to the court of China during Yongle's reign, even from as far away as Egypt.

Trade was conducted by Zheng He's expeditions and it is likely that many of the vessels which accompanied the imperial 'treasure-ships' (*pao-ch'uan*) were private merchant ships engaged in trade. Ma Huan records that although consignments of musk, silk, porcelain, and other valued Chinese products were distributed by the emissaries to the rulers of foreign kingdoms, these and other goods were also vigorously traded, particularly for precious stones and pearls in the lands of the Western Ocean.[18] The potential for trade created by this form of coercive diplomacy was immense. However, it was not to be realized.

The voyages of Yongle's envoys represented on one level the extending of imperial virtue and wisdom to distant barbarian lands. On another level they represented aggressive commercial activity, with an unprecedented degree of imperial involvement. By the time of the fourth expedition, which returned to China in 1415, imperial interest in the expeditions was waning.[19] Opposition in the court to such costly and 'inappropriate' ventures combined with a pressing need to respond to renewed military threats on the northern frontiers turned Yongle's interest away from South-East Asia and the Western Ocean. Official trade by the 'treasure-ships' in the subsequent expeditions remained confined to the pursuit of such luxury items as precious stones and pearls, and private trade remained illegal.

It is evident that a considerable discrepancy existed between the official and actual state of overseas trade in early Ming China. The role of foreign trade in the economy of South China was so central that to challenge it was to threaten the viability of a significant sector of Chinese society. Whilst tributary trade may have gone a long way towards satisfying the porcelain needs of tributary countries, the supply of large quantities of popular wares could not be achieved within the confines of such a limited trading framework. Private trade occurred, organized by powerful syndicates of local officials and ship-owners in defiance of the prohibitions.

That Chinese ceramics were traded at this time is evident from a number of sources. Even within the limits of emissary gifts and tributary trade the volume of ceramics entering South-East Asia may not have been insignificant. Imperial envoys sent by Hongwu to Thailand, Cambodia, and Champa in 1363 took with them gifts of silk brocade and 19,000 pieces of porcelain.[20] Two accounts written by members of Zheng He's naval expeditions confirm the popularity of Chinese porcelain in the countries of South-East Asia and the Western Ocean. Ma Huan, in his *Ying Yai Sheng Lan* (The Overall Survey of the Ocean's Shores), written in 1433 after accompanying Zheng He on three voyages, tells us that the people of Java were 'very fond of the blue-patterned porcelain ware of the Central Country', and that in Sri Lanka the people gave precious stones and pearls in exchange for porcelain dishes and bowls.[21] Fei Xin's 1436 account of sailing in the emperor's 'treasure ships', *Xing Cha Sheng Lan* (Successful Journey on a Legendary Raft), made reference to Chinese blue-and-white porcelain as a valued item in the countries of

South-East Asia, India, and Saudi Arabia. Those countries on the Eastern Route included the Philippines, the Sulu Archipelago, and as far east as Timor. On the Western Route, Thailand, Pattani, Malacca, Java, Jambi, Aru, Aceh, Sri Lanka, the Maldives, Bengal, Calicut, and Mecca were all recorded as markets for Chinese blue-and-white porcelain.[22] It is interesting to note that in both these early Ming accounts, *Longquan* greenware (*Chu Chou*) is no longer mentioned alongside blue-and-white, as it was in Wang Dayuan's account of maritime trade less than a century earlier. The struggle for pre-eminence between greenware and blue-and-white had been resolved in favour of the latter. Production at the Longquan kilns continued but the wares were of inferior quality, heavier and coarser than their fourteenth-century counterparts. By contrast the blue-and-white porcelain of the Jingdezhen kilns was the finest-quality porcelain produced in China, and had an assured overseas market.

The disruption to fourteenth-century Chinese trade in South-East Asia caused by the collapse of the Yuan Dynasty and the negative attitudes of the early Ming emperors appears to have been significant, if not profound. With the decline of Srivijaya's hegemony over the western region of South-East Asia from around the tenth century, the entrepôt trade in South-East Asia was characterized by decentralization of trading locales. Numerous small coastal trading states prospered through the supply of upland natural products to coastal ports for resale to foreign merchants engaged in international trade. Many of these trading settlements appear to have collapsed in the thirteenth and, especially, fourteenth centuries. Few of the coastal trading sites which were active in the Song and Yuan periods have produced ceramics which can be reliably attributed to the late fourteenth- to early fifteenth-century early Ming period.[23] When new entrepôt centres emerged in South-East Asia to participate in the vigorous recovery of regional and international trade with China in the course of the fifteenth century, they were in new locations and displayed a very different ceramic mix from that found in the earlier-period sites.

Ceramic finds from a number of excavated sites provide the material evidence that many South-East Asian trading settlements collapsed in the course of the fourteenth century. Obstacles to Chinese trade meant that South-East Asian states were unable to sell their aromatics, spices and other natural products, nor to purchase the silks and ceramics which were highly valued items in their intra-regional trade. This decline was partly offset by the growing Western demand for South-East Asian spices but this trade remained of limited economic importance until the coming of the Europeans in the sixteenth century.

The pattern of collapse and recovery over the fourteenth and fifteenth centuries can be witnessed at a number of sites in South-East Asia. Examples in Sumatra and Borneo perhaps best illustrate this process. In north-eastern Sumatra, Kota Cina and Pulau Kompei have both been identified as active trading settlements in the twelfth and thirteenth centuries, with Kota Cina at least continuing into the fourteenth century.[24] Neither site has revealed evidence of being an active trading settlement after this time. In the late fourteenth century alternative centres of commerce emerged in north-eastern Sumatra, most notably Samudra–Pasai which, stimulated by the pepper trade, began to dominate trade in fifteenth-century North Sumatra.[25] An indication of the importance attached to China's role in Samudra–Pasai's prosperity can be seen in the frequency of tributary missions sent to China between 1403 and 1424,[26] aided no doubt by the free passage offered by Zheng He's fleets on their return voyages. Archaeological evidence, in the form of excavated ceramics, glass, coins and the presence of Islamic

gravestones, point to a fourteenth- to sixteenth-century occupation, as is indicated by Chinese, European, and Malay sources.[27]

One of the richest pre-Ming period sites in South-East Asia is the Santu-bong River delta region in western Borneo (Sarawak). The delta was active as an iron-smelting centre possibly as early as the ninth or tenth century, and continued as such into the fourteenth century. Extensive excavations have yielded vast quantities of Chinese ceramic sherds, clear evidence of a long period of occupation and possibly an indication that the site also served as a trading port. In the Song period Quanzhou was the centre of the iron industry in South China[28] and it is thus likely that the iron of Santubong was traded with merchants from that port in exchange, in part, for the Song ceramics of Fujian Province. The reasons for the termination of the iron industry at Santubong are unclear, but difficulties in trading with China from the mid-fourteenth century were probably a significant factor.

The abrupt break in commercial relations between the Sarawak region and China is clearly evident from the ceramic remains. The Santubong delta has yielded vast quantities of Chinese *Yue*-type wares, *yingqing*, *Cizhou*-type wares, and glazed stonewares, evidence of up to 400 years of commercial contact with China beginning possibly by the tenth century.[29] On the basis of an apparent absence of post-mid-fourteenth-century trade ceramics, Tom Harrisson postulated a 'Ming-gap',[30] associating the absence of post-Yuan ceramics with the collapse of Sarawak's iron-smelting trade with China. Ming sherds have since been found in Sarawak, at the site of Tanjong Sangidam, near Gedong,[31] but whilst their discovery demolishes the notion of a 'Ming-gap', the limited nature of these finds does not undermine the thesis advanced by Harrisson: that on the basis of the archaeological ceramic evidence, a shift in the centre of commercial activity in fourteenth-century Borneo can be identified. When active trade relations are again in evidence they occur on the northern coast at Brunei, centred on Kota Batu.

Trade relations between China and a kingdom in northern Borneo known as *Po-ni*[32] are known from the ninth century onwards.[33] In 977 trade with China was established through the activity of a trader with an Arabic name, from Guangzhou or Quanzhou, and the first tribute mission was sent from *Po-ni* to China, in defiance of Srivijayan claims to Borneo and its rich forest products.[34] Periodic tributary missions during the Song period indicate a level of commercial activity and finds of Song ceramics at a number of sites in coastal Brunei provide archaeological evidence.[35] A thirteenth-century Chinese tombstone found in Brunei underlines the continuity of Brunei's relations with China. Dated 1264, the tombstone is the earliest dated Chinese inscription found *in situ* in South-East Asia.[36] It contains in its few lines much of interest for the history of Song maritime trade. First, the deceased's family name was 'P'u', a Chinese name derived from the Arabic 'Abu' meaning 'father', and commonly used by descendants of sinicized Arabs in China. Secondly, Master P'u was from Quanzhou which was Song China's principal international port and which, together with Guangzhou, had been host to Muslim merchants in China since the eighth century.

The key to Brunei's importance in international trade was that it supplied the finest-quality camphor known to the Chinese. Zhao Rugua, Inspector of Foreign Trade in Fujian, wrote in 1225 that 'Nau-tzi [camphor] comes from Po-ni...and [secondly] it also comes from the country of Pin-su [Barus region of north Sumatra]'.[37] As a result of its possession of this resource, Brunei had been subjected to successive domination by Srivijaya and Majapahit.[38] With the rise of Malacca in the fifteenth century the Brunei Sultanate became a willing participant in the lucrative international trade. The Portuguese commander responsible for the seizure of Malacca in 1511,

Jorge de Albuquerque, described the nature of the trade at the beginning of the sixteenth century:

> ...the camphor that comes from Burneo does not belong to the King of Burneo, but to another ruler who lives in the island of Burneo, and is lord by himself; he is heathen whereas the King of Burneo is a *Mauro* [Muslim] and the people of his land are *Mauros* also; but these *caffres*, who are called heathen, cultivate the camphor, and exchange it with the people of Burneo for cloth, which the latter obtain from Malacca; the cloths, which are of various kinds, though always made of cotton, are imported from Cambaya [Gujarat] and Bengala.

The Chinese themselves, however, also maintained an active trade direct with Brunei. Emperor Hongwu included the Kingdom of Po-ni among those to whom he sent envoys inviting tribute in 1370. The Emperor wished to cultivate official tributary trade as an alternative to the unregulated private trading activities which prospered along South China's coast. Brunei assumed particular importance because of its geographically strategic location on the southern rim of the South China Sea. Zhao Rugua described Po-ni in 1225 as the most important port of the Eastern Ocean[39] and stated that it served as an entrepôt for regional trade.[40] It continued to retain this important role in South-East Asian trade and its cooperation was viewed as being critical for the effective penetration and control of Chinese overseas trade by Hongwu in the late fourteenth century. Keen to assert his independence from a weakening Majapahit, the Brunei ruler sent the first of many tribute missions in 1371, and in 1408 visited China in person, an unprecedented act which won much praise from the Emperor.[41]

The extensive finds of Chinese ceramics of the late fourteenth and fifteenth centuries at Sungai Lumut and Kota Batu reflect Brunei's growing volume of trade with China. Early Ming blue-and-white wares predominate at Sungai Lumut, along with coarse stoneware jars and a small representation of Thai wares, principally Sawankhalok.[42] The rise of Kota Batu as the capital of the Brunei Sultanate in the fourteenth century is reflected in the extensive Ming blue-and-white finds at that site, together with small quantities of Vietnamese wares.[43] The abundance of ceramic remains at Kota Batu is partly explained by the city's role as a transhipment point for goods traded upland in exchange for forest products, especially the prized camphor. In addition the Sultanate's insistence on payment of government taxes by visiting traders in goods rather than Chinese coins would have added considerably to the supply of ceramics in circulation in the Brunei region.[44] The assemblages of both these major Brunei sites, excluding limited finds of pre-Ming wares at Kota Batu, closely resemble those of Niah and Calatagan.[45] They belong to a predominantly fifteenth-century wave of commercial expansion by the Chinese which continued until European competition became increasingly disruptive in the seventeenth century.

The most important development for the future of South-East Asian trade in the fifteenth and sixteenth centuries was the emergence of many trading ports with regional specializations rather than a single centralized emporium through which all goods passed. The ports along the north coast of Java, for example, were important collecting points for spices from the Moluccas. Tuban had special prominence as a major outlet for the rice exports of the inland kingdom of Majapahit, which were of vital importance to the development of Malacca. Prior to the Ming naval expeditions the Straits of Malacca had been rife with piracy, encouraging shipping from Western Asia to trade with Java via the west coast of Sumatra and the Sunda Straits.[46] Barus camphor and Minangkabau gold could be gathered en route. By the beginning of the fifteenth century Pasai in northern Sumatra had emerged as an important new supplier of pepper, and served as a terminus for much of

36

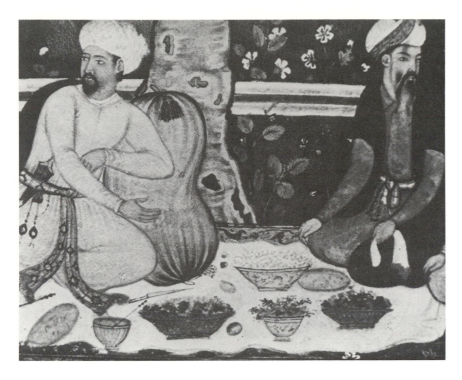

Fig. 13
Mughal courtiers dining from blue-and-white and greenware porcelain dishes. A folio from an illustrated manuscript, the Bābur nama, commissioned by Akbar (1556–1605), c.1590. (British Library, London)

Fig. 14
Jar of fifteenth-century Fujian origin being utilized in upland Sumatra as a container for magic potions. Wooden stopper in the form of a Toba Batak priest figure. (Line drawing by Peter Kraus, Museum fuer Voelkerkunde, Frankfurt am Main)

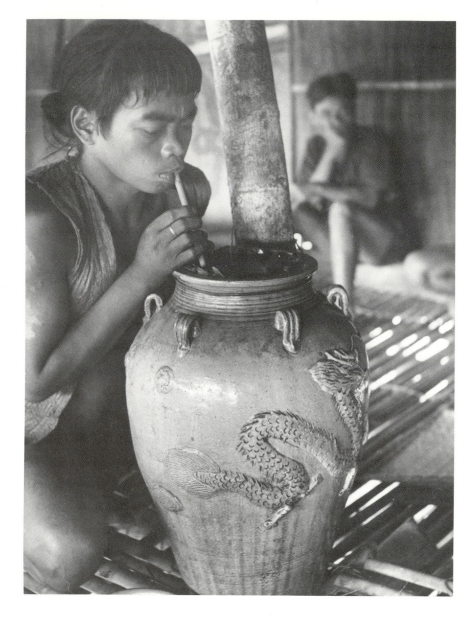

the Indian Ocean and Western trade. The Javanese traders began supplying spices from the eastern archipelago direct to Pasai, thus removing the necessity of travelling further east. Those requiring Chinese goods, however, had to go to Malacca which was emerging in the first decade of the fifteenth century, under Chinese protection, as a port of major importance for international trade.

The founding of Malacca represented an attempted return to the glory of a Srivijaya-style emporium which would serve as a great clearing-house for the goods of both the East and the West. According to the seventeenth-century Malay genealogical text, the *Sejarah Melayu*,[47] the founder was a prince of Palembang who, fleeing a Javanese attack, established himself at Malacca aided by the Celates, a people, we are told by Tomé Pires, renowned for piracy.[48] The Malaccan ruler systematically set about creating favourable conditions for trade, suppressing piracy in the Straits, and providing facilities for traders. Malaccan fleets implemented a policy of expansion which soon extended to the river ports of East Sumatra—Kampar, Siak and Indragiri—which provided access to Minangkabau pepper and gold.

38

Malacca was acutely aware of her vulnerability as a coastal settlement with little productive hinterland. Tin, mined in the upland mountain-valleys, constituted Malacca's only significant local export and also served as the main currency in trade.[49] Food supplies were almost entirely imported from Thailand and Java. Neither Java, which had dominated the spice trade since the thirteenth century, nor the expanding Thai kingdom of Ayudhya welcomed a rival trading power in their midst. The Thais themselves had been extending political control over the northern Malay Peninsula since 1280 and around 1373 established Tenasserim as their major trading link between the Bay of Bengal and Ayudhya.[50] However, despite local hostilities, Malacca succeeded in rapidly establishing itself as the major trading port of fifteenth-century South-East Asia.

The remarkable rise of Malacca is largely explained by a coincidence of Malaccan and imperial Chinese interests. The emperor Yongle, as mentioned earlier, was endeavouring to supplant Chinese private trade with 'imperial' trade and dispatched the great expeditions between 1405 and 1433 largely to this end. Yongle's chief interest, however, lay in the Western Ocean to which Malacca provided strategic access, 'for the monsoons from either direction ended there, and...junks could navigate there with less risk'.[51] Ma Huan, who accompanied several of the imperial voyages, provides the key to Chinese patronage and protection of the newly formed Kingdom of Malacca. He described Malacca as a cantonment for the Chinese fleet, from which ships were dispatched to various places, and to which they returned with foreign goods, to reassemble for the return journey to China.[52]

The imperial fleet first visited Malacca in 1403 and in 1409 the Emperor's principal envoy, Zheng He, conveyed Yongle's formal recognition of the country of 'Man-la-chia' and of its ruler. Malacca had received the support it needed to repudiate its Thai vassalage. With its growing wealth and power, strengthened by the periodic arrival of the huge Chinese fleets during the first two decades of the fifteenth century, Malacca drew much of the Western trade away from Pasai and much of the Chinese trade from Java. Both now converged on Malacca. The conversion of the third ruler of Malacca to Islam in 1436 served to strengthen further the attraction of Malacca for Western Asian Muslim traders, who appear to have largely abandoned sailing any further east than the Straits of Malacca. Arabic navigational texts of the fifteenth century, such as those by Ibn Mājid and Sulaimān al-Mahrī, which describe the routes to Malacca in great detail but those beyond in vague terms, support this.[53] Mainland coasts beyond Singapore are described in the Arabic texts as 'the coasts of China', reflecting the predominant influence which China retained throughout the fifteenth century in the South China Sea.

Malacca rapidly became a centre of Islamic culture and learning, adding a religious bond to its already strong commercial ties with merchants from Bengal, Cambay (Gujarat), and Hormuz, to mention only the principal West Asian ports.[54] The most distant trade was with Venice through the merchants of Cairo who brought arms, woollen cloth and 'golden glassware'. Other important trade items included opium, raisins, dyes of various kinds and, of paramount importance, the cotton textiles of Cambay. In exchange they sought spices, for which a growing demand was emerging in Europe, sandal-wood, benzoin, porcelain, and silks. Fei Xin's account of the Zheng He voyages, published in 1436, clearly indicates that blue-and-white porcelain was in great demand in Western Asia and India.[55] The traveller Ibn Baṭṭūṭa, who visited Delhi in the 1340s during the reign of Muhammad bin Tughluq (1325–54), described large quantities of Chinese blue-and-white porcelain in the Indian court.[56] A group of porcelains excavated in the Kotla Fīrūzshah palace complex at Delhi attest to this. The group consists of forty-four blue-and-white dishes and plates, twenty-three blue-and-white bowls and five

celadons, all broken, apparently as a result of orders from the orthodox Muslim ruler Fīrūzshah who directed that all articles and utensils upon which 'figures and devices were painted' offended the Law (of Allah), and were to be destroyed.[57] Fīrūzshah died in 1388 and the palace was destroyed by Tīmūr in 1398. References to Chinese porcelain in use at the Mughal courts of Bābūr, Akbar, and Jahāngīr attest to the ongoing popularity of Chinese ceramics as a utility ware of sufficient prestige to grace the table of the emperors of India[58] (Fig. 13).

During the reigns of both Yongle (1403–24) and Xuande (1426–35), envoys from Taiwan made yearly purchases of porcelain of up to 80,000 pieces which were traded in Ayudhya, Malacca, and Java.[59] The kings of Ryukyu also took an active role in the lucrative porcelain trade between China and South-East Asia. A Ryukyu shipping certificate of 1509 instructed the vessel 'with a cargo of porcelain and other goods, to proceed to the productive land of Malacca in order to purchase such products as sapanwood and pepper through mutually satisfactory arrangements, and then to return to this country to make preparations for the presentation of tribute to the Ming Celestial Court in a subsequent year'.[60] In this manner Chinese trade porcelain fulfilled the same function for the Ryukyu traders as did the cotton textiles of India used by the Muslim and early European merchants seeking the spices and aromatics of South-East Asia: it provided an acceptable commodity with which to engage in the spice trade.

One of the earliest first-hand descriptions of Chinese porcelain in use in South-East Asia is provided by Pigafetta, who visited the Philippines and Brunei in 1521 with Magellan's fleet en route for the Moluccas. Pigafetta's description of receptions given his party by local rulers provides a unique insight into the place of Chinese ceramics in sixteenth-century South-East Asian society: gifts offered by the Spanish to the ruler of Brunei were received on to porcelain dishes covered with silk; they dined from 'many wooden trays in each of which were ten or twelve china dishes... [and] drank a little china cup of the size of an egg full of the distilled liquor of rice [arak].... They slept... on mattresses filled with cotton and covered with silk, with sheets of Cambay stuff.'[61] Chinese porcelain, still a rarity confined to court circles in Europe, clearly attracted the attention of the European observer. The ceramics may have been traded direct with Chinese merchants in Brunei, or brought back from Malacca, in exchange for Bornean camphor and gold. By the mid-fifteenth century few Chinese traders ventured further west than Malacca. The Indian textiles seen by Pigafetta would also have come from Malacca, where they were the principal trade items used by Muslim traders in acquiring spices. Nearly a century later Erédia similarly observed that 'all kinds of spices, aromatics, metals, precious stones and pearls found their way from foreign ports to Malacca where they were exchanged for cloths...'.[62] The earliest Portuguese to visit China, before 1515, did so in junks emanating from Malacca and wrote enthusiastically of 'as great profit in taking spices to China as in taking them to Portugal'.[63]

Sixteenth-century Spanish descriptions of the Philippines indicate that extensive direct trade with China was well established and that secondary trading networks ensured that porcelains, along with other goods, penetrated many isolated Filipino societies. Legazpi, writing to King Philip in 1567 from Cebu island about the prospects for Spanish commerce and conquest in the region, provided this description of Luzon and Mindoro: 'whither the Chinese and Japanese come yearly to trade. The goods which they bring are silks, webbed stuffs, bells, porcelain, aromatics, tin, printed cotton cloths... and they receive in turn gold and wax.'[64] The Ming-shih also records that 'Fujian people came here [Luzon] for the purpose of trading, because the country was both near and wealthy'.[65] Extensive finds of fourteenth- and fifteenth-century

40

Fujian ceramics in the Philippines, and especially in Central Luzon, provide confirmation of this trade (Fig. 12).[66] Legazpi also described the manner in which the trade goods were dispersed: 'The people of these two islands [Luzon and Mindoro] are Moros [groups which had accepted Islam, based in Mindanao and the Sulu Archipelago] and when they have bought what the Chinese and Japanese bring, they trade throughout the whole island archipelago.'[67]

Archaeological evidence for the use of trade ceramics and other goods in secondary trading in South-East Asia is present in the numerous finds of ceramics in regions which produced goods desired by the Chinese. Isolated finds such as those at Agop Atas, Madai, eastern Sabah, reveal this pattern: ceramics, principally Chinese but with isolated examples of Vietnamese and Thai, were exchanged by traders in the Sulu Archipelago for the edible bird's-nests collected in the area.[68]

In the course of the sixteenth century Portuguese merchants profited by trading direct with China, importing into the country spices, ivory, and aromatic woods for Chinese silks and porcelain which were sold in South-East Asia. The China trade provided the Portuguese with the capital to invest in spices for the lucrative European market. In this activity the European merchants were usurping the entrepreneurial role traditionally fulfilled by the entrepôts of South-East Asia. The Portuguese seizure of Malacca in 1511 was a necessary and critical step in attempting to monopolize the spice trade. However, control of Malacca did not guarantee an effective monopoly. Unlike her great predecessors in Sumatra and Java, Malacca was less a politically unified maritime state than a loose confederation of economic interests.

The Portuguese prospered in Malacca but did not succeed in preventing the native trade continuing, nor the Chinese from actively trading with local kingdoms throughout the sixteenth century, including Johore, established by the defeated Malaccan Sultanate. Johore prospered through its trade with China; large quantities of sixteenth-century Chinese ceramics excavated in the region, mostly blue-and-white and celadons with small quantities of Thai Sawankhalok wares, attest to this.[69] The settlement was attacked by the Portuguese in 1587. Meanwhile, Aceh in northern Sumatra developed an extensive pepper trade with West Asia during this period. Throughout the sixteenth century the Javanese seaports continued to export rice—this was especially true of Jepara, which became the principal coastal outlet for the Central Javanese kingdom of Mataram—and to trade in spices—for which Gresik was the most famous port, attracting Muslim traders from Western Asia.

The end of the sixteenth century and the beginning of the seventeenth century saw the aggressive entry of the Dutch and English as competitors for

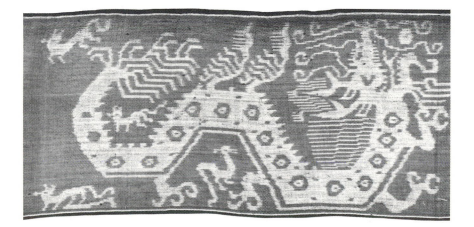

Fig. 16
A woman's cloth, decorated with a Chinese dragon and flaming pearl design in warp ikat technique. The design is most probably derived from Chinese trade ceramics known to the region. East Sumba, Indonesia. (Collection: M. Hiscock)

the rich spice trade of South-East Asia. This expansion, best symbolized by the founding of the Dutch East India Company (VOC) in 1602, marked a new chapter in South-East Asian maritime commerce, in which the trade in quality porcelain shifted its focus substantially from Asia to Europe. The retrieval of Wanli-period (1573–1619) porcelain from the Dutch East-Indiaman *Witte Leeuw*, which was sunk by the Portuguese at St. Helena, off the west coast of Africa, in 1613, underlines the shifting emphasis in China's porcelain trade and highlights the intensity of competition between the European maritime powers for its control.[70] The VOC ship had purchased its cargo of porcelain, pepper, and spices in Banten in 1612. Banten was the centre of trade for the Dutch in the early seventeenth century, providing an alternative to Portuguese Malacca. A contemporary Dutch description of Banten conveys much of the cosmopolitan nature of trade in the seaport city-states of seventeenth-century South-East Asia (Fig. 17): '... in the morning one can find these merchants of all nations, like Portuguese, Arabs, Turks, Chinese, Quillinese, Peguese, Malayans, Bengalese, Gusaratees, Malabarese, Abexinians and from all quarters of India, come to do their trading....' The Chinese 'sell silks of all kinds and in all kinds of beautiful colours ..., porcelain dishes ...'.[71] The *Witte Leeuw* cargo offers a glimpse of the type and quality of Chinese porcelain and stoneware available at the market of Banten in 1612. It also provides a dated context, invaluable in establishing the production period of particular types of ceramics, including the ubiquitous stoneware 'martaban' jars, which have proved notoriously difficult to date with reliability on stylistic grounds.

In 1619 the Dutch established their own trading centre at Sunba Kelapa, renamed Batavia, to attract the spice trade coming from the eastern archipelago. The success of this measure can be judged by the fact that when Malacca was captured by the Dutch in 1641, it had already lost much of its significance as a commercial emporium.[72] The gradual consolidation of Dutch trading power in South-East Asia during the seventeenth century was achieved, first, through its efforts to exclude its Portuguese and English rivals and, secondly, through its attempts to control the profitable indigenous trade. In the early years of the century the Javanese kingdom of Mataram emerged as the centre of Javanese power and subjugated the north coast seaports of Jepara, Cirebon, Tuban, Gresik, and Surabaya. Its wealth flowed from the export of rice which had become a state monopoly. Much of the regional and

Fig. 17

Market at Banten, West Java, illustrating the diversity of products sold by local and foreign merchants. Banten was a trading centre for South-East Asian spices, Chinese porcelain and Indian textiles, the principal commodities in sixteenth- and seventeenth-century Asian trade. (Engraving, published Amsterdam, 1598)

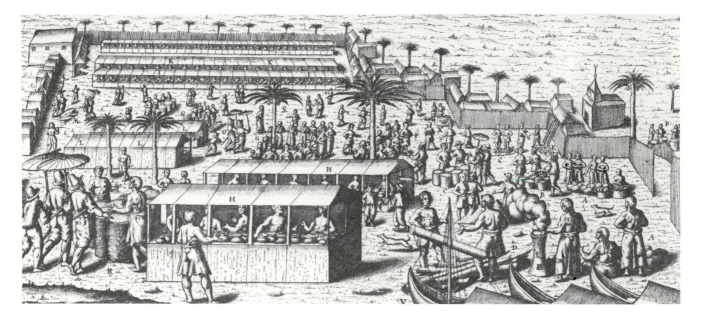

international trade was conducted at Banten, an important centre for the pepper trade with both China and India.[73] In the course of the century, however, the Dutch had captured Malacca (1641), won monopoly contracts for pepper with Palembang (1641) and Jambi (1643), gained territorial and trade concessions in Mataram (1675), broken Banten's independence (1682), and subdued the Moluccas. The consolidation of Dutch power over the century was paralleled, especially in the latter half, by a declining direct role for the Chinese in South-East Asian trade.

The importance of trade ceramics was not to diminish in Asian commerce. The Dutch had come increasingly to satisfy their trade commodity requirements in India, buying cotton textiles to trade in the South-East Asian markets for spices.[74] The expansion of this practice, which accompanied the tightening of Dutch control of the spice trade in eastern Indonesia and the Java Sea area, meant a slackening in demand by the Dutch for trade ceramics for the South-East Asian market. The demand for such wares, however, was to be maintained by an unexpected development—an explosion in demand for Chinese porcelain in the fashionable circles of Europe, noble and bourgeois alike. In 1602 a Dutch ship of the newly formed VOC captured a Portuguese merchantship ('carrack'), the *San Jago*. Its cargo, consisting largely of Chinese porcelain, was confiscated and sold by auction at Middelburg. In 1603 the porcelain cargo of another Portuguese ship, the *Santa Catharina*, was auctioned at Amsterdam. The availability of such wares had previously been extremely limited and confined to royal collections where such items were kept as curiosities, often set in silver or gold mounts. The porcelain auctions proved highly profitable and so began another chapter in the history of trade ceramics—the China trade with Europe.

Within South-East Asia these developments were to have significant repercussions. With growing European domination of regional and international trade many of South-East Asia's city-states were to experience declining prosperity over the century.[75] Few of the trading centres had a strong agrarian base and the reduction of their role in international trade meant a real loss of wealth and power. The trade with China continued to be dominated by the Chinese themselves, despite attempts by the Portuguese and Dutch to control this trade also. Direct Chinese trade with South-East Asia, for the spices, aromatic woods and other new luxury items such as the edible bird's-nests of Borneo and the sea-slug or *bêche-de-mer* (*trepang*) of eastern Indonesia, ensured a flow of Chinese trade ceramics to the region.

1. *Ming Shih-lu*, in Chan Cheung (1967), p. 223.
2. Wang Gungwu (1970a), p. 383.
3. Wang Yi-t'ung (1953), p. 20.
4. Chiu Ling-yeong (1967), p. 215.
5. O. W. Wolters (1970), p. 61.
6. G. Wong, in Southeast Asian Ceramic Society (1978), p. 64.
7. O. W. Wolters (1970), p. 55.
8. Ibid., p. 56.
9. Chan Cheung (1967), p. 224.
10. Cited by G. Wong (1979).
11. Ma Huan (1970), pp. 98–9, and A. Ridho and M. Wahyono (1983).
12. Ma Huan, op. cit., pp. 89–90, and T. G. Th. Pigeaud and H. J. de Graaf (1976).
13. Wang Gungwu (1970a), p. 379.
14. Wang Gungwu (1964).
15. For details of these voyages see J. J. L. Duyvendak (1938) and Ma Huan, op. cit., pp. 5–34.
16. See Wang Gungwu (1968).
17. Lo Jung-Pang (1955), p. 503.
18. Transactions engaged in at Calicut, West India, are described in detail by Ma Huan; see Ma Huan, op. cit., p. 141.
19. Wang Gungwu (1970a), p. 393.
20. M. Medley (1976), p. 193.
21. Ma Huan, op. cit., pp. 97 and 129.

22. Listed by G. Wong in Southeast Asian Ceramic Society (1978), pp. 65–6.

23. It must be acknowledged that ceramics of this period are peculiarly difficult to date. J. A. Pope identified the problem in 1956 when he wrote that 'there is a 75-year hiatus in reliably documented pieces between David vases [1351] ... and those of the beginning of the Hsuan-te reign [1426–35] when date marks begin to come into common use' (J. A. Pope (1956), p. 78).

24. E. P. Edwards McKinnon (1975–7).

25. Ibid., p. 64.

26. K. R. Hall (1981a), p. 32.

27. See ibid., pp. 29–42.

28. Cheng Te-K'un (1969), p. 21.

29. T. Harrisson (1959).

30. T. Harrisson (1958).

31. W. G. Solheim (1978), p. 10.

32. For the case in favour of identifying *Po-ni* with Brunei, see R. Nicholl (1980).

33. O. W. Wolters (1967), p. 175.

34. F. Hirth and W. W. Rockhill (1911), pp. 157–9.

35. M. Omar and P. M. Shariffuddin (1978).

36. W. Franke and Ch'en T'ieh-fan (1973).

37. R. Nicholl (1979), p. 53.

38. Brunei is claimed in the Javanese text *Nāgarakertagama*, of 1365, as part of the Majapahit empire (T. G. Th. Pigeaud, 1960–3, Vol. IV, pp. 31–2).

39. For a description of the 'Eastern Ocean' and 'Western Ocean' navigation routes utilized by the Chinese in South-East Asia, see J. V. G. Mills (1979), pp. 69–93.

40. F. Hirth and W. W. Rockhill, op. cit., pp. 155–8.

41. C. C. Brown (1972).

42. B. Harrisson and P. M. Shariffuddin (1969).

43. T. Harrisson (1956).

44. The practice is described in the *Tung-hsi-yang k'ao*, written in 1617; see Chan Cheung, op. cit., p. 225.

45. See T. Harrisson (1965) and R. Fox (1959).

46. M. A. P. Meilink-Roelofsz (1962), p. 22.

47. See O. W. Wolters (1970), and for a critique of the use of the *Sejarah Melayu* as an historical source, A. Teeuw (1973).

48. Tomé Pires (1944), p. 233.

49. Noted by Ma Huan in 1433, and again by Tomé Pires in 1513.

50. A. D. W. Forbes (1982).

51. Tomé Pires (1944), p. 239.

52. Ma Huan, op. cit., pp. 113–14.

53. G. R. Tibbetts (1979), pp. 230–1.

54. See Tomé Pires, op. cit., pp. 268–70, for an exhaustive list of foreign traders in Malacca.

55. Fei Xin, *Xing Cha Sheng Lan* (Successful Journey on a Legendary Raft), in Southeast Asian Ceramic Society (1978), pp. 65–6.

56. H. A. R. Gibb (1929).

57. E. S. Smart (1975–7), p. 201.

58. Bābūr, see A. S. Beveridge (1969), p. 407; Akbar, see V. A. Smith (1917), pp. 411–12; and Jahangir, see A. Rogers (1909), Vol. 1, p. 206.

59. Southeast Asian Ceramic Society (1978), p. 64.

60. Shunzo Sakamaki (1964), p. 386.

61. A. Pigafetta (1874), p. 11.

62. J. V. G. Mills (1930), p. 34.

63. Andrea Corsali, writing to Duke Guiliano de Medici, from Malacca, 1515, in C. R. Boxer (1953), p. xx.

64. C. R. Boxer (1953), p. xxxix.

65. Ibid., p. xl.

66. For examples, see L. Locsin and C. Y. Locsin (1967).

67. C. R. Boxer, op. cit., p. xxxix.

68. Site excavated in 1980–1 by P. Bellwood, and foreign ceramics analysed by J. Guy. For archaeological context, see P. Bellwood (1981).

69. For the Johore Lama excavation, see A. Lamb, in Malaysian Historical Society (1980), p. 79, and concerning the Batu Pahat hoard, Johore, see Leong Sau Heng (1980), p. 76.

70. C. L. van der Pijl-Ketel (1982).

71. Ibid., pp. 11–12.

72. M. A. P. Meilink-Roelofsz (1962), p. 172.

73. B. H. M. Vlekke (1959), p. 101.

74. S. P. Sen (1962).

75. A. Reid (1980).

6. Vietnamese Trade Ceramics

FROM the late fourteenth century until the end of the sixteenth century, when the emperor Wanli (1573–1619) formally revoked the prohibition on overseas trade, Chinese trade ceramics experienced their greatest competition in the South-East Asian market. Early Ming ceramics are found in South-East Asia, but the concentrations of finds are markedly smaller than for earlier and later periods. The appearance of Vietnamese trade ceramics in insular South-East Asia at this time must be viewed in the light of the internal dynamics of China and her maritime and commercial relations with the outside world. This is not to suggest that the mainland South-East Asian export ceramic industries came into existence only to fill a vacuum created by the policies of the early Ming emperors, though undoubtedly the prohibition on overseas trade did provide an important stimulus; Vietnamese ceramics are known to have had a long history of development before this period. Nonetheless, the fourteenth century marks a watershed in the development of Vietnamese ceramics—the transition from domestic production to participation in the international ceramic trade. It is difficult to document this development within Vietnam itself, despite collections of kiln wasters gathered in Tonkin, such as that assembled by C. Huet in the 1930s from the Thanh-hoa and Hanoi areas.[1] The Huet Collection includes ceramic types familiar from South-East Asian and Japanese excavations, enabling the source of Vietnamese ceramics produced for the international trade to be established. These export types have not yet been identified in Vietnamese habitation sites, though further archaeological work may reverse this situation. In South-East Asia many examples of Vietnamese ceramics have survived as burial items and as family heirloom objects, and it is with the entry of Vietnamese ceramics into the international market that reliable indications for dating first appear.

The earliest datable evidence for Vietnamese ceramics as an item of international trade comes from Japan: a fragment of a bowl painted in underglaze iron-black with a chrysanthemum spray medallion on the interior and an iron chocolate-coloured wash on the base (Fig. 18a). It was excavated from the precinct of the Kanzeon-ji, Dazaifu, Fukuoka Prefecture, Kyushu, together with a wooden plate inscribed in Chinese ink with a date corresponding to 1330.[2] This find firmly establishes that production of Vietnamese underglaze iron-decorated stoneware was in progress by at least the early fourteenth century, although the kilns responsible for these wares have not been located. However, fragments of iron-decorated stonewares similar to this export type have been discovered at Bat Trang on the outskirts of Hanoi.[3]

This class of ware appears to be the dominant Vietnamese trade ceramics of the fourteenth century. It is characterized by a fine greyish-white paste which enables the decorator to paint directly on to the body without first applying a slip. The entire surface was then covered in a clear glaze, which, due to mineral

Fig. 18a & b
Fragments of Vietnamese bowls decorated in underglaze iron-black, excavated in Dazaifu, Kyushu, southern Japan. (a) Excavated from the precincts of the Dazaifu Kanzeon-ji temple, accompanied by a wooden plate dated 1330. (b) Excavated from the precincts of the Dazaifu Kankou-ji temple in association with fourteenth-century Chinese greenwares. (Kyushu Historical Museum, Dazaifu)

impurities, tended to fire a straw colour or to acquire a greenish tinge. Fine crackling of the glaze was common. This decoration was confined to small-scale wares: bowls, saucers, plates, beakers, jars, and bottles.[4] The style of decoration may be described as sketchy and calligraphic, the central motif typically a loosely drawn floral spray enclosed in a single or double circle and with a debased classic scroll on the rim (cf. Plate 108). Whether these wares were developed expressly for export is unclear. C. Huet's collection includes a kiln waster, reportedly from Dai La (Hanoi), in the form of a stack of bowls with the floral spray motif painted in underglaze blue (Fig. 33).

The appearance of underglaze decoration in Vietnamese ceramics must be seen in the light of developments in China. Underglaze painting in iron-brown and copper-green was being successfully used in the decoration of *Changsha* wares by at least the ninth century, as seen in the ewers excavated at Ningbo, Zhejiang Province, in 1973, which were almost certainly destined for export,[5] and the technique soon spread to the kilns of Guangdong. Examples of *Changsha* ware have been discovered from Java to Persia along the great sea routes. Kilns in both the vicinities of Guangzhou and Quanzhou appear to have produced ceramics decorated in underglaze iron for the export market.[6] Commercial traffic between these ports and those of Tonkin would have facilitated the ready transmission of such techniques. Yet, despite the technical parallels, no convincing stylistic prototype for the distinctive Vietnamese iron-decorated wares has been identified, though perhaps the floral-decorated basins from Fujian constitute the most likely source.

The ports of Tonkin and Champa had long been established on the international maritime route which linked China with the *Nanhai* and the West. The *Han Shu* records tribute-bearing missions visiting Tonkin en route to China from the Western Ocean in the first century AD. The ports of embarkation for the *Nanhai* at this time were located in the Gulf of Tonkin. In AD 166 foreigners claiming to be ambassadors of the Roman Empire arrived by sea and were sent by land to the court of Emperor Huan. The *Han Shu* records a well-established land route from the Red River delta area to the Yangzi-jiang via Guangxi and Hunan Provinces.[7] In the course of the first millennium China's overseas trade was dominated by foreigners, particularly Persians, Arabs and Indians, and was concentrated on the great southern port of Guangzhou. In the late eighth century, however, an official of Guangzhou petitioned the Emperor, complaining that 'lately the precious and strange goods brought by

ocean-junks have mostly been taken to An-nam to be traded there'.[8] This shift in international commercial activity to the Vietnamese port was partly a consequence of the sacking of Guangzhou by a rebel Chinese army in 878, in which many members of the foreign merchant community were massacred. The traders sought refuge in Vietnam to continue their commerce. By the time stability returned to South China, Vietnam had firmly established itself in the trade network. When the ninth-century Arab traveller, Ibn Khurdādhbih, wrote his account of a journey to China, he recorded visiting the port of Luqin (Lung-pien, port of Hanoi) before proceeding to Kanfu (Guangzhou).[9]

It is thus clear that Vietnam had long established trade connections leading up to the period when ceramics were first produced for export. What prompted the Vietnamese to enter the international ceramic market in the fourteenth century remains a matter for speculation. The iron-decorated wares have been found in Japan and South-East Asia, but not further west, suggesting that the commercial initiative may have been generated by merchants familiar with Chinese trade routes, rather than Middle Eastern. As a result of the collapse of the Southern Song Empire in the late thirteenth century, Vietnam received a large influx of Chinese refugees who were resettled in Hanoi and permitted to engage in commerce.[10] It is tempting to suggest that the impetus for ceramic exports to already established Chinese markets may have come from this source.

During the second half of the fourteenth century cobalt began to be used in underglaze ceramic decoration, heralding a new era in Vietnamese ceramics. Initially cobalt-blue followed the designs familiar from black iron-decorated wares. While the primary source for imported cobalt was the Middle East, it could also have been supplied from Sumatra, by Muslim merchants who could have sold it as genuine *sulimani*, Persian cobalt.[11] Chinese native sources, such as those discovered in Yunnan, began to supply Jingdezhen only after 1426. Subsequently, the Vietnamese may have been able to tap this source, the Red River providing a natural bridge between Yunnan and Tonkin.

Trade sources clearly show that Vietnamese underglaze cobalt-blue decorated wares were produced in the fourteenth century. A fragment of a bowl, decorated in underglaze cobalt-blue with a sketchy floral spray on the interior and a brown painted slip base, was found in 1980 at Nakijin Gusuku, in the Ryukyus, Okinawa Prefecture, Japan (Fig. 19). Trade between the Ryukyus and Vietnam is recorded from 1363. The castle site from which this sherd was excavated was destroyed in 1416, suggesting a late fourteenth-century production date.[12] The painting style relates directly to the iron-brown decorated wares which are known to be in production nearly a century earlier.

The puzzle in the chronology of Vietnamese blue-and-white ceramics is that the demonstrably fourteenth-century examples show no clear relationship with the great achievements of the Yuan and early Ming decorators of fourteenth-century China. It is only in the next phase of development, which includes the earliest inscribed example of blue-and-white—the dated Istanbul bottle of 1450 (Fig. 21)—that the Chinese experience is reflected with enthusiasm and imagination. There is a prevalence of floral designs, especially the peony, lotus and chrysanthemum, and many pieces feature fish amongst aquatic plants. These are also much favoured motifs in fourteenth-century Chinese ceramic decoration, which raises the possibility that much of the Yuan- and early Ming-inspired repertoire of Vietnamese ceramics does in fact date from as early as the mid-fourteenth century. However, the 1450 landmark remains the one sure point of reference, so that until further evidence comes to light it is obligatory to accept the fifteenth century as the classical period of Vietnamese blue-and-white production.

This later date is supported by evidence from South-East Asian excavations, especially in Luzon, which are rich in fourteenth-century Chinese underglaze

Fig. 19
Fragment of a Vietnamese bowl decorated in underglaze cobalt-blue, excavated at Nakijin Gusuku Castle site, Ryukus, Okinawa Perfecture. (Nakijin-san Educational Committee, Okinawa)

blue wares but completely lacking in Vietnamese wares.[13] Vietnamese blue-and-white wares began appearing in fifteenth-century archaeological contexts; examples were retrieved from the Koh Khram shipwreck in the Gulf of Thailand.[14] This ship, laden principally with Thai export ceramics, is assumed to have been trading out of Ayudhya in the early fifteenth century, when that city served as an important entrepôt for much South-East Asian trade.

Under Mongol rule, China extended its trading relations with the Islamic lands of West Asia and encouraged the activities of Muslim merchants in the port-cities of South China. Lung-pien, the delta area of the Red River and port of Hanoi, had been known to Arab traders from the Tang period, as 'Luqin'. The Yuan blue-and-white style seen in fifteenth-century Vietnamese ceramics came from Chinese prototypes which were in production at Jingdezhen by at least the second half of the fourteenth century. The evidence suggests that this class of ceramics was produced in the first instance for the Islamic markets of West Asia. It is no coincidence that the two greatest collections of early Chinese blue-and-white are preserved in the Middle East, as part of the Ardebil Shrine Collection in Tehran, and in the Topkapi Saray Museum in Istanbul, and that examples have been retrieved from archaeological sites along the length of the great sea route, from Java to Fustāt (Cairo).[15] In almost all of these cases small quantities of Vietnamese ceramics have also been found.

The Middle Eastern collections are critical for the study of fifteenth-century Chinese porcelain, and each contains a key example of Vietnamese blue-and-white. The Ardebil Shrine Collection was assembled from around 1350 and presented in 1611 by the Iranian ruler Shāh 'Abbās to his family shrine. It contains a Vietnamese dish decorated in blue-and-white with a peony-spray medallion surrounded by a band of scalloped petals within a lotus scroll cavetto and a continuous classic scroll rim (Fig. 20). It is engraved on the exterior with the *vaqfnāmehs* or dedicating inscription of the donor, confirming that it entered the collection before 1611. The style of painting, finely executed in an outline-and-wash technique, conforms to the style seen in the decoration of the Vietnamese bottle in the other great Middle Eastern collection, the Topkapi Saray Museum. This collection houses the most important single example known for the chronology of Vietnamese ceramics: the earliest dated

Fig. 20
Vietnamese dish, fifteenth century, decorated in underglaze blue, engraved on the exterior with Shāh 'Abbās's dedicatory inscription and presented to the Ardebil Shrine in 1611. (Archaeological Museum, Tehran)

and provenanced Vietnamese blue-and-white porcelain (Fig. 21). The revelatory inscription, painted in underglaze blue, is discreetly placed in a decorative band separating the peony scroll of the jar from the lotus petal collar on the shoulder, each character alternating with a classic scroll. It can be translated as 'Brushed at leisure by a lady artisan of the Bui clan at Nam-sach Province in the 8th year of Ta Ho (1450)'.[16] This inscription is specifically Vietnamese: it uses periodization according to the Vietnamese dynastic view, dating by the regnal year of the Vietnamese ruler; and it names the painter as Bui, a common surname amongst Vietnamese literati of the fifteenth century. The involvement of a Vietnamese lady in the decorating of prestige ceramics is curious, but some clue may be provided by earlier assertions of cultural self-sufficiency, as seen for example in the Ly edict of 1040 instructing court ladies to weave their own silk.[17] For the history of Vietnamese ceramics two details are of critical importance: that the bottle was executed in Nam-sach, the delta area adjacent to Hanoi and the area of congregation for sea merchants since the Tang occupation; and that it was produced in 1450. Nam-sach Province may thus contain as yet undiscovered kiln and sherd evidence of this sophisticated class of blue-and-white ware. The bottle is one of the finest examples of Vietnamese blue-and-white in existence, displaying brilliant technical control and a sophisticated integration of decoration and form. Examples of this quality are extremely rare. A fragment of comparable quality was excavated at Fustāt by Tsugio Mikami in 1964 (Fig. 22).

A critical event in Sino-Vietnamese relations which may have triggered the new wave of Chinese influence seen in fifteenth-century Vietnamese ceramics was the invasion by the Ming armies of Yongle which occupied Vietnam from 1407 to 1427. Culturally the occupation had a devastating effect, as the

Fig. 21
Vietnamese bottle decorated in underglaze
blue, bearing a dated inscription corresponding
to AD 1450. (Topkapi Saray Museum,
Istanbul)

Fig. 22
Fragment of a Vietnamese jar, mid-fifteenth
century, decorated in underglaze blue,
excavated at Fustāt (Cairo), Egypt. (Idemitsu
Museum of Arts, Tokyo)

occupiers, proclaiming an active policy of sinification, attempted to transform Vietnam into a Chinese province. Libraries and archives are claimed to have been taken to China and are presumed to have perished. Monuments associated with the achievements of the independent Ly and Tran Dynasties (eleventh to fourteenth centuries) were demolished in an attempt to erase the achievements and identity of Vietnamese culture. However, Vietnam effectively resisted Chinese attempts to re-establish permanent political control. Nevertheless, resistance to subtler cultural penetration of Vietnamese society by Chinese values, concepts, and beliefs was less effective. Evidence of this cultural influence, resented as it was by sectors of the Vietnamese intelligentsia, was manifested in many aspects of Vietnamese social and cultural expression. Vietnam's successful venture into the manufacture and export of quality trade ceramics, in direct competition with Chinese wares, was coloured by this relationship.

The expanding production of Chinese-influenced blue-and-white wares in the fifteenth century may be explained by access to markets. The period 1436–65 was marked by the active discouragement of overseas trade by the Chinese court. It is possible that Chinese merchants in Tonkin or entrepreneurs in South China with close commercial links with Tonkin actively encouraged the production of Vietnamese trade ceramics in periods of restricted Chinese trade. Such wares would sell most readily to former Chinese markets if decorated in the Chinese style.

Nonetheless, viewed today, these Vietnamese ceramics stand apart from their Chinese counterparts, different in feeling, quality, and spirit. Whilst utilizing the established motifs of the Yuan–early Ming repertoire, they rarely employed them in a combination that is recognizably Chinese. One of the closest derivations is seen in a superb Vietnamese plate decorated with a leaping carp design (Plate 116). The fish, painted with careful use of shading and cross-hatching, are unusually naturalistic in style. Such accomplished painting is encountered only on the very finest Chinese examples. The composition derives from fourteenth-century Chinese prototypes, examples of which may be seen in the Ardebil Shrine Collection.[18] The delicacy of design of which Vietnamese ceramics are capable is also apparent in a plate decorated with a chrysanthemum spray (Plate 115). The design echoes fourteenth-century Vietnamese iron-decorated wares with single floral-spray design but has an elaboration of detail inspired by the best underglaze painting of Jingdezhen. The style of painting, with its use of outline-and-wash technique, shading, and hatching and the distinctive veining of the leaves, bears close comparison to the Istanbul bottle of 1450.

Large plates of this type appear to have been mainly intended for the Islamic market, including South-East Asia, where such plates were well suited to the communal eating customs of the Muslim household. The Vietnamese ceramic workshops of the fifteenth and sixteenth centuries clearly sought to capture a share of this market. Dishes with a broad flat base and steep cavetto became an important item in the Vietnamese trade ceramic repertoire. Many examples have emerged from insular South-East Asia where they are typically preserved as family heirlooms of considerable value. Fragments have been excavated at Hormuz, an important entrepôt serving the Persian hinterland in the fifteenth and sixteenth centuries, indicating that the Western trade was sustained throughout the period (Fig. 23).[19] The demands of the Islamic market for dishes continued, and as late as 1617 the *Dagh-register* of the Dutch East Indian Company in Batavia recorded confidently that 'if we still have in stock some of the largest dishes, these can be sold with a profit in Arabia and at Surat [India]'.[20] There are no recorded instances of Vietnamese ceramics being traded direct to European markets. The Middle Eastern trade networks were probably the source of a superbly formed and decorated Vietnamese bowl

Fig. 23
Fragments of Vietnamese dishes, fifteenth to sixteenth centuries, decorated in underglaze blue, excavated at Hormuz, Persian Gulf. (Museum für Ostiatische Kunst, Cologne)

Fig. 24
Vietnamese bowl, decorated in underglaze blue, presented by the Duke of Florence to the Prince-Elector of Saxony in 1590. (Johannaun Museum, Dresden)

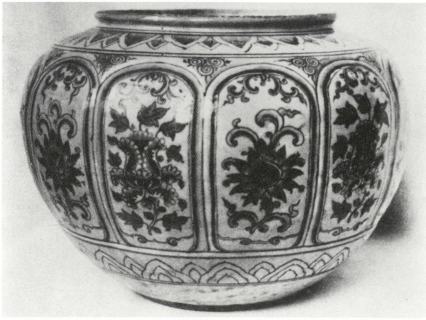

which was presented to the Prince-Elector of Saxony, Christian I, by the Duke of Florence in 1590, together with a number of specimens of sixteenth-century Chinese porcelain (Fig. 24). The gift is first recorded in the 1595 inventory of the Zwinger Castle, Dresden.[21]

The most important market for Vietnamese ceramics was, however, insular South-East Asia. Examples have been retrieved from numerous habitation and burial sites throughout the region, with Java, Sulawesi, and eastern Indonesia providing the richest finds. They have invariably been found in association with Chinese and Thai wares. The trade in luxury goods between Vietnam and insular South-East Asia probably dates from the rise of the Sumatran entrepôt kingdom of Srivijaya in the eighth century. In 1149 merchants arrived in Tonkin from Java and Thailand, seeking permission to settle and engage in commerce. They were allowed to establish a trading centre at Van-don, islands

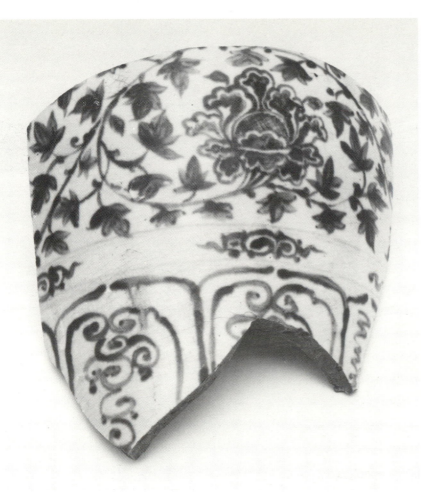

Fig. 25
Fragment of a Vietnamese jar, fifteenth to sixteenth centuries, decorated in underglaze blue, reportedly found in the vicinity of Mojokerto, East Java. (National Gallery of Victoria, Melbourne, presented by Mr M. L. Abbott)

offshore from the Red River delta.[22] The East Javanese kingdom of Majapahit (1292–c.1500), essentially a land-based agrarian power, came to dominate maritime trade in insular South-East Asia during the early phase of Vietnam's ceramic trade. Majapahit accrued a great part of its wealth through its control of the Java Sea and the eastern Indonesian spice trade, and had extensive trading connections both within the region and with the international network. In the vicinity of the former capital, centred at Trowulan, Mojokerto, East Java, extensive finds of Vietnamese trade ceramics have been made, the majority being blue-and-white (Fig. 25).[23] Glazed tiles intended for architectural decoration were found in considerable quantities but regrettably little archaeological information accompanies these finds. The tiles are variously shaped: round, octagonal, cross with square or trefoil projections, and ogival (Fig. 26 and Plate 119). Most are decorated in underglaze blue but others have moulded relief decoration with glaze, and some reveal the use of enamel overglaze. They are heavily constructed with a high foot and recessed base, presumably to facilitate their installation as wall fixtures.

Van Orsoy de Flines, in his pioneering study of foreign ceramics in Indonesia, first drew attention to the existence of Vietnamese glazed tiles decorating a number of fifteenth- and sixteenth-century buildings in Central and East Java.[24] These include the mosque at Demak, believed to have been built at the beginning of the fifteenth century, an early sixteenth-century minaret at Kudus, and buildings at Jepara and Cirebon. The ruins of an old mosque at Mantigan, south of Jepara, include stone relief medallions, round and oblong in shape, which can be dated by association with the old mosque to

Fig. 26a & b
Vietnamese wall tiles. (a) Fragments of tiles decorated in underglaze blue and enamels, circa fifteenth century, excavated at Trowulan, Mojokerto, East Java. (Museum Nasional, Jakarta) (b) Tile decorated in underglaze blue, with a demonic kāla face design. Length 23.5 cm. Fifteenth to sixteenth centuries. Reportedly from East Java. (Courtesy Spinks & Son Ltd., London)

1559.[25] These bear a remarkable resemblance to some of the Vietnamese tiles, such as those which can still be seen at the Demak mosque. Abu Ridho has observed that the glazed tiles may have had a similar decorative function to that of the carved wooden inset panels which still decorate the teak wood partition walls (*gebyok*) in Javanese houses.[26] No findings of Vietnamese wall tiles have been reported outside Java, suggesting that they were expressly commissioned for use, in the first instance, at the Majapahit capital. The Majapahit court poet, Prapanca, in his poem of 1365, the *Nāgarakertagama*, describes the glories of the capital: 'ornamented, splendid...pillars with various woodcarvings...bases are stone-brick, red, fitted with raised work, select, ornamented with figures [probably local terracotta reliefs]...the products of the potters, used as tops of the roofs of the Houses, superior...'.[27] Large quantities of terracotta reliefs and roof tiles have been found in the vicinity of Trowulan, together with the fragments of glazed Vietnamese tiles. Regrettably the court poet does not refer to the imported ceramics which may have contributed to the ornamental splendour of the Majapahit capital by this time. The Vietnamese tiles, currently preserved on the mosques of Java, were probably retrieved from the earlier secular buildings of Majapahit. They may have been produced following sample designs supplied by the Javanese, as comparison with Javanese stone and wooden decorative medallions suggest. Determining when the tiles were installed in the mosques is more problematic. The earliest reported sighting of such ceramics *in situ* is contained in a journal

of a voyage to the East Indies in 1598–1600 by Van Neck. He recorded that two mosques at Banten, an important commercial centre in sixteenth-century West Java, had walls of brick inlaid with porcelain.[28] That foreign ceramics were displayed so prominently on sacred buildings serves to demonstrate the esteem and status which were associated with imported ceramics.

Trade between Java and the countries of the South China Sea had been long established. In recounting the virtues of his patron's rule the court poet stated that 'all kinds of people have continually come from other countries [to Java] in multitudes. These are Jambudwipa, Kamboja, China, Yawana [Annam], Champa...and Siam'.[29] Vietnamese sources concur, recording a steady flow of merchant ships from Java visiting the ports of Tonkin in the fourteenth and fifteenth centuries, trading in sandalwood, pearls, and spices.[30] The commissioning of luxury ceramics for the Majapahit capital probably occurred within the context of this trade. Numerous finds of Vietnamese ceramics throughout the Indonesian islands suggest that they were an important trade item exchanged for the prized spices and scented woods of the region. Majapahit's prosperity was at its height in the fourteenth and early fifteenth centuries and it may be assumed that the importing of Vietnamese ceramics into the region began during this period. The Vietnamese ports at Van-don and in Dien Province, south of Thanh-hoa, were used during the fourteenth century and both areas would warrant archaeological investigation for evidence of this ceramic trade.

With the shifts in Javanese power in the fifteenth century, greater direct trading occurred throughout South-East Asia. This may explain the wider geographical distribution of later Vietnamese trade ceramics. Sumba, for example, has yielded important ceramics, such as a large storage jar known to the author, which came into the possession of a Dutch family whilst resident on the island in the 1930s. Such reports are not unusual. Janse published a similar example found in Mindanao, southern Philippines.[31] The documentation of van Orsoy de Flines's collection, now housed in the Museum Nasional, Jakarta, gives provenances for Vietnamese ceramics collected throughout the archipelago.

The Indonesian region has yielded the rarest types of Vietnamese ceramics. An elaborate candle-holder, decorated in underglaze blue, was reportedly found in South Kalimantan, a region which had many links with Java.[32] A circular pot-stand, or perhaps an inkstone, with three legs, and unglazed upper surface and decorated in underglaze blue, was reportedly found in Indonesia and relates closely to the only other known example, found in East Java.[33] Variations on the form of the *kendi* or ewer reveal the potters producing uniquely Vietnamese forms, such as the moulded pouring vessel in the shape of a phoenix (Plate 131).[34]

The Vietnamese potters took a particular interest in and found a responsive market for covered boxes, and produced them in considerable quantities for the South-East Asian market. Many reflect ceramic practices established in the late Yuan period–faceting, lobing, and otherwise manipulating the ceramic form through moulding and carving. Overglaze enamels were often used in combination with underglaze blue in their decoration. The covers of these vessels provided the decorator with the scope for expressive painting. Floral designs are most common, as seen in the magnificent covered box reportedly from Sulawesi (Plate 117), although landscapes and birds were also popular. Landscapes with human figures are rare and heavily sinicized, as seen on the lid of a covered box (Plate 118) decorated with two figures, beneath a vine-entangled tree, approaching a house with Chinese-style roof. The painting composition derives from a style established in the Southern Song period and accessible through Chinese ceramic decoration of the early Ming period.

Little is known about the distribution systems for Vietnamese ceramics

before the appearance of Dutch records dating from the beginning of the seventeenth century. It seems that they were at one time traded directly, as is evident from the Javanese visits to fourteenth-century Vietnamese ports, and then distributed by secondary trading. Chinese merchants undertook much of this trade in South-East Asia in later centuries and Muslim traders were responsible for their presence in the Middle East. Tomé Pires's account of early sixteenth-century Asian trade, written in Malacca around 1515, said of the people of Tonkin that 'they have porcelain and pottery—some of great value—and these go from there to China to be sold...'.[35] Pires's description suggests that Chinese merchants controlled the distribution of Vietnamese trade ceramics at that time. In times of interruption to the supply of Chinese ceramics, or imperial restrictions on trade as occurred between 1436 and 1476, Chinese merchants may have turned to the Vietnamese producers. With the restoration of Chinese sources, the Vietnamese wares, exposed to competition, would have made up a smaller proportion of the market. Certainly the evidence for Vietnamese trade ceramics in the seventeenth century points to distribution outside sanctioned Chinese control, especially by Japanese, European, and, to some extent, private Chinese ships operating illegally.

Japan's strained relations with Ming China, aggravated by the activities of Japanese pirates, culminated in China severing relations in 1557. Alternative sources, particularly of raw silk, had to be found. As a result, Vietnam became an important supplier of both raw silk and silk fabrics. A Japanese trading community was established at Danang in the late sixteenth century and operated until the Tokugawa prohibition on Japanese participation in overseas trade in 1635 forced its closure. Late Momoyama and early Edo Japan experienced a renaissance in the art of the tea ceremony and exceptional and unusual ceramic utensils were much sought after and highly prized. Tea bowls and storage jars were in greatest demand. Many Vietnamese ceramics appear to have been imported into Japan at this time to satisfy the requirements of the tea ceremony masters. Whilst some of these pieces may have come directly from Vietnam, others were probably acquired by Japanese and Ryukyu merchants trading in the northern Philippines. The famous 'Beni-Annam' tea bowl in the Tokugawa Collection is a coarse type of ware similar to examples excavated in sixteenth-century contexts in the Philippines.[36] Many of the large storage jars, including Vietnamese examples, in the collections of Japanese nobles and temples may have been purchased in the Philippines for resale in Japan, for Japanese ships conducted an active trade in Manila, reaching a peak of activity around 1615–25.[37]

A class of Vietnamese ceramics, known from a number of Japanese collections, appears to have been produced exclusively for the Japanese market, for they are unknown outside Japan. Of particular interest in this context is a group of covered jars, bottles, and ewers in the collection of a merchant family from Toba, south of Kyoto, since the early seventeenth century, now displayed in the Kyoto National Museum. Trade documents in the Ozawa family record that Ozawa Shrouemon engaged in trade with Vietnam, returning to Japan in 1638, by which time the Tokugawa prohibitions discouraged further such ventures. The Vietnamese ceramics, together with other goods, were probably landed at Osaka for transportation to Toba, from where they could have been easily supplied to the wealthy Kyoto market. These wares are characterized by poorly controlled cobalt decoration sketchily executed, and by the use of stamped and moulded motifs, particularly floral bosses and dragons. The tea bowl with dragonfly design (*Annam Tombo-de*) also belongs to this class of Vietnamese blue-and-white wares destined for the Japanese market and is known from a number of historical Japanese collections.[38]

56

Despite Ming and Qing prohibitions many Chinese merchants engaged in trade with Japan. The Cheng family, who commanded a powerful fleet of ships operating out of South China, Taiwan, and South-East Asian ports, developed close trade relations with Japan, Tonkin, and Thailand. Chinese merchants such as the Cheng family were fulfilling their traditional role in Asian trade, and viewed the appearance of European traders in the region with justifiable suspicion. Zheng Chenggong (Coxinga) wrote in 1655 from Xiamen to the Dutch authorities in Batavia, boldly asserting that 'such places as Batavia, Taiwan and Malacca are one inseparable market and I am the master of this area'.[39] The trade in Vietnamese ceramics was facilitated by such merchants, who, together with the Europeans, engaged in a complex system of inter-regional trade.

In the course of the seventeenth century European traders came to challenge the private Chinese merchants' control of the Asian trade. From their base in Batavia, West Java, the Dutch opened a factory at Hirado in 1609, and in 1641 established themselves on Deshima Island in the Bay of Nagasaki. In 1640 the Dutch East India Company opened an office at Kachiu (Hanoi). The seventeenth-century VOC registers make frequent reference to 'Tong-kinese porcelain' being traded to South-East Asia and Japan in the latter half of that century.[40] An apparent upsurge in demand for Vietnamese ceramics may have been the result of a growing demand in Europe for Chinese porcelain creating shortages of supply for the Asian markets.

The first recorded shipment of Vietnamese ceramics arrived in Batavia in 1663 with 10,000 'coarse porcelain bowls' aboard a junk from Tonkin. Over the next twenty years the VOC *Dagh-register* records 1,450,000 pieces of Vietnamese ceramics arriving in Batavia, variously described as coarse or medium quality wares. From Batavia these ceramics entered South-East Asian regional trade, together with Chinese and Japanese wares. The Dutch records unfortunately give no description of the ceramics carried by the VOC ships and junks from Tonkin. By the middle of the seventeenth century VOC ships were regularly sailing from Deshima to Batavia via Tonkin with cargoes of Japanese and Vietnamese ceramics. The Dutch actively stimulated the growing Japanese porcelain industry by exporting its products throughout South-East Asia and to Europe. Vietnam herself became an importer of Japanese porcelain in the seventeenth century. It is thus evident that Vietnam was simultaneously importing some Japanese porcelain whilst exporting her own wares to South-East Asia through the agency of the Dutch. This period also saw marked disruption to Chinese ceramic production concurrent with the gradual collapse of the Ming Dynasty and the struggle of the Manchus to establish their authority in South China. These events, together with the Dutch interest in fostering commerce, stimulated Vietnamese ceramic production until late into the seventeenth century. The reorganization of the kilns at Jingdezhen under imperial control in 1682 contributed to a revitalized Chinese ceramic industry and in 1684 the Qing ban of 1661 on overseas trade was lifted. Investigations of canals near the VOC stores in eighteenth-century Batavia have revealed sherds of Chinese, Japanese, and European ceramics, but to date no Vietnamese.[41] The evidence thus suggests that Vietnamese ceramics lost their market in Asia as Chinese wares resumed their traditional dominance. Vietnamese trade ceramics, it appears, could no longer compete on the Asian market, nor could they penetrate the European market, and so vanished from the arena of international ceramic trade.

1. Collection of Musées Royaux d'Art et d'Histoire, Brussels.
2. I am deeply indebted to Mr Meitoku Kamei of the Kyushu Historical Museum for supplying me with this information and photographs of recent finds of Vietnamese ceramics in Japan.
3. Personal communication, Professor Pham Huy Thang, Director of the Institute of Archaeology, Hanoi, October 1981.
4. Compare Southeast Asian Ceramic Society (1982), Pls. 72–80 and 83.
5. Australian Art Exhibitions Corporation (1976), p. 213.
6. Compare P. Hughes-Stanton and R. Kerr (1981), Pls. 167 and 213.
7. Wang Gungwu (1958), p. 18.
8. Ibid., p. 82.
9. D. D. Leslie *et al.* (1973), p. 148.
10. Chan Hok-lam (1966), pp. 5–6.
11. P. J. Donnelly (1973), p. 237.
12. M. Kamei (1983).
13. L. Locsin and C. Y. Locsin (1967).
14. R. M. Brown (1975), and J. N. Green *et al.* (1981).
15. T. Mikami (1969).
16. K. W. Taylor (1982), p. 20.
17. Ibid., p. 20.
18. J. A. Pope (1956), Pl. 11.
19. I wish to thank Dr U. Wiesner for kindly supplying photographs of Vietnamese sherds excavated at Hormuz. See also U. Wiesner (1979).
20. T. Volker (1954), p. 28.
21. The bowl was published in 1933 as Chinese; see L. Reidemeister (1933), pp. 11–16.
22. K. W. Taylor, op. cit., p. 21.
23. A. Ridho, 'Notes on the Wall Tiles of the Mosque at Demak', in Southeast Asian Ceramic Society (1982), p. 37.
24. E. W. van Orsoy de Flines (1972), p. 67.
25. Reproduced in A. J. Bernet Kempers (1959), Pls. 341 and 347–50.
26. Southeast Asian Ceramic Society (1982), p. 37.
27. T. G. Th. Pigeaud (1960–3), Vol. III, p. 13.
28. T. Volker (1954), pp. 21–2.
29. T. G. Th. Pigeaud (1960–3), Vol. III, p. 98.
30. K. W. Taylor, op. cit. (1982), p. 21.
31. O. R. Janse (1944–5), Pl. 16 (1).
32. Reproduced in C. Lammers and A. Ridho (1974), p. 78.
33. Reproduced in Southeast Asian Ceramic Society (1982), p. 115, and C. Lammers and A. Ridho, op. cit., p. 78.
34. For other examples see U. Wiesner (n.d.), Pl. 173, Oriental Ceramic Society of Hong Kong (1975), Pl. 183, and Yamato Bunkakan Museum (1983), Pl. 16.
35. Tomé Pires (1944), Vol. 1, pp. 226–7.
36. Compare Y. Yabe (1978), Pls. 113 and 114, and R. B. Fox (1959), Pl. 138.
37. S. Iwao (1976), p. 10.
38. See Y. Yabe (1978), Pls. 25–26, and Yamato Bunkakan Museum (1983), Pls. 12–16 and 25–27.
39. S. Iwao (1976), p. 12, and T. Yamawaki (1976), p. 108.
40. T. Volker (1954). This study examines the VOC records for the period 1602–82.
41. Personal communication, Abu Ridho.

7. Thai Ceramics and International Trade

THE ceramics produced in Sukhothai Province in Central Thailand assumed a significant role in the ceramic trade of Asia, especially in the fifteenth and sixteenth centuries. The extent of the Thai contribution has only begun to emerge as excavations in South-East Asia continue to record the presence of these wares and recent investigations at the production sites have provided an indication of the number of kilns involved in the firing of trade wares.[1] The kilns produced not only glazed ceramics for domestic and architectural use but also an extensive range of wares expressly for a growing international market.[2]

The extent and nature of the maritime trade of the Kingdom of Sukhothai in the thirteenth century is not clear,[3] but at the end of that century the *Yuan-shih* records a tributary mission of 1295 as signifying the formal submission of the Kingdom of Hsien (Sukhothai).[4] The Yuan court had a direct interest in greater control over the lucrative trade in South-East Asian natural products which had been substantially deregulated under the Song Dynasty. Chinese merchants had taken up residence at the major centres around the Gulf of Thailand by the thirteenth century. Zhou Daquan's *Notes on the Customs of Cambodia*, based on a Yuan diplomatic mission of 1296–7, described the established practice of Chinese private merchants settling and intermarrying. In exchange for local natural products they traded Chinese gold and silver, the most highly desired Chinese commodities, along with 'tin ware from Chen-chou, lacquered trays from Wen-chou, green porcelain from Ch'uan-chou...'.[5] From Thailand sapanwood and pepper were sent to China and textiles, porcelain, and metal ware traded in return.[6] No mention is made, however, of international trade nor of a ceramic industry, domestic or export, in the famous stele purportedly erected by Ramkhamhaeng in 1292 to record the achievements of his reign, nor in any other inscription of the Sukhothai period.[7]

At some time in the fourteenth century the ceramic industry of Central Thailand, which had hitherto only supplied a local demand, began to produce material for export. By the fifteenth century these Thai wares had become a regular feature of the Asian ceramic trade. This change may well be related to the emergence of the newly founded Kingdom of Ayudhya in the second half of the fourteenth century. Ayudhya emerged in 1351 out of the alliance of the two dominant city-states (*muang*) in the lower Menam Chaophraya basin, Lopburi and Suphanburi. By 1369 this new regional force had broken the power of Angkor and by 1378 had imposed a degree of control over the Kingdom of Sukhothai. However, Sukhothai made repeated attempts to reassert its independence and it was not until 1438 that it was formally integrated into the Ayudhyan kingdom.[8]

Ayudhya quickly assumed a central role in controlling and expanding Thai

international trade, profiting from its strategic location on the confluence of three large rivers to intercept all riverine traffic between the upper Menam Chaophraya basin and the Gulf of Thailand. The remains of large quantities of Thai ceramics, probably destined for the South-East Asian market, have been retrieved from the riverbed at Ayudhya in recent years, pointing to the city's role as a transhipment centre linking the kilns of the Sukhothai region with the international trade system. The participation of the ceramic industry centred around Sukhothai in international trade was thus dependent on the co-operation of the Ayudhyan authorities. Indeed it may be asked whether the initiative for participating in the Asian ceramic trade may not have come from the Ayudhyan merchant community, which may have been substantially Chinese. These merchants may also have been responsible for the introduction of limited quantities of Chinese and Vietnamese ceramics which have been gathered from the kiln-site areas. It should also be noted that merchants from Ryukyu who regularly visited Thailand in the fifteenth century plotted a route from the Ryukyus to Fujian and then followed the coast south, past Guangdong and Vietnam, to the Gulf of Thailand.[9] The opportunities were plentiful for the introduction of Chinese and Vietnamese ceramics, and elements of Thai ceramic form and decoration reflect influences from these sources. The influence of *Longquan* greenwares on Thai Sawankhalok-kiln fluted and foliated plates is particularly apparent, while Vietnamese under-glaze decorated bowls appear to be the inspiration for a similar class of Sukhothai kiln wares.

The private trade carried on by Chinese merchants may be one of the most critical factors in Ayudhya's emergence as a regional power and in the growth of the Thai ceramic trade. Chinese appear to have dominated Ayudhya's fleet, providing much of the skilled personnel.[10] South-East Asian ship construction of this period appears to reflect a mixture of local and Chinese design elements[11] (Figs. 27 and 28). However, the use of South-East Asian crews is suggested by the discovery of Thai earthenware utensils and containers associated with the preparation of betel in marine excavations in the Gulf of Thailand. In recent years the remains of approximately fifty shipwrecks have been located in the Gulf of Thailand and several have been the subject of intensive excavation and documentation.[12] The main cargoes of these vessels

Fig. 27
A South-East Asian ship, 'jong', recorded in Malacca by Manuel Godinho de Erédia before 1613. Although identified by Erédia as a Chinese junk, P.-Y. Manguin (1983) demonstrates that this vessel is not of Chinese origin but belongs to insular South-East Asia, a hybrid vessel reflecting both Chinese and South-East Asian design elements. (Engraving after the manuscript drawing, published L. Janseen, 1881–2)

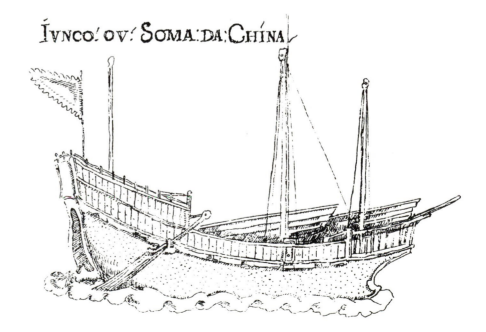

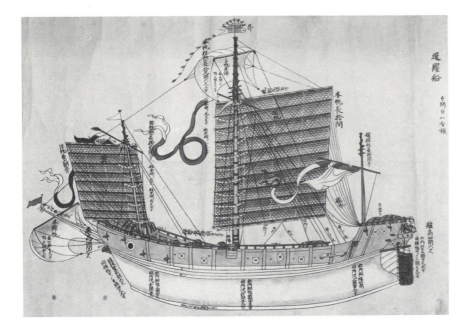

Fig. 28
A trading ship from Thailand, depicted with ships from South China, Java and the Netherlands, in a handscroll painting of twelve foreign boats seen in Japanese ports. Japanese, eighteenth century, based on earlier models. (National Gallery of Victoria, Melbourne)

seem to have been the ceramics of the Sukhothai and Sawankhalok kilns.

The dating of the production spans of the Thai kilns has only been settled in very broad terms, based on external historical and archaeological evidence. Not a single dated ceramic vessel is known from either the Sukhothai or Sawankhalok production centre. The establishment of a reliable internal chronology of wares may emerge from the excavations currently being pursued in Sukhothai Province, but the problem of absolute dating remains. An examination of trading patterns and excavated trade ceramics can assist in delineating more accurately the historical limits of this activity.

So far the earliest datable discovery of Thai glazed ceramics in a trade context comes from Okinawa, Ryukyu. It consists of the base of a stoneware bottle with underglaze iron decoration, a typical product of the export kilns at Sawankhalok.[13] It was excavated at the Nakijin Castle in Okinawa which was built around the middle of the fourteenth century and substantially destroyed by a rival Ryukyu clan in 1416. The Thai sherd was found together with numerous pieces of Chinese ceramics in an archaeological context which indicated they were deposited prior to the destruction of the castle. It can thus be dated between the middle of the fourteenth century and 1416. Three other examples of Thai trade ceramics have been reported in the region. Two brown-glazed jars and a green-glazed bottle were identified in the Akuseki and Yahatasha shrines on the Tokara Islands, situated between the Ryukyus and Kyushu.[14] Though their date of dedication to the shrines is not recorded, the Ryukyu trade is the most likely source of these wares.

The presence of Thai ceramics in the Ryukyus provides evidence of the extensive South-East Asian trade conducted by the rulers and private merchants of the Ryukyus. Their merchant ships, trading with the Chinese merchants of Ayudhya, may represent an important link in the trading network which distributed Thai ceramics, particularly to the Japanese market. The Ryukyu official records, the *Rekidai hōan* (Precious Documents of Successive Generations), spanning the period from 1428 to 1867, provide documentation of an active trade under royal monopoly which linked China, Japan, and South-East Asia in a trading network. The most extensive South-East Asian trade was with Thailand, with over 150 voyages being recorded between 1385 and 1570.[15] The Ryukyu traders' cargo included Chinese porcelain, textiles and iron-ware, and Japanese swords, armour, lacquer ware

61

and gold, with the principal return cargo being sapanwood and pepper. The official records make no mention of ceramics from Thailand, but rather Thai textiles which were highly appreciated in Japan. The trade in Thai ceramics may have been too minor in commercial terms to warrant recording, or this may have been another aspect of the unrecorded private trade which was also conducted.[16]

The remains of a ship and its cargo, regrettably pilfered, which may have belonged to this Ryukyu trading system, were found at Sha Tsui, High Island, Hong Kong. The ceramic evidence examined by the Hong Kong Museum and Archaeological Society reportedly contained brown-glazed sherds, identified as belonging to Sawankhalok storage jars.[17] This type of jar has also been identified at Amami Island, north of the Ryukyus.[18]

Thai ceramics found an unexpected market in Japan in collectors who sought unusual and aesthetically pleasing ceramic wares for use in the tea ceremony, which became very popular in the sixteenth century. A major source of these wares was the northern Philippines. Several sixteenth-century European accounts record the presence of Japanese merchants in Luzon, purchasing ceramics and silk for the Japanese market. When Miguel Legazpi's expedition arrived in the Philippines in 1565 he found Japanese traders active in the area.[19] Many came in search of the prized 'Luzon' jars. Francesco Carletti, a Florentine merchant who sailed from Manila to Nagasaki in 1597 aboard a Japanese ship, specifically refers in his account to the rarity and antiquity of 'earthenware vases' valued in Japan for the 'property of preserving unspoiled a certain leaf they call *cha* [tea]': 'They are not to be found today ... as they were made many hundreds of years ago and are brought from the kingdoms of Cambodia and of Siam and Cochin China and from the islands, Philippines and others, of that sea.'[20] Such jars were used as containers for storing tea leaves and were an important element in the decoration of the tea room (*sukiya*). Carletti appears to distinguish the Luzon wares from the more widely recognized Chinese wares and associate the South-East Asian wares, including Thai, with the great demand for Luzon jars (*Ruson-yaki*) in Japanese tea-ceremony circles. Several writers have suggested that the Japanese term 'Sonkoroku', in use since the sixteenth century, is derived from 'Sawankhalok', which may provide evidence of awareness of the precise origin of these foreign ceramics in Japan.[21]

Thai ceramics found their strongest markets in South-East Asia, and particularly in the Philippines, Java, and Sulawesi, where they were imported in considerable quantities and dispersed widely through secondary trading.[22] Along with Chinese and Vietnamese ceramics, Thai wares assume a significant role in the funerary practices of many South-East Asian communities.[23] Indeed the limited number of controlled excavations in the northern Philippines have revealed the highest concentrations of Thai trade ceramics reported in South-East Asia, rivalled perhaps only by those of southern Sulawesi. A comparison of Thai ceramic wares found in these two regions demonstrates the significance of the Thai kilns' contribution to the international ceramic trade at the peak of their activity.

Thai ceramics have been reported from numerous Philippine sites with the greatest concentrations being recorded in southern Luzon and Mindoro, in the region flanking the Verde Channel. This sea passage leads to the islands of Panay, Negros and Cebu, south to Mindanao, and beyond to the Sulu Archipelago and Sulawesi. The largest finds have been at Calatagan, in Batangas Province, Luzon, and at Puerto Galera, Mindoro. The Calatagan site, comprising several burial grounds, has been the subject of archaeological investigations since 1934.[24] Located on a small peninsula facing the South China Sea, Calatagan is largely a sixteenth-century site, dominated by Middle Ming Chinese blue-and-white porcelain, though with some fifteenth-century

material. In the context of these extensive Chinese finds significant quantities of Sawankhalok wares were found in graves containing the earlier Chinese wares. Fox calculated, on the basis of his findings, a 13 per cent Thai presence at the Pulung Bakaw cemetery and a 22 per cent presence at the Kay Thamas cemetery.[25] The Thai ceramics consisted exclusively of Sawankhalok wares, with no Sukhothai ceramics being identified. Large quantities of Sawankhalok greenwares, mostly jars, and underglaze decorated wares, particularly covered boxes, have been excavated at nearby Puerto Galera, on the northern coast of Mindoro.[26] A Sukhothai presence was recorded, the kilns being represented by two plates decorated with the characteristic fish motif.[27] From these and other reported findings on Panay, Negros, Cebu, Mindanao, Palawan, and Sulu, it appears that the Philippines provided a major market for Thai trade ceramics. It is also evident that this trade was dominated by Sawankhalok wares with only a minor contribution from the Sukhothai kilns. Chinese porcelain found in association with the Thai wares suggests a period of importation spanning from the fifteenth century to at least the middle of the sixteenth century.

A similar pattern emerges from finds in Sulawesi. Of the numerous sites reported from South Sulawesi, Takalar revealed an abundant and representative selection of trade ceramics.[28] The site was dominated by fifteenth- and sixteenth-century Chinese wares with smaller quantities of Sawankhalok and Vietnamese wares. On a visit to a site near Takalar in 1974, Roxanna Brown observed that 'several hundred whole pieces had been collected at depths of one to two metres. The finds included Chinese blue-and-white and celadons, plus Annamese and Sawankhalok wares; much the same mixture as at Kampong Pareko.'[29] The Kampong Pareko site in South Sulawesi was first excavated in 1936 by Japanese collectors who reported that Sawankhalok wares represented 20 per cent of the finds, with a small Vietnamese presence, and the balance being wares of Chinese origin.[30] No Sukhothai wares were identified. Of the very large sample of wares found in Sulawesi classified by the archaeological authorities, approximately 20 per cent are Thai,[31] a representation consistent with Sulawesi and Philippine excavations. The Thai wares were substantially Sawankhalok with Sukhothai wares representing only 15 per cent of the Thai presence.

The overview which emerges from these findings in the Philippines and Sulawesi is of significant Thai participation in the Asian ceramic trade in the fifteenth and sixteenth centuries. Sawankhalok wares were most common, with a minor contribution from the Sukhothai kilns. The Si Satchanalai region had, on surviving evidence, approximately ten times the number of large cross-draft kilns capable of firing glazed stonewares as had Sukhothai.[32] This ratio of Sawankhalok to Sukhothai wares has also been observed in the ceramic cargo of the Koh Khram shipwreck, a vessel engaged in the Thai ceramic trade, which sank in the Gulf of Thailand.[33] Thus the trade evidence reflects with reasonable consistency the estimated production capacities of the Thai kilns, and suggests that the production of glazed stonewares was substantially devoted to the export trade.

Recent maritime investigations of shipwrecks in the Gulf of Thailand have brought to light only limited information relevant to the problem of dating and particularly on the vexed question of when production of Thai trade ceramics ceased. The ceramic cargo of the Koh Khram shipwreck, for example, indicates that when the ship sank both Sukhothai and Sawankhalok wares were still in concurrent production and were being actively traded overseas. On the basis of comparable finds made in association with Chinese ceramics, as in many sites in the Philippines, this ship and its ceramic cargo may be dated between the second half of the fifteenth century and the mid-sixteenth century. Another shipwreck in the Gulf, located at Ko Kradat, contained only Sawankhalok wares in association with Chinese blue-and-white, including a bowl fragment

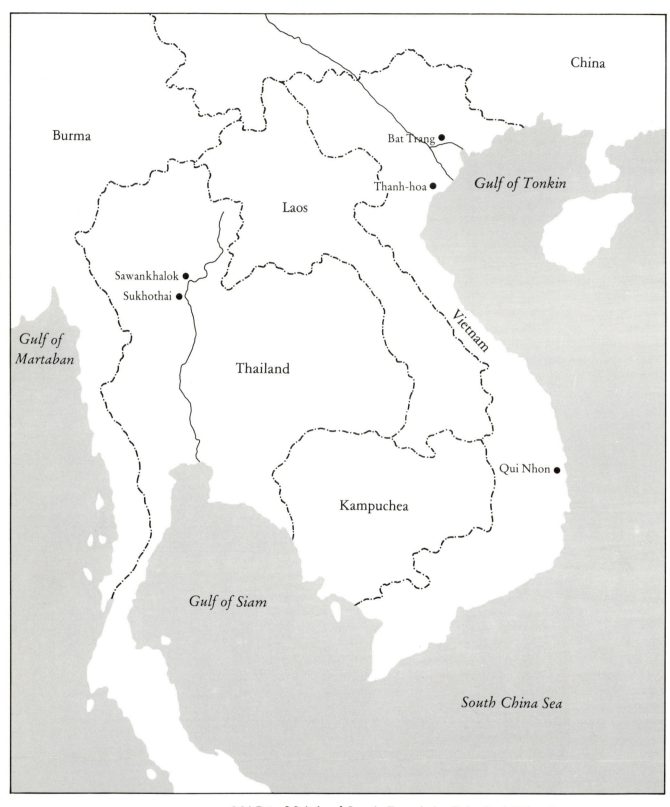

MAP 3 Mainland South-East Asia: Principal Kiln-sites

bearing the Jia Jing reignmark (1522–67).[34] This evidence suggests that in the mid-sixteenth century the Sawankhalok kilns were still in operation. Whether the absence of Sukhothai wares from this vessel indicates that the kilns had already ceased production or merely reflects the composition of a particular consignment, is unclear. Further excavations at the Sukhothai kiln-sites may elucidate this problem. Although the Sawankhalok wares proved to be technically superior to those of Sukhothai, the demise of the Sukhothai kilns may be as much related to the patrons' preference for the better fortified location of Si Satchanalai as to the qualitative differences in the wares. However, the technical superiority of the Sawankhalok wares could not have gone unnoticed. Nevertheless, any inhibitions about the quality of the Sukhothai wares certainly did not discourage the manufacturers from exporting them extensively.

The discovery of Sawankhalok wares in mid-sixteenth-century sites discourages the view that all production ceased when the region of North–Central Thailand became the battlefield for the contending forces of Ayudhya and Chiengmai from the mid-fifteenth century onwards. The shifting of the Ayudhyan kingdom's capital to Phitsanulok, near Sawankhalok, in 1463 to strengthen the northern boundaries against threats from Chiengmai, may have boosted the prosperity of the Sukhothai region. The critical element in the Thai ceramic trade was Ayudhya's control of the Menam Chaophraya basin river system and the access it provided to the international trading network. It is quite plausible that the Sawankhalok kilns continued producing export wares until their distribution system collapsed with the sacking of the city of Ayudhya by the Burmese armies in 1569. The Sukhothai region had been under Burmese control since 1564 and this may be the more relevant date for the disruption of the riverine trading system upon which the export of Thai ceramics depended. The expulsion of the Burmese in 1586 and the restoration of Ayudhyan authority may not have been sufficient to revive the ceramic industry. There would have been strong competition from the Chinese industry, stimulated by the emperor Wanli formally revoking an earlier prohibition on Chinese overseas trade. This argument is based largely on historical supposition but it does have the advantage of being compatible with the external archaeological evidence which points to Thai trade ceramics still being traded around the middle of the sixteenth century.[35]

Thai ceramics rarely found their way beyond the South-East Asian region. However, examples have come to light in the Middle East and at Fustāt, the western terminus for much of the international ceramic trade. Two fragments of green-glazed stoneware identified by the writer as products of the Sawankhalok kilns have been located in sherd collections assembled from Fustāt. One is a rim fragment of a bowl with an incised lotus-bud motif on the interior and vertical fluting on the exterior, deposited in the British Museum in 1891 by the Egypt Exploration Society (Fig. 29). A second example, the base of a bowl with the characteristic firing scar, was collected by a Japanese expedition led by Mikami in 1964 (Fig. 30). Other examples of Thai ceramics along the western trade routes may well be identified in due course; in India, perhaps, where Chinese celadon was highly appreciated.[36] Although the fortunes of Fustāt were in decline by the fourteenth century, the volume of Chinese ceramic imports to Egypt appears to have reached a peak under the Mamlukes around this time, with Yuan and early Ming wares found in abundance.[37] A reduced trade-flow continued even up to the eighteenth century. The integration of the Thai ceramics trade into the Chinese international trading network would explain the presence of Thai ceramics in Egypt and elsewhere. A green-glazed Sawankhalok bottle was acquired in Iran in 1875 on behalf of the Victoria and Albert Museum, London, but as with

Fig. 29
Fragment of a Sawankhalok greenware bowl collected at Fustāt by the Egypt Exploration Society. (British Museum, London)

Fig. 30
Base of a Sawankhalok greenware bowl excavated at Fustāt in 1964 by T. Mikami. (Idemitsu Museum of Arts, Tokyo)

Vietnamese ceramics in Middle Eastern collections, it is most unlikely that the true identity of such wares was ever appreciated.

Chinese long-distance trade experienced rapid expansion in the fifteenth century, stimulated by the experience of the seven great naval expeditions dispatched between 1405 and 1433. Large merchant syndicates built commercial fleets which engaged in trade along the entire East–West trade routes. Chinese merchants were well established in the Gulf of Thailand (at Ayudhya), and at Pattani and Tenasserim, and by the mid-fifteenth century Chinese junks had a strong presence in Malacca and elsewhere.[38] Thai trade ceramic activity benefited directly from its participation in this network and appears to have continued to find a market for its distinctive ceramics until well into the sixteenth century. No evidence has been established, however, for the Thai ceramic trade continuing beyond this period. Volker's examination of

the Dutch East India Company records for the period 1602–82 presents a compelling case against this possibility. He observed that 'nowhere in the *Dagh Registers* nor in the other contemporary papers examined is Siamese ceramic export ware ever once mentioned as a merchandise'.[39] Indeed since the establishment of a VOC factory at Ayudhya in 1608, the Dutch had been active importing Chinese and, later, Japanese porcelain into Thailand. this was at a period when the Dutch also traded Vietnamese ceramics in the years when insufficient supplies of Chinese porcelain could be obtained through their agency in Formosa. If Thai ceramics had still been available the Dutch would presumably have been eager to also use them as a trading commodity. However, no evidence of this is known. It may reasonably be argued therefore that the kilns producing Thai trade ceramics ceased production about the middle of the sixteenth century, possibly as a result of the temporary loss of access to the international trading network, and were not able to be revived when trading possibilities through Ayudhya were restored towards the end of that century.

1. D. Hein *et al.* (1981–2).

2. See 'Thai Ceramics' herein.

3. Central Thailand had of course been on the international trade routes which linked Han China with the late Roman world. A third-century Alexandrian bronze lamp was excavated in Phongtuk, an abandoned site near Nakhon Pathom; see H. G. Quaritch Wales (1969), p. 10.

4. T. E. Flood (1969), p. 245.

5. Zhou Daquan [Chou Ta-Kuan] (1967), p. 34.

6. G. W. Skinner (1957), p. 1.

7. W. Waithayakon (1965).

8. K. Charnvit (1976), Chapter VII.

9. S. Shunzo (1964), p. 388.

10. A fifteenth-century decree used Chinese terminology to designate the titles of ships' crews in Ayudhyan royal junks (K. Charnvit, 1976, p. 82).

11. P.-Y. Manguin (1983).

12. R. M. Brown (1975), P. C. Howitz (1977), J. N. Green (1981), J. N. Green, R. Harper and S. Prishanchittara (1981), and J. N. Green and R. Harper (1983).

13. This find was reported by M. Kamei (1983).

14. M. Kamei (1983).

15. S. Shunzo (1964), pp. 306–7.

16. E. Tomoyose (1978).

17. Ho Ching Hin and B. Ng (1974).

18. Personal communication, M. Kamei (1982).

19. C. N. Spinks (1956), p. 93.

20. F. Carletti (1965), pp. 100–1.

21. C. N. Spinks (1956), p. 97, and O. Karow in R. M. Brown *et al.* (1978), p. 23.

22. K. L. Hutterer (1973) and W. H. Scott (1982).

23. J. S. Guy (1984b).

24. O. R. Janse (1941) and R. B. Fox (1959).

25. R. B. Fox (1959), pp. 360–1.

26. R. C. P. Tenazas (1964).

27. L. Locsin and C. Y. Locsin (1967), Pl. 153.

28. U. Tjandrasamita (1970).

29. R. M. Brown (1974b), p. 3.

30. C. Ito and Y. Kamakura (1941).

31. Hadimuljono and C. C. Macknight (1983).

32. D. Hein *et al.* (1981–2).

33. R. M. Brown (1975).

34. J. N. Green, R. Harper and S. Prishanchittara, op. cit.

35. The present uncertainties over the termination date of the Thai kilns will continue because of the logical difficulties of fixing a secure date by associations. Scientific dating of the youngest wasters of the kiln-sites may provide some answers in the future.

36. M. Greensted and P. Hardie (1982).

37. T. Mikami (1980–1).

38. J. V. Mills (1979), p. 70.

39. T. Volker (1954), p. 72.

8 Some Concluding Remarks

In tracing the introduction of trade ceramics into the South-East Asian region from the ninth to the sixteenth centuries, this study has attempted to cast some light on the historical processes of cultural interaction which have contributed to the cultural matrix identified as 'South-East Asia'. Archaeological evidence in the form of foreign ceramics excavated from settlements and burial sites, port areas and temple precincts, shipwrecks and transhipment areas, all assist in the reconstruction of an understanding of early South-East Asian centres and their interdependence. As the number of identified sites grows, a more comprehensive overview begins to emerge, progressively elucidating the nature of trade patterns and regional differences in ceramic taste.

The earliest datable appearance of trade ceramics in South-East Asia occurs around the ninth century. These are the glazed stonewares of the late Tang period, found scattered along the entire East–West trade route from Java to the Persian Gulf. By the twelfth century momentum had gathered for the production of ceramics as a growing component of China's export trade. Literary sources appear from this time and together with the archaeological evidence confirm the popularity and high regard for Chinese ceramics in the lands in which they were traded. The thirteenth century witnessed the establishment of the Yuan Dynasty and with it South China's entry into the international ceramic trade with an unprecedented vigour. The wares were robust and eclectic in style; the techniques, devised for greater output, innovative and expedient. Expansionist Chinese maritime activities resulted in even greater volumes of ceramics being traded in South-East Asia and beyond.

The fourteenth century witnessed the appearance of Vietnamese ceramics in the international trade and the beginnings of a Thai contribution. Throughout the fifteenth and sixteenth centuries these mainland South-East Asian kilns competed with Chinese ceramics for the markets of South-East Asia and made a significant contribution. In the course of the sixteenth century Thai ceramic production appears to have been disrupted and the distribution network impaired. The initiative was lost and Thai ceramics vanish from South-East Asian sites during the middle part of the sixteenth century. Meanwhile, Vietnamese ceramics had come increasingly to model themselves on the Chinese wares with which they were competing. This may have been the key to their demise for by the seventeenth century they had all but disappeared from international trade, being displaced by resurgent Chinese ceramic activity, whose output now had an additional and critical market in Europe.

What then are the possibilities and limitations of the study of trade ceramics in South-East Asia prior to the seventeenth century? The durability, number and distinctiveness of trade ceramics means that they can provide much historical information about the societies in which they were used, as well as

68

supplying invaluable evidence of cultural contact. In addition the study of ceramics *per se* can be advanced. New classes of ceramics unrecognized in their country of origin have been identified, as exemplified by some fourteenth-century Chinese trade types found in the Philippines. Vietnamese ceramic production in the fourteenth, fifteenth and sixteenth centuries contributed significantly to the Asian ceramic trade and yet the provenance and chronology of these wares has not yet been firmly established. The evidence to date has been largely external, from trade sources, whilst the kiln-sites await investigation within Vietnam. The Thai kilns are now being excavated but it was the external evidence from trade sites, including ceramic cargoes from shipwrecks, which first challenged the assumptions relating to the sequential production spans of the Sukhothai and Sawankhalok kilns. Recent excavations appear to support the trade evidence and contribute to the growing body of evidence which will enable a secure chronology of Thai wares to be established eventually.

Thus, the growing body of evidence from trade ceramic sources is contributing both to an understanding of many aspects of the ceramic traditions of China, Vietnam, and Thailand and to explaining the historical processes of interaction which have given the South-East Asian region its distinctive character.

Chinese Ceramics

Early Wares

THE history of early Chinese trade ceramics must be viewed in the broader context of the evolution of Chinese glazed ceramics in general. The earliest wares found in South-East Asia are *Yue* and related greenwares of the ninth to tenth centuries, emanating from the Yue kilns of northern Zhejiang and distributed through the port of Ningbo.[1] This period saw major developments in the field of glazed ceramics, and by the mid-tenth century *Yue* ware had succumbed to *Longquan* greenware as the mainstay of Chinese ceramic production.[2] *Longquan* greenware evolved directly from the *Yue* ware which had dominated early Chinese glazed stonewares. Over twenty kiln-sites of *Yue* ware are known in Zhejiang Province alone, the home of the famous *Longquan* greenware,[3] and it was also produced in other provinces, especially Henan and Hunan. The Changsha kiln-site in Hunan is renowned for its inventive use of painted and applied decoration on its early glazed wares, of which the ochre-brown splashed ware is the most distinctive type (Plate 1). The kilns of Tongguan and Wazhaping, in particular, appear to be responsible for an imitation *Yue* ware, the distinctive stoneware ewers with moulded relief decoration splashed with green or brown glaze (compare Plate 3), and the highly innovative underglaze painted earthenware bowls. Each of these types of wares has appeared in South-East Asia and sites further west. Lead-glazed wares, the hallmark of Tang ceramics, continued to be produced beyond that period. The examples found in South-East Asia, whilst clearly in the Tang tradition, are identifiable as a late manifestation by their lack of vigour and robustness (Plate 86). Kilns in South China, particularly Fujian, appear to have been producing lead-glazed wares as late as the fourteenth century. Such wares exhibit a buff or grey body and a limited range of glaze colours, with green and amber predominant. The glazes have a tendency to flake from the body (Plates 87 and 88).

In North China white wares were the dominant type and saw the earliest experiments with carved and incised decoration. White wares were known from the beginning of the Tang Dynasty, possibly the Sui Dynasty, and the *Xing* ware of Hebei has been reported in Middle Eastern excavation sites, apparently transmitted via the overland Silk Route which bore so much traffic in the Tang era. By the Song Dynasty the famous *ding* ware was dominating the northern kilns of tenth-century Hebei and was also being produced in the south, especially after the collapse of the Northern Song Empire and the retreat south in 1127. With the establishment of the Southern Song court at Hangzhou, the economic, political and cultural centre of China shifted south also, and elements of the northern ceramic industry appear to have been transferred south, emulated, and developed. Kilns at Jingdezhen are known to have been producing large quantities of white ware inspired by *ding* ware from the Southern Song period well into the Yuan Dynasty.[4]

Black Wares

A lesser represented class of trade ceramics was a black-glazed ware, especially bowls produced at Song kilns in northern Fujian and Zhejiang, including Jian. They are popularly identified by the Japanese name 'temmoku'. These wares were popular within Chinese tea-drinking circles in the Northern Song era but only begin to appear in Japanese and South-East Asian excavation sites during the thirteenth century.[5]

Greenwares

The Longquan kilns, active since the late Five Dynasties, were producing their finest wares in the Southern Song period. The overseas esteem for Chinese glazed ceramics at that time rested largely on these much favoured greenwares. Technical advances with the multi-chambered 'dragon kiln' allowed huge quantities to be produced in a single firing, much of which was destined for export. *Longquan* greenware of the Southern Song Dynasty is renowned for its thick lustrous glaze which, at its best, assumes a jade-like quality. The majority of examples display the Song feeling for strong subtle potting and restrained use of carved and incised decoration (Plate 75).

During the Yuan Dynasty advances were made in firing technology, allowing very large dishes and jars to be produced in great quantity. However, the wares no longer exhibited the qualities which earned Song greenware its deserved fame. The potting was heavier, the glaze thinner and often tinged with yellow. The restrained use of incised and carved decoration was extended to include impressed, moulded, and applied decoration. Similarly, the repertoire of design motifs expanded, both reviving older elements from the Northern and Southern Song tradition and adding others of their own invention. In the latter years of the Southern Song Dynasty and during the Yuan period, kilns producing an imitation *Longquan* ware were very active at Quanzhou, Nanan, Tongan and Putian in Fujian, and at Xicun and Chaozhou in Guangdong. These kilns were established primarily to benefit from the growing international reputation of *Longquan* greenwares, and their products were exported widely in South-East Asia. Physical comparisons of kiln wasters have enabled those wares to be classified and distinguished from their Zhejiang rivals.

The quality of *Longquan* greenware began a decline in the late Yuan Dynasty from which it never recovered. The Longquan kilns were eclipsed during the fourteenth century by the highly inventive and successful developments occurring in the ceramic industry in Jiangxi Province, most notably at the kilns around Jingdezhen.

White Wares

Whilst characterized as a 'northern type', white wares in the *ding* ware tradition were produced extensively in southern China during the Southern Song and Yuan Dynasties. The two principal kiln areas were at Jingdezhen in Jiangxi and Dehua in Fujian. A characteristic early white ware, fragments of which have been retrieved from the Hutian kiln-site at Jingdezhen, has a fine body and an unglazed mouth-rim for inverted stacking in firing stands[6] (Fig. 32). The kilns at Dehua were at this time actively exporting to South-East Asia a white ware of chalky texture and creamy glaze which was usually mould-formed and had impressed and moulded decoration. Upright lotus petals and vegetal scrolls were the standard designs applied to the shallow bowls and covered boxes which typified this ware. It was a 'soft porcelain' which, due to its high alkali content, tended to vitrify at lower temperatures than the porcelain from Jingdezhen. It nonetheless maintained a competitive stance alongside Jingdezhen ware in the South-East Asian market. The white wares of

Fig. 31
A potter throwing cups on the wheel at a factory in Jingdezhen. (Photograph A. D. Brankston, c.1937)

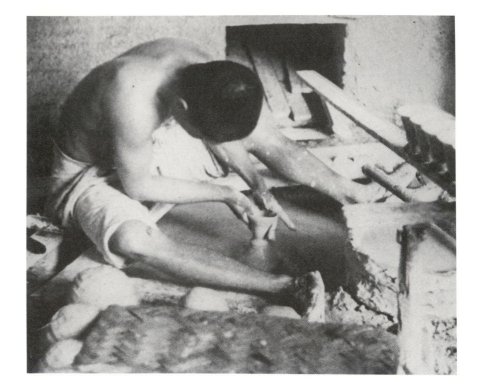

Dehua were in continuous production from Song times onwards and became familiar to a later European market as 'blanc de Chine'.[7]

Yingqing and *Shufu* Wares

The white wares of Jingdezhen underwent a transformation by at least the twelfth century and developed a porcellaneous variant which displayed a fine white translucent body covered with a transparent glaze characterized by a bluish tinge, the result of small iron content in the glaze solution when fired in a reducing atmosphere. It was referred to in contemporary texts as *qingbai* ware ('bluish white'), but is widely identified in present times by the term '*yingqing*' ('shadow blue'), which evokes more precisely the shadowy bluish-green quality of the glaze.[8] Whilst Southern Song *yingqing* was not confined to the kilns of Jingdezhen it appears that the finest quality was produced there.[9] The wares were both plain and decorated, the latter using either incised or moulded design techniques, both of which were derived from the *ding* ware tradition transferred from Hebei around the twelfth century. The Hutian and Xianghu kilns in particular produced the *yingqing* wares of the Song and Yuan periods upon which Jingdezhen's reputation was established, and which, because of their popularity in the overseas trade, prompted widespread imitation in Fujian and Guangdong. The Fujian kilns of Tongan and Nanan in particular produced a high-fired white-bodied ware with a *yingqing* glaze very similar to that of Jingdezhen. On the basis of archaeological studies so far conducted, a Fujian provenance can be assigned to many types of *yingqing* wares known in South-East Asia.

The advent of the Yuan Dynasty saw no marked disruption to the Southern Song tradition but did witness the introduction of new decorative techniques, both applied and painted. Moulded and modelled appliqué were used, with beading (Plate 39) and studding (Plate 52) as the two principal techniques. The elaboration of handle loops into serpentine *chi* dragons was a particularly distinctive achievement of the Yuan potters, adding an exuberance and fanciful dimension to the otherwise restrained Song ceramic forms.

72

The most prophetic aspect of the decorative innovations of the Yuan potters at Jingdezhen, however, lay in the tentative experiments with painted underglaze decoration. Underglaze painting was not new in China, having a long tradition in the famous Cizhou ware of Hebei Province, which is typified by an iron-brown painted design applied to a cream slip, or a similar visual effect achieved by a *sgraffito* technique. The influence of Cizhou ware was spread in South China largely through the wares of Jizhou in Jiangxi Province, an area renowned for its white-and-brown coloured wares. The immediate inspiration for underglaze painted decoration in Jingdezhen ware most probably came from Jizhou, although its origins must be traced back to the underglaze painting innovations begun at the Tongguan kilns of Changsha by at least the ninth century.

Underglaze painted decoration was practised both on *yingqing* ware and on a second type of white ware, *shufu*, which emerged in the early Yuan Dynasty at Jingdezhen. The *Ge Gu Yao Lun*, written in 1378, described *shufu* ware as being 'of thin and even texture . . . (with) incised decoration and small foot' and observed that 'the best bears the mark of Shufu'.[10] *Shufu* ware is typically more heavily potted than *yingqing* ware and is covered with a semi-opaque thick white glaze, the principal forms being bowls, angular and round dishes, and stem cups. Whilst it appears to have been favoured for official use, the Yuan administration placed no restriction on its free trade overseas.

Underglaze Blue and Red

When the early experiments in underglaze painted decoration were undertaken at Jingdezhen, it was the *yingqing* and *shufu* wares which provided the vehicles for these experiments. Small, inexpensive porcellaneous white wares, they allowed scope for considerable experimentation and spontaneity as the aesthetic and technical problems of this new technique were resolved. The earliest experiments in underglaze decoration at Jingdezhen may have been in brown with iron oxide, as a Jizhou influence would suggest. *Yingqing* ware appears from early in the Yuan period with iron oxide seemingly spotted and splashed over the vessels at random. Iron-spots first appeared in early greenware of the fourth century and are known in Tang period *Yue* and *Changsha* wares. The types which were to have significance for the future of Chinese porcelain are decorated with elaborate compartmentalized designs seen, in the early Yuan period, only in painted Cizhou-type wares and incised white wares.[11] The decorations that quickly evolved from these were executed in either underglaze cobalt-blue or copper-red, and very rarely, both.[12]

Copper oxide as a colouring agent for underglaze decoration proved to be highly volatile under firing conditions and this placed considerable technical restraints on its decorative potential. It displayed a tendency to bleed into the glaze whilst in flux and frequently to misfire to a greyish-red colour. The use of either copper-red or cobalt-blue on these early wares appear to have been largely arbitrary; both were used on the same vessel-types and applied in an identical style (compare Plates 50 and 56). However, wares decorated in underglaze red occur far less frequently in South-East Asian finds and over a more limited period of time than do wares decorated in underglaze blue. Confined mainly to the fourteenth century, the use of copper oxide was largely abandoned subsequently in favour of the more predictable cobalt.

Ceramics decorated with a blue pigment derived from cobalt ore appeared in China during the Tang Dynasty when cobalt was used as a colourant in lead glaze. Recent investigations of a number of dated Song sites suggest that early experiments in painted underglaze blue decoration were being conducted by the beginning of the Song period. The earliest examples—fragments of three bowls decorated in underglaze blue—were unearthed from the foundations of the Jinsha pagoda in Zhejiang. Bricks used in the construction of this pagoda

were inscribed 'Second Year of Taiping Hsinkuo', i.e. AD 977.[13] These appear to be the earliest datable examples of underglaze painting in cobalt-blue in Chinese ceramics found to date. The practice of underglaze painting was already well established, using iron and copper, for example, as seen at Changsha by the early ninth century.

The critical development in underglaze cobalt decoration did not occur, however, until the early fourteenth century and was probably due primarily to the introduction of more abundant supplies of Middle Eastern cobalt ore at the instigation of foreign merchants commissioning porcelain for the wealthy West Asian markets. Supplies of local cobalt, capable of producing comparable results, do not appear to have been exploited until as late as the early fifteenth century.[14] Yuan-period kiln-sites at Jingdezhen have yielded the earliest evidence of the manufacture of this phase of blue-and-white ware.[15] This appears to be the earliest provenance for blue-and-white trade porcelain and represents the beginnings of a new chapter in Chinese ceramic history. The rapid advances in blue-and-white decorated porcelains in the late Yuan period are demonstrated in an inscribed temple vase dated 1351 which displays a sophisticated handling of both technical and decorative aspects of underglaze painted decoration.[16] Moulded wares continued to be made, with ever larger dishes with elaborate foliated rims being shaped in moulds. The use of overglaze enamels, most notably red and green, was known from an early type of Cizhou ware, and was practised at Jingdezhen initially on white wares and by the fifteenth century was being used in combination with underglaze blue decoration.

Kilns and Firing Techniques

The technology of Chinese kiln construction and associated kiln furniture was well advanced by the Song Dynasty when the ceramic industry experienced its most rapid period of expansion. Kilns were constructed on two principal models. A beehive-shaped cross-draft design was widely used, including at Jingdezhen where a variety of saggars and stacking rings were employed at different times in order to maximize kiln capacity.[17] The second dominant kiln type was the dragon-kiln, so prominent in Zhejiang and Fujian Provinces. It consisted of a series of connected chambers built on the slope of a hill.[18] As fireclay saggars absorb substantial amounts of heat, alternative stacking methods were devised in Northern Song ding ware kilns. This technology was

Fig. 32
Saggars employed at Jingdezhen in the Song and Yuan periods, allowing for the inverted stacking of bowls but necessitating unglazed rims. The vertical firing saggar required only the foot to remain unglazed. (Line drawings after A. D. Brankston (1938) and Lin Hsin-kuo (1978))

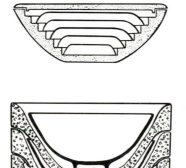
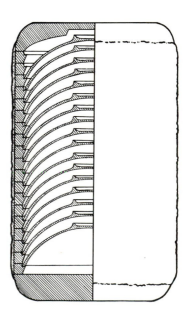

introduced to Jingdezhen and was in use until the Yuan period. The wares were stacked upside down on unfired stepped rings with their mouth-rims unglazed to avoid fusing (Fig. 32). Stepped and multi-ringed saggars of this type were in use for the production of *yingqing* saucers and bowls, on the evidence of the Jingdezhen Hutian kilns, from at least the beginning of the twelfth century. By the early fourteenth century upright firing was widely preferred and it is associated with the introduction of large-scale blue-and-white production.

Problems of Dating

Given the state of knowledge of Chinese ceramics and its long history as a field of connoisseurship and scholarly interest, it is surprising how little reliable information has been amassed from Chinese literary sources, be they antiquarian studies, dynastic histories or manuals of ceramic technology. Much of the present-day knowledge of the provenance of specific types of ceramics has been gained only since systematic archaeological examinations of kiln-sites began earlier this century. Feng Xianming's major survey of the important ceramic finds in China since 1949 is a landmark in the review of the present state of knowledge.[19] It reveals such a diversity of wares being produced at kiln-sites spread geographically, that generalizations concerning the provenance of specific types of wares must now be more carefully scrutinized. Provenance of wares can be fairly readily ascribed on the basis of technical, stylistic, and qualitative elements evident in wasters retrieved from the kiln-sites and waste-heaps. Detailed physical descriptions accompanied by photographs are the essential information sources for those without access to the sherds themselves.[20]

Dating of the wares, however, is a problem of a different magnitude. Epigraphic evidence in the form of dated inscriptions on ceramic vessels, incised into the unfired body or painted on after firing, are extremely rare.[21] Whilst the few dated pieces extant are of the utmost importance as landmarks in the development of their respective ceramic families, they do not provide sufficient evidence around which to build a definitive chronology. At the very best, a tentative grouping of wares can be attempted before and after the dated piece. Recent archaeological investigations have provided additional dated reference points with which to mark out the field. A number of Song- and Yuan-period dated tombs, which contained ceramics amongst their burial furniture, have been valuable indicators of the time by which particular types of wares were in existence, thus providing a *terminus a quo* in the same manner as dated pieces. For example, a tomb near Nanking dated to 1027 yielded a *yingqing* vase with moulded decoration, thus providing an early eleventh century dated context for this ware.[22] Over 7,000 artefacts, largely ceramic, have been retrieved from a Chinese ship which sank off the coast of Korea near Sinan in the early fourteenth century.[23] Of the wares so far examined and reported, almost half are *Longquan* greenware with smaller quantities of Jingdezhen *yingqing* ware, iron-spotted *yingqing*, iron-spotted greenware, black-glazed Jian ware, Jun ware, Jizhou iron-painted ware, and one example of underglaze red.[24] Given the diverse nature of the ship's cargo, it is of particular significance that not a single piece of blue-and-white porcelain was found. Large quantities of dated coins were retrieved, the latest being dated equivalent to 1310. Wooden cargo tags recovered in 1982 included two inscribed in ink with the date '3rd year of Shih-tai', i.e. 1323.[25] This may be accepted as the year in which the vessel sailed, probably from the port of Ningbo, with its rich ceramic cargo.

The Sinan cargo finds suggest that blue-and-white ware was probably not in commercial, exportable production at the time of the wreck. The major contemporary survey of the early Yuan ceramic industry, the *Tao Ji Lue*,

75

published in 1322 by Qing Qi, also makes no mention of underglaze blue decorated wares.[26] The first literary reference occurs in Wang Dayuan's *Doa Yi Zhi Lue* of 1349 where he records that 'Qingbai Hua Ci Qi' (Blue White Decorated Porcelain) was being traded with countries in the South Seas, that is, South-East Asia and beyond. The earliest dated blue-and-white porcelain does not occur until 1338 and is the product of a workshop of Jingdezhen. The second quarter of the fourteenth century is possibly as specific a date as can be assigned, on current knowledge, to the beginnings of commercial blue-and-white porcelain. While primitive experiments in the use of underglaze painted cobalt decoration may well date from the Song Dynasty as a number of excavation reports suggest,[27] the phenomenon of blue-and-white export porcelain, characterized by considerable technical finesse, an innovative approach to design and spirited brushwork, begins in the middle Yuan Dynasty.[28]

Early in the fifteenth century the practice of marking 'official' or 'imperial' wares with the *nianhao* or reignmark of the emperor began. It first appeared on porcelains during the reign of Yongle (1403–24), but such marked wares are very rare. It became a regular practice only from the reign of Xuande (1426–35) onwards. By stylistic and technical analogy unmarked pieces of the period can be attributed a date on the basis of shared characteristics with marked wares.

1. An unusual greenware, *circa* ninth century, in the form of a ewer with a sculptured phoenix-head neck, was collected in southern Sulawesi and is now in Museum Nasional, Jakarta (E. W. van Orsoy de Flines (1972), Pl. 8; for another example, see B. Harrisson (1978), Pl. 7). Its probable place of manufacture has only recently been indicated by kiln-site investigations as Guangzhou in Guangdong Province, which was a major port in South China engaged in active trade with South-East Asia and beyond in the Tang Dynasty.

2. Greenwares may be broadly defined to include all high-fired stonewares covered with an iron-oxide-based glaze fired in a reducing atmosphere. The colour of the glaze and its luminosity depend on the chemical constitution of the glaze, the relative purity of the body, and the conditions of firing. See Glossary.

3. Feng Xianming (1967), p. 15.

4. Lin Hsin-kuo (1978), p. 4.

5. J. C. Y. Watt (1981), p. 74.

6. Lin Hsin-kuo, op. cit., p. 4.

7. See P. J. Donnelly (1969) for an account of this development of early Fujian white wares.

8. See P. David (1955) for the case against the use of the term '*yingqing*'.

9. See Feng Xianming (1967), who reports a diversity of kilns producing *yingqing*, and Oriental Ceramic Society of Hong Kong (1984), pp. 32–6.

10. Quoted in T'an Tan-Chiung (1968), p. 16. See also S. W. Bushell (1977), pp. 54 and 131.

11. A *yingqing meiping* vase, excavated in 1973 from a tomb dated to 1325, has incised decoration consisting of lotus sprays on the shoulder, a dragon amidst waves in the central zone, and lotus petal panels above the foot (reproduced in J. M. Addis (1978), p. 38). All of these decorative components are seen on Yuan blue-and-white later in the century and support the view that many of the decorative elements characteristic of Yuan blue-and-white had already been devised in incised monochrome wares and were adapted directly to the new medium.

12. A large *guan* in the Percival David Foundation demonstrates in one magnificent example the Yuan decorative spirit, combining underglaze blue and red, beading, and relief openwork (reproduced in M. Medley (1974), Pl. B).

13. Chu Boqian (1981).

14. H. Garner (1956), p. 48.

15. Feng Xianming (1967), p. 29, and, J. M. Addis (1975), p. 8.

16. The 'David Vases', Percival David Foundation, University of London (reproduced in H. Garner (1970), Pl. 6).

17. See Lin Hsin-kuo, op. cit., for a detailed discussion of kiln furniture at Jingdezhen in the Song and Yuan periods.

18. A Song-period kiln examined at Chin Ts'un in Longquan was found to be 50.36 metres in length and an average of 2.5 metres in width. It was estimated to accommodate 170 packed saggars, about 8 along its width and stacked 15 high, bringing its capacity to 20,000 to 25,000 pieces for each firing (Chu Boqian (1968), p. 4).

19. Feng Xianming (1967).

20. See, for example, P. Hughes-Stanton and R. Kerr (1981).

21. A *yingqing* figurine of *Kuan-yin* (Goddess of Mercy) in the Nelson Gallery, Kansas City, inscribed in ink on the base with a year equivalent to 1298 or 1299 (L. Sickman (1961), p. 34). A celadon baluster vase in the Percival David Foundation, University of London, has an inscription dated to 1327 (reproduced in M. Medley (1974), Pl. 58) and a blue-and-white temple vase in the same collection is dated equivalent to 1351 (reproduced in H. Garner (1970), Pl. 6).

22. Feng Xianming (1967), p. 36. See also J. M. Addis (1978) for additional examples of early ceramics from dated contexts.

23. Chung Yang-Mo (1977).
24. Announced at the *International Symposium on the Cultural Relics Found off the Sinan Coast*, Nagoya, Japan, September 1983, by the Korean delegates.
25. Youn Moo-Byong and Chung Yang Mo (1983).
26. M. Medley (1974), p. 32.
27. See Southeast Asian Ceramic Society (1978), p. 22, for a review of these reported findings.
28. Its stylistic evolution has been traced in detail by J. A. Pope (1952) and M. Medley (1974).

CHINA

Early Monochrome Wares

1. Bowl with everted rim and square-cut foot. Decorated in brown and green under a yellow ash glaze with a calligraphic floral motif in the centre and brown areas on the rim. Stoneware body with unglazed base.
Diameter 13.5 cm.
Changsha type, Hunan.
Late Tang Dynasty, ninth century.
Collection: M. L. Abbott.

Note: Reportedly from Indonesia. Comparable with examples from Tongguan, Changsha, from where a dated example, inscribed in iron oxide 'third year of Kaicheng' (838) is known; see M. Sato (1981), p. 88. Two examples excavated at Nishapur, Iran; see M. Medley (1981), Pl. 90, and fragments retrieved in the vicinity of Prambanan Temple, Central Java (compare Fig. 4).

2. Bowl with everted rim and square-cut foot. Decorated in brown and green under a yellow ash glaze with a floral or *lingzhi* motif in the centre and brown areas on the rim. Stoneware body with unglazed base.
Diameter 15.5 cm.
Changsha type, Hunan.
Late Tang Dynasty, ninth century.
Collection: M. L. Abbott.

Note: Reportedly from Indonesia (compare Fig. 4).

3. Spouted ewer with three strap handles and a faceted spout. Stoneware with applied grape-vine moulded relief medallions splashed with a brown glaze and covered with a mottled yellowish glaze over a white slip. Base flat and unglazed.
Height 22 cm.
Changsha type, Hunan.
Late Tang Dynasty, eighth to ninth centuries.
Collection: Northern Territory Museum of Arts and Sciences.

Note: The kilns producing these early trade wares were located in 1956 at Tongguan, north of Changsha (M. Medley (1981), p. 90). Examples are known from Nishapur and Sīrāf in Iran as well as Java; see A. Ridho (1982), Pl. I.

4. Spouted jar with two lugs and a strap handle. A thin amber glaze splashed on the shoulder with brown. Glaze stops above the foot, revealing a buff-coloured slip. Light brown stoneware body. Base flat with sharply bevelled edge.
Height 24.2 cm.
Changsha type, Hunan.
Late Tang Dynasty, ninth to tenth centuries.
Collection: Art Gallery of South Australia.

5. Jar of squat form with a raised bevelled neck and four vertical lugs on the shoulder. Stoneware covered with a green–brown glaze stopping well above the foot. Square foot and slightly concave unglazed base.
Height 12 cm.

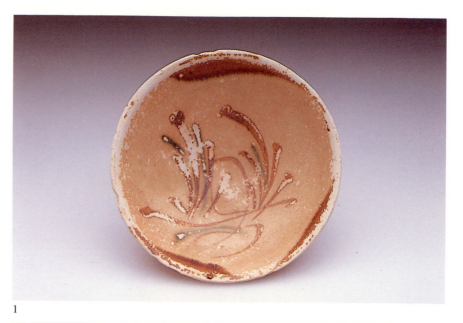

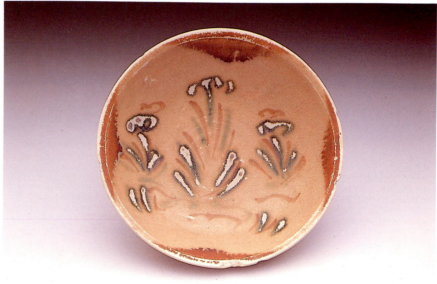

Yuan Dynasty, fourteenth century.
Collection: S. Probert.

Note: Compare L. Locsin and C. Y. Locsin (1967), Pl. 29, and U. Wiesner (n.d.), Pl. 101, both of Philippine origin.

6. Jar of tapering cylindrical form with a rounded neck, ribbed body, and three horizontal lugs on the shoulder. Stoneware body with a mottled brown glaze stopping above the foot. Flat unglazed base.
Height 13.8 cm.
Yuan Dynasty, fourteenth century.
Collection: J. Carnegie.

Note: Acquired in Indonesia.

7. Jar of rounded form with a wide neck and tapering foot, with four horizontal lugs on the shoulder. Stoneware covered with a mottled brown glaze stopping above the foot. Flat unglazed base.
Height 10.4 cm.
Yuan Dynasty, fourteenth century.
Collection: J. Carnegie.

8. Storage jar of ovoid form with a high shoulder and acutely bevelled flared neck. Four horizontal lugs on the shoulder. Buff stoneware body with a grey–green glaze stopping short of the base, which is flat and unglazed.
Height 34 cm.
'Dusun' ware, South China, probably Guangdong.
Late Tang Dynasty, ninth to tenth centuries.
Collection: T. L. Bolster.

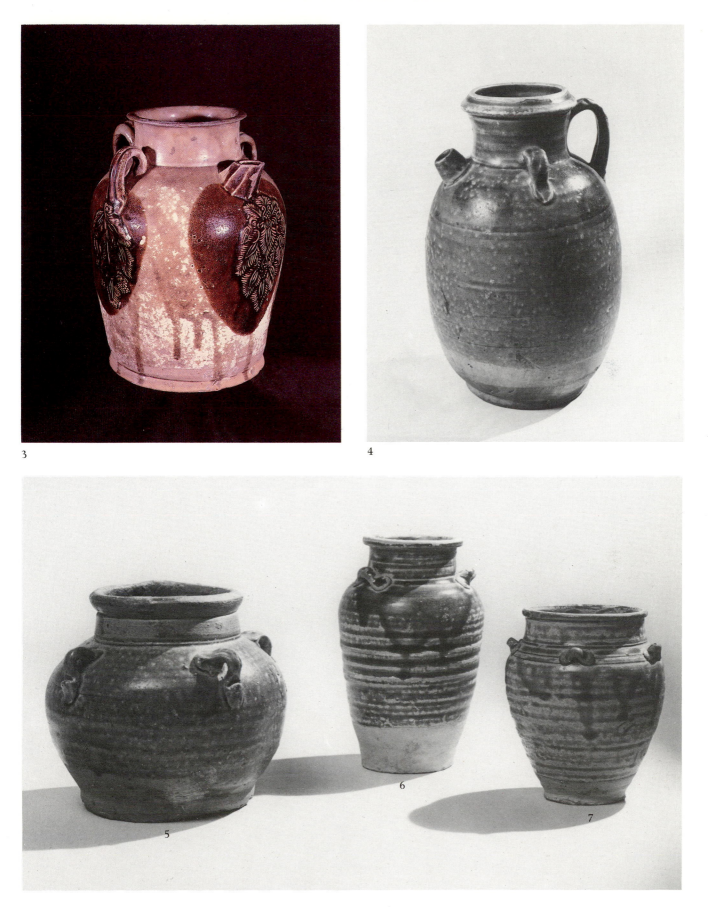

3

4

5

6

7

Note: Comparable examples exhibited at the Guangdong Provincial Museum, Guangzhou, were excavated locally. Identifiable with jars used as shipping containers in South-East Asia, the Indian Ocean, and the Persian Gulf. Name derived from a tribe in Sabah, Malaysia, who prized such vessels. Compare D. Whitehouse (1973), Pl. 18, for ninth-century examples excavated in Sīrāf. Also known from Sri Lanka, Pakistan, and East Africa.

9. Jar of globular form with inverted mouth-rim, raised foot, and carved lotus petal decoration. A thin buff glaze over a pale grey stoneware body.
Height 10 cm.
Yue-type ware, South China, probably Zhejiang.
Five Dynasties to Song Dynasty, tenth to eleventh centuries.
Collection: National Gallery of Victoria.

Note: E. W. van Orsoy de Flines (1972, Pl. 15) published a similar example reportedly collected upland of Jambi, Central Sumatra, and J. M. Addis (1967–9, Pl. 21c) an example of Philippine provenance.

10. Jar of tall ovoid form with everted mouth-rim and four horizontal lugs on the shoulder. A caramel-brown glaze over a buff stoneware body. Base unglazed and concave.
Height 22.5 cm.
South China.
Southern Song Dynasty, twelfth to thirteenth centuries.
Collection: M. L. Abbott.

Note: Compare L. Locsin and C. Y. Locsin (1967), Pl. 42.

11. Jar of squat form with everted mouth-rim and four horizontal lugs on the shoulder. A brown glaze, stopping below the shoulder, over a buff stoneware body. Straight foot and slightly concave unglazed base.
Height 10 cm.
South China.
Southern Song Dynasty, twelfth to thirteenth centuries.
Collection: M. L. Abbott.

Note: On the basis of the Santa Ana excavations, the Locsins suggest a Song date for this type of brown ware. Compare L. Locsin and C. Y. Locsin (1967), Pl. 41.

12. Jar with a cylindrical body and narrow flared neck with four lugs on the shoulder. Stoneware covered with a brown glaze stopping above the foot. Flat unglazed base.
Height 14.7 cm.
Yuan Dynasty, fourteenth century.
Collection: D. and M. Eysbertse.

Note: Compare W. Sorsby (1974), Pl. 71.

13. Jar of ovoid form with everted mouth-rim and four horizontal lugs on the shoulder, covered with a black–brown iron glaze over a buff stoneware body. Base unglazed and slightly concave.

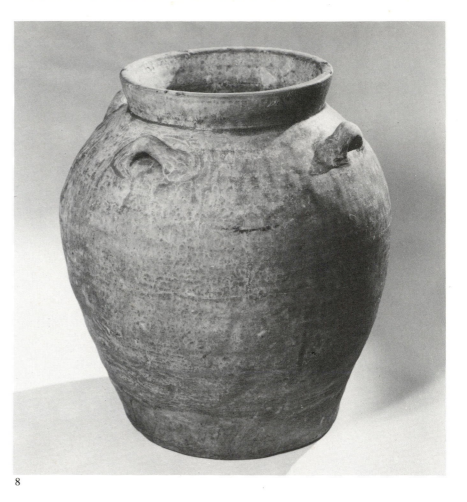

8

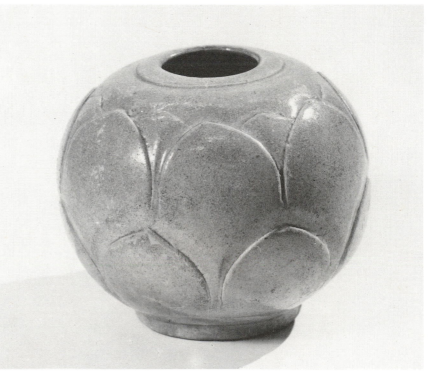

9

80

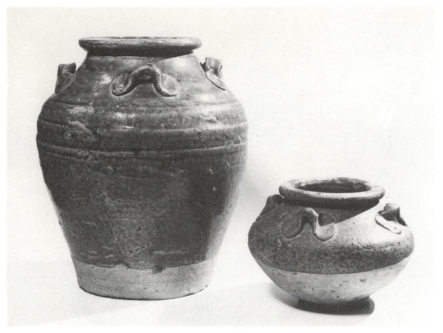

10, 11

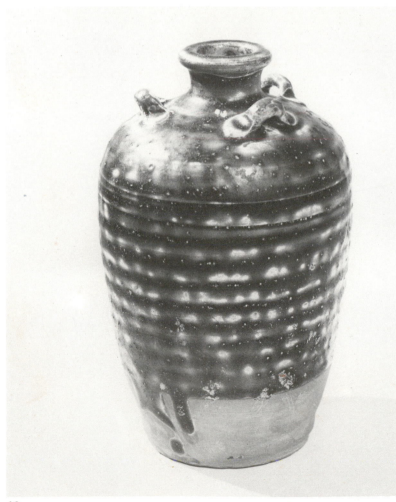

12

Height 14.5 cm.
South China.
Late Song to Yuan Dynasties, thirteenth to fourteenth centuries.
Collection: F. W. Bodor.

Note: Similar examples reported by L. Locsin and C. Y. Locsin (1967, Pl. 151) from excavation at Puerto Galera, Mindoro.

14. Ewer of bulbous form with a wide flared neck, strap handle, and tapering spout. Two moulded tablets conceal lugs on the shoulder, and vertical ribbing on the body. Stoneware body covered with an olive-brown glaze, stopping above the foot-ring.
Height 16.5 cm.
Shangyu, Zhejiang.
Early Song Dynasty, tenth century.
Collection: R. H. Longden.

Note: Reportedly of Indonesian provenance. Compare Southeast Asian Ceramic Society (1983), Pl. 1.

15. Ewer of angular profile with flared mouth, rolled lip, a prominent spout (restored), and a strap handle. A transparent grey-white glaze over a buff stoneware body stopping short of the splayed foot. Base carved to a convex point, unglazed.
Height 21.7 cm.
South China, possibly Guangdong.
Song to Yuan Dynasties, twelfth to fourteenth centuries.
Collection: F. W. Bodor.

Note: J. M. Addis (1967–9, Pl. 26a) reproduces a similar example which he describes as belonging to a 'grey-glazed group' of uncertain provenance. Two similar ewers were excavated at Gedong, Sarawak, in 1968–9; see Southeast Asian Ceramic Society (1979), p. 60. Another example was excavated in Shiga Prefecture, Japan; see G. Hasebe (1977), Pl. 269.

White Wares

16. Stem cup with shallow bowl, everted lip, and ribbed stem. Moulded decoration of two four-clawed dragons with serpentine bodies pursuing a flaming pearl on the cavetto, and a four-petalled flower medallion in the centre. Thick bluish-white glaze over a buff porcelain body.
Height 9.6 cm.
Shufu type, probably Jiangxi.
Yuan Dynasty, fourteenth century.
Collection: F. W. Bodor.

Note: J. M. Addis (1979, p. 26) reported fragments of this type of stem cup from Hutian, Jingdezhen.

17. Covered box of cylindrical form with vertical incised line decoration. Stoneware body covered with a clear glaze. Base unglazed.
Height 7 cm.
Song to Yuan Dynasties, twelfth to thirteenth centuries.
Collection: D. and M. Eysbertse.

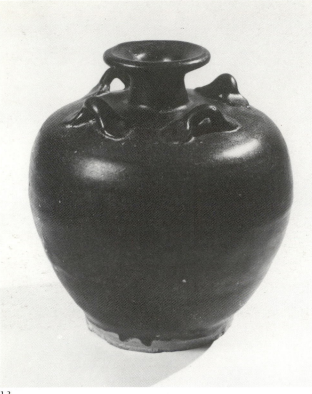

13

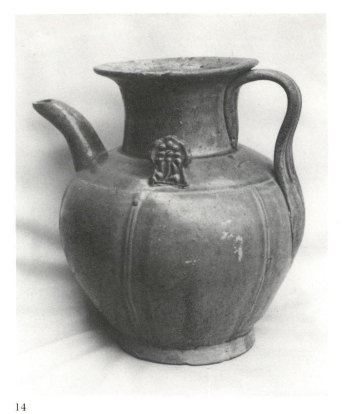

14

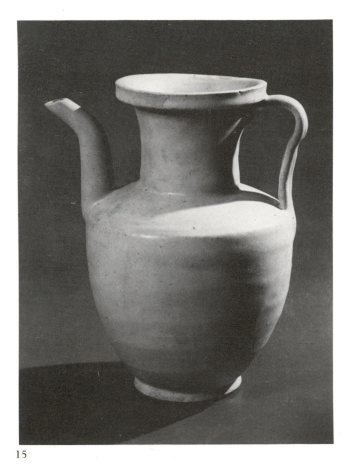

15

16

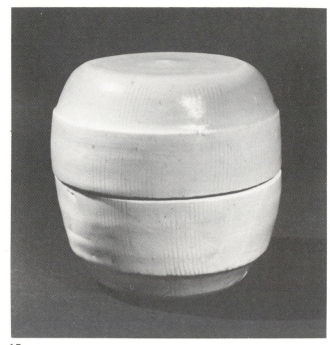

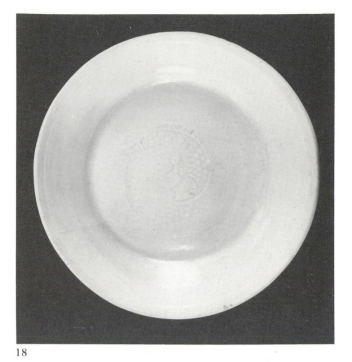

17 18

Note: Examples found in the Sarawak River delta: see T. Harrisson (1959), Fig. 13, and E. Moore (1968). Possibly identifiable with the Nanan kiln, Fujian; compare P. Hughes-Stanton and R. Kerr (1981), Pls. 154–8.

18. Saucer of angular profile with impressed double-fish design in the centre. Transparent glaze over a white porcelain body, the rim unglazed and the foot partly glazed.
Diameter 14 cm.
Dehua ware, Fujian.
Yuan Dynasty, fourteenth century.
Collection: F. W. Bodor.

19. Bottle vase of globular form with vertical neck and slightly flared mouth with a thickened rim. Two pairs of incised horizontal lines adorn the neck. White milky glaze with a bluish tinge over a white porcelain body, the glaze stopping unevenly above the base which is unglazed and slightly concave.
Height 22.5 cm.
Dehua ware, Fujian.
Yuan Dynasty, thirteenth century.
Collection: F. W. Bodor.

Note: E. P. Edwards McKinnon (1975–7, p. 69 and Fig. 9) has identified this form in sherds from North Sumatran sites datable to the late Song-Yuan period.

20. Jar of squat form with four lugs and a short neck with flaring mouth. Moulded peony spray decoration in low relief on the shoulder. A translucent glaze over a white porcelain body. Flat, unglazed base.
Height 4.8 cm.
Dehua ware, Fujian.

Yuan to Ming Dynasties, fourteenth to fifteenth centuries.
Collection: F. W. Bodor.

21. Jar of *guan* form, with swelling shoulder, wide neck, and broad foot. Two-section construction, with horizontal joint. Coarse white body with clear glaze. Flat unglazed foot.
Height 14.5 cm.
Dehua ware, Fujian.
Ming Dynasty, fifteenth century.
Collection: J. Carnegie.

Note: Compare L. Locsin and C. Y. Locsin (1967), Pl. 135, for a very similar example excavated at Puerto Galera, Philippines.

Yingqing Wares

22. Saucer dish with impressed decoration in the interior of two fish surrounded by lotus and other aquatic plants, a key-fret design on the cavetto. *Yingqing* glaze over a porcelain body with only the rim left unglazed.
Diameter 10.6 cm.
Jingdezhen, Jiangxi.
Song Dynasty, thirteenth century.
Collection: H. S. K. Kent.

Note: Such wares were fired in an inverted position stacked in a stepped saggar (see Fig. 12) and often exhibit a slight convexity on the bottom due to sagging whilst inverted. M. Tregear identifies this ware with the Hutian kilns at Jingdezhen (1982, Pl. 198).

23. Saucer dish, finely potted, with incised floral decoration in the interior. *Yingqing* glaze over a porcelain body with the rim unglazed. Slightly convex base.

Diameter 13.4 cm.
Jingdezhen, Jiangxi.
Song to Yuan Dynasties, thirteenth century.
Collection: D. Stock.

Note: Compare I. L. Legeza (1972), Pls. 170–1.

24. Pair of vases of *hulu*-gourd form with flared neck, square-section rim, two vertical lugs on the neck, and bevelled foot. *Yingqing* glaze over a porcelain body burnt pink where exposed.
Height 13.6 cm.
Fujian, possibly Dehua.
Yuan Dynasty, thirteenth to fourteenth centuries.
Collection: C. Nicholas.

Note: This pair of vases are a rare form, modelled on Yuan bronze examples; compare Chung Yang-Mo (1977), Pl. 287. For related ceramic examples, see Southeast Asian Ceramic Society (1983), Pl. 103.

25. Ewer of ovoid form with an angular neck, curved spout, and strap handle. Two modelled lugs of unidentified design bridge the shoulder and neck. Summarily executed incised decoration on the body of vertical sickle-leaf sprays. Two sharply incised lines above the foot. Grey stoneware body covered with a *yingqing* glaze. Base unglazed.
Height 14 cm.
Jingdezhen or Fujian.
Northern Song Dynasty, twelfth century.
Collection: F. W. Bodor.

Note: The unusual modelled lugs appear on a green-glazed ewer retrieved from the Sinan shipwreck (see Chung Yang-Mo (1977), Pl. 26), and are also known from Japanese excavations.

83

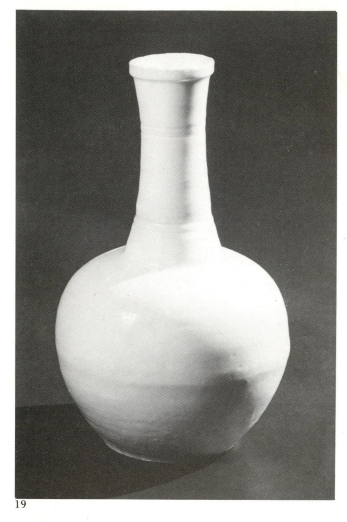

19

21

22

20

23

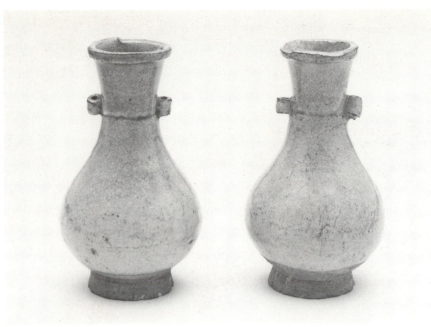

24

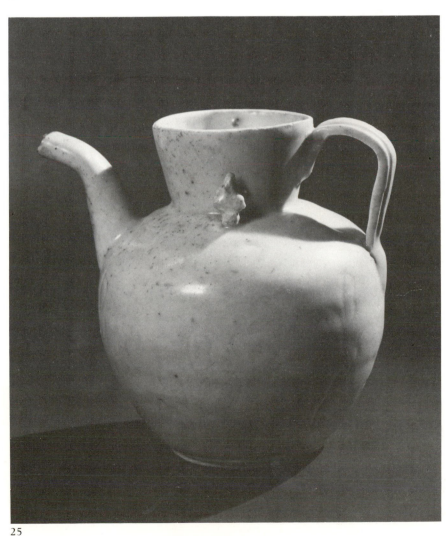

25

26. Ewer of globular form, slightly luted with a cylindrical neck flaring at the mouth. Two horizontal lugs on the shoulder, a short spout, and grooved strap handle. *Yingqing* glaze over a porcelain body, stopping short of the bevelled foot.
Height 9.8 cm.
Jingdezhen or Fujian.
Yuan Dynasty, fourteenth century.
Collection: National Gallery of Victoria.

27. Ewer of pear-shaped form with inverted mouth-rim. Modelled handle in the form of a *chi* dragon and a small curving spout. Porcelain body covered with a pale bluish *yingqing* glaze, the base slightly concave, unglazed and burnt a light tan.
Height 7.9 cm.
Jingdezhen or Fujian.
Yuan Dynasty, fourteenth century.
Collection: F. W. Bodor.

Note: Similar wares, also without covers, were among the wares excavated from the Sinan wreck in 1976–7; see Chung Yang-Mo (1977), Pl. 335.

28. Jar of squat form with moulded vertical fluting and one horizontal lug. *Yingqing* glaze over a porcelain body. Interior, lower exterior and base unglazed and fired red–orange.
Diameter 3.2 cm.
Jingdezhen, Jiangxi.
Yuan Dynasty, fourteenth century.
Collection: D. Stock.

Note: Comparable examples collected in the Philippines; see K. Aga-Oglu (1972), p. 8, and U. Wiesner (n.d.), Pl. 119.

29. Jar of globular form with two lugs and a short neck. Moulded lotus petal lappets on the shoulder and lower section. *Yingqing* glaze over a grey–white porcelain body, stopping above the flat base.
Height 5 cm.
Jingdezhen, Jiangxi.
Yuan Dynasty, fourteenth century.
Collection: D. Stock.

30. Covered box of round form with a domed lid, spiral foliage surrounding a four-pointed star motif in the centre, and a continuous key-fret border decoration. *Yingqing* glaze over a buff–white porcelain body.
Diameter 14.5 cm.
Dehua ware, Fujian.
Yuan Dynasty, fourteenth century.
Collection: J. Carnegie.

Note: A similar example published by E. W. van Orsoy de Flines (1972, Pl. 33) was reportedly collected in southern-central Sulawesi. See S. Lee and Wai-Kam Ho (1968), Pl. 95, for another example of Indonesian provenance. E. P. Edwards McKinnon (1975–7, Fig. 5) reported sherds of this type of ware from North Sumatra and for example from Satingpra, see J. Stargardt (1979), Fig. 5.

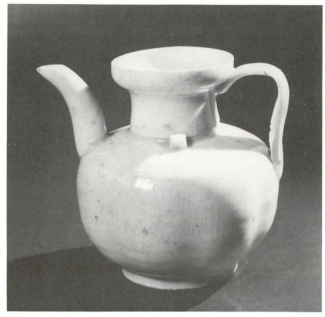

26

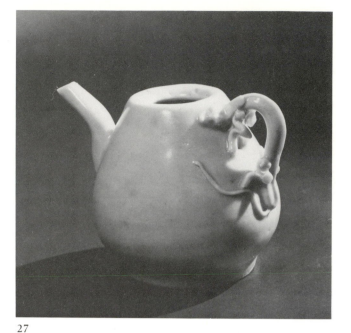

27

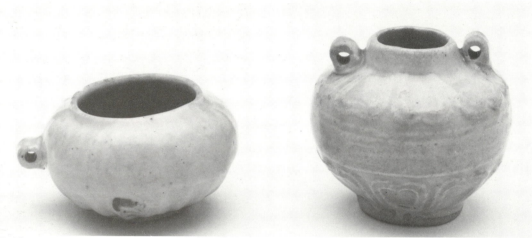

28, 29

31. Covered box of round form with a domed cover. Decorated with moulded lotus plant and grass leaf design on the cover and vertical ribbing on the sides. Clear glaze over a buff-white translucent body.
Diameter 6.6 cm.
Dehua ware, Fujian.
Yuan Dynasty, fourteenth century.
Collection: C. A. Ramsay.

32. Covered box of circular shape with domed lid. Moulded vertical ribbing on side of the lid, and a spray of flowers and leaves moulded in relief in the centre. *Yingqing* glaze over a porcelain body. Interior and flat base unglazed.
Diameter 9.8 cm.
Jingdezhen, Jiangxi.
Yuan Dynasty, fourteenth century.
Collection: F. W. Bodor.

33. Vase with globular body, cylindrical neck, and two vertical lugs on the neck. Double lotus petal design above the foot and a floral scroll on the shoulder in moulded relief. *Yingqing* glaze over a porcelain body. Unglazed slightly concave base.
Height 9.4 cm.
Jingdezhen or Fujian.
Yuan Dynasty, fourteenth century.
Collection: F. W. Bodor.

34. Ewer of gourd form with a dragon handle (restored) and curving spout. *Yingqing* glaze over a porcelain body, the flat base unglazed.
Height 10.7 cm.
Jingdezhen or Fujian.
Yuan Dynasty, fourteenth century.
Collection: P. Elliott.

Note: For similar examples, with an archaeological

context dated to the early fourteenth century, see Chung Yang-Mo (1977), Pl. 334. For an example excavated in Cebu, see W. Robb (1930), Fig. 13.

35. Ewer of flattened cylindrical form with a short everted lip, a small curving spout, and strap handle (restored) surmounted by a horizontal lug. Decorated on both sides with moulded design of a coin medallion containing the four characters '*tian xia tai ping*' (peace on earth), surrounded by radiating petals. *Yingqing* glaze over a porcelain body stopping unevenly on the foot. Base recessed and unglazed.
Height 11.5 cm.
Jingdezhen, Jiangxi.
Yuan Dynasty, fourteenth century.
Collection: F. W. Bodor.

Note: For a similar lidded example, see A. M. Joseph (1973), Pl. 14. and K. Aga-Oglu (1975), Pl. 59.

30

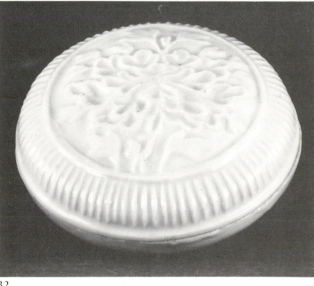

31

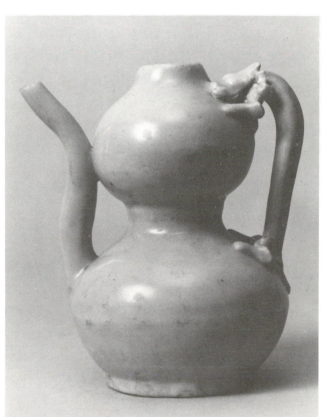

32

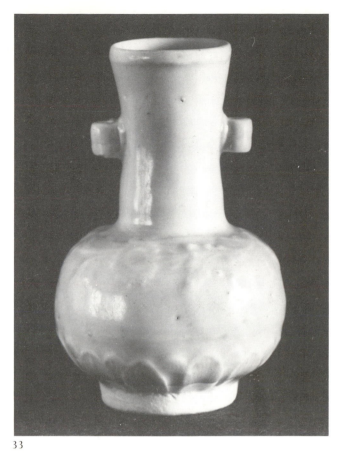

33

34

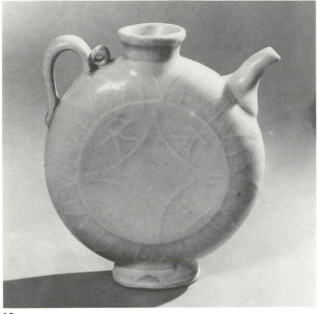

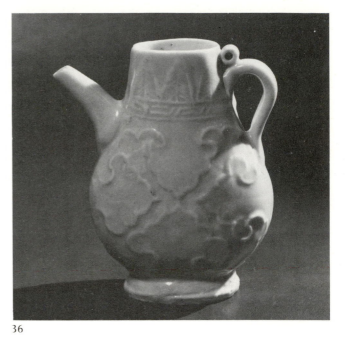

35 36

36. Ewer of flattened pear shape with short curving spout and a strap handle surmounted by a horizontal lug. Moulded decoration of a cruciform pattern with key-fret design and petals above. Covered with *yingqing* glaze over a porcelain body. The base is recessed and unglazed.
Height 10.6 cm.
Jingdezhen, Jiangxi.
Yuan Dynasty, fourteenth century.
Collection: F. W. Bodor.

37. Covered ewer of rectangular form with a short neck, curved spout, and strap handle surmounted by a horizontal lug. Moulded decoration of two hares amongst *lingzhi* on the obverse and two flowers with leaves on the reverse, with classic scroll designs on the shoulder. *Yingqing* glaze covers the porcelain body to the flat base which is unglazed.
Height 9.7 cm.
Jingdezhen, Jiangxi.
Yuan Dynasty, fourteenth century.
Collection: F. W. Bodor.

Note: The pronounced finger-marks, where the potter held the vessel whilst dipping it in the glaze, are visible at the base.

38. Covered ewer of rectangular form with a short neck, curved spout, and moulded handle in the form of a *chi* dragon. Moulded decoration of chrysanthemums and leaves behind rocks, with a classic scroll design on the shoulder. *Yingqing* glaze over a porcelain body. Flat base unglazed.
Height 10 cm.
Jingdezhen, Jiangxi.
Yuan Dynasty, fourteenth century.
Collection: F. W. Bodor.

Note: For a similar example see A. M. Joseph (1973), Pl. 17.

39. Jar of cuboid form with the shoulder rising to a small square mouth. Decorated on each of the four vertical faces with applied beading and on the shoulder with four moulded lugs in the form of *chi* dragons. Covered with a *yingqing* glaze over a porcelain body. Flat base unglazed.
Height 7 cm.
Jingdezhen, Jiangxi.
Yuan Dynasty, fourteenth century.
Collection: F. W. Bodor.

40. Covered jar of squat globular form with vertical fluting and a pronounced luting seam on the body. The cover is moulded in the shape of a foliated lotus leaf with stem. *Yingqing* glaze covers the porcelain body, stopping just short of the flat base.
Height 10.5 cm.
Jingdezhen or Fujian.
Yuan Dynasty, fourteenth century.
Collection: P. Elliott.

Note: A similar example was excavated at Santa Ana, Manila; see L. Locsin and C. Y. Locsin (1967), Pl. 158.

41. Brushpot in the form of a *guan* wine jar, against which is seated a figure dressed in the robes of a scholar. His right hand, resting in the jar, holds a ladle for serving wine. A blue-tinged transparent *yingqing* glaze covers the porcelain body. The base is flat and unglazed and a small hole has been left in the back of the figurine to facilitate firing.
Height 9.8 cm.
Jingdezhen or Fujian.
Yuan Dynasty, fourteenth century.
Collection: F. W. Bodor.

Note: The image is known in several examples and may represent the Tang Dynasty Taoist poet Li Po (701–62), famous for his inspired compositions whilst intoxicated. K. Aga-Oglu (1975, Pl. 71) and U. Wiesner (n.d., Pl. 123) reproduce examples collected in the Philippines, the former reportedly found in Laguna.

Iron-spotted *Yingqing*

42. Water-dropper in the form of a boy on a buffalo, set on a rectangular plinth. Decorated with splashed brown iron spots and a *yingqing* glaze over a porcelain body, the flat base unglazed.
Height 9.5 cm.
Jingdezhen or Fujian.
Yuan Dynasty, fourteenth century.
Collection: F. W. Bodor.
Published: W. Sorsby (1974), Pl. 8.

Note: The Sinan wreck of the early fourteenth century yielded a seated buffalo figurine of this type; see Chung Yang-Mo (1977), Pl. 197. Oriental Ceramic Society of Hong Kong (1979, Pl. 60) reproduces an example reportedly excavated in Bo Pangil, Laguna, Philippines.

43. Lotus-pond bowl in the form of an oval-shaped pond with fluted sides and everted rim containing models of four children playing amongst stemmed lotus and two fish. Decorated with splashed brown iron spots and a *yingqing* glaze over a porcelain body, the flat base unglazed.
Maximum diameter 10.5 cm.
Jingdezhen or Fujian.
Yuan Dynasty, fourteenth century.
Collection: F. W. Bodor.

Note: Of examples known to the writer this piece displays the least random use of iron-spotting, each boy's hair being carefully indicated.

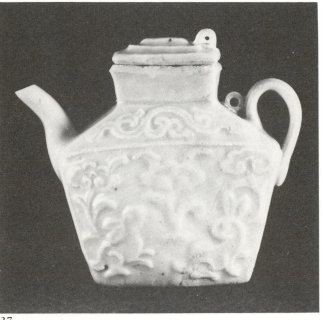

37

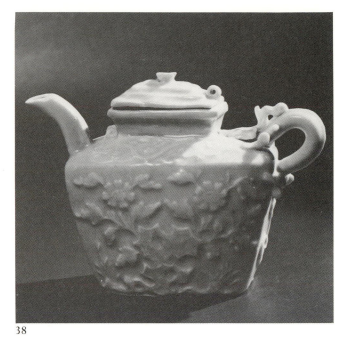

38

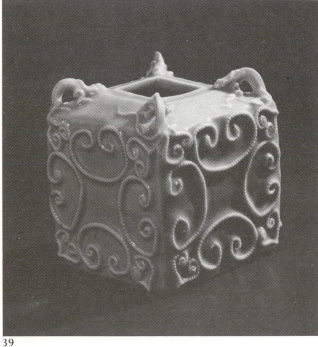

39

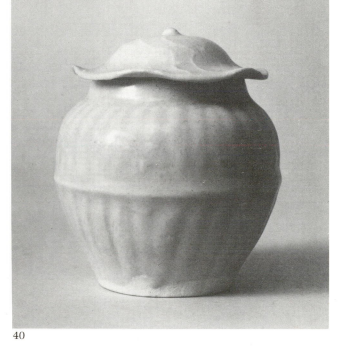

40

44. Covered ewer of gourd form with a curved tapering spout and strap handle, the domed cover surmounted by a lug. Decorated with splashed brown iron spots and a *yingqing* glaze over a porcelain body, the base flat and unglazed.
Height 11.6 cm.
Jingdezhen or Fujian.
Yuan Dynasty, fourteenth century.
Collection: F. W. Bodor.

Note: Iron-spotted gourd ewers, with and without *chi* dragon handles, were found in the Sinan wreck

(see Chung Yang-Mo (1977), Pl. 336), and have been reported from excavation sites in South-East Asia, including the Philippines (L. Locsin and C. Y. Locsin (1967), p. 97) and Sarawak (Southeast Asian Ceramic Society (1979), p. 61).

45. Covered jar of *guan* form, the cover domed with a foliate rim, suggestive of a lotus leaf cover. Decorated with splashed brown iron spots and a *yingqing* glaze over a porcelain body. Base flat and unglazed.
Height 10.1 cm.
Jingdezhen or Fujian.

Yuan Dynasty, fourteenth century.
Collection: F. W. Bodor.

46. Jar of globular form with a short cylindrical lipped neck and two horizontal lugs on the shoulder. Decorated with splashed brown iron spots and a *yingqing* glaze over a porcelain body. Base unglazed.
Height 6.1 cm.
Jingdezhen or Fujian.
Yuan Dynasty, fourteenth century.
Collection: F. W. Bodor.

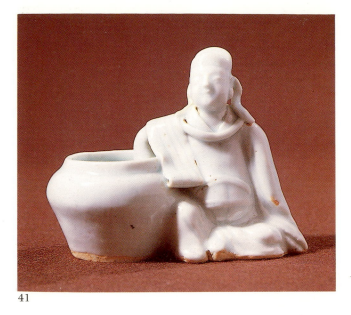

41

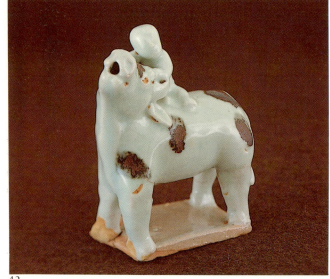

42

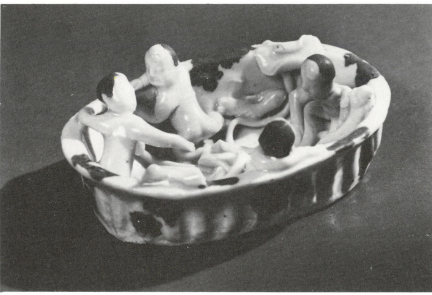

43

47. Jar with high shoulder, a short cylindrical neck, and heavy mouth-rim, with two horizontal lugs. Decorated with splashed brown iron spots in clusters of three and a *yingqing* glaze over a porcelain body. Unglazed base fired a rusty-buff colour.
Height 8.5 cm.
Jingdezhen or Fujian.
Yuan Dynasty, fourteenth century.
Collection: F. W. Bodor.

48. Jar in the form of a *belimbing* fruit with eight panels, a short neck, and two lugs on the shoulder. Decorated with splashed brown iron spots and a *yingqing* glaze over a porcelain body. Base flat and unglazed.
Height 6 cm.
Jingdezhen or Fujian.
Yuan Dynasty, fourteenth century.
Collection: F. W. Bodor.

Note: Similar grave-pieces were excavated in Rizal Province, Luzon (see W. Robb (1930), Fig. 9), and Santa Ana, Manila (see L. Locsin and C. Y. Locsin (1967), Pl. 80).

49. Jar of cuboid form with the shoulder rising to a small square mouth. Decorated on each of the four vertical faces with splashed brown iron spots in clusters of three, on the shoulder are two moulded lugs in the form of *chi* dragons. Covered with a *yingqing* glaze over a porcelain body. Base flat and unglazed.
Height 6 cm.
Jingdezhen or Fujian.
Yuan Dynasty, fourteenth century.
Collection: F. W. Bodor.

Note: Cuboid jars with iron-spotting are rare. One similar example is in the Villaneuva Collection. Manila; see Oriental Ceramic Society of Hong Kong (1979), p. 21.

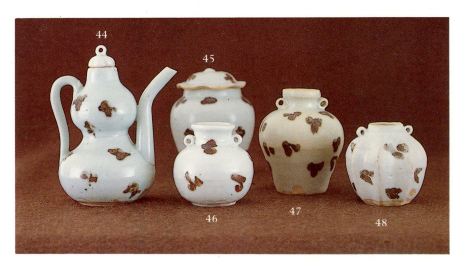

44

45

46

47

48

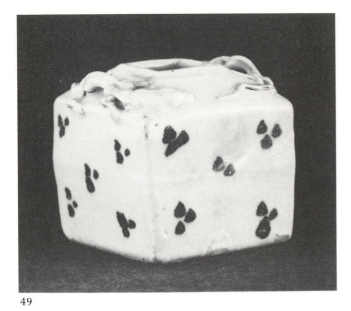

49

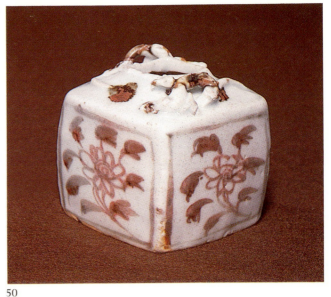

50

Blue-and-white and Underglaze Red Wares

50. Jar of cuboid form with the shoulder rising to a small raised square mouth. Decorated on each of the four vertical faces with a single chrysanthemum with leaves framed in a square, painted in underglaze copper-red which has fired variously on each panel from cherry-red to a grey–red. On the shoulder are two moulded lugs in the form of *chi* dragons, splashed with brown iron spots. Porcelain body covered with a *yingqing* glaze. Base flat and unglazed.
Height 6.7 cm.
Jingdezhen, Jiangxi.
Yuan Dynasty, fourteenth century.
Collection: F. W. Bodor.

Note: J. M. Addis (1967–9, p. 29) reported the discovery of over 36 pieces of underglaze red in the vicinity of Laguna de Bay, southern Luzon, in the late 1960s, but, relative to wares decorated in underglaze blue, underglaze red wares are very rare. No other example of underglaze red in combination with iron-spotted decoration is known to the writer, although Addis (p. 30) refers to one, complete with dragon handles, which he omits to illustrate.

51. Jar of cuboid form with the shoulder rising to a small square mouth and two lugs on the shoulder. Decorated on each of the vertical faces with a single floral spray, sketchily executed. *Yingqing* glaze over a porcelain body.
Height 6 cm.
Jingdezhen, Jiangxi.
Yuan Dynasty, fourteenth century.
Collection: J. Carnegie.

52. Jar of globular form with a short cylindrical lipped neck and two horizontal lugs on the shoulder. The body is divided into six panels by vertical lines of applied studs,

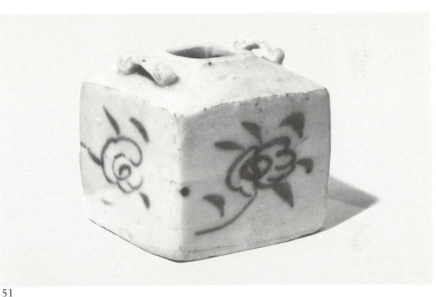

51

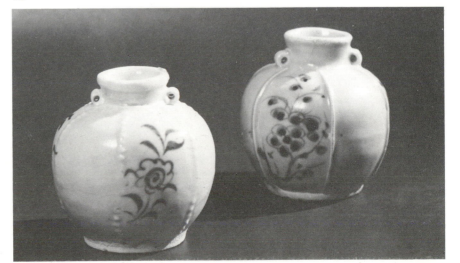

52,53

91

alternate panels being decorated in under-glaze cobalt-blue with a chrysanthemum spray. Porcelain body covered with a transparent glaze stopping short of the foot. Flat base unglazed.
Height 7.7 cm.
Jingdezhen or Fujian.
Yuan Dynasty, fourteenth century.
Collection: F. W. Bodor.

53. Jar of globular form with a short cylindrical lipped neck and two horizontal lugs on the shoulder. The body is divided into six panels by vertical lines of beaded appliqué, alternate panels being decorated in underglaze cobalt-blue, with a floral spray, pine branch and prunus blossom. Porcelain body covered with a transparent glaze. Base unglazed.
Height 8 cm.
Jingdezhen or Fujian.
Yuan Dynasty, fourteenth century.
Collection: C. Nicholas.

Note: A fragment of jar of this type, with underglaze blue and beaded decoration, was retrieved from Fustāt in association with other blue-and-white wares. Collection of the Idemitsu Museum of Arts, Tokyo.

54. Jar in the form of a *belimbing* fruit with eight panels, a short neck, and two lugs on the shoulder. Decorated in underglaze cobalt-blue on alternate panels with floral sprays. Porcelain body with a transparent glaze. Base unglazed.
Height 5.4 cm.
Jingdezhen or Fujian.
Yuan Dynasty, fourteenth century.
Collection: F. W. Bodor.

55. Cup with everted flat lip and a short raised foot. Decorated in underglaze cobalt-blue on the rim with a key-fret design, a chrysanthemum medallion in the centre, and a continuous chrysanthemum scroll on the exterior. Porcelain body with a transparent glaze. Base recessed and underglazed.
Diameter 8.3 cm.
Jingdezhen or Fujian.
Yuan Dynasty, fourteenth century.
Collection: F. W. Bodor.

56. Jar of cuboid form with the shoulder rising to a small raised square mouth with raised lines running diagonally from the corners to the mouth. Decorated on three of the vertical faces with a single chrysanthemum spray with leaves framed in a square and the fourth face with a flaming pearl, painted in underglaze cobalt-blue. On the shoulder are two moulded lugs in the form of *chi* dragons. Porcelain body covered with a transparent glaze, the base flat and unglazed and with a circular firing stand scar.
Height 5.3 cm.
Jingdezhen or Fujian.
Yuan Dynasty, fourteenth century.
Collection: F. W. Bodor.

Note: Prevalent in the Philippines—for example, excavated in Cebu (W. Robb (1930), Fig. 15)—this type has also been reported from South Sulawesi; see A. Ridho (1977), Pl. 164.

57. Jar of globular form with a short cylindrical lipped neck and two prunus blossom sprays and a crescent and full moon above. Porcelain body covered with a transparent glaze. Base unglazed.

Height 6.4 cm.
Jingdezhen or Fujian.
Yuan Dynasty, fourteenth century.
Collection: F. W. Bodor.

58. Jar of globular form with a short cylindrical lipped neck and two horizontal lugs on the shoulder. Decorated in underglaze cobalt-blue with a continuous chrysanthemum scroll set between horizontal lines. Porcelain body covered with a transparent glaze. Base unglazed.
Height 5.6 cm.
Jingdezhen or Fujian.
Yuan Dynasty, fourteenth century.
Collection: F. W. Bodor.

59. Ewer with pear-shaped body, and straight foot. Tapering spout decorated in underglaze cobalt-blue with a flaming pearl design and the loop handle with a line decoration terminating in *ruyi*-type design. A chrysanthemum spray on each side of the body completes the decoration. Porcelain body with a transparent glaze finishing unevenly at the foot. Flat base unglazed.
Height 8.5 cm.
Jingdezhen or Fujian.
Yuan Dynasty, fourteenth century.
Collection: F. W. Bodor.

Note: This example displays early underglaze blue decoration at its best; rich in tone and boldly painted in swift confident strokes of solid colour. J. M. Addis (1968a, Pl. 10), A. M. Joseph (1973, Pl. 64), and K. Aga-Oglu (1975, Pl. 115) reproduce examples of this type of sauce or wine pot but none equals this example in the compositional sophistication and quality of brushstroke.

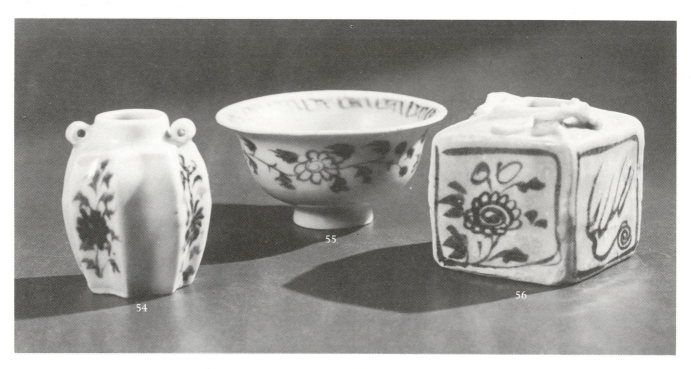
54 55 56

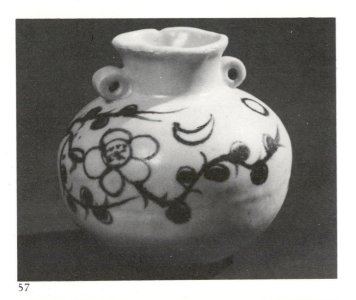

57

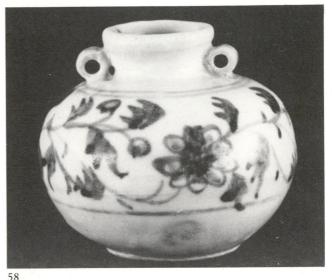

58

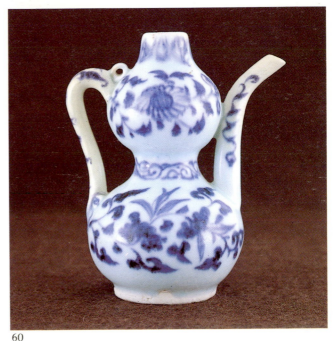

59

60

60. Ewer of gourd form with curved tapering spout (restored) and strap handle (restored). Decorated in underglaze cobalt-blue: the upper section with a chrysanthemum spray, the waist with a classic scroll, the lower section with a *lingzhi* scroll, and the spout with a flaming pearl design. Porcelain body with a transparent glaze finishing unevenly above the foot. Flat base unglazed. Height 12.3 cm.
Jingdezhen or Fujian.
Yuan Dynasty, fourteenth century.
Collection: F. W. Bodor.
Published: A. M. Joseph (1973), Pl. 62.

Note: Whilst more prevalent in Philippine excavations, one example is known from East Kalimantan; see A. Ridho (1977), Pl. 165.

61. Bowl with everted rim and short, slightly splayed foot. Decorated in underglaze cobalt-blue with a classic scroll border on the rim and a lotus bouquet in a central medallion. On the exterior is a continuous lotus scroll above a band of lotus petal lappets. Porcelain body with a transparent glaze neatly trimmed at the bevelled foot. Base unglazed and fired pinkish buff in colour.
Diameter 18.6 cm.
Jingdezhen or Fujian.
Yuan to early Ming Dynasties, fourteenth century.
Collection: F. W. Bodor.

Note: Early blue-and-white of this quality is rare in the South-East Asian context, being largely confined to the Near Eastern market; see J. A. Pope

(1952), Pl. 24, and J. A. Pope (1956), Pl. 24. See also E. W. van Orsoy de Flines (1972), Pl. 36, for an example reportedly collected in central-southern Sulawesi.

62. Covered ewer with broad shoulder, wide neck and straight foot, short spout, and handle with two lugs bridging shoulder and neck. Decorated in underglaze blue with two flaming pearl and cloud motifs. Porcelain body with a transparent glaze finishing unevenly above the foot, with three finger-marks distinctly visible. Flat unglazed base burnt pinkish-red.
Height with cover 12 cm.
South China.
Early Ming Dynasty, early fifteenth century.
Collection: L. Borland.

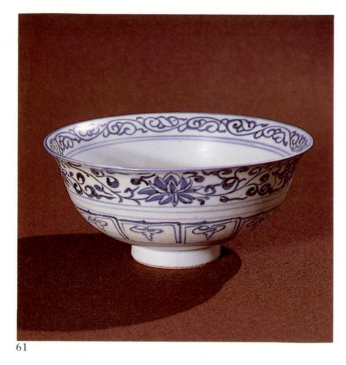

61

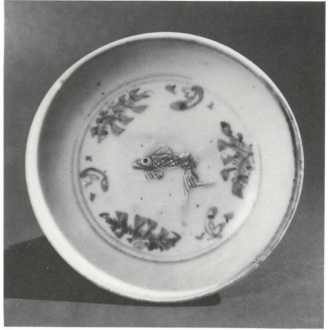

63

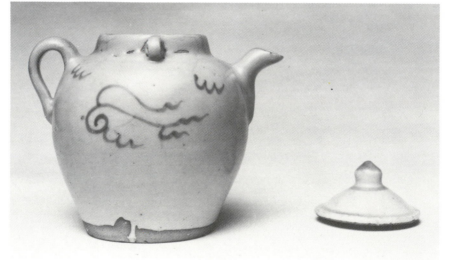

62

63. Saucer dish with curved sides, a recessed 'hole-bottom' base with no foot-rim and a moulded appliqué fish motif in the bottom of the dish. The unglazed fish, painted with a brown iron wash, is surrounded by water plants and a double-line border which is repeated on the rim, painted in underglaze cobalt-blue. Exterior undecorated. Porcelain body with a transparent glaze stopping short of the recessed 'hole-bottom'.
Diameter 11.8 cm.
Ming Dynasty, late fourteenth to fifteenth centuries.
Collection: F. W. Bodor.

Note: R. B. Fox (1959, p. 382) reported finding this type at the Calatagan site, southern Luzon,

and L. Locsin and C. Y. Locsin (1967, p. 111) discovered one at Santa Ana, Manila; they are also frequently found in South Sulawesi.

64. Water-dropper in the form of two ducks, one resting its head on the neck of the other. A circular opening on the back of one duck and a hollow beak on the other, the latter serving as a spout. The features of the ducks are painted in underglaze cobalt-blue, covered with a transparent glaze. A grey–white porcelain body, the flat base unglazed.
Length 7.5 cm.
Ming Dynasty, late fifteenth to early sixteenth centuries.
Collection: F. W. Bodor.

65. Ewer with globular body, a tall flaring neck, a splayed foot-ring, a high handle, and a curving spout supported by an S-bracket. The body is decorated in underglaze cobalt-blue with six panels of alternating floral and cloud designs. A band of plantain leaves on the neck, and flaming pearl designs on the spout. Porcelain body with a transparent glaze. A high foot, glazed on the base but not on the rim.
Height 11.5 cm.
Ming Dynasty, late fifteenth to sixteenth centuries.
Collection: Art Gallery of South Australia.

Note: The Museum Nasional, Jakarta, has a similar example collected in South Sumatra; see A. Ridho (1977), Pl. 193.

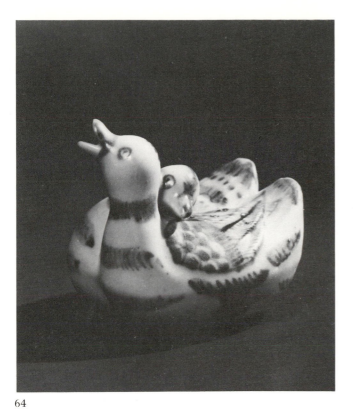

64

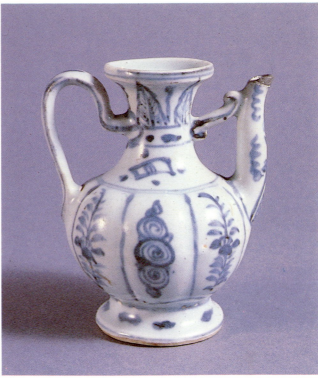

65

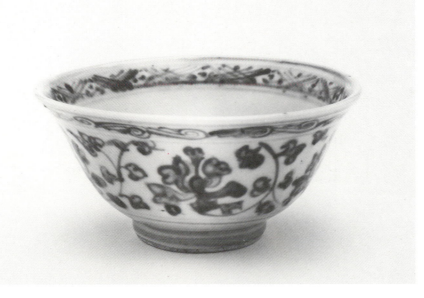

66

66. Bowl with rounded sides, everted rim, and a straight foot-ring. Decorated in underglaze cobalt-blue with a diaper pattern on the interior of the rim and a double-*vajra* with ribbons design in the centre-field. A continuous floral scroll design on the exterior. Porcelain with a transparent glaze. Base recessed and glazed.
Diameter 12.8 cm.
Ming Dynasty, late fifteenth century.
Collection: H. S. K. Kent.

Note: For a discussion of the dating of the *vajra* motif, see J. M. Addis (1968c), p. 5.

67. *Kendi* with a squat globular body, cylindrical neck with a lipped rim, and a mammiform spout. Decorated in underglaze cobalt-blue with flaming pearl designs on the neck and *ruyi* collar with floral scroll infill. A continuous lotus scroll design on the body with a band of petals below. Por-

celain body with a transparent glaze. Base flat and unglazed.
Height 14 cm.
Ming Dynasty, late fifteenth century.
Collection: P. Elliott.

Note: R. B. Fox (1959, p. 383, Pl. 62) reported a similar example, 'rarely encountered in Philippine sites'. Such *kendi* occur more frequently in the Malayo-Indonesian region (see A. Ridho (1977), Pls. 179–81), but are also known in the Near East (see J. A. Pope (1956), Pl. 69).

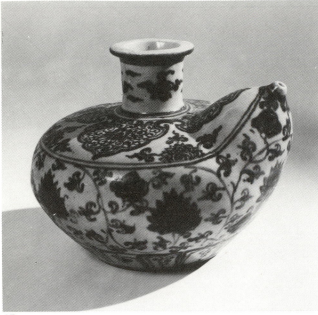

67

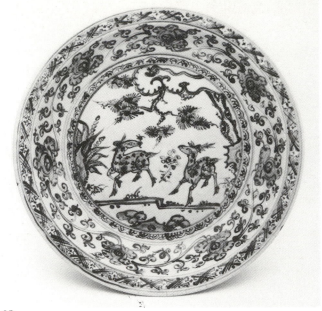

68

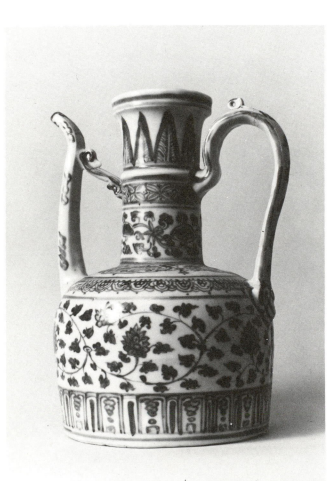

69

70

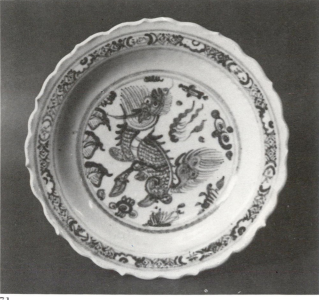

71

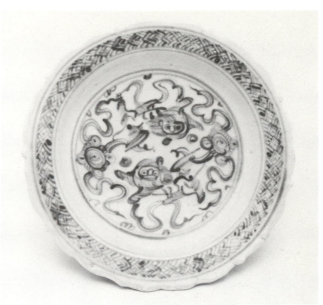

72

68. Dish with a broad bottom, steep cavetto, flattened rim, and a carved recessed 'hole-bottom' base. Decorated in underglaze cobalt-blue in the centre medallion with a rocky landscape with a pine tree, clouds and a *lingzhi*, in which two spotted deer are playfully displayed. A peony scroll in the cavetto and a diaper pattern on the rim. The peony scroll repeated on the exterior. Porcelain body with a clear glaze stopping before the recessed base, which is glazed.
Diameter 32.2 cm.
Ming Dynasty, late fifteenth century.
Collection: H. S. K. Kent.

Note: The deer, famed for its longevity, is often depicted having found the sacred fungus, *lingzhi*, which has life-extending powers. The pine tree, also renowned for its longevity, echoes the decorative theme. Compare Ardebil Shrine Collection (J. A. Pope (1956), Pl. 71) and J. M. Addis (1967–9), Pl. 47d and p. 31 for a discussion of dating.

69. Ewer of cylindrical form with an extended neck, handle, and spout bridged to the neck. Decorated in underglaze blue with a floral and leaf meander, cloud ponds, diaper pattern and plantain leaf design. Base unglazed.
Height 32.5 cm.
Jingdezhen, Jiangxi.
Ming Dynasty, late fifteenth to sixteenth centuries.
Collection: P. Elliott.

Note: For related examples in the Ardebil Shrine Collection, Tehran, see J. A. Pope (1956), Pls. 69, 70.

70. Ewer with extended spout, bridged to the neck, and attenuated strap handle with applied lug. Pear-shaped form, slightly flattened, with square neck and flanged high foot. Decoration in underglaze blue dominated by a fish among rock, waves, and water weeds. Floral motifs, and key-fret design and plantain leaves on the neck. Base glazed, foot unglazed and burnt red at glaze edge.
Height 23.2 cm.
Jingdezhen, Jiangxi.
Ming Dynasty, late sixteenth century.
Collection: J. Carnegie.

Note: For comparable examples in the Ardebil Shrine Collection, Tehran, see J. A. Pope (1956), Pl. 98.

71. Dish with flattened foliate rim and low foot-ring. Decorated in underglaze cobalt-blue with a prancing *qilin* amidst plantain leaves, *lingzhi*, grass, and a flaming pearl, encircled by a double line. On the rim a diaper pattern interspersed with medallions, the alternate panels containing Chinese characters. On the exterior a band of pearls, incised vertical fluting, and a lotus petal band above the foot. Porcelain body with a bluish transparent glaze. Foot-rim unglazed. Slightly convex base glazed.
Diameter 19.8 cm.
Ming Dynasty, sixteenth century.
Collection: C. Nicholas.

Note: Similar examples have been excavated from the Calatagan site, southern Luzon; see R. B. Fox (1959), Pl. 28, and L. Locsin and C. Y. Locsin (1967), Pl. 203. See W. Sorsby (1974), Pl. 105, for a suggested translation of the characters.

72. Dish with flattened foliate rim and low foot-ring. Decorated in underglaze cobalt-blue with two lions playing with brocaded balls and streamers encircled by a double line. Diaper pattern on the rim and vegetal and flower motif on the exterior. Porcelain body with a bluish transparent glaze. Foot-rim unglazed. Base glazed.
Diameter 20.5 cm.
Ming Dynasty, sixteenth century.
Collection: C. Nicholas.

73. *Kendi* with globular body, tall flared neck tapering sharply to a small opening, and a mammiform spout. Decorated in underglaze cobalt-blue with cloud scrolls in white reserved on blue ground, set in vertical panels on the body, a collar band on the shoulder, and lozenge panels on the neck. Porcelain body with a transparent glaze. A hare mark painted in underglaze blue on the glazed base.
Height 15 cm.
Ming Dynasty, late sixteenth century.
Collection: Art Gallery of South Australia.

Note: A *kendi*, displaying the hare mark, is in the Sarawak Museum, Kuching. This is a common mark on popular wares from the sixteenth century onwards; see M. Sullivan (1957a), Pl. 46.

74. *Kendi* in the form of an elephant with a tall cylindrical neck which flares and then narrows acutely to a small lipped opening. The features of the elephant and its elaborate trappings are painted in underglaze cobalt-blue. Porcelain body with a transparent glaze. Base flat and unglazed.
Height 19 cm.
Ming Dynasty, late sixteenth century.
Collection: P. Elliott.

Note: J. A. Pope (1956, Pl. 97, 29.464) illustrates a very similar example from the Ardebil Shrine Collection, Tehran, which has a documented terminal date of 1611. Another example was salvaged from the Dutch East-Indiaman *Witte Leeuw*, which sank at St. Helena in 1613; see R. Stenuit (1978), Pl. 573.

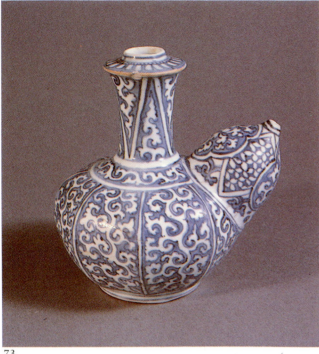

73

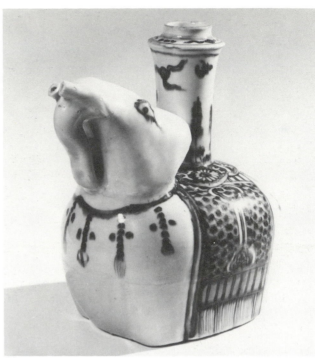

74

Greenwares

75. Dish with curved sides and a flattened rim. Lightly incised decoration with combing depicting a pair of fish with long flaring tails in the centre and a continuous vegetal scroll or water-pattern on the cavetto. Carved lotus petal design on the exterior. Matt green glaze over a porcelain body and base. Foot-rim unglazed.
Diameter 25.3 cm.
Longquan ware, Zhejiang.
Southern Song Dynasty, thirteenth century.
Collection: F. W. Bodor.

Note: E. P. Edwards McKinnon (1975–7, p. 73 and Pl. 46) reported a Song greenware sherd from the Kota Cina excavation, North Sumatra, which resembles this example in its lightly incised fish with characteristic flared tail and extended fins. It is the only example known to Edwards McKinnon in the Sumatran context. The Southeast Asian Ceramic Society (1979, Pl. 65) reproduces a related example from a Singapore collection.

76. Bowl of shallow form with a small foot-rim. The exterior carved with lotus petal design rising from the foot to the rim. Grey stoneware body covered with a green glaze to above the foot-rim. Base glazed.
Diameter 16.8 cm.
Longquan ware, Zhejiang.
Southern Song to Yuan Dynasties, thirteenth to fourteenth centuries.
Collection: F. W. Bodor.

Note: A similar example was retrieved from the Sinan wreck (see Chung Yang-Mo (1977), Pl. 32), and from Satingpra (see J. Stargardt (1979), Fig. 4).

77. Bowl with curved sides and straight foot-ring. Incised and combed decoration of two stemmed flowers freely drawn on the cavetto. Stoneware body with an olive-green crackled glaze stopping unevenly above the foot. Base unglazed.
Diameter 18 cm.
Fujian, possibly Anxi kilns.
Southern Song Dynasty, thirteenth century.
Collection: J. Carnegie.

Note: E. P. Edwards McKinnon (1976) reported an 'olive glazed celadon bowl' with similar incised and combed decoration from the Kota Cina excavation, North Sumatra. The site is dated twelfth- to thirteenth-century; see E. P. Edwards McKinnon (1975–7). Pls. 45 and 65. Compare also L. Locsin and C. Y. Locsin (1967), Pl. 119, and M. Tregear (1982), Fig. 141.

78. Saucer dish with curved sides and a flattened rim. Decorated with two moulded appliqué fish and carved petals on the exterior. Grey–green glaze over a porcelain body. Foot-rim unglazed.
Diameter 12.9 cm.
Longquan ware, Zhejiang.
Southern Song to Yuan Dynasties, thirteenth to fourteenth centuries.
Collection: C. Nicholas.

Note: This type of ware was in continuous production from the Southern Song Dynasty until the early Ming period and is reported from sites throughout South-East Asia.

79. Bowl with a steep cavetto, a thick rounded lip, and high straight foot. Moulded decoration of concentric wave pattern around the centre of the interior, with a band of alternating double-lined trefoil and *ruyi*-type designs above. Beneath each of the eight trefoil frames is a water-bird, each in a different attitude, and beneath each *ruyi*-type design a stemmed flower, usually a lotus.
Diameter 15.6 cm.
Zhejiang, possibly Longquan kilns.
Early Yuan Dynasty, late thirteenth to early fourteenth centuries.
Collection: H. S. K. Kent.

Note: E. P. Edwards McKinnon (1975–7, p. 72 and Pl. 42) reported a bowl of similar profile with the high straight foot, recovered from the sea off Pulau Kompei, North Sumatra. He suggested a possible eleventh- to twelfth-century date, but the unnecessarily heavy potting and the flavour of the moulded decoration of this example point to an early Yuan date. Compare also M. Tregear (1982), Pl. 248.

80. Dish with flat bottom curving sharply to a broad flattened rim. Decorated in the centre with a moulded appliqué four-clawed dragon pursuing a flaming pearl. Incised foliate scroll on the cavetto and moulded lotus petal design on the exterior. Porcelain body covered with a deep green matt glaze, the recessed base glazed, the narrow foot-rim unglazed, and the body burnt a rusty-orange colour.
Diameter 36.3 cm.
Longquan ware, Zhejiang.
Yuan Dynasty, fourteenth century.
Collection: National Gallery of Victoria.

75

77

78

76

Note: The dragon motif is relatively rare in trade wares. A similar example was reported from the Sinan wreck; see Chung Yang-Mo (1977), Pl. 115. B. Harrisson (1978, Pl. 64) reproduces an example acquired in Kalimantan, and S. J. O'Connor (1975, Fig. 2) identifies an example recovered in the vicinity of Nakhon Si Thammarat, peninsular Thailand.

81. Dish with a broad bottom rising to a flattened foliate rim. Incised decoration of a lotus bouquet in the centrefield, a continuous floral scroll on the cavetto, and a scalloped petal design on the rim. The exterior plain. Porcelain body covered with a sea-green glaze, the base glazed except for a broad firing ring which has burnt red.
Diameter 49 cm.
Longquan ware, Zhejiang.
Ming Dynasty, fourteenth to fifteenth centuries.
Collection: Museum of Applied Arts and Sciences.

Note: L. Locsin and C. Y. Locsin (1967, Pl. 212)

reproduce a similar piece collected in Kalingao, Mountain Province, Luzon, where it had been an heirloom object. A. Ridho (1977, Pl. 150) reported another dish collected in Siak, Sumatra.

82. Covered jar of squat bulbous form with ribbed sides, a short wide neck, narrow base, and a foliated lotus leaf cover with carved petals. Grey porcelain body covered with a light green glaze. Base glazed, except for the foot-ring.
Height 7.9 cm.
Longquan ware, Zhejiang.
Yuan Dynasty, fourteenth century.
Collection: D. Komesaroff.

Note: K. Aga-Oglu (1975, Pl. 19) reproduces similar jars collected in the Philippines, and L. Locsin and C. Y. Locsin (1967, Pl. 57) a near-identical example excavated at Santa Ana, Manila.

83. Jar of squat bulbous form with a narrow mouth and lipped rim, two horizontal lugs on the shoulder. Moulded decoration of four floral sprays—chrysanthemum, two

peony and lotus—on the upper half of the body. Below, a moulded band of lotus petals. Grey porcelain body covered with a sea-green matt glaze. Base slightly concave and unglazed.
Height 9.7 cm.
Longquan ware, Zhejiang.
Yuan Dynasty, fourteenth century.
Collection: D. Komesaroff.

Note: A similar example in Museum Nasional, Jakarta, is reportedly from South Sulawesi; see A. Ridho (1977), Pl. 140.

84. Jar of squat bulbous form with a narrow mouth. Section joint visible as a horizontal band below shoulder. Grey porcelain body with a sea-green glassy glaze. Base slightly concave and unglazed.
Height 5.5 cm.
Longquan ware, Zhejiang.
Song to Yuan Dynasties, thirteenth to fourteenth centuries.
Collection: C. Nicholas.

99

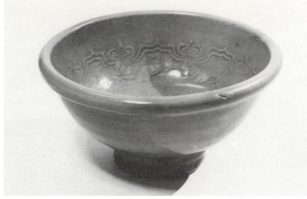

79

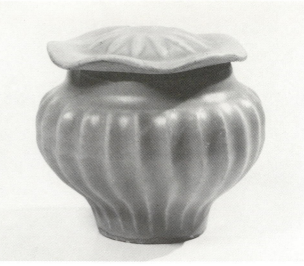

82

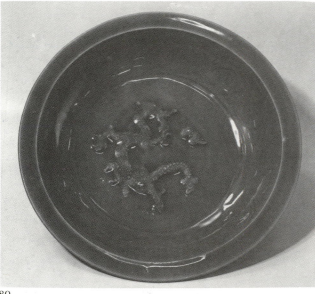

80

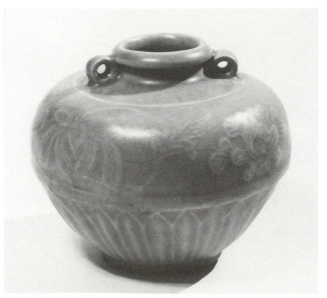

83

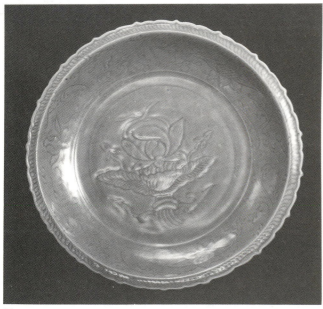

81

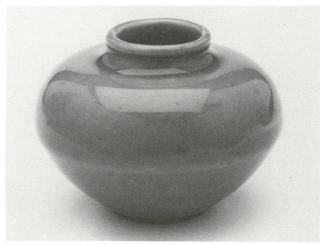

84

85. Covered jar of squat bulbous form with a broad short neck and shallow saucer-dish inset forming a recessed base within the foot-rim. Incised decoration of a lotus petal band on the shoulder, floral spray on the body, and a lotus pearl band above the foot. Domed cover ribbed and with a foliate rim. Light grey porcelain body, covered with a sea-green matt glaze.
Height 17.5 cm.
Longquan ware, Zhejiang.
Song to Yuan Dynasties, thirteenth to fourteenth centuries.
Collection: D. and M. Eysbertse.

Lead-glazed Wares

86. Jar of ovoid form with an extended neck and rolled rim, with five vertical lugs on the shoulder. Grey stoneware body with a luminous green lead glaze extending almost to the foot. Base slightly concave and unglazed.
Height 19 cm.
South China, possibly Fujian.
Yuan Dynasty, fourteenth century.
Collection: Art Gallery of South Australia.

Note: This class of ware is found principally in the northern Philippines: for example, see C. Y. Locsin (1968b), Fig. 7.

87. *Kendi* with cylindrical neck, everted lip, and a tapering spout. Amber-coloured lead glaze, stopping above the base, over a buff stoneware body.
Height 18 cm.
Fujian ware, probably Quanzhou.
Yuan Dynasty, fourteenth century.
Private collection, Melbourne.

Note: Reportedly excavated at Laguna, Luzon, L. Locsin and C. Y. Locsin (1967, Pl. 45) recorded similar wares retrieved from Luzon and Mindoro. For a technical description of glaze types, see C. Locsin (1968b).

88. *Kendi* with cylindrical neck, everted lip, and a tapering spout. Green-coloured lead glaze splashed with amber over a grey stoneware body.
Height 15.5 cm.
Quanzhou ware, Fujian.
Yuan Dynasty, fourteenth century.
Collection: J. Carnegie.

Note: This class of ware, common to fourteenth-century sites in South-East Asia, has recently been identified with the Tz'u-tsao kilns at Quanzhou; see J. C. Y. Watt (1981), p. 78.

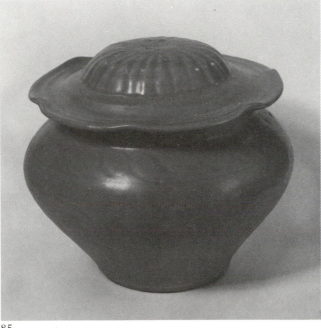

85

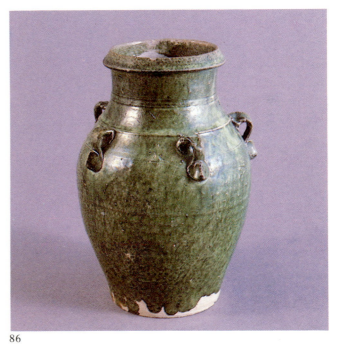

86

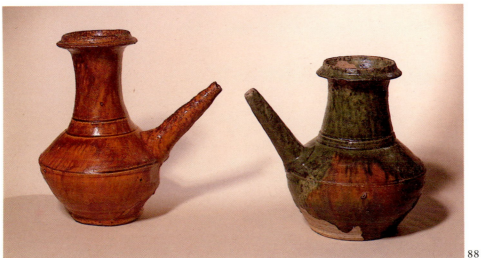

87

88

89. Bottle of pear form with a flared mouth and shallow bevelled foot-ring. Decorated with applied and carved relief decoration and green, turquoise, aubergine and white enamels depicting ducks. Stoneware with lead glazes.
Height 17 cm.
South China, possibly Fujian.
Ming Dynasty, fifteenth to early sixteenth centuries.
Collection: J. Carnegie.

Note: For a discussion of lead-glazed finds in the Philippines see C. Y. Locsin (1968b). The treatment of the lotus motif bears comparison to fourteenth-century Fujian moulded decoration.

90. Jar with a high shoulder and broad mouth. Applied and carved relief decoration with green, yellow, and aubergine enamels depicting ducks in landscape. Flat unglazed base. Stoneware with lead glazes.
Height 9 cm.
South China, possibly Fujian.
Ming Dynasty, fifteenth to early sixteenth centuries.
Collection: D. and M. Eysbertse.

91. Pouring vessel in the form of a pair of ducks, one resting its head across the neck of its mate. Lotus-necked aperture on the back, and pouring hole in the beak of the principal duck. Moulded in two sections, with vertical luting seam visible. Detailing heightened with green, yellow and white enamels. Earthenware with lead glazes.
Length 18 cm.
South China, possibly Fujian.
Ming Dynasty, fifteenth to early sixteenth centuries.
Private collection.

Note: For examples collected in Indonesia, see S. Adhyatman (1981), Pl. 266, and for the Philippines, C. Y. Locsin (1968b), Fig. 41.

92. Ewer in the form of a crayfish rising out of stylized wares. (Upper section restored.) Moulded with green, yellow, and white painted enamel. Earthenware with lead glazes.
Height 18.7 cm.
South China, possibly Fujian.
Ming Dynasty, sixteenth century.
Collection: D. and M. Eysbertse.

Note: A crayfish ewer formed part of a gift to the Prince Elector of Saxony in 1590, now preserved in the Zwinger Collection, Dresden; see L. Reidemeister (1933), Fig. 2. Lead-glazed moulded ewers of this type were traditionally used in head-hunting rites of the Kelabit people of Sarawak; see L. Chin (1980), p. 30.

93. Water-dropper in the form of a peach with the stem forming the spout, and surmounted by a seated monkey. A peach-shaped aperture and moulded leaf decoration. Stoneware with green, yellow, and aubergine lead glazes.
Height 9 cm.
South China, possibly Fujian.
Ming Dynasty, sixteenth century.
Collection: E. Bailleau.

Note: For examples in Indonesian collections see S. Adhyatman (1980), Pl. 267. For this type but with a bird motif, see Oriental Ceramic Society of Hong Kong (1979), Pl. 157.

89

90

91

93

92

Vietnamese Ceramics

THE glazed ceramics of Vietnam represent the most sustained and sophisticated expression of the potter's art in South-East Asia and yet they are perhaps the least understood of those traditions. The lack of critical enquiry into the distinctive character of Vietnamese ceramics has been the product of a tendency to view them, along with other aspects of Vietnamese cultural expression, as 'a curious provincialism', a pale reflection of Chinese culture.

Vietnam has spent much of its past under the sway of China's influence, if not direct control, and it is this history which explains the sinicized aspect of Vietnamese ceramics. The Chinese captured the northern Tonkin region of Vietnam as far south as Thanh-hoa in 111 BC and ruled it as an extension of their southern provinces until AD 979. They briefly re-established direct rule in 1407 when Vietnam was annexed and ruled by a Chinese governor, but Vietnamese resistance ended this control in 1427. The Chinese Tang administration named this region 'Annam', the 'Pacified South', and it is by the term 'Annamese wares' that the distinctive ceramic products of Vietnam were first known.[1]

The history of Vietnamese ceramics does, broadly speaking, parallel the evolution of Chinese ceramics from the Han period onwards in respect of form and style. It is equally true, however, that the Vietnamese potter gave expression to elements of cultural identity which are essentially Vietnamese. This can be seen in the distinctive manipulation of ceramic forms and, more significantly, in the expansion of the decorative repertoire to incorporate motifs and design elements unknown in the Chinese tradition. Moreover, the many motifs which were borrowed from China were reinterpreted with a confidence and sophistication which often produced results imbued with a freshness and energy unmatched in the Chinese originals.

The evolution of glazed ceramics in Vietnam reflects the shifting requirements of Vietnamese society over time. The earliest glazed wares were produced in response to the needs of sinicized elements of Vietnamese society which appeared during the Han occupation in the first and second centuries AD. These vessels, which have been excavated from Han tombs of fired brick, parallel the funerary goods of the same period in China. A new development occurred under the stimulus of Buddhism when, from the sixth century, prosperous Vietnamese Buddhist communities undertook extensive building programmes. The construction of temples, monasteries, and pagodas generated a demand for tiles and glazed bricks. Under the nationalist Ly and Tran Dynasties (eleventh to fourteenth centuries) wares intended for domestic use assumed a new importance with the evolution of a distinctively Vietnamese interpretation of Chinese monochrome and iron-decorated styles. From the early fourteenth century Vietnam entered the international ceramic

104

trade, producing a calligraphic-style iron-decorated ware and, more importantly, the renowned blue-and-white wares which have been found at sites scattered from Japan to the Middle East.

Types of Ware

The repertoire of shapes in Vietnamese trade ceramics is essentially that of Chinese wares, but with an independence of spirit which renders them readily distinguishable from their Chinese prototypes. They stand as refreshing variations on a theme rather than slavish provincial reflections of metropolitan taste. The shapes include large dishes, plates, bowls, saucers, bottles, vases, and jars. Even such distinguished creations of the early Ming potters as the Yongle period (1403–24) conical bowls and stem cups[2] found their equivalents in the Vietnamese repertoire. The Vietnamese stoneware vessels are typically more heavily potted than their Chinese counterparts, with pronounced foot-rings carved on the wheel. The body is a thick paste, pale beige or grey–white in colour and relatively free of impurities. The bases are left plain or are painted with either a colourless glaze (Plate 115) or a chocolate-brown iron-oxide wash. There appears to be no discernible pattern to the treatment of bases on different types of wares. The most distinctive treatment, with a chocolate-brown wash, occurs on a variety of wares ranging from large dishes (Plate 116) to stem bowls.

The range of glaze types is considerable and reflects a desire to emulate Chinese wares in an attempt to capture a share of the export market for high-fired glazed ceramics. Glazed monochrome wares appear as an early export type in Vietnamese ceramics. White, green, black, and brown wares are all known, and each can be assigned its Chinese rival in the trade wares of this time. An interesting development in Vietnamese wares was the use of underglaze iron-black/brown decoration over a slip-covered stoneware body. Whilst clearly drawing on a tradition that had its origins in the Jizhou ware of Jiangxi and ultimately in the Cizhou tradition of North China, the Vietnamese potters created their own distinctive class of decorated wares. The beaker (Plate 107) with spirited calligraphic designs of a debased classic scroll type is an excellent example of this ware. This decorative technique was also used on plates and dishes with the same summary and swift execution (Plate 108). The transition from decorating in iron oxide to employing cobalt is first evidenced in Vietnamese ceramics on plates decorated in this style. Compare, for example, Plates 110 and 111.

The introduction of cobalt-blue into Vietnamese ceramic decoration was a significant development, and witnessed a level of production and export previously unknown in Vietnamese ceramic history. The Chinese had clearly mastered the technical and aesthetic complexities of decorating in underglaze blue by the time of the manufacture of the David temple vases, dated equivalent to 1351.[3] It would appear, however, that Vietnamese blue-and-white did not reach a comparable level of sophistication for another century, as evidenced by the bottle dated 1450 in the Topkapi Saray Museum in Istanbul (Fig. 21). The Vietnamese blue-and-white wares, painted in the style of the iron-decorated wares, appear to date from the latter half of the fourteenth century and reflect the first Vietnamese knowledge of the use of cobalt in ceramic decoration. The transformation from these relatively simple wares to the Istanbul bottle of 1450 would have required a rapid injection of recent Chinese ceramic experience. This could clearly have occurred in the early fifteenth century when China temporarily reasserted her authority over Vietnam from 1407 to 1427. Stylistic indications seem to support this view. The decorative schemes of fourteenth-century Chinese blue-and-white of the Yuan and early Ming periods are evident in Vietnamese blue-and-white of the fifteenth century. This is seen, for example, in the prevalence of floral motifs,

especially the peony, lotus and chrysanthemum, which were favoured flowers in Chinese decoration at this time. The use of the diaper border, key-fret design, classic scroll, floral scroll, and lotus petal panel are elements favoured in late Yuan and early Ming blue-and-white decoration and which find expression in Vietnamese examples.

An originality of mind was brought to bear on landscape and aquatic scenes in Vietnamese plate decoration. Whilst the creatures depicted were familiar from Chinese wares, the arrangement of the design elements and the relationship of the animals to their surroundings were refreshingly original. Birds, fish, horses, and deer are the most common, with the *fu*-lion and phoenix the most frequently depicted mythical creatures. The mythical hybrid *qilin* is a rare subject, occasionally found decorating dishes (Plate 123), and one example is known from a Vietnamese porcelain wall tile, presumed to have come from the Majapahit capital of East Java and now decorating the mosque at Demak in Java.[4] The landscape with water-birds scene on a large plate (Plate 120) displays a predilection for naturalism rarely encountered in the more formalized Chinese version. A similar spontaneity is seen in the landscape with birds decorating the top of a small covered box (Plate 141).

By the mid-fifteenth century blue-and-white wares dominated the Vietnamese ceramic export trade. Around this time an additional type of decorated ware appeared, characterized by the use of overglaze enamels, principally red and green, which were frequently used in combination with underglaze blue decoration (Plate 144). The enamels were fused to the glazed surface in a second firing at a lower temperature, but display a tendency to deteriorate when exposed to the elements or buried in soil. The repertoire of shapes and decorative motifs which were in use at this time became the stock types of Vietnamese glazed ceramics for the next two centuries.

Kilns and Firing Techniques

The kiln-sites which produced these ceramics, largely for the South-East Asian market from the fourteenth century onwards, have not been firmly identified, although historical and archaeological sources suggest a number of possible sites in the vicinity of Hanoi and its port areas at the delta of the Red River, in the north-central province of Thanh-hoa, and at Qui Nhon in Binh Dinh Province, Central Vietnam.[5] Willetts states that the necessary components for

Fig. 33
Stack of bowls with underglaze decoration. Kiln wasters from Dai La, Hanoi. Collection: C. Huet. (Musées Royaux d'Art et d'Histoire, Brussels)

Fig. 34
Stack of brown-glazed bowls. Kiln wasters
from Dai La, Hanoi. Collection: C. Huet.
(Musées Royaux d'Art et d'Histoire, Brussels)

DAI-LA (Hanoi)

high-fired ceramics, kaolin and feldspar, were available in the region of Hanoi.[6] The name of a village south of Hanoi on the Red River, Bat-trang, translates, according to Willetts, as 'pottery factory', and claims a ceramic industry dating from the sixteenth century. The seventeenth-century records of the Dutch East India Company speak of 'Tonkinese wares', supporting a northern location.[7]

Whilst no kilns have been recorded, the ceramics themselves tell us much about the firing techniques employed. Many of the monochrome and early iron- or cobalt-decorated wares show evidence of the use of five- or six-pointed disc supports on which they were stacked in the kiln, one upon the other, as seen in the small scars or pitted blemishes left in the glaze surface in the centre of the dish or bowl. Others have an unglazed ring in the centre of the bowl, which would have allowed the stacking of like-sized wares without danger of the pieces fusing together. Kiln wasters collected by Clement Huet in Hanoi in the 1930s and preserved in the Musées Royaux d'Art et d'Histoire, Brussels, confirm this (Figs. 33 and 34). Bowls were typically stacked with clay separators. Even when an unglazed ring was provided to enable direct stacking, it appears that a crudely shaped ring of clay was placed between the wares. The clay separator had four protuberances which served as legs, minimizing surface contact. A more refined prefired firing disc was also used. Similar discs are known from the fourteenth-century kilns at Sukhothai, Central Thailand, adding a technical dimension to the strong stylistic parallels observable between the ceramics of fourteenth-century Vietnam and Thailand (cf. Figs. 35 and 39).

Fig. 35
Firing supports from Dai La, Hanoi.
Collection: C. Huet. (Musées Royaux d'Art et
d'Histoire, Brussels)

The use of firing rings and discs appears to have largely disappeared with the demise of the early export monochrome and iron-decorated wares. The introduction of larger-scale wares with underglaze blue decoration in the fifteenth century saw alternative techniques being employed. Large dishes are, almost without exception, left with an unglazed rim, unlike their Chinese counterparts. Thus they could have been fired either upside down on a flat, fine clay disc or saggar, or stacked rim-to-rim and base-to-base. Which method was employed will remain unanswered until the kiln-sites are located and the remnants of the saggars, discs or other firing supports are retrieved from the waste-dumps nearby.

1. S. Okuda (1954).
2. Compare, for example, J. M. Addis (1979), Pl. 16.
3. A pair of temple vases, one of which bears an inscription dated to 1351. Percival David Foundation, London (reproduced in H. Garner (1970), Pl. 6).
4. S. Adhyatman (1981), Pl. 78.
5. See above, Chapter 6, and R. M. Brown (1977), pp. 26–9.
6. W. Willetts (1971), p. 10.
7. T. Volker (1954), p. 184.

VIETNAM

Monochrome Wares

94. Beaker of cylindrical form with a slightly everted mouth and sharply bevelled high foot. Light caramel glaze over a buff stoneware body. Lower body and foot unglazed.
Height 8 cm.
Fourteenth to fifteenth centuries.
Collection: M. Hiscock.

Note: A similar example was collected in Takalar, South Sulawesi; see C. Lammers and A. Ridho (1974), p. 22. R. M. Brown (1977, Pl. 18, no. 62) reproduces another example, from Qui Nhon, Central Vietnam, which she suggests is the provenance of such wares. See W. Willetts (1982) for a discussion of the Go-sanh kiln attribution.

95. Beaker of cylindrical form with a slightly everted mouth and narrowing to a square-section foot. Light caramel glaze over a buff stoneware body. Lower body and foot unglazed.

Height 9.4 cm.
Fourteenth to fifteenth centuries.
Collection: National Gallery of Victoria.
Presented by M. L. Abbott.

96. Beaker with slightly inverted mouth-rim and a low broad foot-ring. Buff stoneware body with a crackled cream–white glaze. Five spur scars on the bottom and a mauve–brown iron wash painted on the base.
Height 11.7 cm.
Fourteenth century.
Collection: Art Gallery of South Australia.

Note: For a similar example see W. Willetts (1971), Pl. 111.

97. Bowl with a slightly everted rim and square-section foot. Decorated with impressed petal and floral motifs on the interior, radiating from an unglazed ring in the centre. Stoneware body covered with apple-green

copper glaze to above the foot.
Diameter 16.5 cm.
Fourteenth to fifteenth centuries.
Collection: National Gallery of Victoria.

98. Bowl with a slightly everted rim and bevelled foot. Decorated with impressed petal and floral motifs on the interior, radiating from an unglazed ring in the centre. Stoneware body covered with an off-white glaze to above the foot.
Diameter 16.4 cm.
Fourteenth to fifteenth centuries.
Collection: National Gallery of Victoria.
Presented by M. L. Abbott.

99. Dish with flattened rim and raised lip. Stoneware body covered with a rich chocolate-brown glaze except for an unglazed ring in the centre of the dish. Carved foot-ring and base unglazed.
Diameter 17.7 cm.
Fifteenth century.
Collection: J. Carnegie.

100. Jar of globular form with a small neck and bevelled foot-ring, the body with seven vertical incisions giving a lobed effect. Off-white stoneware body with an apple-green copper glaze stopping irregularly above the foot. Base unglazed.
Diameter 6.5 cm.
Fifteenth century.
Collection: J. Carnegie.

Note: Most frequently found in Java and Sulawesi; see C. Lammers and A. Ridho (1974), p. 19.

101. Dish with sloping sides, a raised scalloped rim, incised fluting on the cavetto, and a carved foot-ring. Stoneware body covered with an apple-green copper glaze except for an unglazed ring in the centre of the dish. Foot-ring unglazed and the base painted with a chocolate-brown iron wash.
Diameter 21.5 cm.
Fifteenth century.
Collection: D. Komesaroff.

94,95

96

97,98

109

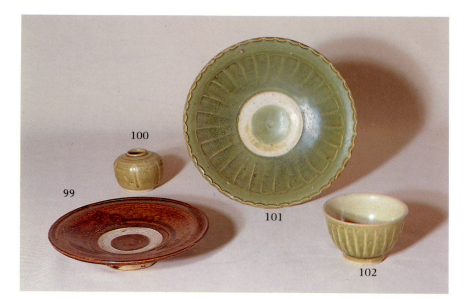

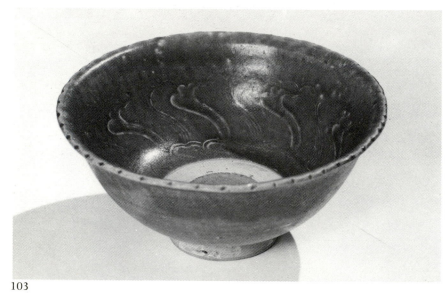

103

104

102. Cup with slightly flared lip, fluted sides, and straight foot-ring. Light buff stoneware body with an apple-green copper glaze trimmed above the foot-rim. Base partially glazed.
Diameter 9.2 cm.
Fifteenth century.
Collection: Art Gallery of South Australia.

103. Bowl with high sides and an everted foliate rim. Decorated with an incised pattern of scalloped petals and spirally radiating incised and combed petal forms. Grey stoneware body covered with dull apple-green copper glaze to above the curved foot-rim and an unglazed ring in the centre of the bowl. The unglazed base painted with a chocolate-brown iron wash.
Diameter 18.2 cm.
Fourteenth century.
Collection: J. H. Myrtle.

Note: Compare W. Willetts (1971), Pl. 133. C. Lammers and A. Ridho (1974, p. 18) reproduce a related example collected in Cirebon, West Java.

104. Bowl with high sides, an everted rim, and high square foot. Buff stoneware body covered with a transparent glaze tinted slightly green. Four firing scars in the interior. Foot and base unglazed.
Diameter 17.5 cm.
Fourteenth century.
Private collection.

Note: Acquired in Sumba, eastern Indonesia.

105. Jar of ovoid form with short neck and rolled mouth-rim, and tapering to a flat base. Decorated with dragon motifs, their bodies arching to form the six lugs on the shoulder. Stoneware body covered with a mottled brown glaze.
Height 53 cm.
Possibly Cham ware, Go-sanh type.
Fifteenth to sixteenth centuries.
Collection: Art Gallery of South Australia.

Note: Compare S. Adhyatman and C. Lammers (1977), p. 64, an heirloom piece from South Sumatra.

Iron-decorated Wares

106. Bowl with an everted lip and a short bevelled foot. Decorated in underglaze iron-brown with a freely drawn floral spray in the centre within a double circle, a classic scroll design on the rim, and a continuous vegetal scroll on the exterior. Stoneware with a transparent glaze with a tint of green. Five spur marks on the bottom, and the unglazed base painted with a chocolate-brown iron wash.
Diameter 16.1 cm.
Fourteenth century
Collection: National Gallery of Victoria.
Presented by M. L. Abbott.

Note: See R. M. Brown (1977), No. 22, for a similar example collected in Sulawesi. Brown is of the opinion that this type of ware is probably the most common of the Vietnamese trade ceramics; see Oriental Ceramic Society of Hong Kong (1979), Pl. 176.

107. Beaker with bowed profile, slightly inverted rim, and sharply bevelled foot-ring. Decorated in underglaze iron-brown with a summarily drawn calligraphic scroll between two pairs of horizontal lines. Buff stoneware body covered with a crackled transparent glaze to above the foot. Base unglazed. Five spur marks on the interior bottom.
Height 11.2 cm.
Fourteenth to early fifteenth centuries.
Collection: J. S. Yu.
Published: W. Willetts (1971), No. 104.

Note: A similar example was excavated in Oton, Philippines (see J. B. Tiongco (1969), Pl. 94) and another collected at Mt. Muria, Central Java (see A. Ridho (1977), Pl. 284).

108. Dish of shallow form with a flat rim and low carved foot. Decorated in underglaze iron-brown with a floral spray in the centre within a circle. Debased classic scroll design on the rim and a plain exterior. Off-white stoneware body with a transparent glaze and a chocolate-brown iron wash on the base. Six spur marks on the interior.
Diameter 27.5 cm.
Fourteenth to early fifteenth centuries.
Private collection.

Note: Fragments of comparable examples excavated at Dazaifu, Kyushu, southern Japan—one example in association with a relic dated equivalent to 1330 (cf. Fig. 18a and 18b).

109. Dish with a shallow bottom, flattened rim, and low carved foot. Decorated in underglazed iron-brown with a floral spray in the centre within a double circle. Debased classic scroll design on the rim and a plain exterior. Off-white stoneware body with greenish transparent glaze. Six spur marks on the bottom. Base unglazed.
Diameter 28.5 cm.
Fourteenth to early fifteenth centuries.
Collection: Art Gallery of South Australia.

110. Dish with a shallow bottom, flattened rim, and a low broad foot. Decorated in underglaze iron-brown, with an encircled floral spray in the centre and a debased classic scroll design on the rim. Stoneware body with a greenish transparent glaze. Five spur marks on the interior and an unglazed base.
Diameter 17.8 cm.
Fourteenth to early fifteenth centuries.
Collection: National Gallery of Victoria. Presented by M. L. Abbott.

Note: A similar example, in the Museum Nasional, Jakarta, was found in Central Sulawesi; see A. Ridho (1977), Pl. 76.

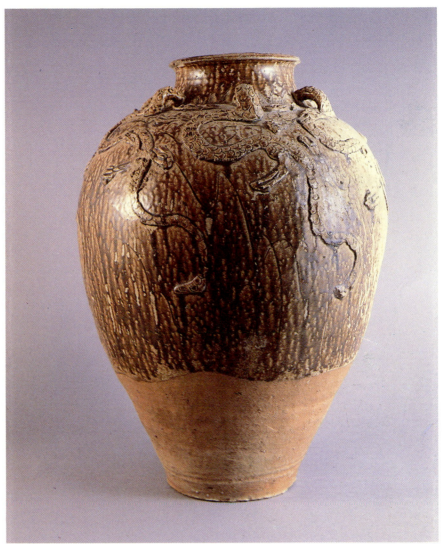

105

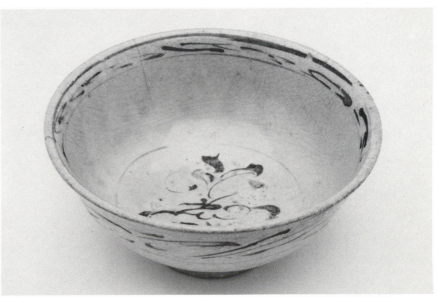

106

111

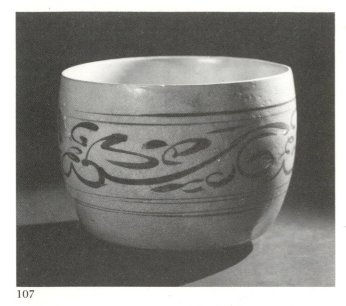

107

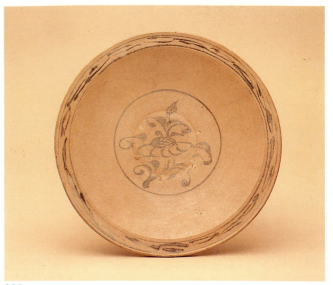

108

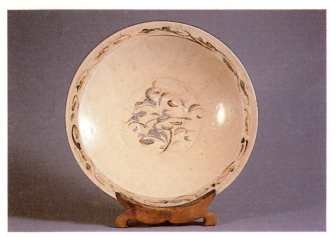

109

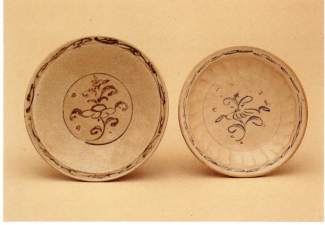

110, 111

Underglaze Blue Wares

111. Dish with a fluted cavetto and flattened rim. Decorated in underglaze cobalt-blue with a floral spray in the centre and a debased classic scroll design on the rim. White stoneware body with a transparent glaze. Five spur marks on the bottom. Foot-ring unglazed and the base painted with a chocolate-brown iron wash.
Diameter 16 cm.
Late fourteenth to fifteenth centuries.
Collection: J. Cole.

Note: Compare Southeast Asian Ceramic Society (1982), Pl. 89.

112. Jar of globular form with a high shoulder tapering to a small raised neck. Decorated in underglaze cobalt-blue with two sketchy floral sprays. Stoneware with a clear transparent glaze running to the low bevelled base which is painted in chocolate-brown iron wash.
Height 7.3 cm.

Late fourteenth to early fifteenth centuries.
Collection: Art Gallery of South Australia.

113. Covered box of circular form with a conical-shaped cover. Decorated in underglaze cobalt-blue with double lotus petal band on the cover and above the foot. Between these bands a continuous landscape with two birds separated by clumps of foliage. Off-white stoneware body with a transparent glaze. Base unglazed.
Height 5.5 cm.
Early fifteenth century.
Collection: J. Cole.

114. Dish with flattened rim, rounded lip, and a carved foot-ring. Decorated in underglaze cobalt-blue with a central carp amidst waterweeds motif, a lotus flower and leaf meander on the cavetto, and a continuous classic scroll on the rim. Cloud collar design on the exterior. White stoneware body with a transparent glaze, mouth-rim and foot-rim unglazed. Base painted with a chocolate-

brown iron wash.
Diameter 38 cm.
Fifteenth century.
Collection: Art Gallery of South Australia.

Note: The style and treatment of this decoration derives from Chinese fourteenth- and early fifteenth-century export wares; compare J. A. Pope (1956), Pl. 11.

115. Dish with flattened rim, rounded lip, and a carved foot-ring. Decorated in underglaze cobalt-blue with a central chrysanthemum spray surrounded by a band of scalloped lotus petals, peony scrolls on the cavetto, and a continuous classic scroll on the rim. Lotus petal panels with flourishes on the exterior. Stoneware body with a transparent glaze, the mouth-rim and foot-rim unglazed and the base painted with a clear glaze.
Diameter 36.6 cm.
Mid-fifteenth century.
Collection: F. W. Bodor.

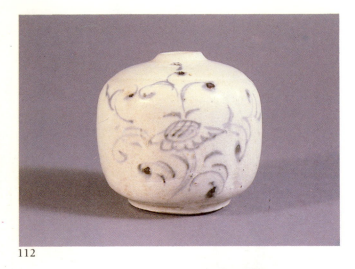

112

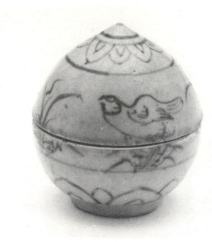

113

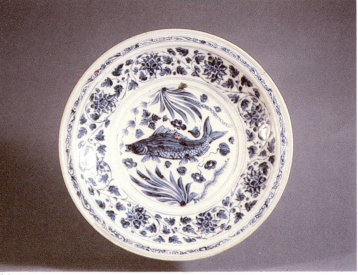

114

Note: This dish relates, in the delicacy of its outline-and-wash painting technique, to the bottle in the Topkapi Saray Museum, Istanbul, which has a dated inscription corresponding to 1450. J. A. Pope (1956, Pl. 57) reproduces a very similar dish from the Ardebil Shrine Collection, Tehran, which was assembled between 1350 and 1610. Comparative examples are also known from South Sumatra and Sulawesi; see C. Lammers and A. Ridho (1974), p. 34.

116. Dish with flattened rim, rounded lip, and a carved foot-ring. Decorated in underglaze cobalt-blue with a central design of two leaping fish amidst waterweed, a peony and leaf meander on the cavetto, and a continuous classic scroll on the rim. Lotus petal panels on the exterior. White stoneware body with a transparent glaze, mouth-rim and foot-rim unglazed. Base painted with a chocolate-brown iron wash.
Diameter 38.5 cm.
Fifteenth century.
Collection: F. W. Bodor.

Note: For examples collected in Indonesia, decorated with variations of this subject, see A. Ridho (1982), Pls. 52, 93, 294, and 295.

117. Covered box of circular form with a flattened cover, ribbed box and cover, and a pronounced lip where the box and cover meet. Decorated in underglaze cobalt-blue with a peony spray medallion on the cover bordered by peony scrolls separated by brackets. It has a keymark on the box and cover in the form of two interlocking classic scrolls. The sides of the cover and box are decorated in alternating panels of peony and chrysanthemum sprays in blue and white and lotus and chrysanthemum sprays reserved in white on blue. A band of scalloped lotus petals near the base. White stoneware body with a transparent glaze which also covers the box interior and base. Interior of the cover, rim and foot-rim unglazed.
Diameter 17.3 cm.
Fifteenth century.
Collection: F. W. Bodor.

Note: An extremely rare example of Vietnamese blue-and-white at its finest. The surviving covers of two lost boxes in the Museum Nasional, Jakarta, are of similar quality and scale: 5A60/3408, 23 cm in diameter, was found in Jambi, South Sumatra, and 5A61/3807, 16.6 cm in diameter, was collected in Sulawesi; see C. Lammers and A. Ridho (1974), pp. 48–9. This example is reportedly also from Sulawesi.

118. Covered box of circular form with a flattened cover, ribbed box and cover, and a square lip where the sections meet (restored). Decorated in underglaze cobalt-blue with a landscape medallion depicting two figures, vine-entwined tree, bamboo and pine, and a partially concealed house in the Chinese style. Surrounded by lotus flower lappets which follow the modelled form of the cover, and the sides with alternating trifid and diaper pattern panels. Box with alternating vegetal spray and diaper pattern panels. Off-white stoneware body with a transparent glaze to the foot. Interior

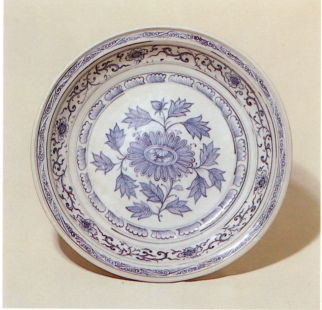

115a

115b

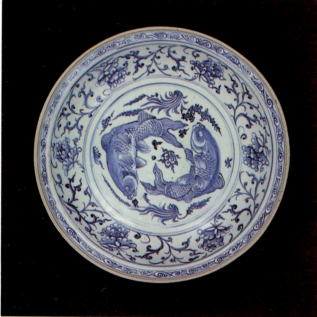

116a

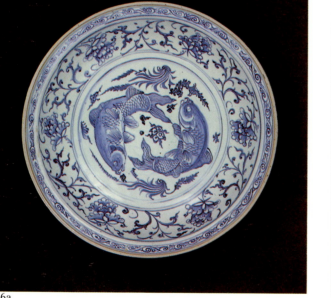

116b

covered with a straw-coloured glaze. Base unglazed.
Diameter 17.5 cm.
Fifteenth to sixteenth centuries.
Private collection.

119. Tile of square-cross form with high walls and recessed back. Decorated in underglaze cobalt-blue, the central medallion with a crane with spread wings, holding a chrysanthemum spray in its beak, surrounded by cloud and floral motifs. Double lines follow the margins of the tile. Off-white stoneware body covered with a transparent glaze.

Length 24.8 cm.
Height 3.2 cm.
Fifteenth century.
Collection: J. M. C. Watson.

Note: Reportedly from Java. Compare Fig. 26.

120. Dish with flattened rim, rounded lip, and a low carved foot-ring. Decorated in underglaze cobalt-blue with a landscape inhabited by two water-birds, a heron perched among lotus plants, a wild goose flying overhead, the design surrounded by a band of scalloped lotus petals; a continuous chrysan-

themum scroll on the cavetto, and a broken diaper border on the rim. Lotus petal panels with flourishes on the exterior. Stoneware body with a transparent glaze, the mouth-rim and foot-rim unglazed and the base painted with a clear glaze.
Diameter 34 cm.
Fifteenth century.
Private collection.

Note: A more elaborate depiction of this unusual subject is seen on a polychromed dish in the Gemeentelijk Museum Het Princessehof, Leeuwarden, reproduced in D. F. Frasche (1976), Fig. 14.

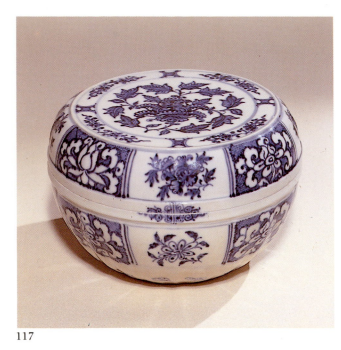

117

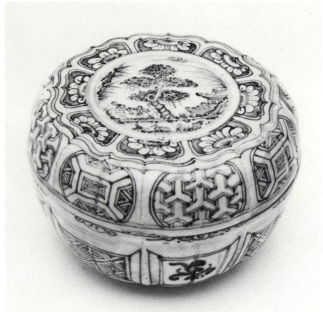

118

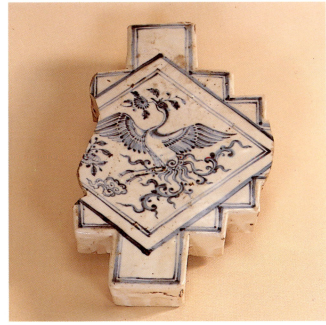

119

120

121. Dish with flattened rim and a straight foot-ring. Decorated in underglaze cobalt-blue with a central peony spray surrounded by a band of alternating cloud scrolls and pillars, a plain cavetto, and a continuous classic scroll on the rim. Lotus petal panels with flourishes on the èxterior. Stoneware body with a transparent glaze, the mouth-rim and foot-rim unglazed and the unglazed base painted with a chocolate-brown iron wash.
Diameter 26.6 cm.
Fifteenth century.
Collection: F. W. Bodor.

122. Bowl with high sides and everted mouth-rim. Decorated in underglaze cobalt-blue with a bird perched on a flowering branch as the central medallion, a shrimp and a fish amidst water-reeds in the cavetto, and a classic scroll band below the rim. The exterior, painted a darker blue, with lotus petal lappets and alternating peony sprays and vegetal sprays. Buff stoneware body with a transparent glaze. The foot-rim, base, and mouth-rim unglazed.
Diameter 15.7 cm.
Fifteenth century.
Collection: F. W. Bodor.

Note: The contrast between the light toned blue of the interior decoration and the dark blue on the exterior suggests that cobalt ore from two different sources were used. A. M. Joseph (1973, p. 137) maintains that X-ray fluorescent tests on a similarly decorated plate (Pl. 97) revealed the use of low manganese content cobalt ore (i.e. imported) on the interior and high manganese content cobalt ore (i.e. local) on the exterior; see H. Gardner (1956), pp. 48–50.

123. Dish with everted rim and a straight foot. Decorated in underglaze cobalt-blue with a flying mythical beast, the *qilin*, within a pair of double lines in the central medal-

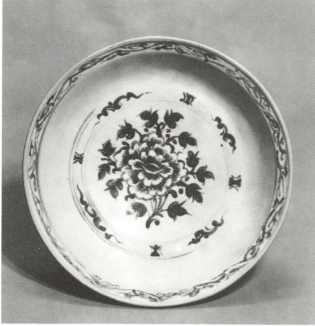

121

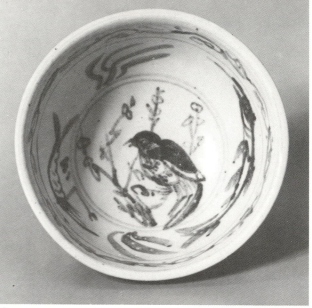

122

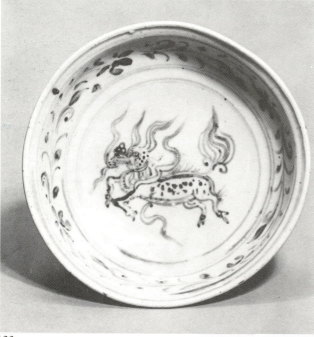

123

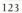

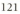

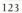

124

lion, with a continuous floral scroll on the cavetto. On the exterior, lotus petal panels. Stoneware body with a transparent glaze, the mouth-rim and foot-rim unglazed and the base painted with a chocolate-brown iron wash.
Diameter 23.8 cm.
Fifteenth century.
Collection: F. W. Bodor.

Note: D. F. Frasche (1976, p. 98) observed that the *qilin* is rarely found in the repertoire of animal motifs. A 'winged horse' design on a dish found in

Lampung, South Sumatra, is probably in fact a Vietnamese variation on the *qilin* theme; see C. Lammers and A. Ridho (1974), p. 38.

124. Dish with flattened rim, rounded lip, and a bevelled foot-ring. Decorated in underglaze cobalt-blue with central lotus pond design surrounded by a band of alternating cloud scrolls and flaming pearls, floral scrolls on the cavetto, and a continuous classic scroll on the rim. Lotus petal panels with flourishes on the exterior. White stoneware

body with a transparent glaze, the mouthrim and foot-rim unglazed. Base painted with a chocolate-brown iron wash.
Diameter 35.2 cm.
Fifteenth century.
Collection: Museum of Applied Arts and Sciences.

Note: The lotus pond design occurs frequently in fourteenth-century Chinese blue-and-white, often with a pair of ducks, but is rare in fifteenth-century wares. For another Vietnamese example see W. Willetts (1971), Pl. 24.

125. Dish with flattened rim, rounded lip, and a carved foot-ring. Decorated in underglaze cobalt-blue with a central lotus spray medallion surrounded by a band of alternating cloud scrolls and pillars. Floral scrolls on the cavetto and a continuous classic scroll on the rim. Lotus petal panels with flourishes on the exterior. Stoneware body with a transparent glaze, the mouth-rim and foot-rim unglazed and the unglazed base painted with a chocolate-brown iron wash.
Diameter 39 cm.
Fifteenth century.
Collection: F. W. Bodor.

126. Jar of globular form with a high shoulder tapering to a small raised neck, and three lugs. Decorated in underglaze cobalt-blue with a collar of lotus petals around the neck, and a continuous floral scroll meander on the body. Off-white stoneware body with a bluish transparent glaze to the foot. Base slightly recessed.
Height 8.5 cm.
Fifteenth century.
Collection: Art Gallery of South Australia.

127. Bowl with everted mouth-rim and high foot-ring. Decorated in underglaze cobalt-blue on the exterior with an alternating peony spray and leaf design, and below a band of lotus panels. Lotus and vine scrolls on the interior. Light grey stoneware body covered with a transparent glaze.
Height 8.5 cm.
Fifteenth to sixteenth centuries.
Collection: Northern Territory Museum of Arts and Sciences.

128. Bowl with high sides and a low foot-ring. Decorated in underglaze blue with floral motif medallion, a continuous classic scroll on the interior rim, and a continuous floral and leaf meander on the upper exterior. Beneath lotus panel with Chinese characters. Design bordered by double lines painted in underglaze manganese, firing purple-aubergine. Base painted with a rust-brown iron wash.
Diameter 19.3 cm.
Fifteenth to sixteenth centuries.
Collection: J. H. Myrtle.

129. Bottle of *yuhuchunping* shape with everted mouth-rim (restored) and short, splayed foot. Decorated in underglaze cobalt-blue with *ruyi* lappets on the interior of the mouth-rim, plantain leaves on the neck, lotus petal panels with flourishes on the shoulder and a band of cloud scrolls. The body with floral scroll medallions separated by concentric wave-pattern panels and above the foot a band of lotus petal panels with flourishes. Stoneware body with a transparent glaze. The foot-rim unglazed and the base painted with a black–brown iron wash.
Height 29 cm.
Fifteenth to sixteenth centuries.
Collection: F. W. Bodor.
Published: A. M. Joseph (1973), Pl. 105.

Note: A comparable Chinese example, attributed to a non-imperial kiln at Jingdezhen of the late fifteenth century, provides a likely prototype for the Vietnamese bottle; see S. Hayashiya and H. Trubner (1977), Pl. 41. Similar Vietnamese bottles reported from Sumbawa and Bali; see C. Lammers and A. Ridho (1974), p. 51.

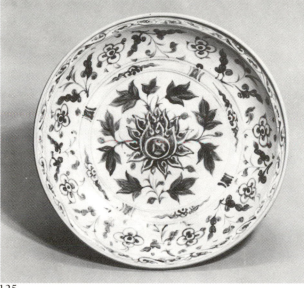

125

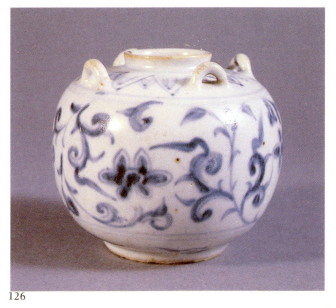

126

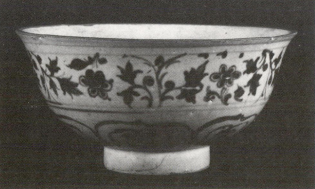

127

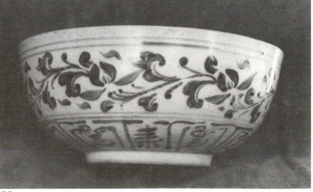

128

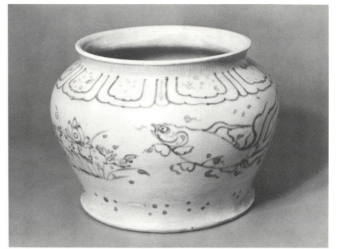

130

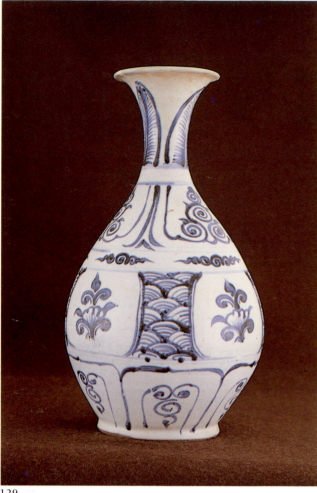

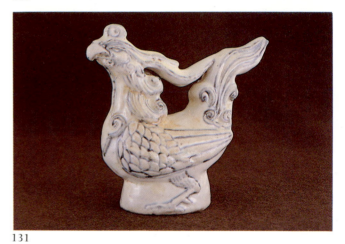

129

131

130. Jar of *guan* form with a broad mouth and rounded rim. Decorated in underglaze cobalt-blue and overglaze green enamel with lotus petal lappets on the shoulder and an aquatic scene of lotus flowers and leaves on the body. Two fish with long flaring tails swimming between aquatic plants. Stoneware with a transparent glaze, the enamel spotted over the design. Base flat and unglazed.
Height 16.8 cm.
Fifteenth to sixteenth centuries.
Collection: F. W. Bodor.

Note: The apparently random use of enamel green is explained by the faint depressions in the glaze surface left by a second enamel, most likely red, which has totally decayed and would have completed the decorative scheme. The lotus petal lappets were decorated with alternating diaper patterns and concentric waves; the fish had scales; and a frieze of lotus petal panels was above the foot. Compare A. M. Joseph (1973), Pl. 124, which displays the same characteristics.

131. Pouring vessel in the form of a standing phoenix with sweeping headfeathers which bridge the head and tail. A hole at the base of the tail and in the beak, the latter serving as a pouring spout. Moulded relief contours heightened in underglaze cobalt-blue. White stoneware body with a transparent glaze, the base flat and unglazed.
Height 15.5 cm.
Length 17.3 cm.
Fifteenth century.
Collection: F. W. Bodor.

Note: Zoomorphic vessels in Vietnamese ceramics are not uncommon, but are rarely of this elaboration. A seated phoenix of similar size was recovered from South Sulawesi (see C. Lammers and A. Ridho (1974), p. 76), and a dragon-shaped vessel was reportedly excavated in 1972 at Bulukumba on the south coast of Sulawesi (see Oriental Ceramic Society of Hong Kong (1979), Pl. 183). One example identical in scale and moulded detail (except for the bridge between head and tail and with a flaring bottle neck on the back which may not be original) is known to the writer, and was collected in the Philippines; see U. Wiesner (n.d.), Pl. 173.

132. Water-dropper in the form of a seated duck with an upturned tail. A rimmed hole on the back. Moulded with incised details and painted decoration in underglaze cobalt-

blue. The beak pierced to serve as a spout. White stoneware body with a transparent glaze. Base flat and unglazed.
Height 8.2 cm.
Fifteenth century.
Collection: F. W. Bodor.

133. *Kendi* with a squat globular body, short cylindrical neck with a broad horizontal flange, small lipped mouth, and a mammiform spout. Decorated in underglaze cobalt-blue with a band of petals on the flange, and a band of double lotus petals around the shoulder, from which five *ruyi* lappets descend, each with a chrysanthemum and leaves reserved on a cross-hatched ground. Single petals on a double line and a double lotus petal band above the foot. Flaming pearls and *lingzhi* on the spout. Stoneware body with a transparent glaze. Base flat and unglazed.
Height 12.5 cm.
Fifteenth century.
Collection: F. W. Bodor.

Note: Comparable examples have been found in Malang, East Java, and Sulawesi (C. Lammers and A. Ridho (1974), p. 74).

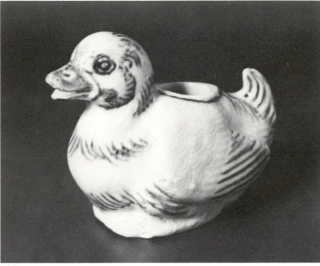

132

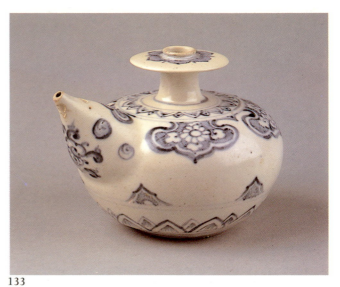

133

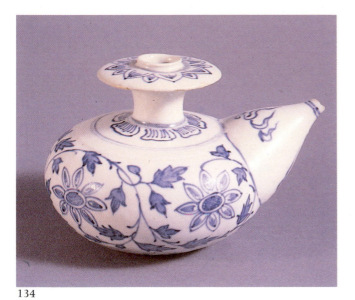

134

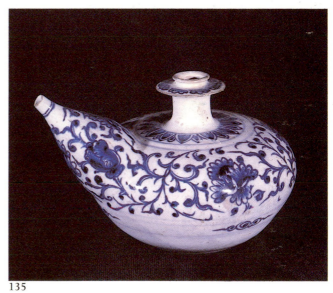

135

134. *Kendi* of squat globular form, with a short cylindrical neck with a broad horizontal flange, small lipped mouth, and a mammiform spout. Decorated in underglaze cobalt-blue with a band of double lotus petals on the flange, collar scalloped, lotus petals on the shoulder, and two flaming pearls on the spout. Chrysanthemum scroll with four flowers decorates the body and cloud scrolls appear in a band above the base. Stoneware body with a transparent glaze. Base flat and unglazed.
Height 11.5 cm.
Fifteenth century.
Collection: Art Gallery of South Australia
Published: A. M. Joseph (1973), Pl. 111.

Note: L Locsin and C. Y. Locsin (1967, Pl. 145) reproduce a similar example excavated in Puerto Galera, Mindoro. Museum Nasional, Jakarta, has another, reportedly found in Sulawesi; see C. Lammers and A. Ridho (1974), p. 74.

135. *Kendi* of squat globular form, with a short cylindrical neck with a broad horizontal flange, small lipped mouth, and a tapering mammiform spout. Decorated in underglaze cobalt-blue with a collar of lotus petals on the shoulder, and peony spray meander on the body, with a band of cloud scrolls beneath. Greyish-white stoneware body (repaired).
Height 20 cm.
Fifteenth century.
Collection: Northern Territory Museum of Arts and Science.

136. Stem bowl of globular form with an inverted rim, on a short waisted stem. Decorated in underglaze cobalt-blue with a rocky landscape with bamboo, bordered with a simplified diaper pattern above and double lotus petal panels below. Stoneware body with a transparent glaze, the mouth-rim unglazed, the foot and base unglazed and painted with a chocolate-brown iron wash.
Height 8.3 cm.
Fifteenth century.
Collection: J. H. Myrtle.

137. Stem bowl of globular form with an inverted rim, on a baluster-shaped stem. Decorated in underglaze cobalt-blue on the body with floral sprays alternating with chrysanthemum painted in reserve, bordered above and below with cloud scrolls. Double lotus petal panels above the foot. Stoneware body with a transparent glaze, the foot and base unglazed and painted, except for the foot-rim, with a chocolate-brown iron wash.
Height 11 cm.
Fifteenth century.
Collection: F. W. Bodor.

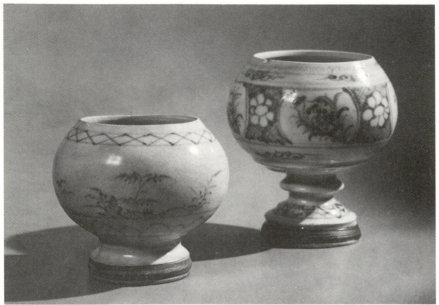

136, 137

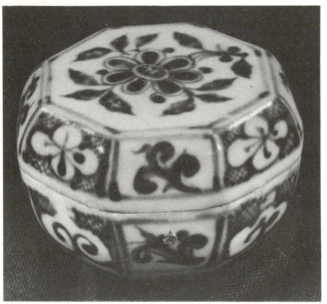

138

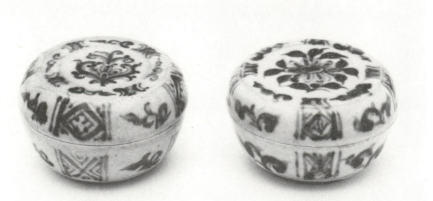

139, 140

Note: In Chinese porcelain the form is typically Xuande-period (1426–35). A similar stem bowl was collected in South Sulawesi; see A. Ridho (1977), Pl. 302. The Princessehof Museum in Leeuwarden has a similar shaped stem bowl, also reportedly from Sulawesi, which is described as fifteenth-century Chinese; see J. A. Pope (1951), Pl. VIII(c) and p. 36.

138. Covered box of flattened, octagonal form with a recessed base. Decorated in underglaze cobalt-blue with a peony spray on the cover and alternating leaf sprays and a floral rosette reserved in white on a cross-hatched ground on the side panels. Buff-coloured stoneware body with a transparent glaze, and the interior wiped with glaze.
Diameter 5.9 cm.
Late fifteenth to sixteenth centuries.
Collection: J. M. C. Watson.

139. Covered box of circular form with a flattened cover. Decorated in underglaze cobalt-blue with a symmetrically arranged floral spray medallion and vegetal sprays between diaper panels on the sides. Stoneware body covered with a transparent glaze, including the interior. Foot-rim and base unglazed.
Diameter 7.5 cm.
Fifteenth century.
Collection: National Gallery of Victoria.
Presented by M. L. Abbott.

140. Covered box of circular form with a flattened cover. Decorated in underglaze cobalt-blue with a chrysanthemum spray centre medallion and vegetal sprays between diaper panels on the sides. Stoneware body covered with a transparent glaze, including the interior. Foot-rim and base unglazed.
Diameter 7.7 cm.
Fifteenth century.
Collection: National Gallery of Victoria.
Presented by M. L. Abbott.

141. Covered box of circular form with moulding and incising. The cover decorated in underglaze cobalt-blue with two birds in a landscape, one in flight, the other resting in reeds. White stoneware body covered with a transparent glaze. Base glazed.
Diameter 8.7 cm.
Fifteenth century.
Collection: D. Komesaroff.

Note: A similar example in the Museum Nasional, Jakarta, was reportedly found in South Sulawesi; see C. Lammers and A. Ridho (1974), Pl. 5A44/4864.

142. Covered box of circular form with a flattened cover. Decorated in underglaze cobalt-blue with a rocky landscape, pine trees, and bamboo. Stoneware body covered with a transparent glaze, the interior with a wiped glaze, and the foot-rim and base unglazed.

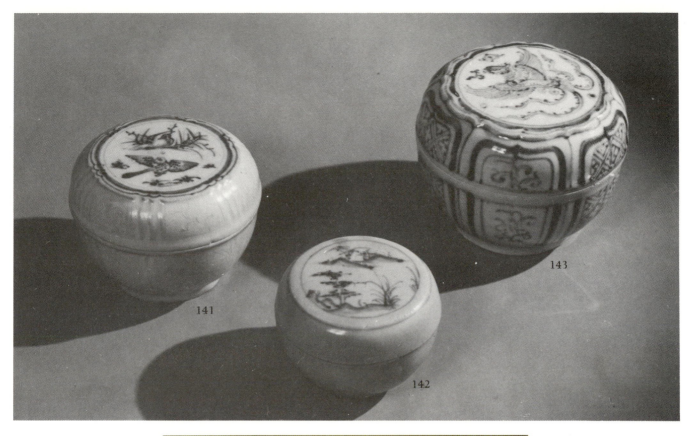

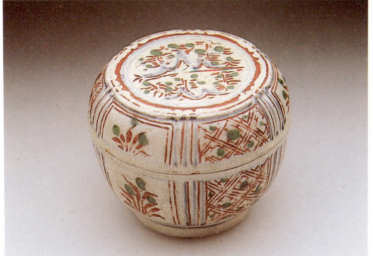

Diameter 7.2 cm.
Fifteenth century.
Collection: National Gallery of Victoria.

Diameter 9.8 cm.
Fifteenth century.
Collection: F. W. Bodor.

Height 8 cm.
Fifteenth to sixteenth centuries.
Collection: M. L. Abbott.

143. Covered box of circular form with a flattened cover and a scalloped rim at the shoulder. Decorated in underglaze cobalt-blue with a phoenix in flight on the cover, lotus petal lappets on the sides of the cover and base decorated with alternating diaper patterns and vegetal sprays. Stoneware with a transparent glaze. Base unglazed.

144. Covered box of circular form with a flattened cover and ribbed box and cover. Decorated in underglaze cobalt-blue and overglaze red and green enamels, with a mountainous landscape on the cover, and alternating vegetal spray and diaper pattern panels on the sides. White stoneware body with a transparent glaze. Base recessed and unglazed.

145. Jar with a short cylindrical neck, everted rim, and a high shoulder with three lugs. Decorated in underglaze cobalt-blue with marks on the lip, a double lotus petal collar on the shoulder, and a floral scroll on the body. Lotus petal panels with flourishes above the foot. Grey stoneware body with a transparent glaze. Base flat and unglazed.

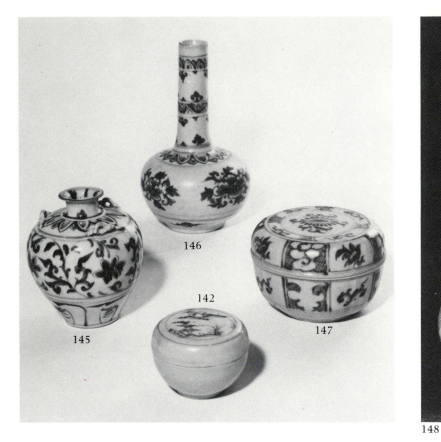

146

142

145

147

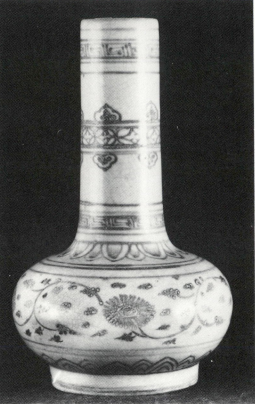

148

Height 11 cm.
Sixteenth century.
Collection: National Gallery of Victoria.

Note: Similar jars reported from Sumatra and Sulawesi; see C. Lammers and A. Ridho (1974), p. 69.

146. Bottle of globular form with a tall cylindrical neck and bevelled foot-ring. Decorated in underglaze cobalt-blue on the neck with a band of double lotus petal panels and a chevron band, each flanked with trefoils and triangles. A double lotus petal collar on the shoulder and four peony sprays on the body, bordered with horizontal double

lines. Cloud scrolls above the foot. White stoneware body with a transparent glaze. Base carved and unglazed.
Height 19.1 cm.
Sixteenth century.
Collection: National Gallery of Victoria.

147. Covered box of circular form with a flattened cover. Decorated in underglaze cobalt-blue with a chrysanthemum spray on the cover and alternating vegetal sprays and *ruyi* lappets reserved against a cross-hatched ground. White stoneware body with a transparent glaze. Base recessed and unglazed.

Diameter 11 cm.
Fifteenth to sixteenth centuries.
Collection: National Gallery of Victoria.

148. Bottle of squat form with a columnar neck and high foot-ring. Decorated in underglaze cobalt-blue with a chrysanthemum spray meander bordered by lotus petal bands. Key-fret and diaper pattern bands on the neck. Stoneware body with a transparent glaze (repaired).
Height 16 cm.
Sixteenth century.
Collection: F. W. Bodor.

Note: Compare R. M. Brown (1977), Fig. 41.

Thai Ceramics

THE beginning of glazed ceramic production in Thailand is intimately bound up with the origin of the Thai kingdom itself. Successive waves of migration out of south-western China from Tang times onwards led to Thai settlement of the upper reaches of the river valleys of northern Thailand, Laos, and Burma. The Thai peoples assimilated with the Mons, Burmans, and Khmers, and by the early twelfth century had begun to form small principalities in the upper Menam Chaophraya valley of North–Central Thailand, which in turn came under the sway of the Khmer Empire.[1] The first autonomous Thai kingdom was established in the mid-thirteenth century after the provincial rulers of the Sukhothai region broke their Khmer allegiances in 1238.[2] The twin cities of Sukhothai and Si Satchanalai served as the capital, and the kingdom rose to an early apex of power and prosperity during the reign of Ramkhamhaeng (c.1279?–1298). He expanded the kingdom territorially, ordered the preparation of a written form for the Thai language, and encouraged free commerce. Temple-building appears to have been an important royal function, partly as a meritorious act and, more importantly, as a display of a ruler's ability to mobilize large forces of manpower. Construction activities were pursued at intervals by the rulers of the Sukhothai kingdom, particularly under Ramkhamhaeng's son, Lodaiya (r.1298–1346/7), who undertook a restoration building programme at Sukhothai, utilizing bricks and ceramic products.[3]

Sukhothai architecture and the plastic arts reached their apogee under Lidaiya (r.1347–c.1374) with extensive temple construction undertaken at both Sukhothai and Si Satchanalai. It may have been these demands which provided the stimulus for expanding the local ceramic industry into an extensive operation, the remains of which can still be seen at Sukhothai and in the vicinity of Si Satchanalai, some 50 kilometres to the north. At both Sukhothai and Sawankhalok[4] fragments have been found of glazed stoneware architectural fixtures in the form of roof tiles, finials, piping, railings, relief plaques, and sculptural temple guardians (yaksa). Fournereau observed in 1891 that it appeared that ceramic architectural fixtures at Sukhothai 'take the place held by the sculptures in sandstone among the Khmers'.[5] The extensive building programme, which probably began around the 1340s and continued into the fifteenth century, was served by the kilns established on the outskirts of each city. The Sukhothai kilns are concentrated to the north of Wat Phra Phailuang with a smaller group immediately north of the Sukhothai city wall. These number over fifty, of which fifteen have been identified to date as cross-draft kilns capable of producing glazed stoneware. The kilns at Si Satchanalai are clustered in three groups along the Yom River north-west of the city wall, at Pa Yang, Tukatha and Ko Noi, and 124 have been located to date, with the largest concentration at Ko Noi.[6] It is anticipated that these kiln numbers will increase as further excavations are conducted in the region.

123

The kilns produced not only glazed ceramics for domestic and architectural use but also an extensive range of wares expressly for international trade. Excavations conducted at Si Satchanalai by the Thai Ceramics Dating Project between 1980 and 1984 have identified two types of kiln which can be seen as developmental phases in the evolution of the all-brick construction cross-draft kilns used for the firing of glazed stoneware ceramics for the export trade.[7] It appears on the basis of these discoveries that the mature-phase kiln technology employed at Si Satchanalai was utilized for the firing of glazed stoneware ceramics and that the development of this advanced kiln type coincides with the production of wares associated with international trade. The technically less sophisticated kilns, slab clay bank kilns and a bank kiln with stepped firebox and brick chimney, appear to belong to a pre-export phase of production, though they may have continued concurrently with the export production kilns, catering to low-fired domestic requirements. These two developmental types of kiln appear to be absent at Sukhothai, where surveys have revealed cross-draft kilns of the same type as the mature kilns at Si Satchanalai. This suggests that the glazed stoneware production at Sukhothai, producing domestic, architectural and export ceramics, began with the introduction of the advanced kiln technology which had been developed at Si Satchanalai. These findings challenge the accepted chronology of development which has argued, on stylistic and technical comparisons of the ceramics themselves, that the Sawankhalok wares, being technically more refined, therefore represent a later development emerging out of the more primitive, and hence earlier, achievements of the Sukhothai potters.[8] They also challenge present-day ideas about the directions of stylistic influence and development.

SUKHOTHAI

Types of Ware

The ceramics of the Sukhothai kilns are technically inferior to those of the Sawankhalok kilns. They display a limited range of shapes with plates, bowls and pear-shaped bottles predominant, and are characterized by a distinctive coarse, impure body which fires a dark brown and is speckled with white particles. The poorly levigated clay, combined with limited control over firing conditions, resulted in vessels characterized by sagging and warping and with a glaze which failed to vitrify with the body and thus tend to flake and degrade readily. The stoneware body was usually covered, except for the foot, with a thick white slip which served as a ground for the much favoured iron-black/brown painted decoration. The decorated vessel was in turn dipped in a clear glaze solution. The presence of iron impurities in the glaze often gave it a greenish tint, suggestive of an underdeveloped greenware.[9] Apart from a small classic group of wares decorated in monochrome white and unglazed wares, Sukhothai stonewares were all decorated in the underglaze painted iron technique.

The decorative motif par excellence in Sukhothai wares is the fish medallion, painted in a summary calligraphic style which would do credit to a Chinese decorator (Plates 161 and 162). Other designs include the solar whorl (*cakra*) (Plate 159), classic scroll, floral sprays, and the enigmatic sun-burst designs which were either stamped or painted. The range of design is not great and shares with the Vietnamese wares decorated in the same technique a similarity to South Chinese wares of the Jizhou tradition. Whether the parallels with Chinese wares reflect direct contact with Chinese potters or, as seems more likely, an influence transmitted through the presence of Chinese and Vietnamese ceramics, is uncertain. Certainly Vietnamese underglaze decorated ceramics have been found in the region and were clearly available, along with Chinese porcelain, to serve as models (Fig. 36). On occasions the

stylistic parallels can be very close as seen in the floral spray medallion common to both Sukhothai and Vietnamese plates and bowls (cf. Plates 108 and 160). Amongst the Sawankhalok wares equally direct borrowings from Chinese sources can be readily observed; for example, in the use of the conch on waves motif (Fig. 37). Sukhothai wares certainly display an awareness of Chinese traditions, but like Sawankhalok wares, do not contain anything to demonstrate a direct Chinese presence in their production.

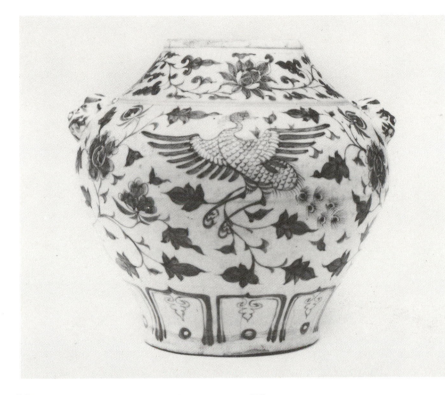

Fig. 36
A Chinese guan *decorated in underglaze blue, Yuan Dynasty, reportedly excavated at Sukhothai. Comparable examples known in the Ardebil Shrine Collection and Topkapi Saray Museum, Istanbul. (Courtesy Sotheby Parke Bernet, London)*

Fig. 37a & b
The influence of Chinese ceramic decoration on Thai wares is evidenced in a sherd from Sawankhalok. (a) Glazed stoneware sherd painted in underglaze iron-black with a conch shell against a concentric wave pattern design, Sawankhalok ware. Collected by Reginald Le May and donated to the British Museum in 1926. (b) Porcelain bowl decorated in underglaze cobalt-blue with a conch shell against a concentric wave pattern design. Chinese export ware, early sixteenth century. Acquired in Jakarta. (Ostasiatiska Museet, Stockholm)

37a

37b

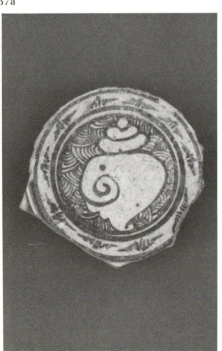

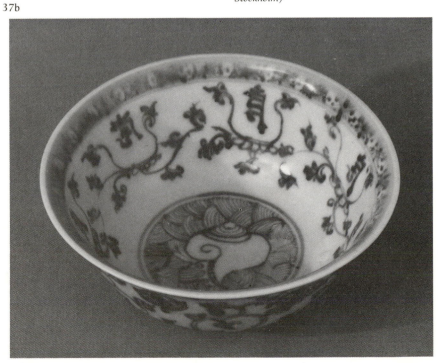

Kilns and Firing Techniques

The wares were fired in kilns of brick construction of a cross-draft design (Fig. 38) of a type which, according to Feng Xianming, 'have a close relationship with some types of Chinese kilns . . . [and which] are generally very similar to the Jingdezhen kiln types'.[10] The Sukhothai wares were stacked on the sloping sandy floor of the kiln, the first plate set on a tubular firing stand, and subsequent ones separated by a flat disc support with typically five spurs which rested on the bottom of the plate below (Fig. 39a and 39b). The majority of wares have the characteristic spur marks in the bowl; a few are free of this blemish and were presumably fired on the top of the stack. Some also display a circular firing stand scar on the base in addition to the spur marks, indicating they were on the bottom of the stack.[11] This method of stacking the kiln, prompted no doubt by a desire to accommodate the maximum number of pieces in a single firing, is only rarely found in China, in some Cizhou-type wares, but is common in early Vietnamese ceramic production. This similarity with Vietnamese wares adds a technical dimension to the observable stylistic parallels between these two ceramic traditions.

Fig. 38
A Sukhothai cross-draft kiln of the type producing export wares during the fifteenth and sixteenth centuries. (Courtesy Don Hein)

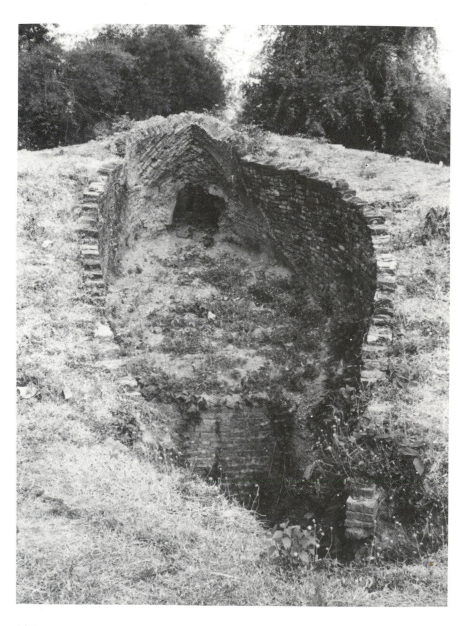

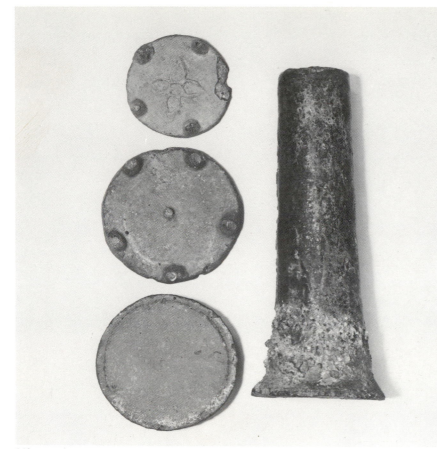

39b

39a

Fig. 39a & b
Firing supports employed at the Thai kilns,
fifteenth to sixteenth centuries. The spurred
discs from the Tao Turiang kilns, Sukhothai,
the tubular pontil from the Ko Noi kilns,
Sawankhalok.

SAWANKHALOK

Types of Ware

The Sawankhalok wares display a greater range of shapes and glaze types. The repertoire included dishes with scalloped and foliated rims, a variety of zoomorphic *kendi*, bottles, water-droppers, assorted figurines, and innumerable types of covered boxes. The glaze types were similarly more extensive, with the use of celadon as the greatest single innovation. Underglaze iron-black/brown decoration was used, but without the white slip characteristic of Sukhothai wares. Monochrome glazes—black, brown, and white—were applied to an extended range of wares, and brown and white were used together in an inventive style, combined with incised decoration, to achieve some of the most pleasing effects in Thai ceramics. The use of a green glaze, usually in combination with underglaze incised decoration, but very occasionally used with underglaze iron-brown painted decoration (Plates 182 and 183), was only moderately successful by Chinese standards. Whilst Sawankhalok greenware shows affinities to *Longquan* greenware from Zhejiang Province, this influence need not necessarily have been direct but could have come from Guangdong Province in the south where Longquan-inspired greenware was being produced in the fifteenth century.[12] Greenware constituted, along with iron-decorated wares, the principal product of the Sawankhalok kilns. The glaze is typically thick and glassy, often crazed, and displays a tendency to pool in the bottom of the bowl and to form heavy droplets on the foot-ring. It ranges in colour from a translucent sea-green to an opaque, almost turquoise-blue. The variations in colour indicate an inconsistency in the control of the kiln temperature and the reduction atmosphere.

127

40a

40b

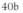

Fig. 40a & b
Fragments of Sawankhalok greenware dishes decorated with underglaze iron-black painting. (a) Fish amidst water-reeds design, of Yuan inspiration. Waster from a Sawankhalok kiln-site. Compare Plate 116 for a Vietnamese blue-and-white version of this subject. (Private collection, Melbourne) (b) An elaboration of the popular Yuan lotus pond design with fish, crab, shrimp and two birds feeding. (British Museum, London)

Curiously, two of the most elaborately decorated Sawankhalok greenwares known to the writer are both drawn in underglaze iron pigment rather than incised. One shows a pair of fish (or a 'flattened' fish) swimming amidst water-reeds (Fig. 40a), and the other a magnificent lotus plant with crab, catfish, and two water-birds catching fish (Fig. 40b).

The body of Sawankhalok wares shows a similar variety, ranging from off-white to grey to red–brown, and is typically speckled with black particles. It is finer and denser than that of Sukhothai wares and therefore less subject to warping, sagging, and to the pitted glaze surface caused by escaping air bubbles which plagued the Sukhothai potters.

Kilns and Firing Techniques

The all-brick cross-draft kilns are, according to the investigations carried out by the Thai Ceramics Dating Project, somewhat larger than their Sukhothai counterparts and are certainly more numerous. The kiln has a tapering domed profile with a lowered fire-pit, an ascending firing floor, and round shaft chimney (Fig. 41). Each ceramic piece was mounted on a tubular firing stand as at Sukhothai, but the stacking between disc supports was not practised. Whilst fewer pieces could be fired in the kiln with this method, it avoided the disfiguring effect of the spur marks. The Sawankhalok tubular firing stands range considerably in size but tend to be taller than their Sukhothai counterparts. Both display evidence of ash glaze from the kiln and sand particles fused to the foot (Fig. 39b). Feng Xianming has observed that Si Satchanalai green-glazed wares have close similarities to those produced at Longquan kilns in their designs and methods of glazing and that the kiln types are very similar.[13]

128

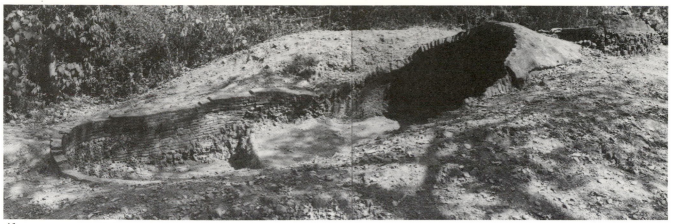

41a

41b

Fig. 41a & b
A Sawankhalok cross-draft kiln at Ko Noi of the type producing export wares during the fifteenth and sixteenth centuries. (Photograph and line drawing courtesy Don Hein)

1. D. G. E. Hall (1955), p. 169.
2. G. Coedès (1968), p. 195.
3. A. B. Griswold and Prasert Na Nagara (1972).
4. The Ayudhya period name given to the district in which the walled city of Si Satchanalai and the kilns to its north on the Yom River, are located. See the excellent maps prepared by Don Hein in R. J. Richards (1977), pp. 16–17.
5. D. F. Frasche (1976), p. 45.
6. D. Hein *et al.* (1981–2), p. 38.
7. See D. Hein (1980), D. Hein *et al.* (1981–2), R. J. Richards *et al.* (1984), and P. L. Burns (1984).
8. See, for example, C. N. Spinks (1965).
9. The writer has a waster which was a surface find at the Tao Turiang kilns outside the northern wall of Old Sukhothai. It is a fragment of a bowl originally about 11 cm in diameter, with its foot fused to the spurred disc support. It has the characteristic brown body with white speckles, a cream slip, and a pale green glassy celadon-type glaze. Whether this was an early attempt at greenware or was intended as a glazed white ware which fired green because of iron impurities in the glaze, is unclear. Certainly there was no systematic attempt to produce greenware at the Sukhothai kilns.
10. Feng Xianming, Chairman's Comment in P. L. Burns (1984), p. 403.
11. For examples, see W. Willetts (1971), Pl. 168, and B. Refuge (1976), p. 14.
12. J. C. Y. Watt (1971), p. 6.
13. Feng Xianming, Chairman's Comment in P. L. Burns, op. cit., p. 403.

129

THAILAND

Monochrome Wares

149. Covered jar of globular form with a high foot-ring, four lugs on the shoulder, and a domed cover with a knop handle. Decorated with a cream–white glaze over a pink stoneware body, the glaze stopping short of the foot. Unglazed base has a circular firing stand scar.
Height 15.2 cm.
Sawankhalok ware.
Fifteenth to sixteenth centuries.
Collection: Art Gallery of South Australia.

Note: A similar example was excavated at Calatagan, Batangas, southern Luzon; see R. B. Fox (1959), Pl. 118.

150. Stem dish with high sides, an everted rim, and a narrow waisted stand joining a domed foot. Decorated with a cream–white glaze over a light grey stoneware body, the glaze stopping above the bevelled foot. Unglazed base, deeply recessed, with a circular firing stand scar.
Diameter 16.3 cm.
Sawankhalok ware.
Fifteenth to sixteenth centuries.
Collection: Art Gallery of South Australia.
Published: R. J. Richards (1977), No. 183.

Note: White glazed stem dishes are unusual, a celadon glaze is more typical, compare Plate 197. One example, with an unusual lipped foot, was excavated in Oton, Philippines; see J. B. Tiongco (1969), Pl. 38.

151. Jar of compressed globular form with deeply ribbed body, a small lipped mouth, and low, slightly splayed foot. Decorated in a bluish-cream glaze over an ochre stoneware body, the glaze stopping short of the foot. Unglazed base has a circular firing stand scar.
Height 6.7 cm.
Sawankhalok ware.
Fifteenth to sixteenth centuries.
Collection: Art Gallery of South Australia.
Published: R. J. Richards (1977), No. 179.

152. Bottle of squat form with short neck and low foot-ring. Decorated in a pearly-white glaze over a grey-brown stoneware body, the glaze stopping irregularly on the lower body. Base unglazed.
Height 9.1 cm.
Sawankhalok ware.
Fifteenth to sixteenth centuries.
Collection: Art Gallery of South Australia.
Published: R. J. Richards (1977), No. 180.

Note: R. B. Fox (1959, Pl. 117) published three examples excavated at the Calatagan site in Batangas, southern Luzon.

153. Bottle of ovoid form with inverted mouth-rim, two lugs at the shoulder, and a bevelled foot-ring. Decorated with incised horizontal bands on the shoulder and upper body and a caramel-brown glaze stopping short of the foot. Dark brown stoneware body. Unglazed base has a circular firing stand scar.
Height 15 cm.
Sawankhalok ware.
Fifteenth to sixteenth centuries.
Private collection, Melbourne.

Note: Acquired in Java. R. B. Fox (1959, Pl. 109) published three examples excavated at the Calatagan site in Batangas, southern Luzon. The Museum Nasional, Jakarta, has an example collected in Aceh, North Sumatra; see A. Ridho (1977), Pl. 306.

154. Storage jar of ovoid form, cylindrical neck and flared mouth, with four lugs on the high shoulder. Buff stoneware body covered with a dark brown glaze on the upper body which runs irregularly to the base. Base flat and unglazed.
Height 38 cm.
Sawankhalok ware.
Fifteenth to sixteenth centuries.
Collection: T. L. Bolster.

Note: A similar example was found at Calatagan, Batangas, in southern Luzon; see L. Locsin and C. Y. Locsin (1967), Pl. 186. R. M. Brown (1975), Fig. 14, shows a jar of similar form, retrieved from the Koh Khram sunken ship, discovered in 1974 in the Gulf of Thailand.

155. Jar of ovoid form with everted mouth-rim, four horizontal lugs on the shoulder, and a flat base. Stoneware body covered with a deteriorating brown glaze, the exposed body and base fired brown.
Height 30.5 cm.
Sawankhalok ware.
Fifteenth to sixteenth centuries.
Collection: Northern Territory Museum of Arts and Sciences.

Note: Reportedly recovered from a shipwreck in the Gulf of Thailand. Compare J. N. Green and R. Harper (1983).

156. Figurine in the form of a standing elephant with a bowl set on his back. Decorated with a dark brown glaze over a buff stoneware body.

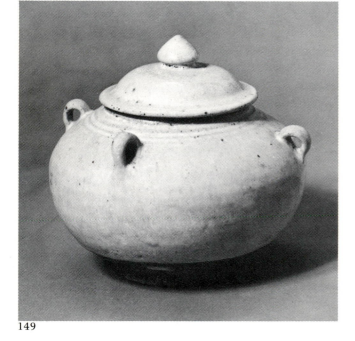

149

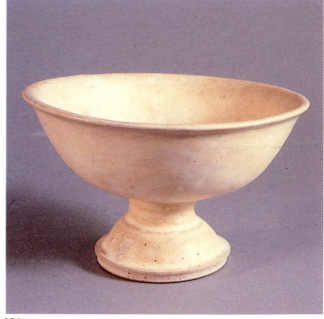

150

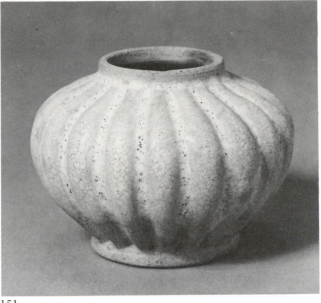

151

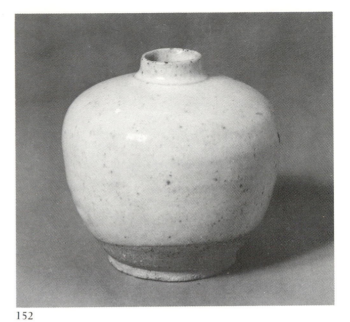

152

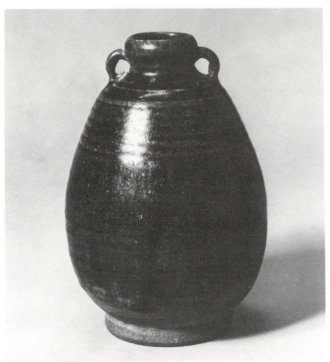

153

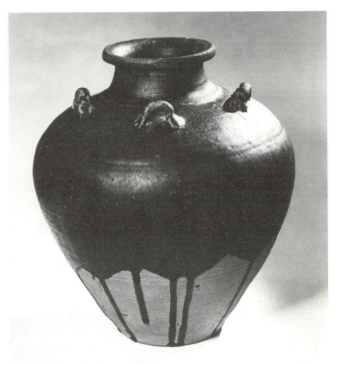

154

Height 7.2 cm.
Sawankhalok ware.
Fourteenth to sixteenth centuries.
Collection: Art Gallery of South Australia.

Note: A similar example was excavated in Oton, Philippines; see J. B. Tiongco (1969), Pl. 163.

157. Covered box of squat circular form with a knop handle. Decorated with a mottled brown glaze. Buff stoneware body, unglazed base with circular firing stand scar. Diameter 10.6 cm.

Sawankhalok ware.
Fifteenth to sixteenth centuries.
Collection: Art Gallery of South Australia.

Iron-decorated Wares

158. Bowl with everted rim and bevelled foot-ring. Decorated in underglaze iron-brown over a cream slip, with a floral motif within a double circle in the interior, and a continuous vegetal meander on the exterior. Brown stoneware body covered with a transparent glaze, the slip and glaze stopping

at the foot. Five spur marks on the interior.
Diameter 15 cm.
Sukhothai ware.
Circa fifteenth century.
Private collection.

159. Bowl with everted rim and bevelled foot-ring. Decorated in underglaze iron-brown over a cream slip, with a solar whorl or *chakra* medallion, tiered crown design on the cavetto, and a band of wash below the rim with incised diagonal hatching exposing

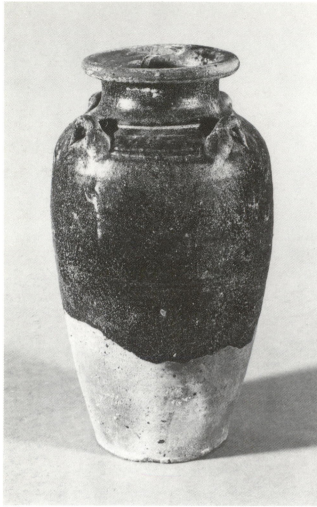

155

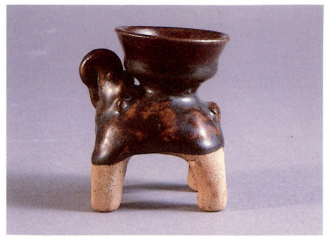

156

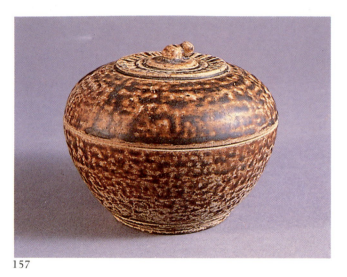

157

the slip. The exterior has a tiered crown design between horizontal lines. Buff stoneware body covered with a transparent glaze, the slip and glaze stopping above the foot. Base recessed and unglazed. Five spur marks in the centre of the bowl.
Diameter 19.8 cm.
Sukhothai ware.
Fifteenth to sixteenth centuries.
Private collection, Melbourne.

Note: Acquired in Java. Another example from Indonesia reported by C. N. Spinks (1959, Fig. 10).

160. Bowl with high sides, everted rim, and high foot. Decorated in underglaze iron-brown over a cream slip with a chrysanthemum spray centre medallion, bordered by three lines. A plain cavetto and below the rim a sketchily executed classic scroll bounded by lines. On the exterior a classic scroll also bordered with horizontal lines. Brown stoneware body, covered with a transparent glaze. Unglazed base has a circular firing stand scar.
Diameter 22.2 cm.
Sukhothai ware.

Fifteenth to sixteenth centuries.
Collection: Art Gallery of South Australia.
Published: R. J. Richards (1977), No. 18.

Note: A similar example was excavated from a grave site in Cebu island, Philippines, by Otley Beyer and reported by W. Robb (1930, Fig. 27). Another was collected in the Palembang Highlands, Sumatra, and is now in the Museum Nasional, Jakarta; see R. M. Brown (1977), No. 102.

161. Dish with a broad cavetto, flattened rim, and a high straight foot. Decorated in underglaze iron-brown over a cream slip with a spotted fish in the centre medallion, eight stems of waterweed in the cavetto, and regular dash marks on the rim. Exterior plain except for three horizontal bands. Grey stoneware body covered with a transparent glaze, stopping irregularly on the foot-ring. Base recessed and unglazed. Five spur marks in the centre of the bowl.
Diameter 27 cm.
Sukhothai ware.
Fifteenth to sixteenth centuries.
Collection: Art Gallery of South Australia.

Note: Encrustations on the base suggest this is a marine-excavated piece.

162. Dish with a broad cavetto, flattened rim, and a low carved foot. Decorated in underglaze iron-brown over a cream slip with a spotted fish in the centre medallion, waterweeds in the cavetto, and regular dash marks bordered by double lines on the rim. Exterior plain except for three lines below the rim. Buff stoneware body flecked with white, covered with a transparent glaze stopping near the foot. Base unglazed. Five spur marks in the centre of the dish.
Diameter 31.8 cm.
Sukhothai ware.
Fifteenth to sixteenth centuries.
Collection: National Gallery of Victoria.

Note: A hundred and fifty examples of this type of ware were retrieved from the Koh Khram wreck in the Gulf of Thailand (see R. M. Brown (1975), p. 370), and examples are reported widely from Indonesian sources (see C. N. Spinks (1959), Figs. 5–10), and the Philippines (see L. Locsin and C. Y. Locsin (1967), Pl. 153).

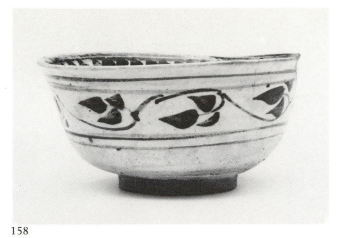
158

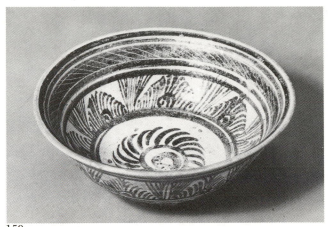
159

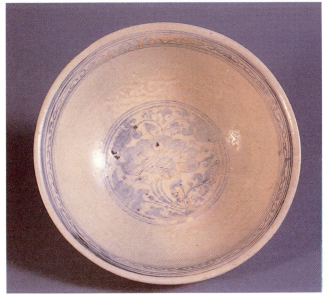
160

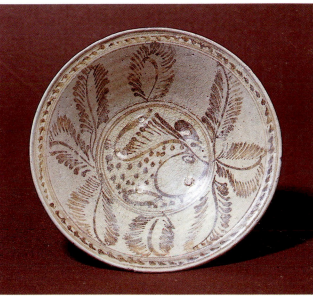
161

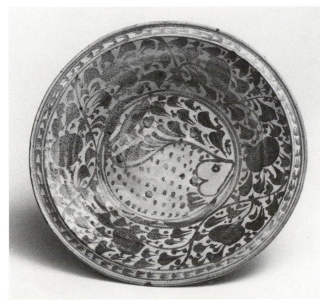
162

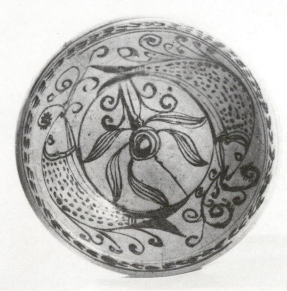
163

163. Dish with sloping cavetto and rounded rim. Decorated in underglaze iron-brown with a central floral spray and two fish in the cavetto, bordered by regular dash marks on the rim. Exterior with a debased classic scroll meander. Stoneware body with a transparent glaze. Base unglazed, and with a circular firing scar.
Diameter 26 cm.
Sawankhalok ware.
Fourteenth to fifteenth centuries.
Collection: D. and M. Eysbertse.

Note: A similar example collected in Cebu island, Philippines; see R. M. Brown (1977), Fig. 101.

164. Covered box of circular form with a flattened cover, button handle, and straight foot-ring. Decorated with incised vine scroll on the cover painted with an underglaze iron-brown wash. The rim of both cover and body covered with a cream–white glaze. Pink stoneware body. Unglazed base has a circular firing stand scar.
Diameter 12.6 cm.
Sawankhalok ware.
Fifteenth to sixteenth centuries.
Collection: Art Gallery of South Australia.
Published: R. J. Richards (1977), No. 171.

Note: A similar example was excavated in Oton, Philippines; see J. B. Tiongco (1969), Pl. 202.

165. Covered box with high sides, flattened cover, and a knop handle. Decorated with incised six-petalled flower and saw-tooth border on the cover, and a vine scroll on the body. The design heightened in reserve technique with painted iron-brown and cream–white glaze on the cover and iron-brown wash and white glaze on the body. Buff stoneware body. Unglazed base has a circular firing stand scar.
Diameter 13.2 cm.
Sawankhalok ware.
Fifteenth to sixteenth centuries.
Collection: Art Gallery of South Australia.
Published: R. J. Richards (1977), No. 186.

166. Covered box of circular form with a domed cover carved in the shape of a persimmon. Decorated with incised vine scroll on the body and saw-tooth pattern on the rim of the cover, the design heightened with painted iron-brown wash and a cream–white glaze. Pink stoneware body. Unglazed base has a circular firing stand scar.
Diameter 13.3 cm.
Sawankhalok ware.
Fifteenth to sixteenth centuries.
Collection: Art Gallery of South Australia.
Published: R. J. Richards (1977), No. 194.

Note: For a similar example collected in southern Sulawesi, see C. N. Spinks (1959), Fig. 28; and for the Philippines, see L. Locsin and C. Y. Locsin (1967), Pl. 185.

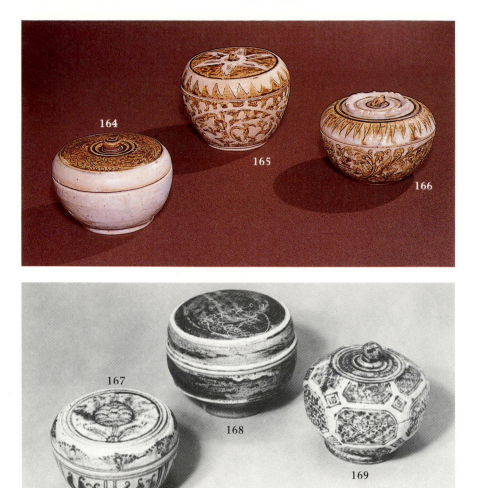

167. Covered box of circular form with a flattened cover, bevelled rim, and a high splayed foot. Decorated in underglaze iron-brown with a lotus bud and fern leaves on the cover, and a band of fern leaves on the rim. The body divided by pairs of double lines into seven panels, each with fern leaves. Grey stoneware body with a bluish-green transparent glaze stopping above the foot. Unglazed base has a circular firing stand scar.
Diameter 12.8 cm.
Sawankhalok ware.
Fifteenth to sixteenth centuries.
Collection: D. Komesaroff.

168. Covered box of circular form with straight sides, a flattened cover, and a high splayed foot. Decorated in underglaze iron-brown and white glaze over a cream slip with three lotus buds incised on the cover to reveal the slip. White-speckled brown stoneware body with a transparent glaze stopping above the foot. Interior covered with the slip and glaze.
Diameter 15 cm.
Sukhothai ware.

Fifteenth to sixteenth centuries.
Collection: Art Gallery of South Australia.
Published: R. J. Richards (1977), No. 25a.

Note: This *sgraffito*-type technique is often found in Sukhothai wares as a substitute for, or in combination with, painted designs. A similar shaped covered box was excavated at the Calatagan site in Batangas, Philippines; see R. B. Fox (1959), Pl. 120.

169. Covered box of circular form with the entire surface faceted. Cover with a handle in the form of a sleeping duck, and a high bevelled foot-ring. Decorated in underglaze iron-black with alternating vine scrolls and diaper pattern on each facet. The handle painted in iron-brown and the grey stoneware body covered with a transparent glaze. Unglazed base has a circular firing stand scar.
Diameter 13 cm.
Sawankhalok ware.
Fifteenth to sixteenth centuries.
Collection: Art Gallery of South Australia.
Presented by F. W. Bodor.

Note: A very similar example was excavated at Calatagan, Batangas, Philippines; see R. B. Fox (1959), Pl. 121.

170. Covered box of squat form with a domed cover, the knop handle in the shape of a flower stem. Decorated in underglaze iron-black with three lotus buds and leaf meander. Buff stoneware body with greyish transparent glaze to the foot. Base recessed and unglazed, with a circular firing stand scar.
Diameter 11 cm.
Sawankhalok ware.
Fifteenth to sixteenth centuries.
Private collection.

171. Covered box of circular form with a flattened cover and knop handle. Decorated in underglaze iron-black with leaf panel design on the cover and continuous vine-leaf meander design on the body. Grey stoneware body with a bluish transparent glaze to the foot. Unglazed base with a circular firing stand scar.
Diameter 13 cm.
Sawankhalok ware.
Fifteenth to sixteenth centuries.
Private collection.

172. Covered box of circular form with a domed cover and knop handle. Decorated in underglaze iron-black with alternating vegetal and cross-hatching panels, with lobing highlighted in green-brown. Buff stoneware body with a greenish transparent glaze stopping above the foot which is painted in iron-brown. Unglazed base with a circular firing stand scar.
Diameter 12.5 cm.
Sawankhalok ware.
Fifteenth to sixteenth centuries.
Private collection.

173. Covered box of rounded form, with concave base. Decorated in underglaze iron-black with a fish-scale motif. Buff stoneware body, grey speckles, covered with a transparent glaze.
Diameter 10.3 cm.
Sawankhalok ware.
Fifteenth to sixteenth centuries.
Collection: Art Gallery of South Australia.
Published: R. J. Richards (1977), No. 41.

174. Covered box of squat form with a raised neck and high bevelled foot. Decorated in underglaze iron-black painted line and stamped star decoration. Lid and shoulder painted with iron-brown direct on to biscuit. Grey stoneware body with circular firing stand scar on base.
Diameter 11.9 cm.
Sawankhalok ware.
Fifteenth to sixteenth centuries.
Collection: Art Gallery of South Australia.
Published: R. J. Richards (1977), No. 86.

Note: The stamped star motif also appears in Vietnamese examples, which may be its origin; compare D. F. Frasche (1976), Pl. 66.

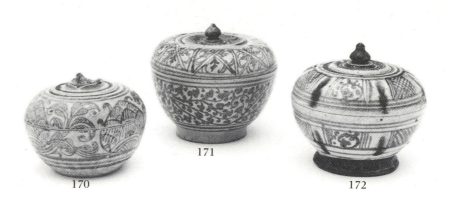
170 171 172

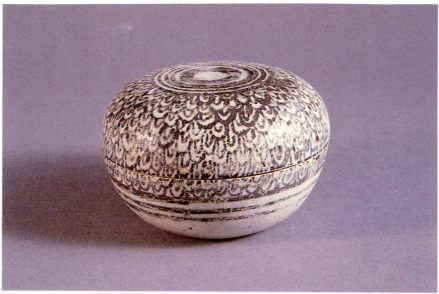
173

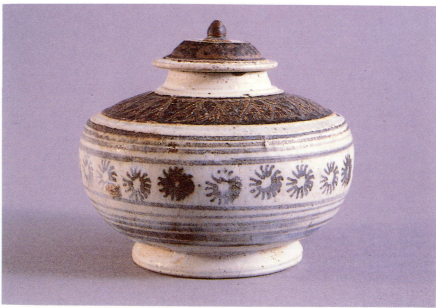
174

175. Covered box of circular form with a knop handle and a flat base. The modelled features of a bird on the cover, detailed in underglaze iron-brown. Buff stoneware body with a greenish-white transparent glaze stopping above the base which displays a circular firing stand scar.
Diameter 13 cm.
Sawankhalok ware.
Fifteenth to sixteenth centuries.
Private collection.

176. Covered box of rounded form with domed cover. Body tapering to the base. Decorated in underglaze iron-black with vine scroll panels alternating with lattice pattern, bordered by bands of horizontal lines. Stoneware body with a bluish-white semi-opaque glaze which runs irregularly to the foot. Unglazed base has a circular firing stand scar.
Diameter 15.8 cm.
Sawankhalok ware.
Fifteenth to sixteenth centuries.

Collection: Art Gallery of South Australia.
Published: R. J. Richards (1977), No. 71.

177. Bottle of gourd form with a tapering neck and flat base. Decorated in underglaze iron-brown with two bands of debased lotus panels framing floral(?) motifs on the upper body and vine scrolls bordered by bands of horizontal lines on the lower body. Grey stoneware body with a whitish transparent glaze stopping above the base which displays a circular firing stand scar.
Height 14.2 cm.
Sawankhalok ware.
Fifteenth to sixteenth centuries.
Collection: Art Gallery of South Australia.
Published: R. J. Richards (1977), No. 131A.

178. Pouring vessel in the form of a goose with a slender neck (restored), globular body, down-turned tail, and prominent handle. Descriptive details of beak, eyes, wings, and feet are painted in underglaze iron-brown covered with a bluish-cream semi-opaque glaze. Buff stoneware body,

thick glazed foot-ring, and with a circular firing stand scar on the base which has partially collapsed in firing.
Height 29.5 cm.
Sawankhalok ware.
Fifteenth to sixteenth centuries.
Collection: Art Gallery of South Australia.
Published: R. J. Richards (1977), No. 343.

179. *Kendi* of squat globular form with a short neck and horizontal flange, mammiform spout, and a bevelled foot-ring. Decorated in underglaze iron-brown with interlocking quatrefoil panels with floral sprays and vegetal scroll infill. Spout with three phoenix amidst vegetal scrolls, and fern-like cloud collar on the shoulders. Brown stoneware body with a white slip to above the foot and covered with a transparent glaze (repaired).
Height 14.5 cm.
Sawankhalok ware.
Fifteenth to sixteenth centuries.
Collection: Northern Territory Museum of Arts and Sciences.

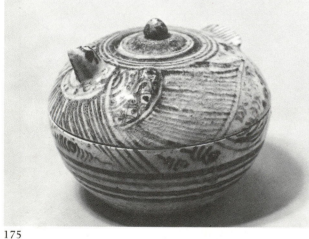

175

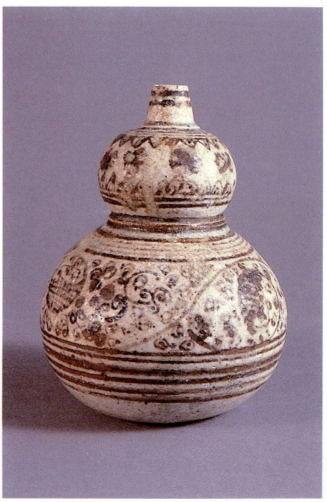

177

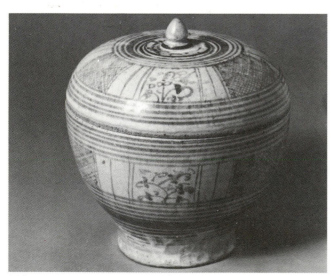

176

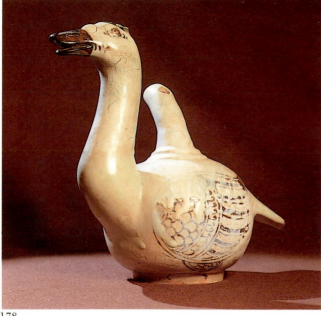

178

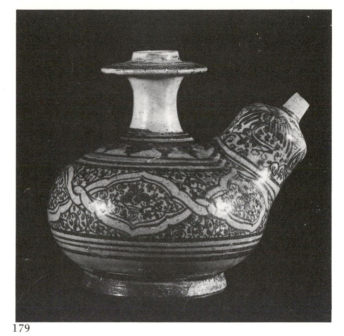

179

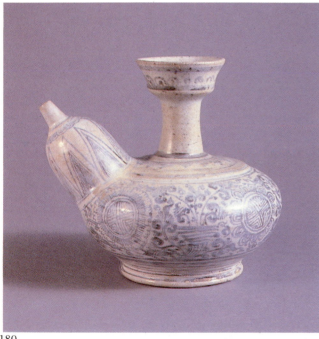

180

181

180. *Kendi* of squat globular form, with a tall cylindrical neck with a cup-like everted mouth, a mammiform spout, and a bevelled foot-ring. Decorated in underglaze iron-black with a band of petals between lines on the mouth, a collar of fern leaves on the shoulder, and four finely hatched flowers interspersed with vegetal sprays on the body. Spout with lotus petals on the neck and a collar of petals below the nipple. Buff stoneware body with a bluish-cream glaze. Unglazed base has a circular firing stand scar.

Height 15.4 cm.
Sawankhalok ware.
Fifteenth to sixteenth centuries.
Collection: Art Gallery of South Australia.
Published: R. J. Richards (1977), No. 129.

181. Figurine in the form of a kneeling woman, supporting on her right shoulder a hollow vessel and in her left hand a fan. Modelled and incised with decoration in iron-brown wash and a greenish-white glaze on the face and upper part of the body.

Grey stoneware body, unglazed. Base flat and unglazed.
Height 7.2 cm.
Sawankhalok ware.
Fifteenth to sixteenth centuries.
Collection: J. Carnegie.

Note: Such figurines, with the hollow vessel on the shoulder, may have served as incense holders. C. N. Spinks (1959, Pls. 26-27) published three examples, one with a reported provenance of North-Central Java. Male examples are rare but not unknown; see U. Wiesner (n.d.), Pl. 154, collected in the Philippines.

137

Iron-decorated Greenwares

182. Jar of globular form with small short neck and high foot-ring. Decorated in underglaze iron-black, with three floral sprays on the upper body banded at the collar and the waist with horizontal lines. Pink stoneware body with a crackled grey–green glaze above the foot. Unglazed base has a circular firing stand scar.
Height 9.3 cm.
Sawankhalok ware.
Fifteenth to sixteenth centuries.
Collection: Art Gallery of South Australia.
Published: R. J. Richards (1977), No. 258.

183. *Kendi* in the form of a bird, with globular body, the tiered feather tail and modelled head serving as handle and spout respectively. A cylindrical neck, with flared mouth, projecting vertically from the body, the rim fused with glaze to the head and tail. Descriptive details of the head, wings, tail feathers, and feet are painted in underglaze iron-brown. A vine tendril painted on the breast. Pink stoneware body covered with a crackled green glaze stopping irregularly above the bevelled foot. Base recessed and unglazed.
Height 10.3 cm.
Sawankhalok ware.
Fifteenth to sixteenth centuries.
Collection: Art Gallery of South Australia.
Published: R. J. Richards (1977), No. 334.

Greenwares

184. *Kendi* in the form of a bird, with globular body, the tail and head serving as handle and spout respectively. A cylindrical neck, with a cup-like mouth, projecting vertically from the body, glaze fusing the mouth to head and tail. Bird's eye and comb modelled and the body incised with descrip-tive detail of wings and tail features. A scalloped flower medallion on the breast. Ochre stoneware body covered with a crackled blue–green glaze to the foot. Unglazed base has a circular firing stand scar.
Height 9.7 cm.
Sawankhalok ware.
Fifteenth to sixteenth centuries.
Collection: Art Gallery of South Australia.
Published: R. J. Richards (1977), No. 333.

Note: Two larger examples with green glaze were found in Aceh, North Sumatra; see C. N. Spinks (1959), Figs. 38 and 39.

185. Jar of squat form with a bevelled neck and two lugs bridging the neck and shoulder. Pink stoneware body covered with a green glaze. Flat unglazed base.
Height 6 cm.
Sawankhalok ware.
Fifteenth to sixteenth centuries.
Private collection.

186. Bottle of ovoid form with everted mouth-rim, two lugs at the shoulder, and a bevelled foot-ring. Decorated with incised horizontal bands on the shoulder. Pink stoneware body with an olive-green glaze stopping well above the foot.
Height 12.3 cm.
Sawankhalok ware.
Fifteenth to sixteenth centuries.
Private collection.

187. Cup of cylindrical form with a waisted foot and decorated with diagonal grooves on the exterior. Pink stoneware body with a blue–green glaze stopping above the foot. Base flat and unglazed.
Height 5 cm.
Sawankhalok ware.
Fifteenth to sixteenth centuries.
Private collection.

188. Jar of squat globular form with a narrow neck and straight foot-ring. Decorated with a collar of incised double lotus petals on the shoulder, banded by double lines. Buff stoneware body covered with a matt blue–green glaze stopping irregularly at the foot. Unglazed base has a circular firing stand scar.
Height 5.8 cm.
Sawankhalok ware.
Fifteenth to sixteenth centuries.
Collection: Art Gallery of South Australia.
Published: R. J. Richards (1977), No. 257.

189. Covered jar of squat cylindrical form modelled into swelling lobed panels tapering to a small mouth. Cover of low conical form with a small knop handle and incised with radiating strokes. Pink stoneware body covered with a blue–green glaze to the foot-ring. Unglazed base has a circular firing stand scar.
Height 4 cm.
Sawankhalok ware.
Fifteenth to sixteenth centuries.
Collection: Art Gallery of South Australia.

190. Jar of gourd form with small flared mouth, two lugs at the waist, and bevelled foot-ring. Incised decoration on the lower section of irregular cross-hatching and two rings on the shoulder. Pink stoneware body covered with a blue–green glaze to the foot. Unglazed base has a circular firing stand scar.
Height 8.5 cm.
Sawankhalok ware.
Fifteenth to sixteenth centuries.
Private collection, Melbourne.

Note: L. Locsin and C. Y. Locsin (1967, Pl. 171) reproduce three examples from Philippine sites. C. N. Spinks (1959, Fig. 45) reported an example retrieved from the western coast of Sulawesi.

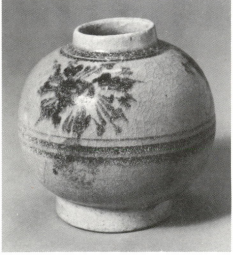

182

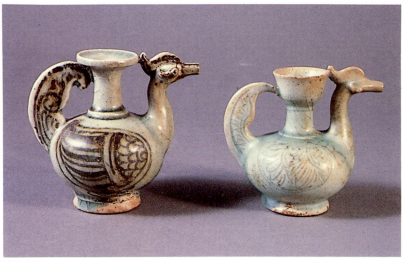

183, 184

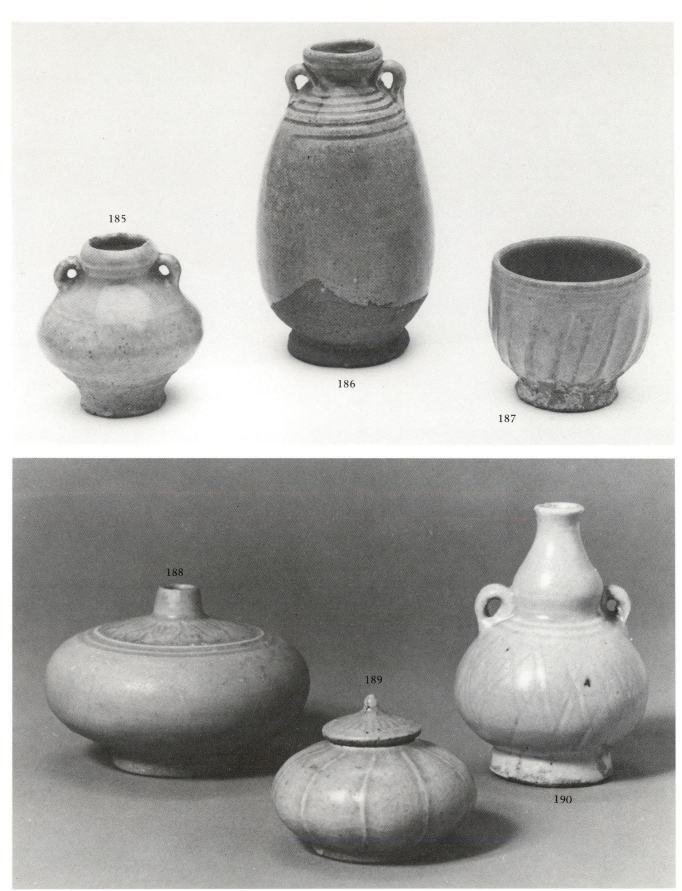

185

186

187

188

189

190

139

191. Bottle of pear shape with flared neck. Decorated with a central panel of incised lotus flowers on the body with bands of lotus petals above and below. Pink stoneware body covered with a glossy green glaze to above the foot. Unglazed base.
Height 20 cm.
Fifteenth to sixteenth centuries.
Collection: D. and M. Eysbertse.

192. Bottle of globular form with high shoulder rising to a small neck. Two lugs on the shoulder and a straight foot-ring. Incised decoration with collar of petals on the shoulder, five inverted lotus flowers on the body and a band of petals above the foot, each section separated by bands of lines. Pink stoneware body covered with a blue–green glaze to the foot. Unglazed base has a circular firing stand scar.
Height 17.7 cm.
Sawankhalok ware.
Fifteenth to sixteenth centuries.
Collection: Art Gallery of South Australia.
Published: R. J. Richards (1977), No. 239.

Note: A similar example in the Princessehof Museum, Leeuwarden, was acquired in Indonesia in 1928; see B. Harrisson (1978), Pl. 131.

193. Bottle of globular form with short neck and cupped mouth-rim, two lugs from shoulder to neck, and a straight foot-ring. Decorated with two bands of carved cloud-like lappets on the shoulder and an incised feathery grass scroll below, each separated by bands of lines. Pronounced vertical luting on the lower body. Buff stoneware body covered with a grey-green glaze stopping irregularly at the foot. Unglazed base has a circular firing stand scar.
Height 15.8 cm.
Sawankhalok ware.
Fifteenth to sixteenth centuries.
Collection: Art Gallery of South Australia.
Published: R. J. Richards (1977), No. 240.

Note: Similar examples retrieved from Puerto Galera, Mindoro (see L. Locsin and C. Y. Locsin (1967), Pl. 166), and from Central Bali (see C. N. Spinks (1959), Fig. 44).

194. Dish with a flattened petalled rim and a straight foot-ring. Decorated with a three-petalled flower centre medallion modelled in low relief. Incised classic scroll on the upper cavetto, a band of incised vertical lotus petal panels on the exterior. Pink stoneware body covered with a sea-green glaze. Unglazed base has a circular firing stand scar.
Diameter 32 cm.
Sawankhalok ware.
Fifteenth to sixteenth centuries.
Collection: Art Gallery of South Australia.

195. Dish of deep form with a flattened, foliate rim and a high straight foot-ring. Decorated with four incised lotus buds on the cavetto, the centre plain except for incised circles. The exterior incised with deep vertical flutings. Pink sandstone body, covered with a glassy olive-green glaze to above the foot. Base unglazed, with a circular firing stand scar.
Diameter 24 cm.
Sawankhalok ware.
Fifteenth to sixteenth centuries.
Collection: National Gallery of Victoria.
Presented by M. L. Abbott.

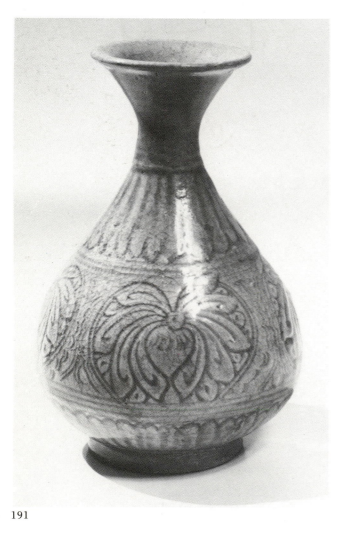

191

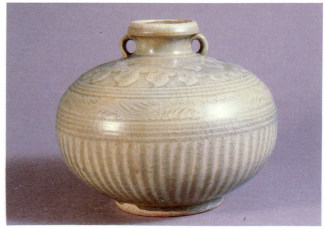

192

193

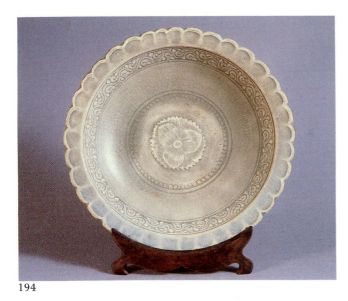

194

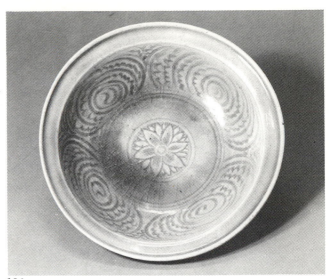

196

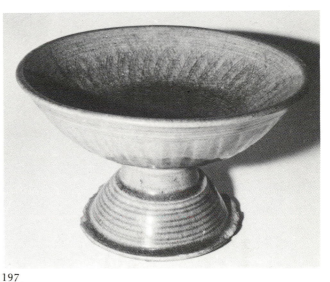

195 197

Note: L. Locsin and C. Y. Locsin (1967, Pls. 163–7) reproduce similar dishes excavated at Puerto Galera, Mindoro. See also C. N. Spinks (1959), Fig. 48, for a dish collected in Central Java, and Fig. 25, for one from East Sumba. The Koh Khram shipwreck in the Gulf of Thailand has yielded over 1,500 pieces of greenware so far, including dishes of this type.

196. Dish with flattened rim, rounded lip, and a tapering foot-ring. Decorated with an incised lotus flower in the centre medallion and four combed lotus sprays on the cavetto. The exterior plain. Buff-pink stoneware body covered to the foot-rim with a blue–green glaze. Unglazed base has a circular firing stand scar.
Diameter 26.8 cm.
Sawankhalok ware.
Fifteenth to sixteenth centuries.
Collection: D. Komesaroff.

Note: A grave site excavated in South Sulawesi in 1970 yielded a similar dish; see U. Tjandrasamita (1970), p. 21.

197. Dish with pedestal foot. Slightly flaring rim and a waisted stand flaring at the foot. Decorated with an incised petal motif on the interior and carved vertical grooves on the exterior. Stoneware body covered with a green glaze, pooling on the interior. Base unglazed.
Diameter 22 cm.
Sawankhalok ware.
Fifteenth to sixteenth centuries.
Collection: Formerly Jane Carnegie.

Note: Compare A. Ridho (1982), Pl. 95, from Sulawesi. Such vessels probably intended for holding offerings, and modelled after South-East Asian metal forms.

141

Comparative Chronology

China	Vietnam	Thailand
200 BC–AD 220 Han Dynasty	500 BC–AD 250 Dong-son culture	
220–589 Six Dynasties	111 BC–AD 979 Chinese occupation of Vietnam	AD 450 Earliest Sanskrit inscription
	100–537 Fu-nan	
	c.375 Sanskrit inscription from Champa	
589–618 Sui Dynasty		c.600 Khmer inscriptions in eastern provinces
618–906 Tang Dynasty	787 Javanese sea raids against Champa	
907–960 Five Dynasties		c.800 Expansion of Srivijaya into Menam Plain
907–1125 Liao Dynasty	939 Independence of Vietnam	1022–5 Khmer expansion
960–1127 Northern Song Dynasty	1009–1225 Ly Dynasty	c.1113–45 Khmer expansion into Sukhothai region
1128–1279 Southern Song Dynasty		c.1150 Lopburi rebels against Khmer rule
1115–1234 Jin Dynasty	1225–1400 Tran Dynasty	c.1220–50 Founding of kingdom of Sukhothai
1279–1368 Yuan Dynasty	1283–5 Mongol invasion of Champa	1350 Founding of kingdom of Ayudhya
1368–1644 Ming Dynasty	1400 Founding of capital of Thanh-hoa	1378 Ayudhya imposes lordship on Sukhothai
	1407–27 Ming occupation	1438 Sukhothai annexed by Ayudhya
		1463–91 Phitsanulok capital of kingdom of Ayudhya
	1428–1788 Le-Mac Dynasties	
		1569 Burmese conquest of Ayudhya

Glossary

Baidunzi

White felspathic material essential for the manufacture of porcelain and porcelain glazes, combined with *gaolingtu* to lower the latter's melting point. Name derived from '*bai tun ci*' meaning 'little white bricks', as the material excavated, crushed, washed and moulded into small bricks for transportation to the potteries.

Cavetto

Curved inner wall of a dish or bowl.

Celadon

Glaze coloured green by the introduction of iron oxide, fired in a reducing atmosphere. Stoneware or porcelain. Term coined in Europe, supposedly derived from a character in a seventeenth-century French play also dressed in a similarly coloured costume. *See* Greenware.

Chi

A type of dragon, known from Han times, distinguished by a small head and neck and the absence of horns; normally yellow in colour.

Cizhou ware

Named after the products of the Cizhou kilns in Hebei Province, but produced widely and regarded as a type rather than a specific kiln product. A sturdy stoneware, first produced in the Northern Song Dynasty, characterized by a grey body usually covered with a white slip, decorated with boldly painted designs in brown or black iron oxide, and covered with a creamy transparent glaze. In the Southern Song period, overglaze red and green enamel introduced, but relatively rare.

Dehua ware

Named after a pottery centre in Fujian Province. Fine porcelain varying in tone from a greyish white to a creamish white covered with a clear glaze. Later referred to as *blanc de chine*. The Dehua kilns were in full operation in the Ming period and may have begun as early as AD 1000.

Ding ware

White porcelain of the Song period, with an ivory glaze and carved or moulded decoration, usually of birds, dragons or floral motifs, made in Hebei Province. Name derived from the Dingzhou kiln in Hebei where the ware was first produced in the second half of the tenth century. Production continued into the Yuan period.

Gaolingtu

White plastic clay of a decomposed felspar base, which takes its name from a rich deposit located north of Jingdezhen called Gaoling—'High Ridge'—in the Jiangxi mountains. Principal source for the Jingdezhen porcelain industry. *Gaolingtu*, combined with *baidunzi*, forms the body of the porcelain, and turns a pure white in firing.

Greenware–*qingci*

Broad generic term better suited to identify that class of wares described by the European term 'celadon'. Technically identified as having a high-fired (minimum 1200 °C) glaze which is felspathic and contains elements of iron which produce the green colour in the glaze. Tonality varies with iron content and firing conditions. *See* Celadon.

Guan

Jar with broad rounded shoulder and wide mouth, intended usually as a vessel for wine.

Huihuiqing

'Mohammedan blue', the name given to the underglaze blue produced in early porcelain painted with an imported Middle Eastern cobalt.

Jingdezhen

Major centre of the Chinese ceramic industry, in Jiangxi Province. Kilns probably began production as early as the Tang Dynasty (618–906) and production still continues today. It was the first ceramic centre to produce good quality, blue-and-white ceramics in any quantity, during the Yuan period, 1280–1368.

Jizhou

Kilns in Jiangxi Province, active from the Tang Dynasty. Believed that potters from Cizhou in North China might have moved south to Jizhou when the Song capital transferred south to Hangzhou in the twelfth century. Early wares of Jingdezhen show the influence of *Jizhou* ware in the use of underglaze decoration in the choice of motifs, but whereas the Jizhou potters used iron oxides for underglaze decoration, the potters of Jingdezhen principally used cobalt oxide and, for a short time, copper oxide.

Kendi

Malay name for a spouted drinking or pouring vessel, derived from the Indian '*kundika*'.

Lingzhi

Glossy ganoderma (*Ganoderma lucidum*), a Chinese medicine. The herb of longevity in Taoist magic, generally represented as a fungus or mushroom depicted naturalistically, or stylized into scrolls.

Longquan ware

Greenware (celadon) which derives its name from the southern Zhejiang town of Longquan. The ware characterized by a greyish-white body and thick grey-green glaze. The body, where exposed, has a tendency to burn a brown-red in firing.

Nianhao

The title of an emperor's reign, painted as a reignmark on porcelain destined for use in the Imperial household. In practice not confined exclusively to imperial wares.

Oxidizing firing
The furnace is well supplied with oxygen and the fire is clear. Iron oxide, contained in the clay, becomes ferric oxide and colours the exposed body red.

Porcelain
High-fired pottery, fired at about 1300–1350 °C, composed mainly of *gaolingtu* and *baidunzi*. It is entirely vitrified, white, extremely hard, resonant when struck, and translucent when thin. Generally covered with a felspathic glaze.

Qilin
Chinese unicorn; fabulous creature with a horned dragon's head, hoofed feet and tufted tail, symbolizing longevity, happiness and good portent.

Qingbai
Literally 'bluish-white'. Fine white porcelain of the Song and Yuan periods with a highly vitrified, bluish glaze. Also called '*yingqing*', meaning 'shadowed blue or green'. Together with *shufu*, *qingbai* was a prototype for the first blue-and-white wares in the fourteenth century.

Reduction firing
With little oxygen entering the furnace, the combustion is smoky. The kiln fills with carbon monoxide, which turns to carbon dioxide by taking oxygen from the ferric oxide in the clay. The iron oxide becomes ferrous oxide and colours the body grey. If the clay has no trace of iron oxide, it remains white whatever the type of firing.

Ruyi
Literally 'as one wishes'. An 's'-shaped ornamental sceptre usually made of jade and carried by Buddhist deities as an emblem of authority. Popularly depicted, as a symbol of good luck, on porcelain decoration, especially as lappets on fourteenth-century blue-and-white.

Saggar
Box of refractory clay in which one or more porcelains are placed during firing, to shelter them from direct contact with the flames or falling ash. In reduction firing, the saggar should be air-tight. For an oxidized firing, air is allowed to enter.

Sgraffito
Decorative technique in which two layers of slip are placed one over the other, typically brown over white, and the design incised through the upper layer and the whole covered with a transparent glaze.

Shufu
White porcelain of the Yuan period. The decoration moulded in low relief under a white semi-opaque glaze and often included the characters *shu* and *fu*, literally 'imperial palace'. Together with *qingbai* ware, it was a prototype for the porcelains in underglaze blue in the fourteenth century.

Spurs
Clay firing supports separating individual pieces stacked in the kiln. See Fig. 39.

Stoneware
Pottery fired at about 1200–1280 °C, at which temperature it melts, vitrifies and becomes impermeable. The body is heavy, solid, close-grained, and not translucent.

Swatow ware
Boldly decorated wares made in the Ming period in South China, which were exported through the port of Swatow. Bases generally glazed and often with patches of sand adhered to the foot-ring.

'Three Friends in Winter'
Human virtues personified in nature. Bamboo, an evergreen, is a symbol of longevity, and bending in the wind is seen as a loyal friend even in poverty. Pine, the second friend, is also an evergreen and therefore seen as a symbol of longevity and as a steadfast friend in adversity. The prunus is the emblem of life, blossoming from apparent dormancy.

Xing ware
A porcelain ware named after the Xingzhow kiln in Hebei Province.

Yao
A kiln, its products referred to as the wares of that kiln.

Yingqing
High-fired wares with a clear bluish-green glaze made at a number of kilns from the Song period (960–1279) onwards. *See also Qingbai.*

Yue ware
Named after Shao-hsing in Zhejiang Province, produced as early as the third to fourth centuries and continued into the early Song period. Ware characterized by a grey stoneware body, and an olive-green to grey glaze; an early greenware.

Yuhuchunping
Pear-shaped bottle with a trumpet neck, usually a wine vessel.

Select Bibliography

Abbreviations

BMJ Brunei Museum Journal.
JMBRAS Journal of the Malaysian Branch of the Royal Asiatic Society.
JSS Journal of the Siam Society.
SMJ Sarawak Museum Journal.
SPAFA Southeast Asian Ministers of Education Organization Project in Archaeology and Fine
 Arts.
TOCS Transactions of the Oriental Ceramic Society.

Aalderink, B. V., *Ceramic Wares of Siam*, Amsterdam, Aalderink, B. V., 1978.
Abaya, C. G., 'The Brown Wares', *Manila Trade Pottery Seminar. Introductory Notes*, 1968
 (reprinted 1976).
_____ *The Villanueva Collection of Oriental Pottery*, Manila, R. T. Villanueva Foundation Inc.,
 1974.
Addis, J. M., 'A Group of Underglaze Red', *TOCS*, Vol. 31 (1957–9), pp. 15–37.
_____ 'A Group of Underglaze Red—A Postscript', *TOCS*, Vol. 36 (1964–6), pp. 89–102.
_____ 'Chinese Porcelain Found in the Philippines', *TOCS*, Vol. 37 (1967–9), pp. 17–36.
_____ 'Early Blue and White Excavated in the Philippines', *Manila Trade Pottery Seminar.
 Introductory Notes*, 1968a (reprinted 1976).
_____ 'Shu fu Type Wares Excavated in the Philippines', *Manila Trade Pottery Seminar.
 Introductory Notes*, 1968b (reprinted 1976).
_____ 'Some Buddhist Motifs as a Clue to Dating', *Manila Trade Pottery Seminar. Introductory
 Notes*, 1968c (reprinted 1976).
_____ 'Some Ch'ing Pai and White Wares Found in the Philippines', *Manila Trade Pottery Seminar.
 Introductory Notes*, 1968d (reprinted 1976).
_____ 'Underglaze Red Discovered in the Philippines', *Manila Trade Pottery Seminar. Introductory
 Notes*, 1968e (reprinted 1976).
_____ 'The Dating of Chinese Porcelain Found in the Philippines: A Historical Retrospect',
 Philippine Studies, Vol. 16, No. 2 (1968f), pp. 371–80.
_____ 'A Visit to Ching-te Chen', *TOCS*, Vol. 41 (1975–7), pp. 1–34.
_____ *Chinese Ceramics from Datable Tombs and Some Other Dated Material: A Handbook*, London,
 Sotheby Parke Bernet, 1978.
_____ *Chinese Porcelain from the Addis Collection*, London, British Museum Publications,
 1979.
_____ 'Porcelain—Stone and Kaolin: Late Yuan Developments at Hutian', *TOCS*, Vol. 45
 (1980–1), pp. 54–66.
Adhyatman, S., *Pameran Keramik Indonesia Tradisionil Dari Jaman Prasejarah Hingga Kini*, Jakarta,
 Ceramic Society of Indonesia, 1978.
_____ *The Adam Malik Ceramic Collection*, Jakarta, Ceramic Society of Indonesia, 1980.
_____ *Antique Ceramics Found in Indonesia, Various Uses and Origins*, Jakarta, Ceramic Society of
 Indonesia, 1981.
_____ *Notes on Early Olive Green Wares Found in Indonesia*, Jakarta, Ceramic Society of Indonesia,
 1983.
_____ 'Burmese Ceramics', *Himpunan Keramik Indonesia Bulletin*, May 1985, pp. 3–41.
_____ *Kendi*, Jakarta, Himpunan Keramik Indonesia, 1987.
Adhyatman, S. and Lammers, C., *Martavans in Indonesia*, Jakarta, Ceramic Society of Indonesia,
 1977.
Adhyatman, S. and Ridho, A., *Martavans in Indonesia*, Jakarta, Ceramic Society of Indonesia,
 1984 (revised ed.).

Aga-Oglu, K., 'Ming Export Blue and White Jars in the University of Michigan Collection', *The Art Quarterly*, Vol. 11 (1948), pp. 201–17.

_____ 'The Relationship between the Ying-ch'ing, Shu-fu and Early Blue and White', *Far Eastern Ceramic Bulletin*, Vol. I, No. 8 (1949), pp. 27–33.

_____ 'Early Blue and White Pot Excavated in the Philippines', *Far Eastern Ceramic Bulletin*, Vol. II, No. 4 (1950), pp. 64–71.

_____ 'Five Examples of Annamese Pottery', *Bulletin of the University of Michigan Museum of Art*, 5 (1954), pp. 6–11.

_____ 'Ming Porcelains from Sites in the Philippines', *Archives of the Chinese Art Society of America*, Vol. XVII (1963), pp. 7–19.

_____ *The Williams Collection of Far Eastern Ceramics*, Ann Arbor, University of Michigan, 1972.

_____ *The Williams Collection of Far Eastern Ceramics, Tonnancour Section*, Ann Arbor, University of Michigan, 1975.

Ambary, H. M., 'A Preliminary Report on the Excavation of the Urban Sites in Banten (West Java)', Jakarta, Pusat Penelitian Purabakala dan Peninggalan Nasional, 1977.

_____ 'Discovery of Potsherds in Sumatran Sites', paper presented to the *Symposium on Trade Pottery in East and Southeast Asia*, Hong Kong, 1978.

_____ (ed.), *Excavation Report at Pasar Ikan Jakarta*, Jakarta, Ceramic Society of Indonesia, 1981.

Arasaratnam, S., 'The Use of Dutch Material for Southeast Asian Historical Writing', *Journal of Southeast Asian History*, Vol. 3, No. 1 (1962), pp. 95–105.

Archipel, *Trade and Shipping in the Southern Sea. Selected Readings from Archipel 18 (1979)*, Bangkok, SPAFA, 1985.

Ashton, L., 'China and Egypt', *TOCS*, Vol. 11 (1933–4), pp. 62–72.

Asmar, T. and Bronson, B., *Laporan Ekskavasi Ratu Baka 1973*, Jakarta, National Research Centre of Archaeology, n.d.

Asmar, T. and Bronson, B. *et al.*, *Laporan Penelitian Rembang 1975*, Jakarta, National Research Centre of Archaeology, n.d.

Atil, E., 'Chinese Ceramics in Near Eastern Collections', *International Symposium on Chinese Ceramics, 1977*, Seattle, Seattle Art Museum, 1981, pp. 41–50.

Auret, C. and Maggs, T., 'The Great Ship *Sao Bento*: Remains from a Mid-sixteenth Century Portuguese Wreck on the Pondoland Coast', *Annals Natal Museum*, Vol. 25, No. 1 (1982), pp. 1–39.

Australian Art Exhibition Corporation, *The Chinese Exhibition*, Melbourne, Australian Art Exhibition Corporation, 1976.

Ayers, J., 'Some Characteristic Wares of the Yuan Dynasty', *TOCS*, Vol. 29 (1954–5), pp. 69–86.

_____ 'The Discovery of a Yuan Ship at Sinan, South-West Korea. A First Report', *Oriental Art*, Vol. xxiv, No. 1 (1978), pp. 79–85.

_____ (ed.), *Chinese Ceramics in the Topkapi Saray Museum, Istanbul: A Complete Catalogue*, 3 vols., London, Sotheby's Publications, 1986.

Barbetti, M. and Hein, D., 'Palaeomagnetism and High-resolution Dating of Ceramic Kilns in Thailand: A Progress Report', *World Archaeology*, Vol. 21, No. 1 (1989), pp. 51–70.

Barbosa, D., *The Book of Duarte Barbosa, An Account of the Countries Bordering on the Indian Ocean and Their Inhabitants A.D. 1518*, translated by M. S. Davies, Hakluyt Society XLIV, XLIX, 2 parts, London, 2nd ed., 1918, 1921.

Bassett, D. K., 'European Influence in Southeast Asia, c.1500–1630', *Journal of Southeast Asian History*, Vol. 4, No. 2 (1963), pp. 134–65.

Bellwood, P., 'Chinese Trade Ceramics in Archaeological Contexts in Northern Borneo', 1981 (unpublished paper).

Bellwood, P. and Omar, M., 'Trade Patterns and Political Developments in Brunei and Adjacent Areas, A.D. 700–1500', *BMJ*, Vol. 4, No. 4 (1980), pp. 155–79.

Bernet Kempers, A. J., *Ancient Indonesian Art*, Amsterdam, C. P. J. van der Peet, 1959.

Beurdeley, M., *Porcelain of the East India Companies*, London, Barrie & Rockliff, 1962.

Beveridge, A. S., *The Babur-nama in English*, London, 1969 (reprint).

Beyer, H. O., 'Outline Review of Philippine Archaeology by Islands and Provinces', *Philippine Journal of Science*, Vol. 77, Nos. 3–4 (1947), pp. 205–374.

Bezacier, L., *Manuel d'Archeologie d'Extreme-Orient*, Part 1, Vol. 11, Le Vietnam, Paris, 1972.

Blair, E. H. and Robertson, J. A., *The Philippine Islands: 1543–1898*, Cleveland, Clark & Co., 1903–9.

Blussé, L., 'Chinese Trade in Batavia during the Days of the V.O.C.', *Archipel*, No. 18 (1979), pp. 195–214.

Boode, P., 'Some Remarks on Pre-Ming and Early Fifteenth Century Blue and White Chinese Porcelains, with Special Reference to Pieces Found in the Dutch East Indies', *TOCS*, Vol. 21 (1945–6), pp. 9–17.

Boxer, C. R., *South China in the 16th Century, Being the Narratives of Galeote Pereita, Fr. Gaspar da Cruz, Fr. Martin de Rada, 1550–1575*, London, Hakluyt Society, 1953.

Brankston, A. D., *Early Ming Wares of Chingtechen*, Peiping, Henri Vetch, 1938 (reprinted Hong Kong, Vetch & Lee, 1970, and Oxford University Press, 1983).

Bronson, B., 'Exchange at the Upstream and Downstream Ends: Notes towards a Functional Model of the Coastal State in Southeast Asia', in K. L. Hutterer (ed.), *Economic Exchange and Social Inter-action in Southeast Asia: Perspectives from Pre-history, History and Ethnography*, Ann Arbor, University of Michigan, 1977, pp. 39–52.

Bronson, B. and Wisseman, J., 'An Archaeological Survey in Sumatra, 1973', *Sumatra Research Bulletin*, Vol. IV, No. 1 (1974), pp. 87–94.

Brown, C. C. (trans.), *Sejarah Melayu*, reprinted Kuala Lumpur, Oxford University Press, 1970.

———— 'An Early Account of Brunei by Sung Lien', *BMJ*, Vol. 2, No. 4 (1972), pp. 219–31.

———— 'The Eastern Ocean in the Yung-Lo Ta-Tien', *BMJ*, Vol. 4, No. 2 (1978), pp. 46–58.

Brown, R. M., 'Ceramic Excavations in the Philippines', *Transactions of the Southeast Asian Ceramic Society*, No. 1 (1973).

———— *The Legacy of Phra Ruang*, London, Bluett & Sons Ltd., 1974a.

———— 'The History of Ceramic Finds in Sulawesi', *Transactions of the Southeast Asian Ceramic Society*, No. 5 (1974b).

———— 'Preliminary Report on the Koh Khram Sunken Ship', *Oriental Art*, Vol. XXI, No. 4 (1975), pp. 356–70.

———— *The Ceramics of South-East Asia: Their Dating and Identification*, Singapore, Oxford University Press, 1977; 2nd ed., 1988.

———— *et al.*, *Legend and Reality: Early Ceramics from Southeast Asia*, Kuala Lumpur, Oxford University Press, 1978.

Bulbeck, F. D., 'Survey of Open Archaeological Sites in South Sulawesi, 1986–1987', *Indo-Pacific Prehistory Association Bulletin*, 7 (1986–7), pp. 36–50.

Burns, P. L., 'Ceramics Production at Sisatchanalai, Thailand', in *Proceedings of the XXXI International Congress of Human Sciences in Asia and North Africa (Tokyo-Kyoto, 1983)*, Tokyo, The Tōhō Gakkai, 1984, Vol. 1, pp. 401–3.

Bushell, S. W., *Chinese Pottery and Porcelain, being a Translation of the Tao Shua*, Kuala Lumpur, Oxford University Press, 1977 (reprint of 1910 ed.)

Carletti, F., *My Voyage Around the World (1594–1606)*, London, Methuen, 1965.

Carswell, J., 'China and the Near East: The Recent Discovery of Chinese Porcelain in Syria', *Percival David Foundation Colloquies on Art and Archaeology in Asia*, No. 3 (1973), pp. 20–5.

———— 'China and Islam in the Maldive Islands', *TOCS*, Vol. 41 (1976–7), pp. 119–98.

———— 'China and Islam. A Survey of the Coast of India & Ceylon', *TOCS*, Vol. 42 (1977–8), pp. 24–68.

———— 'Medieval Trading Port in the Indian Ocean', *The Illustrated London News*, October 1983, p. 84.

Chamoraman, C., 'Some Historical International Ports of the Malay Peninsula', *The Great Circle*, Vol. 2, No. 1 (1980), pp. 18–23.

Chan Cheung, 'The Smuggling Trade between China and Southeast Asia during the Ming Dynasty', in F. S. Drake (ed.), *Symposium on Historical, Archaeological and Linguistic Studies on Southern China, Southeast Asia and the Hong Kong Region*, Hong Kong, Hong Kong University Press, 1967, pp. 223–7.

Chan Hok-lam, 'Chinese Refugees in Annam and Champa at the End of the Sung Dynasty', *Journal of Southeast Asian History*, Vol. VII, No. 2 (1966), pp. 1–10.

Chandran, J. and Baharuddin, J. (eds.), *Lembah Bujang. The Bujang Valley*, Kuala Lumpur, Persatuan Sejarah Malaysia, 1980.

Chang T'ien-Tse, *Sino-Portuguese Trade from 1514 to 1644*, Leiden, 1934 (reprinted 1969).

Changsha Cultural Bureau, 'Tang Kiln-sites of Tongguan, Changsha', *The Southeast Asian Ceramic Society, New Discoveries in Chinese Ceramics*, No. 3 (1981), pp. 1–42.

Chareonwongse, P. (ed.), *Sangkalok Sisatchanalai*, Bangkok, Department of Fine Arts, 1987 (in Thai).

Charnvit, K., *The Rise of Ayudhya: A History of Siam in the Fourteenth and Fifteenth Centuries*, Kuala Lumpur, Oxford University Press, 1976.

Chau Ju-kua *see* Zhao Rugua.

Cheng Te-K'un, *Archaeology in Sarawak*, Cambridge, Heffer and Sons, 1969.

———— 'Tang Ceramic Wares of Ch'ang-sha', *Journal of the Institute of Chinese Studies*, Vol. III, No. 1 (1970), pp. 163–216.

———— 'The Study of Ceramic Wares in Southeast Asia', *Journal of the Institute of Chinese Studies*, Vol. 5, No. 5 (1972), pp. 1–40.

Chin, L., 'Trade Pottery Discovered in Sarawak 1948–1976', *SMJ*, Vol. XXV, No. 46 (1977a), pp. 3–9.

———— 'Impact of Trade Ceramic Objects on Some Aspects of Local Culture', *SMJ*, Vol. XXV, No. 46 (1977b), pp. 67–9.

———— *Cultural Heritage of Sarawak*, Kuching, Sarawak Museum, 1980.

———— *Ceramics in the Sarawak Museum*, Kuching, Sarawak Museum, 1988.

Chin, L. and Nyandoh, R., 'Archaeological Work in Sarawak', *SMJ*, Vol. XXIII, No. 44 (1975), pp. 1–7.

147

Chindavij, N., *Chinese Ceramics from Archaeological Sites in Thailand*, Bangkok, Department of Fine Arts, 1986.

Chitrabongs, M. R. C., *Thai Ceramics*, Bangkok, 1985 (in Thai).

Chittick, N., 'East African Trade with the Orient', in D. S. Richards (ed.), *Islam and the Trade of Asia*, Oxford, B. Cassirer, 1970, pp. 97–104.

——— *Kilwa, An Islamic Trading City on the East African Coast*, 2 vols., Nairobi, BIEA, 1974.

Chiu Ling-yeong, 'Chinese Maritime Expansion, 1368–1644', *Journal of the Oriental Society of Australia*, Vol. 3, No. 1 (1965), pp. 27–47.

——— 'Sino-Javanese Relations in the Early Ming Period', in F. S. Drake (ed.), *Symposium on Historical, Archaeological and Linguistic Studies on Southern China, Southeast Asia and the Hong Kong Region*, Hong Kong, Hong Kong University Press, 1967, pp. 214–21.

Chou Ta-Kuan *see* Zhou Daquan.

Chu Boqian, 'Report on the Excavation of Lung-ch'uan Celadon Kiln-sites in Chekiang', *Oriental Ceramic Society. Chinese Translations*, No. 2 (1968).

——— 'Important Discoveries of Early Blue and White Porcelains. Song Blue and White from Zhejiang', *The Southeast Asian Ceramic Society. New Discoveries in Chinese Ceramics*, No. 3 (1981), pp. 43–6.

Chung Yang-Mo, *Cultural Relics Found off the Sinan Coast*, Seoul, National Museum of Korea, 1977.

Coedès, G., 'The Excavations at P'ong Tuk and Their Importance for the Ancient History of Siam', *JSS*, Vol. 21, Pt. 3 (1928), pp. 195–210.

——— 'Les Statues Decapitees de Savank'alok', *Bulletin et Travaux de L'Institut Indochinois pour L'Etude de L'Homme*, Vol. 11, No. 2 (1939), pp. 189–90.

——— *The Making of Southeast Asia*, London, Routledge & Kegan Paul, 1966.

——— *The Indianized States of Southeast Asia*, Honolulu, East–West Center Press, 1968.

Cole, F. C., 'Chinese Pottery in the Philippines', *Field Museum of Natural History*, Chicago, Field Museum of Natural History, 1912–13 (reprinted Kraus, 1968).

Colless, B. E., 'The Early Western Ports of the Malay Peninsula', *Journal of Tropical Geography*, Vol. 29 (1969a), pp. 1–9.

——— 'Persian Merchants and Missionaries in Medieval Malaya', *JMBRAS*, Vol. 2, Pt. 2 (1969b), pp. 10–47.

——— 'Majapahit Revisited: External Evidence on the Geography and Ethnology of East Java in the Majapahit Period', *JMBRAS*, Vol. 48, Pt. 2 (1975), pp. 124–61.

Collis, M. S., 'Fresh Light on the Route Taken by Export Porcelains from China to India and the Near East during the Ming Period', *TOCS*, Vol. 13 (1935–6), pp. 9–29.

Cortesão, A. (trans.), *The Suma Oriental of Tomé Pires*, 2 vols., London, Hakluyt Society, 1944 (reprinted 1980). *See also entry under* Pires, Tomé.

D'Argencé R.-Y. L., *Les Ceramiques a base chocolatée au Musée Louis Finot de L'Ecole Francaise D'Extreme Orient*, Paris, Ecole Francaise d'Extreme-Orient, 1958.

Dars, J., 'Les jongues chinoises de haute mer sous les Song et less Yuan', *Archipel*, 18 (1979), pp. 41–56.

David, P., 'Ying-ch'ing, a Plea for a Better Term', *Oriental Art*, Vol. 1, No. 2 (1955), pp. 52–3.

Di Meglio, R. R., 'Arab Trade with Indonesia and the Malay Peninsula from the 8th to the 16th Century', in D. S. Richards (ed.), *Islam and the Trade of Asia*, Oxford, B. Cassirer, 1970, pp. 305–35.

Dofflemyer, V., *Southeast Asian Ceramics from the Collection of Margot and Hans Ries*, Pasadena, Pacific Asia Museum, 1989.

Donnelly, P. J., *Blanc de Chine*, London, Faber & Faber, 1969.

——— 'Chinese and Annamese Ceramics from the Philippines and Indonesia', *Connoisseur*, Vol. 184, No. 742 (1973), pp. 235–9.

——— 'Chinese Porcelain with Inscriptions in the Arabic Script', *Connoisseur*, Vol. 188, No. 755 (1975), pp. 7–13.

Duyvendak, J. J. L., 'The True Dates of the Chinese Maritime Expeditions in the Early 15th Century', *T'oung Pao*, Vol. XXXIV (1938), pp. 341–412.

——— *China's Discovery of Africa*, London, Probsthian, 1949.

Edwards McKinnon, E. P., 'Oriental Ceramics Excavated in North Sumatra', *TOCS*, Vol. 41 (1975–7), pp. 59–118.

——— 'Research into the Disposition of Ceramic Sites in North Sumatra', *The Southeast Asian Ceramic Society* (1976).

——— 'Research at Kota Cina, a Sung–Yuan Period Trading Site in East Sumatra', *Archipel*, 14 (1977), pp. 19–32.

——— 'A Note on the Discovery of Spur-marked Yueh-type Sherds at Bulik Seguntang Palembang', *JMBRAS*, Vol. LIII, Pt. 2 (1979), pp. 40–7.

——— 'A Brief Note on Muara Kumpeh Hilir: An Early Port Site on the Batang Hari', *SPAFA Digest*, Vol. III, No. 2 (1982), pp. 37–40.

——— 'Beyond Serandib: A Note on Lambri at the Northern Tip of Aceh', *Indonesia*, No. 46 (1988), pp. 103–21.

Edwards McKinnon, E. and Milner, A. C., 'A Letter from Sumatra: A Visit to Some Early Sumatran Historical Sites', *Indonesia Circle*, 18 (1979), pp. 3–21.

Edwards McKinnon, E. and Sinta Dermawan, B., 'Further Ceramic Discoveries at Sumatran Sites', *The Southeast Asian Ceramic Society. Transactions*, No. 8 (1981), pp. 2–17.

Eng-Lee Seok Chee *et al.*, *Kendis*, Singapore, National Museum, 1984.

Fatami, S. Q., 'In Quest of Kalah', *Journal of Southeast Asian History*, Vol. 1, No. 2 (1960), pp. 62–101.

Feng Xianming, 'Important Finds of Chinese Ceramics since 1949', *Oriental Ceramic Society. Chinese Translations*, No. 1 (1967).

_____ 'Some Problems Concerning the Origins of Blue and White Porcelains', *The Southeast Asian Ceramic Society. New Discoveries in Chinese Ceramics*, No. 3 (1981a), pp. 50–6.

_____ 'Export of Chinese Porcelains up to the Yuan Dynasty', *SPAFA Digest*, Vol. II, No. 1 (1981b), pp. 4–7, and Vol. II, No. 2 (1981c), pp. 37–41.

Flood, T. E., 'Sukhothai–Mongol Relations: A Note on Relevant Chinese and Thai Sources', *JSS*, Vol. LVII, No. 2 (1969), pp. 201–57.

Forbes, A. D. W., 'Tenasserim: The Thai Kingdom of Ayutthaya's Link with the Indian Ocean', *Indian Ocean Newsletter*, Vol. 3, No. 1 (1982), pp. 1–3.

Fournereau, L., 'La Céramique du Thais, Le Siam Ancien', *Annales du Musée Guimet*, 1908.

Fox, R. B., 'The Calatagan Excavations. Two Fifteenth Century Burial Sites in Batangas, Philippines', *Philippine Studies*, Vol. 7, No. 3 (1959), pp. 325–90.

_____ 'Chinese Pottery in the Philippines', in S. S. C. Liao (ed.), *Chinese Participation in Philippine Culture and Economy*, Manila, 1964, pp. 96–113.

_____ 'The Archaeological Record of Chinese Influences in the Philippines', *Philippine Studies: A Quarterly*, Vol. 15, No. 1 (1967), pp. 41–62.

Franke, W. and Ch'en T'ieh-fan, 'A Chinese Tomb Inscription of A.D. 1264 Discovered Recently in Brunei', *BMJ*, Vol. 3, No. 1 (1973), pp. 91–6.

Frasche, D. F., *Southeast Asian Ceramics. Ninth through Seventeenth Centuries*, New York, The Asia Society, 1976.

Frierman, J. D., 'T'ang and Sung Ceramics Exported to the West in the Light of Archaeological Discoveries', *Oriental Art*, No. XXIV, Pt. 2 (1978), pp. 195–200.

Fujian, 'A Brief Report on the Latest Excavations of an Ancient Kiln Site at Dehua in Fujian', *The Southeast Asian Ceramic Society, Chinese Translations*, No. 2 (1980), pp. 1–14.

Fung Ping Shan Museum, *Exhibition of Ceramic Finds from Ancient Kilns in China*, Hong Kong, University of Hong Kong, 1981.

_____ *Ceramic Finds from Tang and Song Kilns in Guangdong*, Hong Kong, Fung Ping Shan Museum, University of Hong Kong, 1985.

Gardiner, K., 'Vietnam and Southern Han: Part I', *Papers on Far Eastern History*, Vol. 23 (1981), pp. 64–110, and Part II, Vol. 28 (1983), pp. 23–48.

Garner, H., 'The Use of Imported and Native Cobalt in Chinese Blue & White', *Oriental Art*, Vol. 2, No. 2 (1956), pp. 48–50.

_____ *Oriental Blue and White*, London, Faber & Faber, 3rd ed., 1970.

Gibb, H. A. R. (trans.), *Ibn Battuta. Travels in Asia and Africa 1325–1354*, London, Routledge & Kegan Paul, 1929. *See also entry under* Ibn Battuta.

Gibson-Hill, C. A., 'Johore Lama and Other Ancient Sites on the Johore River', *JMBRAS*, Vol. 28, Pt. 2 (1955), pp. 126–97.

Gittinger, M., *Master Dyers to the World. Technique and Trade in Early Indian Dyed Cotton Textiles*, Washington, Textile Museum, 1982.

Goddio, F., *Discovery and Archaeological Excavation of a 16th Century Trading Vessel in the Philippines*, Lausanne, 1988.

Goloubew, V., 'La Province de Thanh-hoa et sa céramique', *Revue de Arts Asiatiques*, VII (1931–2), pp. 112–16.

Gompertz, G. St. G. M., *Celadon Wares*, London, Faber & Faber, 1968.

Goto Museum, *South-East Asian Ceramics*, Tokyo, The Goto Museum, 1986.

Gray, B., 'Blue and White Vessels in Persian Miniatures of the 14th and 15th Centuries Re-examined', *TOCS*, Vol. 24 (1948–9), pp. 23–30.

_____ 'Chinese Porcelain of the 14th Century; I. Blue and White for the Arab Trade', *British Museum Quarterly*, Vol. XXIII, No. 3 (1960), pp. 86–91, and 'II. With Copper-Red Decoration or Celadon Glaze', *British Museum Quarterly*, Vol. XXIV, No. 1 & 2 (1961), pp. 50–3.

_____ 'The Export of Chinese Porcelain to India', *TOCS*, Vol. 36 (1964–6), pp. 21–37.

_____ 'The Export of Chinese Porcelain to the Islamic World: Some Reflections on Its Significance for Islamic Art before 1400', *TOCS*, Vol. 41 (1975–7), pp. 231–61.

_____ *Sung Porcelain and Stoneware*, London, Faber & Faber, 1983.

Green, J. N., 'Further Light on the Koh Khram Wrecksite', *The Southeast Asian Ceramic Society Transactions*, No. 8 (1981), pp. 18–26.

Green, J. N. and Harper, R., *The Excavation of the Pattaya Wrecksite and Survey of Three Other Sites, Thailand, 1982*, Fremantle, Australian Institute for Maritime Archaeology, 1983.

_____ 'The Maritime Archaeology of Shipwrecks and Ceramics in Southeast Asia', *Australian Institute for Maritime Archaeology Special Publication No. 4*, Melbourne, 1987, pp. 1–37.

Green, J. N., Harper, R., and Intakosi, V., 'The Ko Si Chang Three Shipwreck Excavation 1986', *Australian Institute for Maritime Archaeology Special Publication No. 4*, Melbourne, 1987, pp. 39–79.

Green, J. N., Harper, R. and Prishanchittara, S., *The Excavation of the Ko Kradat Wrecksite: Thailand 1979–80*, Perth, Western Australia Museum, 1981.

Greensted, M. and Hardie, P., *Chinese Ceramics: the Indian Connection*, Bristol, City of Bristol Museum and Art Gallery, 1982.

Griffing, R. P. Jr., 'Dating Annamese Blue and White', *Orientations*, Vol. 7, No. 5 (1976), pp. 32–50.

Grimm, T., 'Thailand in the Light of Official Chinese Historiography, A Chapter in the History of the Ming Dynasty', *JSS*, Vol. 49, No. 1 (1961), pp. 1–20.

Griswold, A. B. and Prasert Na Nagara, 'Epigraphic and Historical Studies, No. 10: King Lodaiya of Sukhodaya and his Contemporaries', *JSS*, Vol. 60, No. 1 (1972), pp. 21–152.

_____ 'A 15th Century Siamese Historical Poem', in C. D. Cowan and O. W. Wolters (eds.), *Southeast Asian History and Historiography: Essays Presented to D. G. E. Hall*, Ithaca, Cornell University Press, 1976, pp. 123–63.

Groslier, B. P., 'Introduction to the Ceramic Wares of Angkor', in Southeast Asian Ceramic Society, *Khmer Ceramics 9th–14th Century*, Singapore, Southeast Asian Ceramic Society, 1981a, pp. 9–39.

_____ 'La céramique chinoise en Asie du Sud-est: quelques points de méthode', *Archipel*, 21 (1981b), pp. 93–121.

Gutman, P., 'The Martaban Trade–An Examination of the Literature, c. 7th–18th Centuries', paper presented to the *Symposium on Trade Pottery in East and Southeast Asia*, Hong Kong, 1978.

_____ 'The Martaban Trade–An Examination of the Literature, c. 7th–18th Centuries', *Burmese Ceramics*, Adelaide, University of Adelaide, Research Centre for Southeast Asian Ceramics Paper 6, 1989.

Guy, J. S., *Oriental Trade Ceramics in Southeast Asia: 10th to 16th Century*, Melbourne, National Gallery of Victoria, 1980.

_____ 'A Summary Analysis of Foreign Ceramic Finds on Panay Island', in *Philippine Quarterly of Culture and Society*, Vol. 9, No. 3 (1981), pp. 217–24.

_____ 'Vietnamese Trade Ceramics', in Southeast Asian Ceramic Society, *Vietnamese Ceramics*, Singapore, Southeast Asian Ceramic Society, 1982, pp. 28–35.

_____ 'Vietnamese Ceramics', in T. Mikami (ed.), *Ceramic Art of the World, Vol. 16, Southeast Asian Ceramics*, Tokyo, Shogakukan, 1984a, pp. 119–50.

_____ 'Trade Ceramics in Southeast Asia and the Acculturation Process', *Trade Ceramic Studies*, No. 4 (1984b), pp. 117–26.

_____ 'Vietnamese Ceramics and Cultural Identity: Evidence from the Ly and Tran Dynasties', in D. Marr and A. Milner (eds.), *Southeast Asia in the 9th to 14th Centuries. Proceedings of a Symposium Held at the Australian National University, May 1984*, Singapore, Institute of Southeast Asian Studies (forthcoming).

_____ *Ceramic Excavation Sites in Southeast Asia: A Preliminary Gazetteer*, Adelaide, University of Adelaide, Research Centre for Southeast Asian Ceramics Paper 3, 1987.

_____ 'Glazed Ceramics Retrieved from MAD I', in P. Bellwood (ed.), *Archaeological Research in South-Eastern Sabah*, Sabah Museum, Monograph Vol. 2, 1988, pp. 231–4.

_____ 'The Vietnamese Wall Tiles of Majapahit', *TOCS*, Vol. 53 (1988–9).

_____ *Ceramic Traditions of South-East Asia*, Singapore, Oxford University Press, 1989.

_____ 'Southeast Asian Glazed Ceramic Design: A Study of Sources', in G. Kunagawa (ed.), *Proceedings of a Symposium on the Ceramic Art of China, 16–17 September, 1989*, Los Angeles County Museum of Art (forthcoming).

Guy, J. and Richards, R. J., *Architectural Ceramics of the Sukhothai Kingdom*, Adelaide, University of Adelaide, Research Centre for Southeast Asian Ceramics Paper 5, 1989.

Ha Thac Can and Nguyen Bich, 'Discovery of the Chu Dau Kiln', *Arts of Asia*, Vol. 19, No. 3 (1989), pp. 116–21.

Hadimuljono and Macknight, C. C., 'Imported Ceramics in South Sulawesi', *Review of Indonesian and Malayan Affairs*, Vol. 17 (1983), pp. 66–91.

Hall, D. G. E., *A History of Southeast Asia*, London, Macmillan, 1955.

Hall, K. R., 'Khmer Commercial Development and Foreign Contacts under Suryavarman I', *Journal of the Economic and Social History of the Orient*, Vol. XVIII, Pt. III (1975), pp. 318–36.

_____ 'Eleventh Century Commercial Developments in Angkor and Champa', *Journal of Southeast Asian Studies*, Vol. 10, No. 2 (1979), pp. 420–34.

_____ *Trade and Statecraft in the Age of Cōlas*, New Delhi, Adhinav Publications, 1980.

_____ 'Trade and Statecraft in the Western Archipelago at the Dawn of the European Age', *JMBRAS*, Vol. LIV, Pt. 1 (1981a), pp. 21–47.

_____ 'The Expansion of Maritime Trade in the Indian Ocean and Its Impact upon Early State Development in the Malay World', *Review of Indonesian and Malayan Affairs*, Vol. 15, No. 2 (1981b).

Hall, K. R. and Whitmore, J. K., 'Southeast Asian Trade and the Isthmian Struggle, 1000–1200 A.D.', in K. R. Hall and J. K. Whitmore (eds.), *Explorations in Early Southeast Asian History: The Origins of Southeast Asian Statecraft*, Ann Arbor, University of Michigan, 1976, pp. 303–40.

Hansman, J., *Julfar, An Arabian Port: Its Settlement and Far Eastern Ceramic Trade from the 14th to the 19th Centuries*, London, Royal Asiatic Society, 1985.

Hardie, P., 'China's Ceramic Trade with India', *TOCS*, Vol. 48 (1983–4), pp. 15–33.

Harper, R., *A Study of Painted Underglaze Decorated Sherds Sisatchanalai, Thailand*, Adelaide, University of Adelaide, Research Centre for Southeast Asian Ceramics Paper 2, 1987.

Harrisson, B., 'Classification of Archaeological Trade Ceramics from Kota Batu', *BMJ*, Vol. 2, No. 1 (1970), pp. 114–88.

_____ *Oriental Celadon. The Princessehof Collections*, Leeuwarden, Gemeentelijk Museum Het Princessehof, 1978.

_____ *Pusaka, Heirloom Jars of Borneo*, Singapore, Oxford University Press, 1986 (reprinted 1990).

Harrisson, B. and Shariffuddin, P. M., 'Sungai Lumut, a 15th Century Burial Ground', *BMJ*, Vol. 1, No. 1 (1969), pp. 24–56.

Harrisson, T., 'Note on Chinese Ceramic Taste in Borneo', *Far Eastern Ceramic Bulletin*, Vol. III, No. 4 (1951), pp. 16–18.

_____ 'Ceramics Penetrating Central Borneo', *SMJ*, Vol. 6, No. 6 (1955a), pp. 549–60.

_____ 'Some Ceramics Excavated in Borneo', *TOCS*, 23 (1955b), pp. 11–21.

_____ 'The Preliminary Report of the Kota Batu Excavation', *SMJ*, Vol. VII (1956), pp. 283–319.

_____ '"The Ming Gap" and Kota Batu, Brunei', *SMJ*, Vol. VIII (1958), pp. 273–7.

_____ 'Export Wares Found in West Borneo', *Oriental Art*, Vol. V, No. 1 (1959), pp. 42–51.

_____ 'Trade Porcelain and Stoneware in Southeast Asia (including Borneo)', *SMJ*, Vol. X, No. 17–18 (1961), pp. 222–6.

_____ 'The Great Cave of Niah', *SMJ*, Vol. XII, No. 25 (1965), pp. 413–18.

_____ 'The Kelabit "Duck Ewer" in Sarawak Museum', *SMJ*, Vol. XVI, No. 32–33 (1968), p. 100.

_____ 'Carbon-14 Dates from Kota Batu, Brunei', *Asian Perspectives*, Vol. XVI, No. 2 (1973), pp. 197–9.

_____ 'Borneo Archaeology in the Future: Comments on Dr. Solheim's Paper', in G. N. Appell and L. R. Wright (eds.), *The Status of Social Science Research in Borneo*, Ithaca, Cornell University, 1978, pp. 17–19.

Harrisson, T. and Harrisson, B., 'The Prehistoric Cemetery of Tanjong Kubor', *SMJ*, Vol. VIII, No. 10 (1957).

_____ 'The Prehistory of Sabah', *Sabah Society Journal*, Vol. IV (1969–70).

Harrisson, T. and O'Connor, S. J., 'Western Peninsular Thailand and West Sarawak—Ceramic and Statuary Comparisons', *SMJ*, Vol. XII, No. 23 (1964), pp. 562–7.

_____ *Excavations of the Prehistoric Iron Industry in West Borneo*, 2 vols., Ithaca, Cornell University, Southeast Asia Program Data Paper No. 72, 1969.

Hasebe, G., *Ceramic Art of the World, Volume 12. Sung Dynasty*, Tokyo, Shogakukan, 1977.

_____ 'Ceramics with Underglaze Iron-oxide Design from South China', paper presented to the *Symposium on Trade Pottery in East and Southeast Asia*, Hong Kong, 1978.

_____ *Ancient Ceramics from Thailand and Vietnam*, Tokyo, Shoto Museum of Art, 1988 (in Japanese).

_____ *Song Ceramics*, Tokyo, Society of Chinese Ceramic History, 1989 (in Japanese).

Hasebe, G. and Omori, K., *Southeast Asian Ceramics from the Collection of Mr and Mrs Andrew M. Drzik*, Tokyo, privately published, 1983.

Hasebe, G. and Yabe, Y., *Chinese Ceramics Excavated in Japan*, Tokyo, Tokyo National Museum, 1978.

Hayashiya, S. and Trubner, H., *Chinese Ceramics from Japanese Collections. Tang through Ming Dynasties*, New York, Asia Society, 1977.

Hein, D., 'Sawankhalok Kilns—A Recent Discovery', *Bulletin of the Art Gallery of South Australia*, Vol. 38 (1980), pp. 10–17.

Hein, D. *et al.*, 'Sawankhalok Kilns—Further Discoveries', *Bulletin of the Art Gallery of South Australia*, Vol. 39 (1981–2), pp. 37–47.

Hein, D. *et al.*, 'An Alternative View of the Origin of Ceramic Production at Sisatchanalai and Sukhothai, Thailand', *SPAFA Digest*, Vol. VII, No. 1 (1986), pp. 22–33.

Hein, D. and Barbetti, M., 'Sisatchanalai and the Development of Glazed Stoneware in Southeast Asia', *Siam Society Newsletter*, Vol. 4, No. 3 (1988), pp. 8–18.

Hein, D. and Sangkhanukit, P., *Report on the Excavation of the Ban Tao Hai Kilns, Phitsanulok, Thailand*, Adelaide, University of Adelaide, Research Centre for Southeast Asian Ceramics Paper 1, 1987.

Hirth, F. and Rockhill, W. W. (trans. and annot.), *Chau Ju-kua; His Work on the Chinese and Arab*

Trade in the Twelfth and Thirteenth Centuries, Entitled Chu-fan-chi, St. Petersberg, Imperial Academy of Sciences, 1911 (reprinted Amsterdam, 1966, and Taipei, 1967). *See also entry under* Zhao Rugua (Chau Ju-kua).

Ho Ching Hin and Ng, B., 'Sha Tsui, High Island', *Journal of the Hong Kong Archaeological Society*, Vol. V (1974), pp. 28–33.

Ho Chuimei, Minnan Blue and White Wares', in R. Scott and G. Hutt (eds.), *Style in the East Asia Tradition. Colloquies on Art and Archaeology in Asia No. 14*, University of London, 1987.

Hobson, R. L., 'Potsherds from Brahminabad', *TOCS* (1928–30), pp. 21–3.

_____ 'Blue and White before the Ming Dynasty. A Pair of Dated Yuan Vases', *Old Furniture*, Vol. VI (1929), pp. 3–8.

Holmgren, J., *Chinese Colonization of Northern Vietnam: Administrative Geography and Political Developments in the Tongking Delta, First to Sixth Centuries A.D.*, Canberra, Australian National University Press, 1980.

Horridge, A., *The Prahu. Traditional Sailing Boat of Indonesia*, Kuala Lumpur, Oxford University Press, 1981; 2nd ed., Singapore, Oxford University Press, 1985.

Howitz, P. C., 'Two Ancient Shipwrecks in the Gulf of Thailand. A Report on Archaeological Investigations', *JSS*, Vol. 65, Pt. 2 (1977), pp. 1–22.

_____ *Ceramics from the Sea. Evidence from the Koh Kradad Shipwreck Excavated in 1979*, Bangkok, Silpakorn University, 1979.

Hsu Yun-Ts'iao, 'The Contribution of Chinese Sources to the Ancient History of Southeast Asia', *Journal of South-East Asian Researches*, No. 3 (1967), pp. 9–15.

_____ 'The Revamping of Ocean-going Sea Routes Made in the Yuan and Ming Dynasties and Repercussions in Southeast Asian History', *Chinese Culture*, Vol. 19, No. 3 (1978), pp. 49–54.

Huet, C., 'Contribution a l'étude de la céramique en Indochine', *Bulletin des Musées Royaux d'Art et d'Histoire*, No. 4 (1941), pp. 74–84; No. 1 (1942), pp. 2–9; No. 3 (1942), pp. 50–61.

Hughes-Stanton, P. and Kerr, R., *Kiln Sites of Ancient China—Recent Finds of Pottery and Porcelain*, London, Oriental Ceramic Society, 1981.

Hutterer, K. L., *An Archaeological Picture of a Pre-Spanish Cebuano Community*, Cebu City, San Carlos University, 1973.

_____ 'The Evolution of Philippine Lowland Societies', *Mankind*, No. 9 (1974), pp. 287–99.

Ibn Battuta, *Travels in Asia and Africa 1325–1354*, translated by H. A. R. Gibb, London, Routledge & Kegan Paul, 1929 (reprinted 1983). *See also entry under* Gibb, H. A. R.

Ito, C. and Kamakura, Y., *Nankai Koto Kame. Ancient Pottery and Porcelain in Southern Lands*, Tokyo, Houn-sha, 1941; translated by the Translation Unit of the Australian National University, Canberra, unpublished typescript, 1971.

Itoi, K., *Thai Ceramics from the Sōsai Collection*, Toyama Museum of Fine Art, 1985 (in Japanese); English translation, Singapore, Oxford University Press, 1989.

Itoi, K. and Shimazu, H., *Ceramics of Southeast Asia. Khmer, Thai and Annamese Wares*, Tokyo, Yuzankaku, 1984 (in Japanese).

Iwao, Seiichi, 'Japanese Foreign Trade in the 16th and 17th Centuries', *Acta Asiatica*, No. 30 (1976), pp. 1–18.

Jack-Hinton, C., 'A Note on a Ch'eng Hua *Nien Hao* from Kampang Makam, Kota Tinggi, and Some Remarks on the Johore River Trade in the 15th Century', *Federations Museum Journal*, Vol. VIII (1963), pp. 32–5.

_____ 'Marco Polo in Southeast Asia', *Journal of Southeast Asian History*, Vol. 5, No. 2 (1964), pp. 43–103.

Janse, O. R., 'An Archaeological Expedition to Indo-China and the Philippines', *Harvard Journal of Asiatic Studies*, Vol. 6, No. 2 (1941), pp. 247–68.

_____ 'Notes on Chinese Influences on the Philippines in Pre-Spanish Times', *Harvard Journal of Asiatic Studies*, Vol. 8 (1944–5), pp. 34–62.

_____ *Archaeological Research in Indo-China*, 3 vols., Cambridge, Mass., Harvard University Press, I, 1947 and II, 1951; Bruges, St. Catherine Press, III, 1958.

Janseen, L., *Malaca, l'Inde meridionale et le Cathay*, 2 vols., Brussels, 1881–2.

Jenyns, S., 'The Chinese Porcelains in the Topkapi Saray, Istanbul', *TOCS*, Vol. 36 (1964–6), pp. 43–72.

Jörg, C. J. A., *Porcelain and the Dutch China Trade*, The Hague, Martinus Nijhoff, 1982.

_____ *The Geldermalsen. History and Porcelain*, Groningen, Kemper, 1986.

Joseph, A. M., *Ming Porcelains, Their Origins and Development*, London, Bibelot, 1971.

_____ *Chinese and Annamese Ceramics Found in the Philippines and Indonesia*, London, Hugh Moss Ltd., 1973.

Kaboy, T. and Moore, E., 'Ceramics and Their Uses among the Coastal Melanaus; A Field Survey', *SMJ*, Vol. 15, Nos. 30–31 (1967), pp. 10–29.

Kamakura, Y., *Celebes Okinawa Hakkutsu Ko-Toji* (Old Pottery and Porcelain Excavated in Loochoo Island and the Celebes), Tokyo, 1937 (reprinted 1976).

Kamei, M., 'Chinese Ceramics Excavated in Japan from the Nara to Heian Periods', in *International Symposium on Chinese Ceramics*, Seattle Art Museum, 1977, pp. 23–30.

152

_____ 'Vietnamese and Thai Ceramics Excavated from Japan', *SPAFA Final Report. Workshop to Standardize Studies on Ceramics of East and Southeast Asia*, Cebu City, Philippines, SEAMEO, 1983, pp. 189–204.

_____ 'Cultural Contacts between Japan and China as Reflected by Tang Sansai', in *Windows on the Japanese Past: Studies in Archaeology and Prehistory*, Ann Arbor, University of Michigan, Center for Japanese Studies, 1986, pp. 405–14.

Khan, F. A., *Bambhore*, Karachi, 1969.

Kuwayama, G., 'Influences of the Wares in Southeast Asia on Japanese Ceramics', in *International Symposium on Japanese Ceramics*, Seattle Art Museum, 1972, pp. 171–8.

Lamb, A., 'Research at Pengkalan Bujang; A Preliminary Report', *Federation Museums Journal*, Vol. VI (1961a), pp. 21–37.

_____ 'Kedah and Takuapa, Some Tentative Historical Conclusions', *Federation Museums Journal*, Vol. VI (1961b), pp. 69–88.

_____ 'Takuapa: The Probable Site of a Pre-Malaccan Entrepot in the Malay Peninsula', in J. Bastin and R. Roolvink (eds.), *Malayan and Indonesian Studies*, Oxford, Clarendon Press (1964a), pp. 76–86.

_____ 'A Visit to Siraf, an Ancient Port on the Persian Gulf', *JMBRAS*, Vol. 37, No. 1 (1964b), pp. 1–19.

_____ 'Notes on Satingphra', *JMBRAS*, Vol. 37, Pt. 1 (1964c), pp. 74–87.

_____ 'Old Middle Eastern Glass in the Malay Peninsula', in Ba Shin *et al.* (eds.), *Essays Offered to G. H. Luce*, Ascona, Artibus Asiae, 1966, Vol. 2, pp. 74–88.

Lammers, C. and Ridho, A., *Annamese Ceramics in the Museum Pusat, Jakarta*, Jakarta, Ceramic Society of Indonesia, 1974.

Lane, A., 'The Gaignières-Fonthill Vase; a Chinese Porcelain of about 1300', *Burlington Magazine*, Vol. CIII (1961), pp. 124–32.

Latham, R. (trans.), *The Travels of Marco Polo*, Harmondsworth, Penguin, 1958.

Le May, R., 'The Ceramic Wares of North-Central Siam I & II', *Burlington Magazine*, Vol. LXIII, Nos. 367 and 368 (1933), pp. 156–66, pp. 203–11.

Lee, S. and Wai-Kam Ho, *Chinese Arts under the Mongols: The Yuan Dynasty*, Cleveland, Cleveland Museum of Art, 1968.

Legaspi, A. M., *Bolinao. A 14th–15th Century Burial Site*, Manila, National Museum, 1974.

Legeza, I. L., *A Descriptive and Illustrated Catalogue of the Malcolm MacDonald Collection of Chinese Ceramics in the Gulbenkian Museum of Oriental Art and Archaeology*, London, Oxford University Press, 1972.

_____ 'Trade Ceramics in the Local Cultures of the South Sea (*Nan-hai*) Islands', paper presented to the *Symposium on Trade Pottery in East and Southeast Asia*, Hong Kong, 1978.

Lem, Hon Heng, *Keramik aus Thailand, Sukhothai und Sawankhalok*, Bremen, Landesmuseum Für Kunst und Kulturgeschichte, 1977.

Leong Sau Heng, 'Archaeology in Peninsular Malaysia (1976–1979)', *Indonesia Circle*, No. 22 (1980), pp. 73–8.

Leslie, D. D. *et al.*, *Essays on the Sources for Chinese History*, Canberra, Australian National University Press, 1973.

Leur, J. C. van, *Indonesian Trade and Society*, The Hague, W. van Hoeve, 1955.

Li Dejin, Jiang Zhongyi and Guan Jiakun, 'Chinese Porcelain Found in a Shipwreck on the Seabed off Sinan, Korea', *The Southeast Asian Ceramic Society, Chinese Translations*, No. 2 (1980), pp. 25–50.

Li Zhiyian, 'Tang Porcelain', *The Southeast Asian Ceramic Society, Chinese Translations*, No. 1 (1979), pp. 14–28.

Li Zhi-wen, 'Development and Export of Yueh Ware and Tongguan Ware', *Trade Ceramics Studies*, No. 2 (1982a), pp. 7–20.

_____ 'Development and Export of Longquan Celadon', *Trade Ceramics Studies*, No. 2 (1982b), pp. 27–36.

_____ 'Dehua and Other Ancient Kilns in South China', *Trade Ceramics Studies*, No. 2 (1982c), pp. 37–46.

Lin Hsin-kuo, 'A Study of Mang-k'ou Wares and Fu-shao Technique of Sung and Yuan at Ching-te Chen', *Oriental Ceramic Society. Chinese Translations*, No. 8 (1978).

Liu Xinyuan, 'The Potting of Bowls and Kindred Vessels of Various Periods Recovered from the Hutian Kiln-site', *The Southeast Asian Ceramic Society. New Discoveries in Chinese Ceramics*, No. 4 (1982), pp. 20–31.

Liu Xinyuan and Bai Kun, 'A Survey of the Hutian Kiln-site in Jingdezhen', *The Southeast Asian Ceramic Society. New Discoveries in Chinese Ceramics*, No. 4 (1982), pp. 2–19.

Lo Hsiang-lin, 'Islam in Canton in the Sung Period. Some Fragmentary Records', in F. S. Drake (ed.), *Symposium on Historical Archaeology and Linguistic Studies in Southeast Asia*, Hong Kong, Hong Kong University Press, 1967, pp. 176–9.

Lo Jung-Pang, 'The Emergence of China as a Sea-power during the Late Sung and Early Yuan Periods', *Far Eastern Quarterly*, Vol. XIV, No. 4 (1955), pp. 489–503.

_____ 'Maritime Commerce and Its Relation to the Sung Navy', *Journal of the Economic and Social History of the Orient*, 12 (January 1969), pp. 57–101.

_____ 'Chinese Shipping and East-West Trade from the 10th to the 14th Century', in M. Mollat (ed.), *Sociétés et Compagnies de Commerce en Orient et dans l'Ocean Indien*, Paris, SEVPEN, 1970, pp. 167–76.

Locsin, C. Y., 'A Group of Painted Wares from Chi-Chou and Some Related Wares Excavated in the Philippines', *Manila Trade Pottery Seminar. Introductory Notes*, 1968a (reprinted 1976).

_____ 'Lead-glazed Wares Found in The Philippines', *Manila Trade Pottery Seminar. Introductory Notes*, 1968b (reprinted 1976).

_____ 'A Group of White Wares from Te-hua', *Manila Trade Pottery Seminar. Introductory Notes*, 1968c (reprinted 1976).

Locsin, L. and Locsin, C. Y., *Oriental Ceramics Discovered in The Philippines*, Tokyo, C. Tuttle Co., 1967.

Lodewyckz, W., *De Eerste Schipvaart der Netherlanders Naar Oest-Indie onder Cornelis de Houtman 1595–1597*, I. Linschoten-Vereeniging, Vol. VII, 's-Gravenhage, Martinus Nijhoff, 1915.

McBain, A. Y., 'Sukhothai and Sawankhalok Ceramics', *BMJ*, Vol. 4, No. 3 (1979), pp. 78–99.

Ma Huan, *Ying-Yai Sheng-Lan (The Overall Survey of the Ocean's Shores) (1433)*, translated by J. V. G. Mills, Cambridge, Cambridge University Press, Hakluyt Society, 1970. *See also entry under* Mills, J. V. G.

Macknight, C. C., 'The Nature of Early Maritime Trade: Some Points of Analogy from the Eastern Part of the Indonesian Archipelago', *World Archaeology*, Vol. 5, No. 2 (1973), pp. 198–210.

_____ 'The Study of *Praus* in the Indonesian Archipelago', *Great Circle*, Vol. 2, No. 2 (1980), pp. 117–28.

Majib, Z., 'Temmoku Ware: A Case of Ceramics Analysis Applied to the Study of Sarawak's Link with China in the Historical Period', *Trade Ceramic Studies*, No. 2 (1982), pp. 111–21.

Malaysian Historical Society, *Lembah Bujang*, Kuala Lumpur, Persatuan Sejarah Malaysia, 1980.

Malleret, L., *L'archéologie du delta du Mekong*, 4 vols., Paris, Ecole Francaise d'Extreme-Orient, 1959–63.

Manguin, P.-Y., 'The Southeast Asian Ship: An Historical Approach', *Journal of Southeast Asian Studies*, Vol. XI, No. 2 (1980), pp. 266–76.

_____ 'Relationship and Cross-influences between Southeast Asian and Chinese Shipbuilding Traditions', paper presented to *International Association of Historians of Asia*, Manila, 1983.

_____ 'Etudes Sumatranaises. 1. Palembang et Sriwijaya: Anciennes Hypotheses, Recherches Nouvelles (Palembang Quest)', *Bulletin de l'École Francaise d'Extreme-Orient*, Vol. LXXVI (1987), pp. 337–402.

Maveety, P. J., *Ceramics of Thailand*, Stanford, Stanford University Museum of Art, 1980.

Medley, M., 'Regrouping Fifteenth Century Blue-and-white', *TOCS*, Vol. 34 (1962–3).

_____ 'Ching-te Chen and the Problem of the Imperial Kilns', *Bulletin of the School of Oriental and African Studies*, Vol. 29, No. 2 (1966), pp. 326–38.

_____ 'Review of W. Willetts' Ceramic Art of Southeast Asia', *Apollo*, Vol. XCV, No. 120 (1972a), p. 150.

_____ *Metalwork and Chinese Ceramics*, London, Percival David Foundation. 1972b.

_____ 'A Note on Some Origins and Evolutions in Chekiang Celedon', *Art and Archaeological Research Papers*, 3 (1973a), pp. 33–44.

_____ 'The Yuan-Ming Transformation in the Blue and Red Decorated Porcelains of China', *Ars Orientalis*, Vol. 9 (1973b), pp. 89–101.

_____ 'A Fourteenth-century Blue and White Chinese Box', *Oriental Art*, Vol. XIX, No. 4 (1973c), pp. 433–7.

_____ 'Chinese Ceramics and Islamic Design', *Percival David Foundation Colloquies on Art and Archaeology in Asia*, No. 3 (1973d), pp. 1–10.

_____ *Yuan Porcelain and Stoneware*, London, Faber & Faber, 1974.

_____ 'Sources of Decoration in Chinese Porcelain from the 14th to the 16th Century', *Percival David Foundation Colloquies on Art and Archaeology in Asia*, No. 5 (1975), pp. 58–73.

_____ *The Chinese Potter. A History of Chinese Ceramics*, Oxford, Phaidon, 1976.

_____ (ed.), *Decorative Techniques and Styles in Asian Ceramics*, Percival David Foundation Colloquies on Art and Archaeology in Asia, No. 8, 1979.

_____ *T'ang Pottery and Porcelain*, London, Faber & Faber, 1981.

Medway, Lord, 'The Antiquity of Trade in Edible Bird's-Nests', *Federation Museums Journal*, Vol. VIII (1963), pp. 36–47.

Meilink-Roelofsz, M. A. P., *Asian Trade and European Influence in the Indonesian Archipelago between about 1500 and 1630*, The Hague, Martinus Nijhoff, 1962.

_____ 'Trade and Islam in the Malay-Indonesian Archipelago Prior to the Arrival of the Europeans', in D. S. Richards (ed.), *Islam and the Trade of Asia*, Oxford, Cassirer, 1970, pp. 137–57.

Miedema, H., *Martavanen*, Leeuwarden, Gemeentelijk Museum het Princessehof, 1964.

Mikami, T., *Tōji no Michi (Ceramic Road)*, Tokyo, Iwanami, 1969.

_____ 'Medieval Chinese Ceramics Found on Okinawa Island', in *International Symposium on Chinese Ceramics*, Seattle Art Museum, 1977, pp. 36–40.

_____ 'Ch'ang-sha Ware as Trade Ceramics, Its Distribution and Dating', paper presented to the *Symposium on Trade Pottery in East and Southeast Asia*, Hong Kong, 1978.

_____ 'China and Egypt: Fustat', *TOCS*, Vol. 45 (1980–1), pp. 67–90.

_____ 'Trade Ceramics Found in Pasar Ikan Site', *Trade Ceramics Studies*, No. 2 (1982), pp. 111–20.

_____ 'The Yuan Blue and White–Viewed as Trade Porcelains', *Idemitsu Museum of Arts Bulletin*, No. 50 (1985), pp. 2–15 (in Japanese).

_____ (ed.), *Ceramic Art of the World. Volume 13: Liao, Chin and Yuan Dynasties*, Tokyo, Shogakukan, 1981.

_____ (ed.), *Ceramic Art of the World. Volume 16, Southeast Asia*, Tokyo, Shogakukan, 1984.

Mikami, T., Kemal Cig and Banri Namikawa, *Topkapi Saray Collection, Chinese Ceramics*, Tokyo, Heibonsha, 1974.

Miksic, J., 'Classical Archaeology in Sumatra', *Indonesia*, Vol. 30 (1980), pp. 43–66.

_____ *Archaeological Research on the "Forbidden Hill" of Singapore: Excavations at Fort Canning, 1984*, Singapore, National Museum, 1985.

_____ 'Archaeological Studies of Style, Information Transfer and the Transition from Classical to Islamic Periods in Indonesia', *Journal of Southeast Asian Studies*, Vol. XX, No. 1 (1989), pp. 1–10.

Millar, A. T., *Old Goa and the Trade in Chinese Porcelain*, Bombay, Ruby Printers, 1977.

Mills, J. V. G. (trans.), 'Eredia's Description of Malaca, Meredional India, and Cathay', *JMBRAS*, Vol. VIII, Pt. 1 (1930), pp. 1–288.

_____ (trans.), *Ma Huan. Ying-Yai Sheng-Lan. The Overall Survey of the Ocean's Shores (1433)*, Cambridge, Hakluyt Society, 1970. *See also entry under* Ma Huan.

_____ 'Chinese Navigators in Insulinde about A.D. 1500', *Archipel*, 18 (1979), pp. 69–93.

Milner, A. C., Edwards McKinnon, E. and Tengku Luckman Sinar, S. H., 'A Note on Aru and Kota Cina', *Indonesia*, No. 26 (1978), pp. 1–42.

Mino, Y. and Wilson, P., *An Index of Chinese Ceramic Kiln Sites from the Six Dynasties to the Present*, Toronto, Royal Ontario Museum, 1973.

Mirsky, J. (ed.), *The Great Chinese Travellers*, New York, Random House, 1964.

Misugi, T., *Chinese Porcelain Collections in the Near East, Topkapi and Ardebil*, 3 vols., Hong Kong, University of Hong Kong Press, 1982.

Moore, E., 'Si Chun Ceramics in Sarawak', *SMJ*, Vol. XVI (1968), pp. 85–99.

_____ 'A Suggested Classification of Stonewares of Martabani Type', *SMJ*, Vol. XVIII, No. 36–37 (1970), pp. 1–99.

Morimoto, A., 'A Study of So-called Sung Ceramics Found in North Vietnam–About the Huet Collection at the Royal Museum of Art and History in Brussels', *Toyo Toji*, Vol. 9 (1979–83), pp. 5–86.

_____ 'Chinese Porcelain Excavated from North Vietnam', *Trade Ceramic Studies*, No. 7 (1987), pp. 122–53.

Morita, T., 'A Tentative Chronological Dating of Chinese White Ware', *Trade Ceramics Studies*, No. 2 (1982), pp. 47–54.

Mundardjito *et al.*, *Laporan Penelitian Banten 1976*, Jakarta, Berita Penelitian Arkeologi No. 18, 1978.

Needham, J., *Science and Civilization in China*, Vol. 1, Cambridge, Cambridge University Press, 1954.

Nguyen Phuc Long, 'Les Nouvelles Recherches Archeologiques au Vietnam', *Arts Asiatiques*, Vol. XXXI (1975).

Nicholl, R. (ed.), *European Sources for the History of Brunei in the Sixteenth Century*, Brunei Museum, 1975.

_____ 'Brunei and Camphor', *BMJ*, Vol. 4, No. 3 (1979), pp. 52–76.

_____ 'Notes on Some Controversial Issues in Brunei History', *Archipel*, No. 19 (1980), pp. 25–41.

_____ 'Brunei Rediscovered: A Survey of Early Times', *Journal of Southeast Asian Studies*, Vol. XIV, No. 1 (1983), pp. 32–45.

Nilakantra Sastri, K. A., 'Takuapa and Its Tamil Inscription', *JMBRAS*, Vol. 22, Pt. 1 (1949), pp. 25–30.

O'Connor, S. J., 'Tambralinga and the Khmer Empire', *JSS*, Vol. 63, No. 1 (1975), pp. 161–75.

Okuda, S., *Sōkoroku Zukan* (Sawankhalok Ceramics), Tokyo, 1944.

_____ *Annam Toji Zukan* (Annamese Ceramics), Tokyo, Zauho Press, 1954.

Omar, M., 'A Preliminary Account of Surface Finds from Tanjong Batu Beach, Muara', *BMJ* (1975), pp. 158–74.

_____ 'Radio Carbon Dates from Kupang and Sungai Lumut, Brunei', *BMJ*, Vol. 4, No. 3 (1979), pp. 75–7.

_____ *Archaeological Excavations in Protohistoric Brunei*, Brunei, Brunei Museum, 1981.

Omar, M. and Shariffuddin, P. M., 'Distribution of Chinese and Siamese Ceramics in Brunei', *BMJ*, Vol. 4, No. 2 (1978), pp. 59–66.

Ono, M., 'Classification and Dating of Blue and White Bowls and Plates of the 15th and 16th Centuries', *Trade Ceramics Studies*, No. 2 (1982), pp. 71–88.

Oriental Ceramic Society of Hong Kong, *Exhibition of Chinese Blue and White Porcelain and Related Underglaze Red*, Hong Kong, Oriental Ceramic Society of Hong Kong, 1975.

_____ *South-East Asian and Chinese Trade Pottery*, Hong Kong, Oriental Ceramic Society of Hong Kong, 1979.

_____ *Jingdezhen Wares. The Yuan Evolution*, Hong Kong, Oriental Ceramic Society of Hong Kong, 1984.

Othman bin Mohd. Yatim, 'History of Trade Potteries in Peninsular Malaya', paper presented to the *Symposium on Trade Pottery in East and Southeast Asia*, Hong Kong, 1978.

_____ *Tembikar China Berunsur Islam dalam Koleksi Muzium Negara (Chinese Islamic Wares in the Collection of the National Museum)*, Kuala Lumpur, Muzium Negara, 1981.

_____ 'Discoveries and Research on Ancient Trade Ceramics in Peninsular Malaysia', *SPAFA Digest*, Vol. IX, No. 2 (1988), pp. 2–8.

Ouyang Shibin and Huang Yunpeng, 'Some Blue and White and Underglaze Red Porcelain Wares from Two Jingtai Tombs', *The Southeast Asian Ceramic Society. New Discoveries in Chinese Ceramics*, No. 4 (1982), pp. 32–40.

Peacock, B. A. V., 'Recent Archaeological Discoveries in Malaya (1957)', *JMBRAS*, Vol. 31, Pt. 1 (1958), pp. 180–7.

_____ 'Two Celadon Plates from the Sungai Muda, Kedah', *Malaya in History*, Vol. V, No. 1 (1959), pp. 33–5.

Pearson, R. J., *Archaeology of the Ryuku Island*, Hawaii, University of Hawaii Press, 1969.

Piccus, R. P., *Important Annamese Ceramics. The Mr and Mrs R. P. Piccus Collection, 7th December, 1984*, London, Christie's, 1984.

Pigafetta, A., 'Account of Magellan's Voyage', in Lord Stanley of Alderley (ed.), *The First Voyage Around the World by Magellan*, New York, B. Franklin, 1874, pp. 35–163 (reprinted Hakluyt Society, ed. 1963).

Pigeaud, T. G. Th., *Java in the Fourteenth Century. A Study in Cultural History. The Nāgara-Kertagama by Rakawi prapanca of Majapahit, 1365 A.D.*, The Hague, Martinus Nijhoff, 1960–3.

Pigeaud, T. G. Th. and Graaf, H. J. de, *Islamic States in Java, 1500–1700*, Verhandelingen KITLV 70, The Hague, Martinus Nijhoff, 1976.

Pintado, M. J., 'Some Portuguese Historical Sources on Malacca History', *Heritage*, No. 3 (1978), pp. 20–62.

Pires, Tomé, *The Suma Oriental of Tomé Pires*, translated by A. Cortesão, 2 vols., London, Hakluyt Society, 1944 (reprinted 1980). See also entry under Cortesão, A.

Plumer, J. M., *Temmoku; A Study of the Ware of Chien*, Tokyo, Idemitsu Art Gallery, 1972.

Pope, J. A., 'The Princessehof Museum in Leeuwarden', *Archives of the Chinese Art Society of America*, Vol. 5 (1951), pp. 23–37.

_____ *Fourteenth Century Blue and White; A Group of Chinese Porcelains in the Topkapi Sarayi Muzesi, Istanbul*, Washington, Smithsonian Institution, 1952 (rev. ed. 1970).

_____ *Chinese Porcelains from the Ardebil Shrine*, Washington, Smithsonian Institution, 1956 (reprinted, Sotheby Parke Bernet, 1981).

_____ 'Marks on Chinese Ceramics Excavated in Brunei and Sarawak', *SMJ*, Vol. VIII, No. 11 (1958), pp. 267–72.

Pusat Penelitian Archeologi Nasional, *Studies on Ceramics*, Jakarta, Pusat Penelitian Archeologi Nasional, 1984.

Quaritch Wales, H. G., *Dvaravati*, London, Bernard Quaritch Ltd., 1969.

Rackham, B., 'The Earliest Arrivals of Pre-Ming Wares in the West', *TOCS* (1923–4), pp. 10–16.

Raphael, O. C., 'Chinese Porcelain Jar in the Treasury of San Marco', *TOCS* (1931–2), pp. 13–15.

Refuge, B., *Sawankalok, de export-ceramiek van Siam*, Lochem, De Tijdstroom, 1976.

Reid, A., 'The Structure of Cities in Southeast Asia, 15th to 17th Century', *Journal of Southeast Asian Studies*, Vol. XI, No. 2 (1980), pp. 235–50.

Reidemeister, L., 'Eine Schenkung chinesischer Porzellane aus dem Ende des 16. Jahrhunderts', *Ostasiatische Zeitschrift*, Vol. 5, No. 7 (1933), pp. 11–16.

Reischauer, E. O., 'Notes on T'ang Dynasty Sea-Routes', *Harvard Journal of Asiatic Studies*, Vol. 5 (1940), pp. 142–64.

Richards, R. J., *Thai Ceramics from the Art Gallery of South Australia*, Adelaide, Board of the Art Gallery of South Australia, 1977.

Richards, R. J. *et al.*, 'Sukhothai Province Kiln Sites and Their Findings', in T. Mikami (ed.), *Ceramic Art of the World. Vol. 16, Southeast Asian Ceramics*, Tokyo, Shogakukan, 1984, pp. 197–208.

Ridho, A., *Oriental Ceramics. The World's Great Collections. Vol. 3 Museum Pusat, Jakarta*, Tokyo, Kodansha, 1977 (reprinted 1982).

_____ 'The Trade Pottery and Its Connection with the Local History of Indonesia', paper

presented to the *Symposium on Trade Pottery in East and Southeast Asia*, Hong Kong, 1978.

_____ 'Fourteenth Century Chinese Ceramics Found in Indonesia', *Trade Ceramic Studies*, No. 1 (1981), pp. 89–91.

_____ 'Notes on the Wall Tiles of the Mosque at Demak', in Southeast Asian Ceramic Society, *Vietnamese Ceramics*, Singapore, 1982, pp. 36–7.

_____ 'Ceramic Analysis Result Trowulan Site, Stage VII, 1982', in *SPAFA Workshop to Standardize Studies on Ceramics of East and Southeast Asia, Cebu City, Philippines, February 1983. Final Report*, Bangkok, SEAMEO, 1983.

_____ *White Wares*, Jakarta, Ceramic Society of Indonesia, 1985.

Ridho, A. and Wahyono, M., 'The Ceramics Found in Tuban, East Java', *Trade Ceramic Studies*, No. 3 (1983), pp. 77–82.

Robb, W., 'New Data on Chinese and Siamese Ceramic Wares of the 14th and 15th Centuries', *Philippine Magazine*, Vol. XXVII, Nos. 3 and 4 (1930).

Rockhill, W. W., 'Notes on the Relations and Trade of China with the Eastern Archipelago and the Coasts of the Indian Ocean during the 14th Century', *T'oung-Pao*, Vol. XVI, Pt. II (1915).

Rogers, A., *The Tūzuk-i Jahāngīrī, or Memoirs of Jahāngīr*, 2 vols., London, Royal Asiatic Society, 1909.

Rogers, M., 'China and Islam—The Archaeological Evidence in the Mashriq', in D. S. Richards (ed.), *Islam and the Trade of Asia*, Oxford, B. Cassirer, 1970.

Rooney, D., *Khmer Ceramics*, Singapore, Oxford University Press, 1984.

Salmon, C. and Lombard, D., 'Un vaisseau du XIIIèmes. retrouvé avec sa cargaison dans la rade de "Zaitun"', *Archipel*, 18 (1979), pp. 57–68.

Sandhu, K. S. and Wheatley, P. (eds.), *Melaka: Transformation of a Malay Capital, c.1400–1980*, 2 vols., Kuala Lumpur, Oxford University Press, 1983.

Sassoon, C., *Chinese Porcelain Marks from Coastal Sites in Kenya*, Oxford, British Archaeological Reports, 1978.

Sato, M., *Chinese Ceramics*, Tokyo, Weatherhill, 1981.

Satow, E., 'Visit to the Ruins of Sukhothai and Sawankhalok, Siam', *Journal of the Society of Arts*, Vol. XL, No. 2073, 1892, pp. 849–56.

Sauvaget, J., *Ahbar as—Sin wal—Hind Relation de la Chine et de l'Inde redigee en 851*, Paris, Les Belles Letters, 1948.

Scanlon, G. T., 'Egypt and China: Trade and Imitation', in D. S. Richards (ed.), *Islam and the Trade of Asia*, Oxford, B. Cassirer, 1970.

Schafer, E. H., *The Golden Peaches of Samarkand: A Study of T'ang Exotics*, Berkeley, University of California Press, 1963.

_____ *The Vermilion Bird. T'ang Images of the South*, Berkeley, University of California Press, 1967.

Scott, W. H., 'Boat-building and Seamanship in Classic Philippine Society', *Philippine Studies*, 30 (1982), pp. 335–76.

Sen, S. P., 'The Role of Indian Textiles in Southeast Asian Trade in the Seventeenth Century', *Journal of Southeast Asian History*, Vol. 3, No. 2 (1962), pp. 92–110.

Shaw, J. C., *Northern Thai Ceramics*, Kuala Lumpur, Oxford University Press, 1981.

_____ 'Tak Hilltop Burial Sites', *Arts of Asia*, July–August 1985, pp. 95–102.

Shimazu, N., *Nankai Shutsudo No Chukuku Toji*, Tokyo, 1979.

Shunzo, S., 'Ryu-kyu and Southeast Asia', *Journal of Asian Studies*, Vol. XXIII, No. 3 (1964), pp. 383–9.

Siam Society, *Thai Pottery and Ceramics*, Bangkok, The Siam Society, 1986.

Sickman, L., 'A Ch'ing-pai Porcelain Figure Bearing a Date', *Archives of the Chinese Art Society of America*, XV (1961), p. 34.

Silva, J. B. da, 'Some Chinese Porcelains Found in South Arabia', *Oriental Art*, Vol. XIV, No. 1 (1968), pp. 41–5.

Skinner, G. W., *Chinese Society in Thailand*, Ithaca, Cornell University Press, 1957.

Smart, E. S., 'Fourteenth Century Chinese Porcelain from a Tughlaq Palace in Delhi', *TOCS*, Vol. 41 (1975–7), pp. 199–230.

Smith, D. H., 'Zaitun's Five Centuries of Sino-Foreign Trade', *JRAS* (1958), Pts. 3 and 4, pp. 165–77.

Smith, V. A., *Akbar the Great Mogul*, Oxford, Clarendon Press, 1917.

Soekmono, R., 'Archaeology and Indonesian History', in Soedjatmoko (ed.), *An Introduction to Indonesian Historiography*, Ithaca, Cornell University Press, 1965, pp. 36–46.

Solheim, W. G., 'The "Antiquities" Problem', *Asian Perspectives*, Vol. XVI, No. 2 (1973), pp. 113–24.

_____ 'Borneo Archaeology, Past and Future', in G. N. Appell and L. R. Wright (eds.), *The Status of Social Science Research in Borneo*, Ithaca, Cornell University, 1978, pp. 8–16.

Sorsby, W., *Southeast Asian and Early Chinese Export Ceramics*, London, William Sorsby Ltd., 1974.

Southeast Asian Ceramic Society, *Ceramic Art of Southeast Asia*, Singapore, Southeast Asian Ceramic Society, 1971.

_____ *Chinese White Wares*, Singapore, Southeast Asian Ceramic Society, 1973.

_____ *Chinese Blue and White Ceramics*, Singapore, Arts Orientalis, 1978.

_____ *Chinese Celadons and Other Related Wares in Southeast Asia*, Singapore, Arts Orientalis, 1979.

_____ *Khmer Ceramics 9th–14th Century*, Singapore, Southeast Asian Ceramic Society, 1981.

_____ *Vietnamese Ceramics*, Singapore, Southeast Asian Ceramic Society, and Kuala Lumpur, Oxford University Press, 1982.

_____ *Song Ceramics*, Singapore, Southeast Asian Ceramic Society, 1983.

_____ (West Malaysian Chapter), *A Ceramic Legacy of Asia's Maritime Trade. Song Dynasty Guangdong Wares and Other 11th to 19th Century Trade Ceramic Found on Tioman Island, Malaysia*, Singapore, Oxford University Press, 1985.

SPAFA, 'Settlement Patterns at Laem Po, Chaiya in the Srivijaya Period', *SPAFA Digest*, Vol. II, No. 1 (1981), pp. 8–9.

_____ *Final Report. Workshop on Ceramics of East and Southeast Asia, Kuching, Sarawak, Malaysia, May 18–26, 1981*, Bangkok, Southeast Asian Ministers of Education Organization, 1982.

_____ *Final Report. Workshop to Standardize Studies on Ceramics of East and Southeast Asia, Cebu City, Philippines, February 15–20, 1983*, Bangkok, Southeast Asian Ministers of Education Organization, 1983.

_____ *Final Report. Consultative Workshop on Research on Maritime Shipping and Trade Networks in Southeast Asia, Cisarua, West Java, Nov. 20–27, 1984*, Bangkok, SPAFA, 1985.

Spinks, C. N., 'Siam and the Pottery Trade of Asia', *Journal of the Siam Society*, Vol. XLIV, No. 2 (1956), pp. 61–105.

_____ *Siamese Pottery in Indonesia*, Bangkok, The Siam Society, 1959.

_____ 'A Ceramic Interlude in Siam', *Artibus Asiae*, Vol. XXIII, No. 2 (1960), pp. 95–110.

_____ *The Ceramic Wares of Siam*, Bangkok, The Siam Society, 1965 (rev. eds. 1971 and 1978).

_____ *The Covered Bowls of the Sawankalok Kilns*, Bangkok, The Siam Society, 1970.

Stargardt, J., 'Southern Thai Waterways: Archaeological Evidence on Agriculture, Shipping and Trade in the Srivijayan Period', *Man*, Vol. VIII, No. 1 (1973), pp. 5–29.

_____ 'L'isthme de la Péninsule Malaise dans les navigations au long cours. Nouvelles données archéologiques', *Archipel*, 18 (1979), pp. 15–40.

_____ *Satingpra I. The Environmental and Economic Archaeology of South Thailand*, Oxford, ISEAS/BAR, 1983.

Stenuit, R., 'De "Witte Leeuw", De shipbreuk van een schip van de V.O.C. in 1613 en het onder-waterzoek naar het wrak in 1976', *Bulletin van het Rijksmuseum*, Vol. 25, No. 4 (1977), pp. 165–78 and 193–201.

_____ 'The Sunken Treasure of St. Helena', *National Geographic*, October 1978, pp. 562–76.

Suleiman, S., 'A Few Observations on the Use of Ceramics in Indonesia', *Aspects of Indonesian Archaeology*, No. 7, Jakarta, Departemen P & K, 1980.

Sullivan, M., 'Kendi', *Archives of the Chinese Art Society of America*, Vol. XI (1957a), pp. 40–58.

_____ 'Chinese Export Porcelain in Singapore', *Oriental Art*, Vol. III, No. 4 (1957b), pp. 145–51; and Vol. IV, No. 1 (1958), pp. 18–21.

_____ 'Notes on Chinese Export Wares in Southeast Asia', *TOCS*, Vol. 33 (1960–2), pp. 61–77.

Suzuki, S., 'Outline of the Investigation into the Trade Ceramics in Malaysia and Indonesia', *Trade Ceramics Studies*, No. 2 (1982), pp. 105–10.

Sweetman, J. and Guérin, N., *The Spouted Ewer and Its Relatives in the Far East*, Falmer, Barlow Gallery, University of Sussex, 1983.

T'an Tan-Chiung, 'Trade Porcelain and Imperial Porcelain', *National Palace Museum Quarterly*, Vol. III, No. I (1968), pp. 13–34.

Tang Changpu, 'Song and Yuan Blue and White Porcelains Unearthed at a Jizhou Kiln in Jiangxi', *The Southeast Asian Ceramic Society, New Discoveries in Chinese Ceramics*, No. 3 (1981), pp. 47–9.

Tantoco, R. and Tantoco, D. W., *Oriental Pottery and Porcelain from the Collection of Imelda Romualdez Marcos*, Manila, Marcos Foundation Museum, 1976.

Taylor, K. W., 'The Rise of Dai Viet and the Establishment of Thang-long', in K. R. Hall and J. K. Whitmore (eds.), *Explorations in Early Southeast Asian History*, Ann Arbor, University of Michigan, 1976.

_____ 'A Brief Summary of Vietnamese History', in Southeast Asian Ceramic Society, *Vietnamese History*, Singapore, 1982, pp. 14–23.

_____ *The Birth of Vietnam*, Berkeley, University of California Press, 1983.

Teeuw, A., 'Review, The Fall of Srivijaya in Malay History by O. W. Wolters', *Journal of Asian Studies*, Vol. 32 (1973), pp. 206–8.

Tenazas, R. C. P., 'A Brief Report on Proto-historic Trade Potteries from Burial Sites in Puerto Galera, Oriental Mindoro', *Philippine Sociological Review*, Vol. XII, Nos. 1 & 2 (1964), pp. 114–21.

_____ 'Underwater Archaeological Investigation of the Rang Kwian Shipwreck', *SPAFA Digest*, Vol. 11, No. 2 (1981), pp. 31–2.

_____ *A Report on the Archaeology of the Locsin/University of San Carlos Excavations in Pila, Laguna, 1967–68*, Manila, n.d.

Theseira, O. A., 'A Report of the Finds of Five Ceramics in Kampung Tayor, Kemaman, Trengganu', *Federation Museums Journal*, Vol. 21 (1976), pp. 25–34.

Tibbetts, G. R., 'Early Muslim Traders in Southeast Asia', *JMBRAS*, Vol. 30, No. 1 (1957), pp. 1–45.

_____ *A Study of the Arabic Texts Containing Material on Southeast Asia*, London, Royal Asiatic Society, 1979.

Tichane, R., *Ching-te-chen. Views of a Porcelain City*, New York, New York State Institute for Glaze Research, 1983.

T'ien Ju-K'ang, 'China and the Pepper Trade', *Hemisphere*, Vol. 26, No. 4 (1982), pp. 220–2.

Tiongco, J. B., *The Oton Diggings*, Iloilo, Philippines, privately published, 1969.

Tjandrasamita, U., *The South Sulawesi Excavation. Final Report*, Jakarta, Jajasan Purbakala, 1970.

Tomoyose, E., 'Pottery Trade of Ryukyu from 14th to 17th Century', paper presented to the *Symposium on Trade Pottery in East and Southeast Asia*, Hong Kong, 1978.

Tran Quoc Vuong and Nguyen Vinh Long, *Hanoi. From the Origins to the 19th Century*, Hanoi, Vietnamese Studies No. 48, 1977.

Tregear, M., 'Manila Trade Pottery Seminar', *Oriental Art*, 14 (1968), pp. 327–8.

_____ *Catalogue of Chinese Greenware in the Ashmolean Museum Oxford*, Oxford, Clarendon Press, 1976.

_____ 'Fukien Wares Exported to Japan, with Specific Reference to the Sutra Mounds of the 12th Century', in *International Symposium on Chinese Ceramics*, Seattle, Seattle Art Museum, 1977, pp. 66–9.

_____ *Song Ceramics*, London, Thames & Hudson, 1981.

Treloar, F. E., 'Stoneware Bottles in the Sarawak Museum: Vessels for Mercury Trade?', *SMJ*, Vol. XX, Nos. 40–41.

Ueda, Hideo, 'Classification of Celadon Bowls from the 14th to 16th Century', *Trade Ceramics Studies*, No. 2 (1982), pp. 55–70.

Van der Pijl-Ketel, C. L. (ed.), *The Ceramic Load of the 'Witte Leeuw' (1613)*, Amsterdam, Rijksmuseum, 1982.

Van Orsoy de Flines, E. W., *Onderzoek naar en van keramische scherven in de bodem in Noordelijk Midden-Java 1940–42*, Bandung, A. C. Nix, 1947.

_____ *Guide to the Ceramic Collection of the Museum Pusat*, Jakarta, Museum Pusat, 1972 (1st ed. in Dutch, 1949).

Vlekke, B. H. M., *Nusantara. A History of Indonesia*, The Hague, W. van Hoeve, 1959.

Volker, T., *Porcelain and the Dutch East India Company*, Leiden, E. J. Brill, 1954.

_____ 'The Sawankhalok Story Retold', *Mededelingenblad Nederlandse Vereniging van Vrienden vande Ceramiek*, 93 (1979), pp. 1–52.

Wagner, B. A., 'Stylistic Evidence for a Re-dating of Sawankhalok Painted Covered Boxes', *Oriental Art*, Vol. XXV, No. 4 (1979), pp. 482–91.

Waithayakon, W., *Stone Inscriptions of Sukhothai*, Bangkok, The Siam Society, 1965.

Wang Gungwu, 'The Nanhai Trade. A Study of the Early History of Chinese Trade in the South China Sea', *JMBRAS*, Vol. XXXI, Pt. 2 (1958).

_____ 'The Opening of Relations between China and Malacca, 1403–5', in J. Bastin and R. Roolvink (eds.), *Malayan and Indonesian Studies*, London, 1964, pp. 87–104.

_____ 'Early Ming Relations with Southeast Asia: A Background Essay', in J. Fairbank (ed.), *The Chinese World Order: Traditional China's Foreign Relations*, Cambridge, Mass., Harvard University Press, 1968, pp. 34–62.

_____ 'China and Southeast Asia 1402–1424', in J. Chen and N. Tarling (eds.), *Studies in the Social History of China and Southeast Asia. Essays in Memory of V. Purcell*, Cambridge, Cambridge University Press, 1970a, pp. 375–401.

_____ '"Public" and "Private" Overseas Trade in Chinese History', in M. Mollat (ed.), *Sociétés et Campagnies de Commerce en Orient et dans l'Ocean Indien*, Paris, SEVPEN, 1970b, pp. 215–26.

Wang Yi-t'ung, *Official Relations between China and Japan, 1368–1549*, Cambridge, Mass., Harvard University Press, 1953.

Watson, W., *Tang and Liao Ceramics*, New York, Rizzoli, 1984.

Watt, J. C. Y., 'South-East Asian Pottery–Thai in particular', *Bulletin of the Art Gallery of South Australia*, Vol. XXXII, No. 4 (1971).

_____ *Te Hua Porcelain*, Hong Kong, Chinese University of Hong Kong, 1975.

_____ 'Hsi-ts'un, Ch'ao-an and other Ceramic Wares of Kwangtung in the Northern Sung Period', paper presented to the *Symposium on Trade Pottery in East and Southeast Asia*, Hong Kong, 1978.

_____ 'The Ceramic Wares of Fukien of the Sung and Yuan Periods', *Trade Ceramic Studies*, No. 1 (1981), pp. 73–82.

Weier, L. E., 'Thailand: A 14th–15th Century Shipwreck at Sattahip', *International Journal of Nautical Archaeology*, Vol. 4, No. 2 (1975), pp. 385–6.

Wen Wu, 1955, No. 5, p. 98.

Wheatley, P., 'Chinese Sources for the Historical Geography of Malaya before A.D. 1500', *Malayan Journal of Tropical Geography*, 9 (1956), pp. 71-8.

‗‗‗‗‗‗ 'Geographical Notes on Some Commodities Involved in Sung Maritime Trade', *JMBRAS*, Vol. XXXII, Pt. 2, No. 186 (1959), pp. 1-140.

‗‗‗‗‗‗ *The Golden Khersonese*, Kuala Lumpur, University of Malaya Press, 1961.

‗‗‗‗‗‗ 'Satyantra in Suvarnadvipa: From Reciprocity to Redistribution in Ancient Southeast Asia', in J. A. Sabloff and C. C. Lamberg-Karlovsky (eds.), *Ancient Civilization and Trade*, Albuquerque, University of New Mexico Press, 1975, pp. 227-83.

Whitehouse, D., 'Chinese Stoneware from Siraf: The Earliest Finds', in N. Hammond (ed.), *South Asian Archaeology*, London, Duckworth, 1973, pp. 241-55.

‗‗‗‗‗‗ 'Maritime Trade in the Arabian Sea. The 9th and 10th Centuries AD', in M. Taddei (ed.), *South Asian Archaeology*, Naples, Instituto Universitario Orientale, 1979, Vol. 2, pp. 865-85.

Whitmore, J. K., 'The Opening of Southeast Asia, Trading Patterns through the Centuries', in K. L. Hutterer (ed.), *Economic Exchange and Social Interaction in Southeast Asia: Perspectives from Prehistory, History and Ethnography*, Ann Arbor, University of Michigan, 1977, pp. 139-54.

Wiesner, U., *Chinesische Keramik auf den Philippinen: die sammlung Eric E. Geiling*, Cologne, Museum für Ostasiatische Kunst, n.d.

‗‗‗‗‗‗ *Chinesische Keramik auf Hormoz: spuren einer handelsmetropole im Persischen Golf*, Cologne, Museum für Ostasiatische Kunst, 1979.

Wijayapala, W. and Pricket, M. E., *Sri Lanka and the International Trade. An Exhibition of Ancient Imported Ceramics Found in Sri Lanka's Archaeological Sites*, Colombo, Archaeological Department, 1986.

Wilkinson, C. K., *Nishapur, Pottery of the Islamic Period*, New York, 1974.

Willetts, W., 'Ceylon and China', *Transactions of the Archaeological Society of South India 1960-62 (Silver Jubilee Volume)*, Madras, 1962, pp. 97-119.

‗‗‗‗‗‗ *Ceramic Art of Southeast Asia*, Singapore, Southeast Asian Ceramic Society, 1971.

‗‗‗‗‗‗ 'Bridges: Internal and External Formal Relationships in Vietnamese Ceramics of the 11th-16th Centuries', in Southeast Asian Ceramic Society, *Vietnamese Ceramics*, Singapore, 1982, pp. 1-12.

Wirgin, J., 'Some Ceramic Wares from Chi-Chou', *Bulletin of the Museum of Far Eastern Antiquities*, No. 34 (1962), pp. 53-71.

‗‗‗‗‗‗ 'Sung Ceramic Designs', *Bulletin of The Museum of Far Eastern Antiquities*, No. 42 (1970).

Wisseman, J., 'Markets and Trade in Pre-Majapahit Java', in K. L. Hutterer (ed.), *Economic Exchange and Social Interaction in Southeast Asia: Perspectives from Prehistory, History and Ethnography*, Ann Arbor, University of Michigan, 1977a, pp. 197-212.

‗‗‗‗‗‗ 'Archaeological Research in Rembang District, North Central Java, 1975', *Indonesia Circle*, No. 13 (1977b), pp. 8-14.

Wolters, O. W., 'Tambralinga', *Bulletin of the School of Oriental and African Studies*, Vol. XXI (1958), pp. 587-607.

‗‗‗‗‗‗ *Early Indonesian Commerce*, Ithaca, Cornell University Press, 1967.

‗‗‗‗‗‗ *The Fall of Srivijaya in Malay History*, Ithaca, Cornell University Press, 1970.

‗‗‗‗‗‗ 'Studying Srivijaya', *JMBRAS*, Vol. 52, Pt. 2 (1979a), pp. 1-32.

‗‗‗‗‗‗ 'A Note on Sungsang Village at the Estuary of the Musi River in Southeastern Sumatra: A Reconsideration of the Historical Geography of the Palembang Region', *Indonesia*, 27 (1979b), pp. 33-50.

‗‗‗‗‗‗ *History, Culture, and Region in Southeast Asian Perspectives*, Singapore, Institute of Southeast Asian Studies, 1982.

‗‗‗‗‗‗ 'A Few and Miscellaneous *Pi-chi* Jottings on Early Indonesia', *Indonesia*, 36 (1983), pp. 49-65.

Wong, G., 'The Exportation of Chinese Han Pottery to Southeast Asia', *Heritage*, I (1977), pp. 1-14.

‗‗‗‗‗‗ 'A Comment on the Tributary Trade between China and Southeast Asia, and the Place of Porcelain in this Trade, during the Period of the Song Dynasty in China', *The Southeast Asian Ceramic Society Transactions*, No. 7 (1979).

Woodward, H. W., 'A Chinese Silk Depicted at Candi Sewu', in K. L. Hutterer (ed.), *Economic Exchange and Social Interaction in Southeast Asia: Perspectives from Prehistory, History and Ethnography*, Ann Arbor, University of Michigan, 1977, pp. 233-44.

‗‗‗‗‗‗ 'The Dating of Sukhothai and Sawankhalok Ceramics: Some Considerations', *JSS*, Vol. 66, Pt. 1 (1978), pp. 1-7.

Wu Ching-Hong, 'The Rise and Decline of Ch'uan-chou's International Trade and Its Relation to the Philippine Islands', *International Association of Historians of Asia*, Taipei, 1962, pp. 469-83.

Yabe, Y., 'Chinese Ceramics of the 12th to 14th Century Excavated in Japan', in *International Symposium on Chinese Ceramics*, Seattle Art Museum, 1977, pp. 57-66.

‗‗‗‗‗‗ *Tai Betonamu no Tōji (Ceramics of Vietnam and Thailand)*, Tōji Taikei, Vol. 47, Tokyo, Heibonsha, 1978.

Yamato Bunkakan Museum, *Southeast Asian Ceramics*, Nara, Yamato Bunkakan, 1983.

Yamawaki, Teijirō, 'The Great Trading Merchants, Cocksinja and His Son', *Acta Asiatica*, No. 30 (1976), pp. 106–16.

Ye Wencheng and Xu Benzhang, 'The Extensive International Market for Dehua Porcelain', *Oriental Ceramic Society Chinese Translations*, No. 10, 1982, pp. 1–15.

Youn Moo-Byong and Chung Yang Mo, *The Sunken Treasure off the Sinan Coast*, Tokyo, Tokyo National Museum, 1983.

Yule, H., *Cathay and the Way Thither*, 4 vols., London, Hakluyt Society, 1913–16.

Zainie, C. M., 'The Sinan Shipwreck and Early Muramachi Art Collections', *Oriental Art*, Vol. 25, No. 1 (1979), pp. 103–14.

Zainie, C. and Harrisson, T., 'Early Chinese Stonewares Excavated in Sarawak 1947 to 1967', *SMJ*, Vol. XV, No. 30–31 (1967), pp. 30–90.

Zhao Rugua (Chau Ju-kua), *Chu-fan-chi*, translated by F. Hirth and W. W. Rockhill, St. Petersberg, Imperial Academy of Sciences 1911 (reprinted Amsterdam, 1966, and Taipei, Ch'eng Wen, 1967). *See also entry under* Hirth, F. and Rockhill, W. W.

Zhou Daquan (Chou Ta-Kuan), *Notes on the Customs of Cambodia*, Bangkok, Social Science Association Press, 1967.

Index

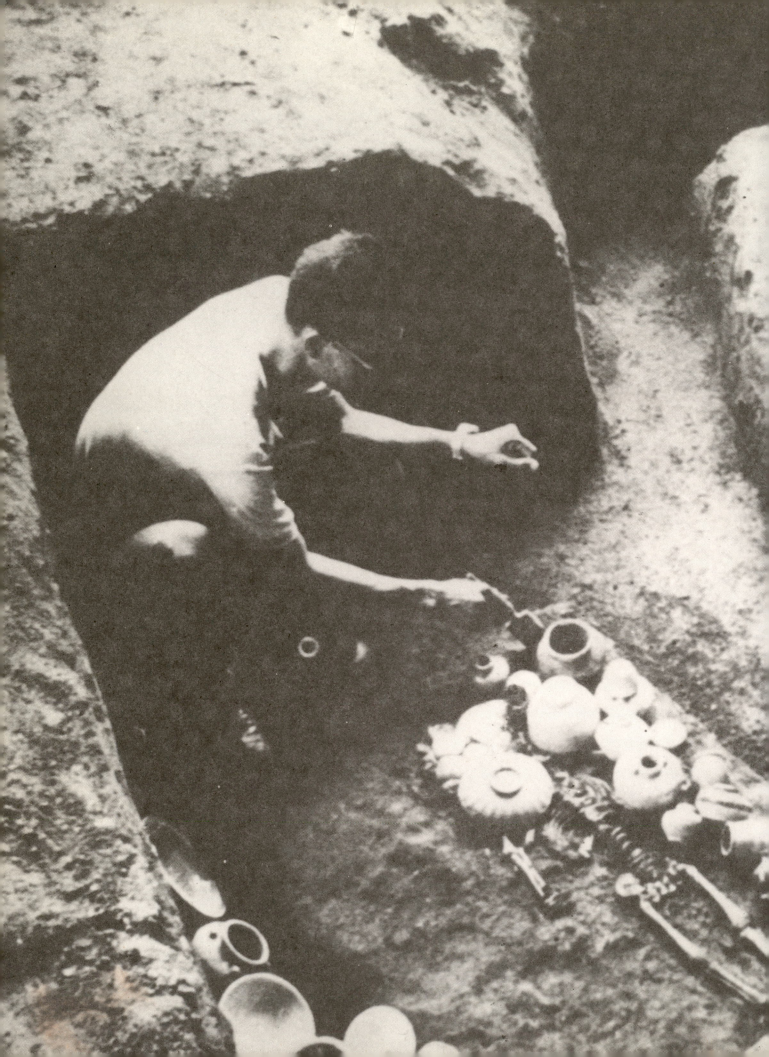